DEGAS,
SICKERT AND
TOULOUSE-LAUTREC
LONDON AND PARIS
1870–1910

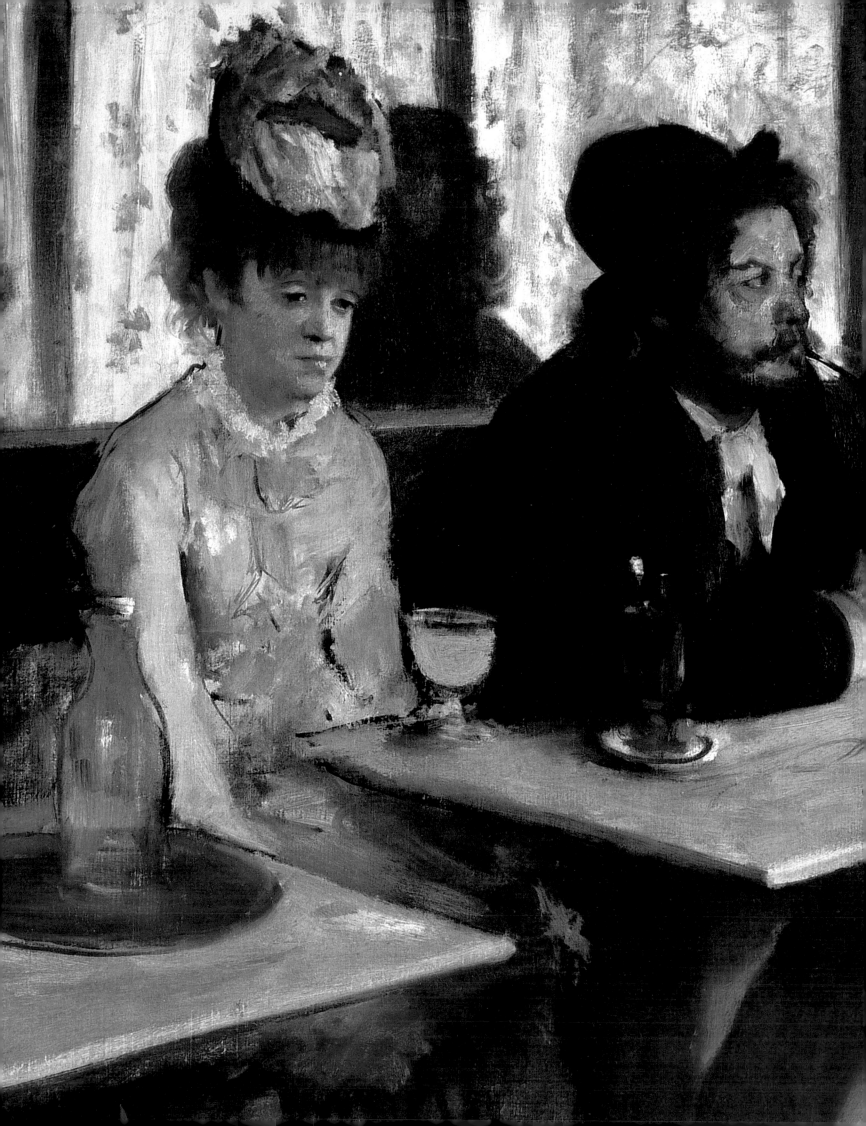

Anna Gruetzner Robins and Richard Thomson

DEGAS, SICKERT AND TOULOUSE-LAUTREC

LONDON AND PARIS

1870–1910

Tate Publishing

Sole Sponsor

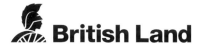 **British Land**

First published 2005 by order of the Tate Trustees
by Tate Publishing, a division of Tate Enterprises Ltd,
Millbank, London SW1P 4RG
www.tate.org.uk/publishing

on the occasion of the exhibition
Degas, Sickert and Toulouse-Lautrec
London and Paris 1870–1910

TATE BRITAIN, LONDON

5 October 2005 – 15 January 2006

and touring to

THE PHILLIPS COLLECTION, WASHINGTON, DC

18 February – 14 May 2006

Cover:
Edgar Degas,
Dancers in the Rehearsal Room
c.1882–5
(no.43, detail)

Frontispiece:
Edgar Degas,
L'Absinthe 1875–6
(no.42, detail)

British Library Cataloguing in Publication Data
A catalogue record for this book is available from the British Library

ISBN 1-85437-634-9 (hbk)
ISBN 1-85437-548-2 (pbk)

Distributed in the United States and Canada
by Harry N. Abrams, Inc., New York

Library of Congress Cataloging in Publication Data
Library of Congress Control Number: 2005930846

Printed in Italy by Conti Tipocolor, Florence
Typesetting and page layout by Richard Hollis

Measurements of artworks are given in centimetres,
height before width and depth, followed by inches.

SPONSOR'S FOREWORD

Degas, Sickert and Toulouse-Lautrec – what a trio of evocative names! They are the three leading artists in this new exhibition at Tate Britain which is sponsored by British Land.

The exhibition explores the creative dialogue between British and French artists in the late nineteenth and early twentieth centuries, showing particularly the influence of the work of French artists in Britain and also identifying the exchange of artistic ideas between Britain and France during this seminal period in the development of modern art.

While the works of Degas, Sickert and Toulouse-Lautrec form the heart of the exhibition, it also presents what were then innovative depictions of life at that period by other prominent painters, such as Pierre Bonnard, Edouard Vuillard and James Whistler, as well as James Tissot, Henri Fantin-Latour and William Rothenstein.

British Land's sponsorships for Tate Britain began in 1990 with *Wright of Derby* and continued with *Ben Nicholson* in 1993 and *Gainsborough* in 2003. We are more than pleased to be at the Tate again for this inspired adventure.

John Ritblat
Chairman
The British Land Company PLC

FOREWORD

The old cliché that the words 'British' and 'modern' do not properly belong together may rarely be voiced these days, but there is some lingering suspicion that, until relatively recently, Britain lagged behind Europe and the United States in an appreciation of the avant-garde in the visual arts. In particular, it is imagined that British artists and critics were unable to respond to the vibrant, daring innovations of French art in the late nineteenth and early twentieth centuries. The bright colours, strident compositions and frank subject matter associated with Impressionism have been seen as anathema to British taste, appreciated too little, too late. But although our exhibition *Turner Whistler Monet* and much recent scholarship have disturbed that comfortable, traditional assumption of British art's position in a kind of eternal lay-by alongside the road of modernism, old prejudices die hard. This is in itself an incentive – especially in a gallery such as Tate Britain where the very idea of a history of art structured by national schools can be most poignantly questioned – to take further an investigation into how creative international dialogues evolve, how they are structured, and what impact they have on the creation of great works of art.

The present exhibition sets out to explore such territory at the end of the nineteenth century. Our guest curators, Richard Thomson, Watson Gordon Professor of Fine Art at the University of Edinburgh, and Anna Gruetzner Robins, Reader in History of Art at the University of Reading, are to be congratulated for assembling an exhibition which provides such a full and persuasive argument for the fundamental importance of the dialogue between British and French artists in the years that gave birth to modern art. By highlighting the profoundly influential and innovative work of Edgar Degas, Henri de Toulouse-Lautrec and Walter Richard Sickert, they bring into clear focus the complex web of artistic influences and friendships that underpinned the development of modern art in London and in Paris, and the vital role of critics and exhibitions, collectors and tastemakers, and of the modern city itself – as subject matter and aesthetic stimulus. They have selected outstanding works of art by Degas and Toulouse-Lautrec and their contemporaries in France, and matched them with an extraordinary range of works by British artists – Sickert most prominently, but also Philip Wilson Steer, William Rothenstein, Elizabeth Forbes, Charles Conder, Arthur Melville and many others. Here, we believe for the first time, Sickert and his peers are placed in a properly European context, as partners to their generally more celebrated French contemporaries. Not only were these artists closely linked, and in constant practical dialogue, but they were as individuals very often of a distinctly cosmopolitan character. Sickert, for example, was born in Germany to a Danish father and Anglo-Irish mother, raised and trained in Britain, and periodically based in France. Giuseppe de Nittis, meanwhile, an Italian practising in Paris, produced brilliant depictions of London life. The dynamic nature of such interchange defies any crudely reductive definition of a British artistic identity in these years.

There is, in fact, much evidence of the early enthusiasm of British artists, critics and collectors – and the art-loving public at large – for the most advanced, innovative and sometimes controversial kinds of modern art in the period 1870–1910. The earliest work by Degas to enter a British national collection was *The Ballet Scene from Meyerbeer's Opera 'Robert le Diable'* (1876; no.23). This was bought by the London-based collector Constantine Ionides in 1881, and given to the Victoria and Albert Museum in 1900. The exhibition includes many other works by prominent French artists seen, appreciated and purchased in Britain during these decades, and highlights the important exhibitions of works by Degas and Toulouse-Lautrec. True, as Anna Gruetzner Robins shows, there was much in the way of dismissive criticism when Degas's remarkable *L'Absinthe* (1875–6; no.42) was shown in London in 1893, criticism which conforms to the most pessimistic accounts of the reactionary tastes that prevailed in Britain. But there were also the signs of a deeper understanding, and a genuine appreciation of a work of art which – when we discover the true nature of its subject – remains shocking even now. Amongst much else, I hope this exhibition is a testament to the ability of art to surprise, unsettle, excite and inspire gallery visitors both in the past and today.

The exhibition contains many exceptional and delicate works of art whose absence from the collections of their owners will, I know, be keenly felt. The support of all our lenders, institutional and private, is warmly appreciated, as our curators' acknowledgements testify. I would like to add to their thanks my own gratitude to the Tate staff who have brought this major show to fruition. Judith Nesbitt, Chief Curator at Tate Britain, has skilfully guided the organization of the project with the close support of Catherine Putz, Exhibitions Co-ordinator, and Gillian Buttimer, Exhibitions Registrar. Martin Myrone, Curator of Eighteenth and Nineteenth-Century Art, has shaped and managed the project from day to day over several years, and has had,

as always, a considerable impact on the shape and content of the finished exhibition. In this he has been closely supported by Heather Birchall, Assistant Curator, who has been inexhaustible in her commitment to the project; she has also contributed the biographies and the chronology that appear in this publication. I would also like to thank Robert Upstone, Curator, Modern British Art, Tate Collection, for his help and advice on countless fronts, and Sarah Hyde, Head of Interpretation, for the lucid and informative gallery texts and interpretative materials within the exhibition.

The four essays by Richard Thomson and Anna Gruetzner Robins published here demonstrate the depth of scholarship which has informed the selection of works, the range of reference of our curators, and, in my view, the incisive character of their judgements. To them my warmest thanks. The production of the catalogue has been overseen by Nicola Bion: with Leigh Amor, Picture Researcher, and Emma Woodiwiss, Production Controller, Nicola has faced an unusually complex production and a challenging schedule. The exhibition itself was designed and installed by Alan Farlie of RFK Architects, and his team. This is their third major exhibition for us, after *Pre-Raphaelite Vision* in 2003 and *Turner Whistler Monet* in 2005; we greatly admire their work.

Following its run in London, the exhibition will be seen at The Phillips Collection, Washington, DC, an institution with whom we are delighted and honoured to collaborate for the first time. We are very grateful to those many lenders who have been able to send their works to this second venue. At The Phillips Collection we should particularly salute the Director, Jay Gates, and thank Eliza Rathbone, Chief Curator and Director of Curatorial Affairs, for her enthusiastic support of the exhibition from its earliest stages, and her close attention to its progress and realisation.

In London, the exhibition has been sponsored by British Land. I would like to express my personal thanks to its Chairman, John Ritblat, for his wholehearted commitment to this project from the outset. His support for British art over the years, and for Tate, has been consistent and remarkable.

Stephen Deuchar
Director
Tate Britain

ACKNOWLEDGEMENTS

Anna Robins and Richard Thomson would especially like to thank: Stijn Alsteens, Institut Néerlandais, Paris; David Beevers, The Royal Pavilion, Libraries and Museums; Richard Beresford, Art Gallery of New South Wales; Patrick Bourne, Fine Art Society; The British Academy; Ruth Bromberg; Roger Brown, University of Reading; Hans Buis, Institut Néerlandais; Hélène Carrère d'Encausse, President of the Commission des Bibliothèques et Archives de l'Institut de France and Secretary of the Académie Française; Georgina Catt, Fine Art Society; Michael Clarke, National Galleries of Scotland, Edinburgh; Alexandra Corney, Victoria and Albert Museum, London; William Darby, Browse and Darby; Danièle Devynck, Musée Toulouse-Lautrec, Albi; Pauline Dey, Dunford House; Douglas Druick, Art Institute of Chicago; Ann Dumas; Patricia Evans; Kate Arnold Foster, University of Reading; Frances Fowle, National Galleries of Scotland, Edinburgh; Antony Griffiths, British Museum; Vivien Hamilton, Glasgow Museums; Martha Harron; The Houghton Library, Harvard University; John House, Courtauld Institute of Art; Barry Humphries; Richard Kendall; Ellen Lee, Indianapolis Museum of Art; Simon Lee, University of Reading; Tim McCann, West Sussex Public Record Office; Margaret MacDonald, Centre for Whistler Studies, Glasgow; Andrew McIntosh Patrick, Fine Art Society; Andrea Martin, Usher Gallery, Lincoln; Mme Mireille-Pastoureau, Bibliothèque de l'Institut de France; Jane Munro, Fitzwilliam Museum, Cambridge; Anna Mustonen; Maureen O'Brien, Rhode Island School of Design; Christine Penney, Special Collections, University of Birmingham; Gill Perry, Open University; Christopher Riopelle, National Gallery, London; Joseph Rishel, Philadelphia Museum of Art; Pamela Robertson, Hunterian Museum and Art Gallery, Glasgow; David, Daniel and Sophie Robins; Jane Sargent, Fitzwilliam Museum, Cambridge; Susan Alyson Stein, The Metropolitan Museum of Art, New York; Peyton Skipwith, Fine Art Society; Amy Smith, University of Reading; Evelyn Smith and Jenni Spencer Davies, Glynn Vivian Art Gallery and Museum, Swansea; Ann Steed, Aberdeen Art Gallery; MaryAnne Stevens, Royal Academy of Arts, London; Matthew Sturgis; Belinda Thomson; Nigel Thorp, Centre for Whistler Studies, Glasgow; Lisa Tickner, Middlesex University; Margaret Timmers, Victoria and Albert Museum, London; Gary Tinterow, The Metropolitan Museum of Art, New York; Angus Trumble, Yale Center for British Art, New Haven; John Zarobell, Philadelphia Museum of Art. We are particularly grateful to Henri Loyrette who, when Director of the Musée d'Orsay, Paris, immediately recognised the crucial importance of *L'Absinthe* for the exhibition, and to his successor Serge Lemoine.

At Tate we are especially grateful to Nicholas Serota and Stephen Deuchar, to Sheena Wagstaff for her initial interest in such a project, to Martin Myrone and Heather Birchall with whom we have worked closely on the project, Meg Duff, Adrian Glew, Sarah Hyde, Judith Nesbitt, Robert Upstone, Victoria Walsh and the staff of the Hyman Kreitman Research Centre, and at Tate Publishing to our Editor, Nicola Bion, and Production Controller, Emma Woodiwiss. We have been most fortunate with our designers, Alan Farlie for the exhibition and Richard Hollis for the catalogue. We must also thank John Ritblat and The British Land Company PLC for their invaluable support.

Richard Thomson and Anna Gruetzner Robins

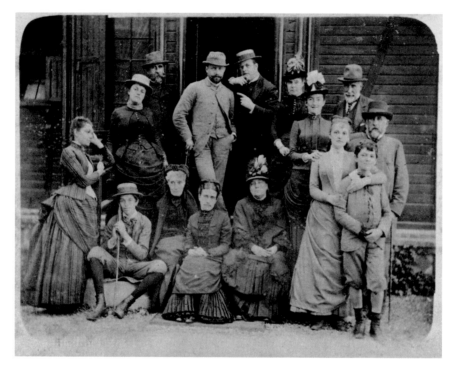

fig.1
Friends at Dieppe, 1895
Photograph from a glass negative
Bibliothèque Nationale de France, Paris
Back row from left:
Ludovic Halévy, Walter Sickert, Jacques-Emile Blanche and Ellen Sickert;
Degas is on the far right, below Albert Cavé.

INTRODUCTION

Anna Gruetzner Robins and Richard Thomson

In the mid-1870s the most significant single holding of the works of Edgar Degas, then one of the most advanced artists in Europe, was the collection of Captain Henry Hill, in Brighton. The following decade, a group of British artists and critics, with Walter Sickert at their head, promoted Degas's reputation as a 'great artist'. The largest exhibition of the work of Henri de Toulouse-Lautrec during his lifetime was held in London, at the Goupil Gallery in Regent Street, in 1898. During the 1900s, Sickert made his mark as a modern artist in Paris. These four abrupt statements of fact may seem surprising. For surely a cursory purview of the dynamic in late nineteenth-century British and French art would place on the one side aesthetics such as late Pre-Raphaelitism and Leighton's classicism, and on the other Impressionist *sensation* and Symbolist *synthèse*, quite contrasting directions in artistic endeavour. However, the engagement between Britain and France between 1870 and 1910, the four decades broadly covered by this exhibition, was much more intense and stimulating, commercial and contested, than is usually acknowledged. What we have sought to explore is the depth and intricacy of that dialogue.

The dialogue took place at a number of different levels. First, French art was quite widely exhibited in London, at dealers' galleries and at institutional shows. Of course this applied to established landscape painters and renowned figures from the Paris Salons, but also – and perhaps surprisingly – to more radical artists, whose reputations were still controversial in Paris. Degas, for example, made a point of having his work seen in London in the mid-1870s. His work sold, his reputation increased, and by the 1880s his standing in Britain was considerable. Thus another dimension to this dialogue is collecting. Degas had a very notable success with British collectors, whereas Lautrec, despite his impressive reputation in 1890s Britain as a poster designer, did not. Exhibitions attracted not only purchasers but critics. As journalists, art critics brought into play a combination of professional acumen, personal taste and – when writing about foreign art – national prejudices, which, in the case of Degas's *L'Absinthe* in 1893, provoked aesthetic and Francophobic confrontation.

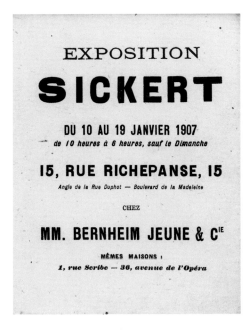

fig.3
Catalogue for Sickert's exhibition at theBernheim Jeune gallery,
Paris, 1907

There is another dimension. For this was a genuine dialogue. While there is no doubt that Degas, for one, was a dominant and paradigmatic figure, British artists made their impact in France and on French artists. When William Rothenstein and Charles Conder exhibited in Paris in 1892 they made sales, and the show was appreciatively visited by Degas and Camille Pissarro. Walter Sickert, in particular, was a real cosmopolitan. At the turn of the century he was a French resident, at Dieppe, and during the 1900s he, Pierre Bonnard and Edouard Vuillard engaged in a

fig.2
Invitation card to Toulose-Lautrec's exhibition
at the Goupil Gallery, London, 1898

fig.4
Degas and Sickert, Dieppe 1885

three-way conversation with their painting. This exhibition breaks new ground in presenting these exchanges, inter-relationships and rivalries on the wall. By showing paintings by Degas alongside those by James Tissot or Sickert, by juxtaposing Sickert's with Vuillard's, we allow the works themselves to suggest their own divergences and consonances.

The exhibition is about a particular kind of art: based on the human figure, drawing its subjects chiefly from metropolitan life. In many ways, but not exclusively, the show centres on art made in and about the two capital cities, London and Paris. Painting is at the centre of the show, as artists grappled with a medium by the later nineteenth century heavy with cultural expectations, trying to manipulate it to articulate what they saw as the visual imperatives demanded by modern existence, at once dynamic, fluid and ambiguous. Prints of different kinds also feature, as purveyors of new possibilities and as outreach to wider publics. Central to the dialogues the exhibition explores is the body, the artist's primary material, but also – in its pose, costume and context – a vital means of articulating notions of modernity: who people were, how they interacted, how the body conveyed individuality in the flux of the everyday. Focus on the body has suggested the inclusion of some sculpture, itself in dialogue with painting. Pictorial composition too is pivotal. The ways in which pictures were put together, perhaps by clustering or cropping figures, by stressing perspectives or leaving voids, were contrived to give a sense of momentary perception in the urban environment. New pictorial means for new social and perceptual experience: that search for visual equivalents to the pulses of modernity preoccupied artists on both sides of the Channel.

Contemporaries were conscious of the inconsistencies between British and French art. In his review of the inaugural exhibition at the Grosvenor Gallery in 1877 Henry James, writing with the objectivity of a cultivated American, observed: 'The pictures, with very few exceptions, are "subjects"; they belong to what the French call the anecdotical class. You immediately perceive, moreover, that they are subjects addressed to a taste of a particularly unimaginative and unaesthetic order – to the taste of the British merchant and paterfamilias and his excellently regulated family.'[1] Twenty years later the Anglo-Irish novelist George Moore could only concur about conformity and bad taste in the proliferation of 'The same articles ... vulgarly painted sunsets, vulgarly painted doctors, vulgarly painted babies.'[2] Both condemned British taste for, and British artists' provision of, art that was facile, descriptive and illustrative. James's account of the

Royal Academy summer exhibition in 1878 identified what he found was lacking in British art: 'you immediately see that the exhibition is only in a secondary sense *plastic* [his italics]; that the plastic is not what English spectators look for in a picture, or what the artist has taken the precaution of putting into it.'[3]

By 'plastic' James meant both a manipulation of form and a consciousness of the formal possibilities of the medium. Increasingly artists of progressive inclination in Britain were striving to achieve this. The modern position was consistently articulated in Sickert's writings. When he defended James Whistler's economical drawing by saying that it instinctively understood 'the music of spaces' or when he described a singer in a music hall leaning forward so that she was set off against the 'sombre tones' of the audience because she was caught in 'a ray of green limelight' and the 'yellow radiance of the footlights' Sickert was celebrating the 'plastic'.[4] At essence, this is an exhibition about artists manipulating the 'plastic' to the modern, exploring combinations of formal possibilities and quotidian subjects, engaging in dialogue with other artists the better to express one's own temperament.

The primary linking theme of this exhibition is Degas and Britain: his friendships with British artists, with French artists working in Britain, the high regard for his work amongst British critics, and his popularity with British collectors. Degas had an extensive network of contacts in London. These friendships proved to be a springboard for cementing his reputation amongst British artists, critics, and collectors of the next generation. An ever extending circle of British admirers included Sickert, who was taking an interest in Degas before they first met in 1883, Rothenstein who was taught by Alphonse Legros, Degas's old friend, and the critics D.S. MacColl, George Moore and Roger Fry who all made tracks to Degas's Paris studio.

From the 1870s Degas had an appreciative critical following in Britain. Sidney Colvin's description of 'the scheme of various whites, gauzes and muslins … without a shadow of … sentiment' in Degas's *Dance Class at the Opéra* (1872, Musée d'Orsay) foreshadows the enthusiastic and perceptive reception accorded to Degas by later British writers.[5] During the following decade Degas's cause was taken up by the critic Frederick Wedmore, the novelist and critic George Moore, who claimed that Degas was 'one of the greatest artists the world has ever known', and Sickert, who repeated Moore's sentiment countless times. Degas's rise to stardom in Britain during the 1880s interlinked with the burgeoning of a celebrity culture catering for a mass-market

interest in living artists. He was seen simultaneously to be a modern artist with a great talent as a draughtsman, but whose lineage could be traced back to the Old Masters, so preparing the ground for his public acceptance.

In the 1890s the writers who are best known for their support for Degas at the time of the controversy over *L'Absinthe* developed a new critical language to describe the pictorial qualities of his art. No other Impressionists matched Degas's critical reputation in Britain. The campaign to link Degas with a past tradition of art probably explains why Degas's *Robert le Diable* (no.23), from the Constantine Ionides collection, was the first Impressionist painting to enter a British public collection when the Victoria and Albert Museum accepted it as a gift in 1900. Pictures quickly entered other public collections. But these represent a small proportion of the objects in various media by Degas bought by British collectors in this period. Between 1872 and 1910, his work was exhibited on at least forty separate occasions in Great Britain and Ireland. The dealer Paul Durand-Ruel paved the way by showing two Degas pictures in 1872 in London, one of several Impressionist shows in the city that he organised before staging a spectacular exhibition of French Impressionism in 1905 with thirty-five works by Degas.

The networks of friendships between Degas and artists with links to Britain, British critics, and British collectors that this exhibition explores add another dimension to the early historiography of Degas. The efforts to market Lautrec's work in London in the later 1890s might be seen as an attempt to capitalise on Degas's established reputation. Finally, the exhibition crosses the Channel and explores Sickert's contacts, not just with Degas, but with other French artists, dealers, critics and collectors. Sickert had a considerable standing in Paris. Perhaps more than any other modern British artist before 1910 Sickert gained the respect of the French.

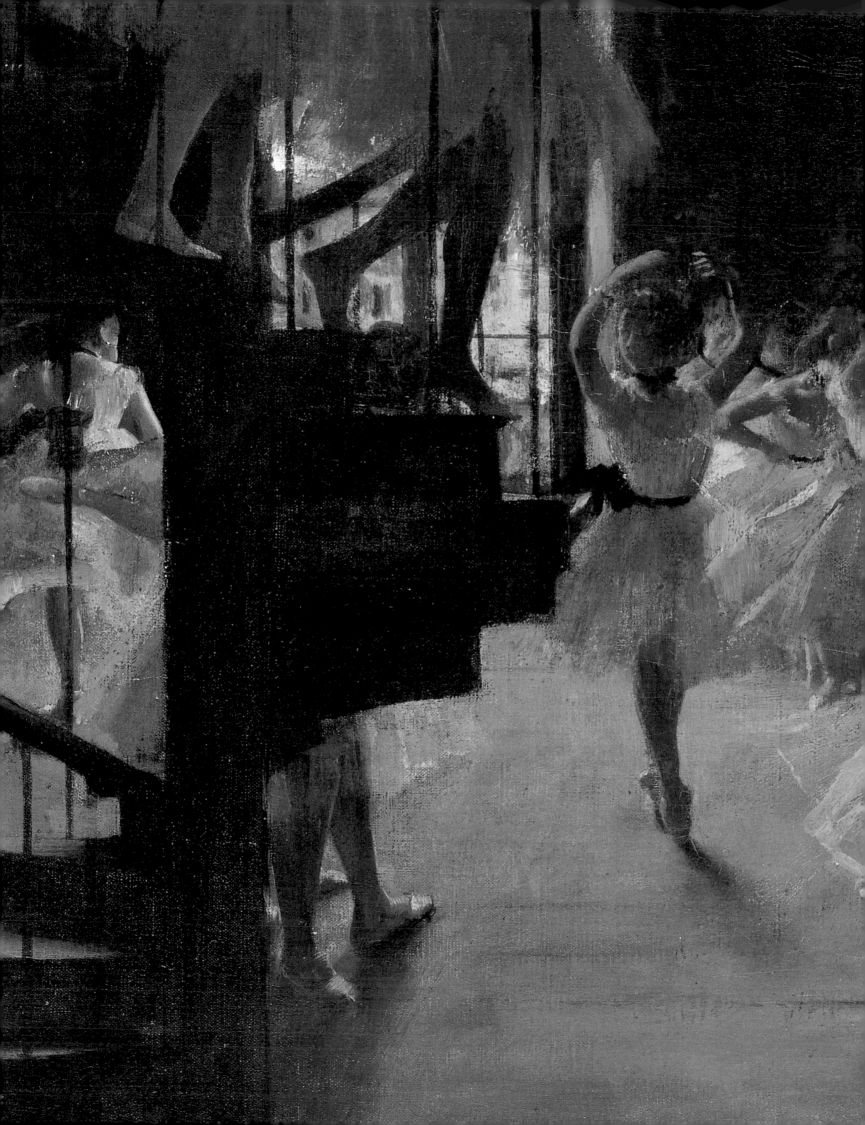

Richard Thomson

MODERNITY, FIGURE, METROPOLIS
IMPORTING THE NEW PAINTING TO BRITAIN IN THE 1870s

LONDON AND ITS FRENCH VISITORS

1870: Great Britain was in her imperial pomp. Industrial and commercial giant of Europe, the heavy industries of the Midlands, the textile mills of Yorkshire and the North-West, the shipyards of the Tyne and the Clyde, and the coalmines of South Wales fuelled her economic strength. With a global empire that embraced the vast dominions of Canada, India and Australia, ruled Caribbean islands and Pacific archipelagos, and was spreading its reach through the dark continent, Africa, Britain's power was unparalleled. She had adeptly kept her distance from disruptive continental struggles, refusing France's pleas to intervene in her catastrophic war with Prussia and the German states, which had seen Paris besieged over the winter of 1870–1, with abject defeat and the civil war of the Paris Commune rapidly ensuing. Pax Britannica reigned and prospered.

The great turbine that drove the empire, the hub of the imperium, was London. It was there that laws were drafted, policies were defined, far-reaching decisions about finance, trade, colonisation or military intervention were made. Such a motor was a spectacle itself, the world's greatest metropolis, and was, by its very nature, in a constant state of regenerative flux. The 1871 census gave London's population as 3,254,260.[1] This was almost twice as much as Paris's 1.8 million, though the French capital had grown more rapidly over the last twenty years, owing to industrial expansion and the redevelopment of the city under the Prefect of the Seine, Georges Haussmann. Significant as Haussmann's changes had been – creating new parks and thoroughfares, building markets, improving sewerage and lighting – London had not lagged behind her French neighbour. Established in 1855, the Metropolitan Board of Works had given a coherent lead in the improvement of roads and drainage. By the late 1870s gas lighting, introduced in the first two decades of the nineteenth century, was increasingly giving way to the cleaner and less stuffy electricity. Richard D'Oyly Carte's Savoy Theatre, for instance, converted in 1881.[2] Indeed, in 1863 London opened the world's first underground railway, an achievement only emulated by Paris in 1900.

Innovations in transport and communications were continuous and incremental. With the opening of Liverpool Street Station in 1874 commuters were delivered close to their City offices, while the advent of Bank tube station in 1900 brought them even closer.[3] William Preece brought the first pair of telephones to Britain in 1877, following their invention in the United States the previous year. 1878 saw the first telephone lines erected, linking Hay's Wharf to its office across the Thames, and in 1879 the first public telephone exchange was opened, at 36 Coleman Street, with eight subscribers. By 1902 the capital had five exchanges: Central, City, Mayfair, Victoria and Western. Here was the dynamic city, a metropolis constantly mutating under the pressures of population, business and progress, adapting to the accelerating pace of late nineteenth-century life and the new technologies that propelled it. At one level, the modernity of late Victorian London articulated itself by its very incoherence, by a ramshackle energy that many visitors admired. Writing in the *Galaxy* in August 1877, the American writer Henry James suggested that London 'pleases by accident, by contrast, and by the immensity of its scale. It is an enormous, opulent society expanding to the enjoyment of the privileges and responsibilities of wealth and power, with nothing of that amiable coquetry of attitude toward the public at large which seems somehow to animate the performers in the Parisian spectacle.' A similar response was elicited in a quite different medium by the French printmaker Félix Buhot. His *Westminster Bridge*, crafted in 1884, combines a multiplicity of images with a rich *cuisine* of techniques to evoke the London that James described as 'such a vast amount of human life, so complex a society' (fig.5).[4] Buhot hid the bridge beneath a chaotic welter of traffic and people, offsetting the far silhouette of the Houses of Parliament against a building under construction, control against progress. The barely contained energies of the central images brim over into the multiple marginal motifs, the shipping and port scenes redolent of commerce and the speeding train in rushing perspective of modernity's dynamic.

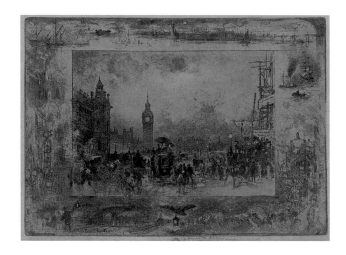

fig. 5
Félix Buhot: *Westminster Bridge*, 1884
Etching, dry-point and roller, 39.7 × 28.3 | 15⁷/₈ × 11¹/₈
Arsène Bonafous-Murat, Paris

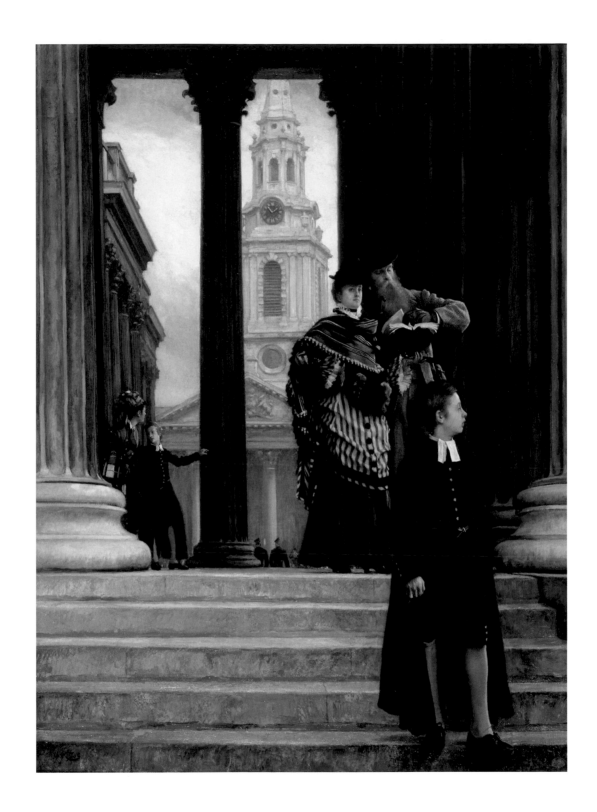

1
James Tissot
London Visitors c.1874
Oil on canvas 86.3 × 63.5 | 34¼ × 24¾
Milwaukee Art Museum, Layton Art Collection,
Gift of Frederick Layton

Both American writer and French printmaker were responding to the spectacle of contemporary London, attempting to convey the city's modernity, an amalgam of the huge and harsh, kaleidoscopic and elusive. British artists also strove, in their different idioms and media, to give visual accounts of modern urban experience. One can easily inventory solutions, unitary or serial, as divergent as Ford Madox Brown's intricate and long-pondered canvas *Work* (Manchester City Art Gallery), first shown in 1865; the damp, moonlit northern streets and ports of Atkinson Grimshaw's paintings; or the profusion of often brilliantly observed fragments of city life that appeared cumulatively in the wood engravings of the *Illustrated London News* or the *Graphic*. But while the later Victorians were fascinated by the metropolitan spectacle – evident from the prose and poetry of writers as various as Anthony Trollope and George Gissing to Richard Le Gallienne and Hubert Crackenthorpe – British painters had shied, it might be argued, from gearing advanced pictorial devices and concepts to the complexities of the modern metropolis. James Whistler, like James an expatriate American, was arguably the only artist to have consistently attempted this in London during the 1870s, his efforts resulting in the humiliating setback of his confrontation in court with the critic John Ruskin in 1877. Moreover, the Grosvenor Gallery, established by Sir Coutts Lindsay in 1877, may have been a challenge to the trite conservatism of the annual Royal Academy exhibitions, but it was at essence a commercial initiative, designed to create an élite in British art, not an avant-garde. In the main, British painting in the 1870s flourished in a diversity – of classical subjects, costume pieces, genre paintings and landscapes – which did little or nothing to encourage an active engagement with how to represent the intractable fluidity of the modern metropolis.

French artists, however, did have the representational means and the aesthetic notions that could engage with the contemporary city in ways which their British colleagues, as yet, could not. A key exemplar of this is James Tissot. Born in the commercial city of Nantes in 1836 and trained at the Ecole des Beaux-Arts in Paris during the late 1850s, Tissot undoubtedly understood painting as a lucrative career. During the 1860s he made money with costume subjects which – varied in theme, sophisticated in body language, and highly finished – won him success in the Second Empire Salons. Having served in the Siege of Paris, Tissot seems to have calculated that post-war France would not suit his ambitions nearly as well as flourishing London, where he settled in 1871. The following year he exhibited at the Royal Academy, later switching to the Grosvenor Gallery, and in the eleven years he lived in London he earned 1,200,000 francs, a very considerable sum.[5] In 1874 Tissot exhibited *London Visitors* (Toledo Museum of Art) at the RA, a canvas whose success required him to paint a smaller reduction, no doubt for another sale (no.1). The art critic of *The Times* approvingly described the theme of this 'thorough approximation of English types and subjects by this clever French painter. A young country gentleman and his young wife are standing under the portico of the National Gallery. He consults his guidebook or catalogue; she, looking rather bored, points towards Whitehall.'[6] But whereas for *The Times*'s reviewer Tissot's composition and subject were admirably clear the *Art Journal*'s critic found the picture 'without distinct and intelligible meaning'.[7]

The response of the *Art Journal* may well have been due to a perplexity aroused by the apparent incoherence of the relations between the figures. In the foreground a boy in the uniform of Christ's Hospital School drifts distractedly down the steps; behind him the couple are physically together but their concentration is divided, and the woman's gesture with her umbrella is oddly disconnected from her gaze; only the relation between the other bluecoat boy and the woman to whom he gives directions is obvious in narrative terms, and they are a subsidiary group in the rear of the picture. But Tissot's manipulation of his cast in the fiction of *London Visitors* is cunning. The subject does cohere if we read the tweedy provincial as tediously engaged with his guidebook, while his outwardly prim wife minxily catches the eye of the painting's spectator, implicitly the man who has just dropped on the steps the still smouldering cigar he was smoking while waiting for her to emerge from the National Gallery and to whom her umbrella indicates a rendez-vous when she has slipped away from her spouse.[8] Significantly, Tissot concerned himself not merely with setting up a plausible and intricate psychological incident. He couched it within the likely patterns and rhythms of urban life – the haphazardly passing boy, the dialogue in the background, the discarded cigar (omitted from the smaller version reproduced here) – while at the same time suggesting the momentary spaces that one perceives in the constant flux of the city and the odd angles – here up the steps, and then down the other side towards St Martin-in-the-Fields – that our shifting positions in space require our gaze to negotiate. In its deliberate disjunctions and the way it makes us relive our unconscious yet constant

processes of perception, as well as by its clandestine subject, *London Visitors* is a complex picture. Perhaps the critics of *The Times* and the *Art Journal* intuited that it was a painting which implied social irregularity, even adultery, and chose not to point this out to their readers; perhaps Tissot's insinuation passed them by. But however far the critics were able to construe it, *London Visitors* goes further. It combined subtle psychological plausibility with pictorial structure; it discreetly sited impropriety among the hallowed portals of art and religion, cheekily insisting that the shadowy sexual exploits described in such volumes as 'Walter's' *My Secret Life* (1888–92) sneaked themselves into the respectable street-life of the city; and it used composition to draw the spectator into the fiction of the picture, reminding us of how we see and sense the metropolis. For London, this was a new grammar for the representation of urban existence.

British and French artists regularly took the Channel packet to visit each other's capitals. As President of the Royal Academy Sir Frederic Leighton served on the jury that judged the painting at the 1878 Paris Exposition Universelle, while senior French artists such as Ernest Meissonier and Jean-Léon Gérôme were honorary Academicians. For some less established artists it was expedient to take up residence in London, where the technical expertise learnt in French art schools was at a premium. Alphonse Legros had settled in London in the summer of 1863. There he exhibited at the RA, taught drawing at the South Kensington Museum, and in 1876 became Professor at the Slade School of Art, University College London, a post he held until his retirement in 1892. Quite apart from his own distinguished if austere character as an artist and his undoubted impact on the Slade and successive generations of British students, Legros was crucial for his support to French artists visiting London.

This was particularly significant in the early 1870s. He helped the sculptor Jules Dalou, who arrived in London in spring 1871, *persona non grata* in France owing to his recent imprudent involvement in the Paris Commune. Legros found Dalou much-needed employment teaching modelling at South Kensington and secured commissions from his own prestigious patron, George Howard, Earl of Carlisle.[9] Dalou returned to France when the Communards were amnestied in 1880. Jean-Charles Cazin, formerly a fellow student with Legros at Horace Lecoq de Boisbaudran's Ecole Gratuite de Dessin in Paris, also arrived in 1871 with his painter wife Marie. They stayed until 1875, Cazin working at C.J.C. Bailey and Co's Fulham Pottery, making ceramics.[10] Another French artist who joined Legros's circle during an extended period of residence in London was Alfred Besnard. Besnard had won the grand academic Prix de Rome at the Paris Ecole des Beaux-Arts in 1874. The following year in Rome he met Charlotte Vital-Dubray, the daughter of a French sculptor based in London, who had herself won a British sculpture scholarship to study in Italy. When she returned to London in 1878 Besnard pursued her, and the next year they married.[11] The couple remained in Britain until 1883, Besnard's admiration for Reynolds and Gainsborough manifesting itself in portraits of leading figures such as Sir Bartle Frere, Admiral Sir Edmund Camberwell and Lord Wolseley. Given Besnard's major importance as an innovative decorator of public buildings in Paris between the 1880s and 1910, it is noteworthy that his first essays in mural painting were made during his British sojourn in a church in Staffordshire.[12] For

various motives – political, commercial, romantic – a number of mature and interesting French artists found their way to London in the 1870s.

Another sphere where there was a lively cross-over between French and British artists was that of caricature. The later nineteenth century was a golden age for the illustrated magazine. Periodicals given over to current events, notably the British *Illustrated London News* and the French *L'Illustration*, prudently shared topical wood-engravings. Both nations had long and lively traditions of social and political caricature, manifested in the popular press. On 7 November 1868 the journalist and socialite Thomas Gibson Bowles launched *Vanity Fair*. A weekly magazine with columns on politics, finance, public life and gossip, *Vanity Fair* distinguished itself from its rivals by including in every issue a full page caricature of a celebrity reproduced in the still uncommon medium of colour lithography. The first two caricatures published in *Vanity Fair* were, almost inevitably, the two titanic political opponents of the day, Disraeli and Gladstone (fig.6). Both were by an Italian artist, Carlo Pellegrini. Aristocratic, homosexual and unkempt, Pellegrini had arrived in Britain in 1864, soon joining the Prince of Wales's set. Throughout the 1870s he worked sporadically for *Vanity Fair*, alternating caricatures with attempts to reinvent himself as a portrait painter.[13]

Pellegrini's typical caricatures showed the figure full-length and in approximate profile. The size of the head was usually enhanced, individual features exaggerated, and characteristic mien highlighted. We do not know how Edgar Degas, who had Italian relatives and many Italian friends, met Pellegrini, but in a notebook relative to a trip to London in September 1875 he noted the caricaturist's address at 8 George Street, off Hanover Square.[14] Around that time Degas made a vivid portrait of Pellegrini (no.2). It corresponds closely to the journalist Frank Harris's description: 'hardly more than five feet two in height, squat and stout, with a face like a masque [sic] of Socrates, and always curiously ill-dressed.'[15] Degas set the figure full-length, face in profile, picking out no doubt characteristic traits such as the brandished cigarette, baggy trousers, and bowler clasped behind the back. In addition, the abruptly anonymous homage of Degas's dedication – *à lui*, to him – seems to have been a jovial play on the signature on Pellegrini's caricatures: 'Ape'.[16] (It had been 'Singe' on the first two caricatures of Disraeli and Gladstone.) Pellegrini riposted with a caricature of Degas, inscribed *à vous*.[17] Degas went beyond the constraints of the *Vanity Fair* format, of course. As was often his way in the 1870s, he took a vantage slightly above the figure, thereby stressing the tubbiness of Pellegrini's build. He also implied with ochre and green washes some kind of outdoor background, whereas the caricatures were usually devoid of any context. But the vitality and effective economy of the draughtsmanship, as well as the unerring eye for telling physical actuality, indicate how closely Degas responded to caricature and its vibrancy in London's visual culture.

If Degas was a French painter responding to British caricatures, Bowles's London periodical also employed French artists. Tissot, who had on occasion sent paintings to British exhibitions during the 1860s, had contributed sixteen drawings to the early issues of *Vanity Fair*, a direct engagement with the London art world which surely contributed to his decision to settle in London after the Franco-Prussian War.[18] These caricatures were signed 'Coïdé', perhaps because they were a collaboration between Bowles's notions and Tissot's draughtsmanship, thus '*co-idée*'.[19] Bowles employed a number of other Frenchmen as caricaturists for *Vanity Fair*: Charles Auguste Loye, who signed his work 'Montbard', the sculptor Comte Prosper d'Epinay, and from 1877–84 the gifted portrait painter Théobald Chartran.[20]

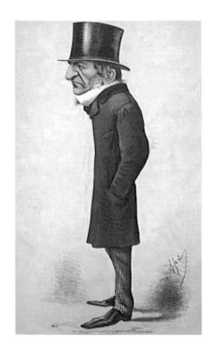

fig.6
Carlo Pellegrini
William Ewart Gladstone 1869
Colour lithograph 30.2 × 17.8 | 11⁷/₈ × 7
National Portrait Gallery, London

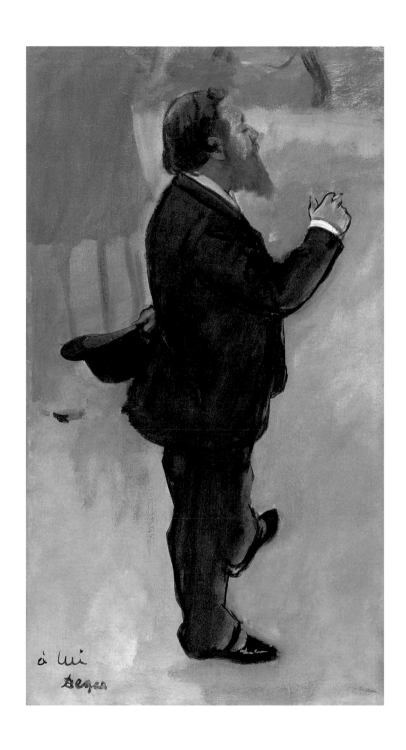

2
Edgar Degas
Carlo Pellegrini c.1876–7
Oil on paper mounted on board 63.2 × 34 | 24³⁄₄ × 13³⁄₈
Tate. Presented by the National Art Collections Fund 1916

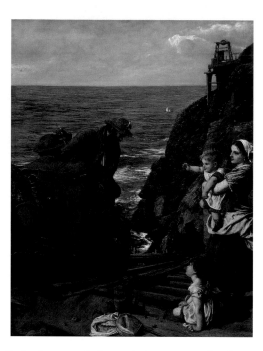

Another French artist who was highly regarded in Britain was Gustave Doré. While best known as an illustrator of books, Doré was keen both for acclaim as a serious painter of historical and religious subjects and for commercial success. London, a free market aesthetically as well as economically, seemed to offer scope which Paris, with the more doctrinaire academic taste of its art world's upper echelons, did not. Messrs Fairless and Beeforth opened the Doré Gallery in 1868, moving to another Bond Street address the following year. People paid one shilling to see Doré's prolific drawings and huge canvases, and over the twenty-three years the Gallery ran there were perhaps 2.5 million visitors.[21] In collaboration with his friend the British journalist Blanchard Jerrold, Doré produced the book *London: A Pilgrimage* in 1872. Jerrold's text and Doré's drawings, covering the slums of Whitechapel as well as more upbeat subjects such as the University Boat Race, was not only a popular success but also established a mythic image of contemporary London and Londoners. The images of the urban poor and their drab quarters 'compose no picture for the colourist', confessed Jerrold, admitting that 'all classes and ranks of Englishmen in London have the air of men seriously engaged in the sordid cares of commercial life.'[22] This construction of London was infectious. In the preface of his 1877 novel *Le Fugitive*, set in London, the French writer Jules Claretie recalled his nocturnal perambulations around the city's 'impoverished and frightening' districts in the company of the Italian painter Giuseppe de Nittis.[23] Claretie's imagination was coloured by a Doré-like horror.

British artists might also have significant reputations in France, even if they made little impact on the Parisian art market. At the most public and elevated level there were the prizes awarded at major exhibitions, such as the high-ranking medals that both Sir John Millais and Hubert Herkomer won at the 1878 Exposition Universelle. But there was another stratum of appreciation: the talk of the studios, the *succès d'estime*. One rather surprising recipient of this kind of accolade was James Clark Hook, whose stock subject was the sea and fisherfolk. In his book on British painting published for a French audience in the early 1880s, the critic Ernest Chesneau praised Hook's work at length. One painting he singled out was *From Under the Sea* (fig.7). Chesneau admired its construction, the steeply angled rails leading down to the tin-mine, the 'cliff face that cuts the composition vertically, denying infinite perspectives into the distance.'[24] Significantly, Hook's work had already attracted the attention of Degas, who at the time of the 1868 Exposition

Universelle had entered the artist's name and submission in a notebook.[25] What Hook's work offered to Degas in the late 1860s, as the French artist gradually developed what would become his sophisticated naturalistic devices, was pictorial lessons in unusual angles of vision and placement of figures.

But, if there were some instances of British painters being valued by their French contemporaries for their artistic qualities, in commercial terms the traffic was empathically the other way. This is evident from the correspondence of Degas to his friend Tissot in London. 'Why the devil did you not send me a line?', he complained in September 1871, only a few months after Tissot's establishment in London: 'They tell me you are earning a lot of money. Do give me some figures.'[26] Eighteen months later, while sojourning in New Orleans with the American branch of his family, Degas wrote to Tissot describing a painting – *The Cotton Office* (1873, Musée de Beaux-Arts, Pau) – which he had under way: 'a fairly vigorous picture which is destined for Agnew and which he should place in Manchester.'[27] The fact that Degas had targeted both a London dealer, Thomas Agnew, and an appropriate market, collectors in wealthy 'Cottonopolis', shows a grasp of the British art trade that is consistent with both his correspondence and his activities during the early and mid-1870s. Between 1871 and 1876 Degas

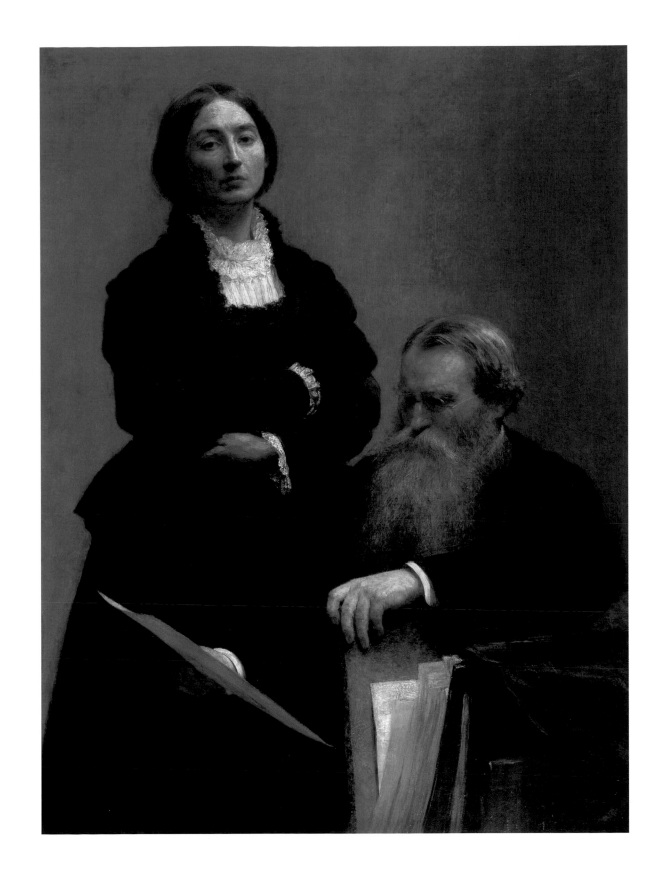

3
Henri Fantin-Latour
Mr and Mrs Edwin Edwards 1875
Oil on canvas 130.8×98.1 | 51.5×38⅝
Tate. Presented by Mrs E. Edwards 1904

occupied himself willingly with the London market, exhibiting a substantial number of paintings there and making important sales. This was commercially astute. London was a city of opportunity for French artists. Not only was it prosperous but there was also a nascent infrastructure in place, from the collegial support of the established Legros to the visible institutional success of the Doré Gallery. This infrastructure was further enhanced by the opening of a gallery, the Society of French Artists, by the Parisian dealer Paul Durand-Ruel in December 1870. Like several artists – among them the still-life and genre painter François Bonvin and the landscapists Charles Daubigny and Claude Monet – Durand-Ruel retreated to London in late 1870 as France collapsed before the Prussian-led invasion.[28] If business in Paris was to be indefinitely disrupted, it could usefully be developed in London. In essence Durand-Ruel used the accident of the Franco-Prussian War to diversify his business, following the example of the larger and longer established dealer Goupil et Cie., a French firm trading both in works of art and lucrative printed and photographic reproductions which, founded in 1827, had run a London gallery since 1841 and succursales in other major cities.[29] The effectiveness of Durand-Ruel's dual operation is evident from the case of Henri Fantin-Latour's *Coin de table* (1872, Musée d'Orsay, Paris), a group portrait of contemporary French poets including Paul Verlaine and his incendiary lover Arthur Rimbaud. Shown at the Paris Salon in the spring of 1872, and then in Durand-Ruel's Paris gallery, the picture failed to sell. The dealer shipped it to London, showing it in November at the Winter Exhibition of the Society of French Artists, where Durand-Ruel's manager Charles Deschamps sold it on 16th to a young Manchester collector named Crowley for £400.[30] Cross-channel commerce could be efficacious.

Fantin-Latour, another old friend and fellow student of Legros, had an established reputation in Britain, based on his highly naturalistic still-life paintings of flowers and fruits. In early 1861 Fantin had met Edwin Edwards, and their friendship flourished when Fantin spent that summer at Edwards's house at Sunbury-on-Thames. Edwards (1823–79) had been a solicitor in the Ecclesiastical and Admiralty Courts until 1859, since when he had devoted himself to art, chiefly as an etcher. In 1852 Edwards had married Ruth Escombe (c.1833–1907), who proved an astute amateur commercial manager.[31] She purchased still-lifes directly from Fantin, selling them on to her British friends. This brought the retiring Fantin needed funds,

and built up his reputation in Britain. In early 1874 Fantin invited the couple to Paris to sit for their portrait. His original idea was to have Edwards working at an etching table with his wife standing nearby like a muse, the notion of inspiration being typical of Fantin's pictures on musical themes. However, the dynamics of the relationship between the three led to a different solution. Edwards's ambition to succeed as an artist had foundered, and he and his wife were increasingly dependent on selling Fantin's work as a livelihood.[32] With Edwards a failure and Fantin less a friend than a resource, it was Ruth who had the dominant role. This is articulated in the portrait (no.3). Executed in Fantin's typically restrained palette of olive-ochres and muted greys, with a disciplined yet personal touch, the technique elides with the reserved, puritanical, even subtly hostile psychology of this remarkable double portrait. While Edwards appears withdrawn into a private silence as he examines a print, his wife stands, posed frontally and with her arms crossed over her chest. This posture is both assertive, indeed more conventional in portraiture for a male than a female figure, and at the same time defensive, as if she self-protectively distances herself from the artist while returning his gaze with a firm yet slightly disengaged stare. The portrait was well received at the 1875 Paris Salon, Emile Zola for one praising its naturalism, though the press was less responsive when the canvas was exhibited at the RA the following year.[33] In his discreet way, Fantin had produced a challengingly modern portrait, subverting conventional gender roles and using formal and spatial relationships as well as his tidy touch as a means not merely of mimesis but of suggesting elusive psychological truths.

In the 1870s the range of French pictures sold in Britain and British collectors who bought them is as varied as it is haphazard. Three examples can suffice to demonstrate this. Tissot's *The Gallery of HMS Calcutta* (no.17), painted about 1876, was lent the following year to the summer exhibition at the Grosvenor Gallery by John Robertson Reid.[34] Robertson Reid (1851–1926) was a Scottish artist, born in Edinburgh, who had trained there at the Royal Scottish Academy Schools. He later moved to Cornwall, painting naturalist subjects influenced by Jules Bastien-Lepage and William McTaggart; his *Toil and Pleasure* was shown at the RA in 1879 and purchased by the Chantrey Bequest.[35] It is possible that, as a fellow artist, Robertson Reid bought directly from Tissot, and apt that a painter engaged with modern styles and subjects should buy a painting that was at once an investment and a salutary example

of up-to-the-minute use of composition and body language to suggest a sense of the momentary. Gustave Moreau, who had known Tissot when they were both studying in Italy during the late 1850s, had remained stubbornly Paris-based, working not on contemporary themes but on history paintings refined in manner and elevated in meaning. In 1878 his large canvas *Jacob and the Angel* (1878, Fogg Art Museum, Cambridge, Mass.) had been purchased by the wealthy Russo-Jewish Raffalovich family, resident in Manchester.[36] That September Moreau wrote to Mme Raffalovich thanking her for agreeing to lend this important recent canvas to the current Exposition Universelle in Paris.[37] A third example, Camille Pissarro, was neither a dandyish observer of fashionable life like Tissot nor a decorated practitioner of *la grande peinture* like Moreau, but a frank, naturalistic landscape painter working in a daringly abrupt new style. Yet Pissarro too found buyers in Britain. His friend Théodore Duret came from Cognac, and worked in the family business selling brandy. Duret et de Brie had a London office, and in June 1871 Duret took its compatriot manager Jules Berthel to visit Pissarro in the south London suburb of Norwood, where the artist had taken up temporary residence having fled with his family from the Franco-Prussian War. Berthel took the opportunity to purchase *A Road in Upper Norwood* (1871, Neue Pinakothek, Munich), a quite coarsely brushed representation of the new housing of the capital's tentacular suburbs.[38] One of the Pissarros shown at Durand-Ruel's Summer Exhibition of the Society of French Artists in 1872 – no.27, *Village near Paris* – is now identifiable as *Rue des Voisins, Louveciennes* (1871, Manchester City Art Gallery). That canvas was purchased, probably after the exhibition, by Samuel Barlow (1825–1893) of Stakehill, Lancashire, who had made a fortune from his bleach works. Barlow's collection eventually contained a significant number of modern French works, with five Fantins, four Pissarros, two paintings by Camille Corot and one each by Daubigny and Henri Harpignies.[39] Recent French art of widely ranging subjects and even quite progressive aesthetics, including work by an artist like Pissarro who had a very modest profile in France, could find buyers in Britain, collectors as varied as plutocratic émigrés, self-made Mancunian industrialists, and small businessmen.

Another significant collector of recent French art, as well as old master paintings, was Constantine Alexander Ionides. Born in Cheetham Hill, Manchester in 1833, Ionides worked for the family's trading company in their native Aegean as a young man. In 1864 he settled in London at 8 Holland Villas Road,

befriending artists such as Legros and George Frederick Watts. Ionides put together the core of his collection between 1875 and 1885, among which was an important work by Degas, *The Ballet Scene from Meyerbeer's Opera 'Robert le Diable'* (no.23). The painting had belonged to the French opera singer Jean-Baptiste Faure, who had a major collection of works by Degas, Monet, Edouard Manet and others from the Impressionist circle. Faure sold the picture to Durand-Ruel on 28 February 1881 for 3,000 francs, and the dealer sold it on to Ionides on 7 June that year for the substantial sum of 6,000 francs.[40]

However, the most adventurous collector of advanced French painting in Britain in the mid-1870s was the Brighton resident Captain Henry Hill (1812–1882), given his remarkable eye for the work of Degas. Hill had been the quartermaster of the 1st Sussex Rifle Volunteers, and had made his money selling clothing and bedding to the army. At his house at 53 Marine Parade he laid out 'a cluster of moderately-sized, well-lighted rooms, devoted entirely to the purposes of a gallery', recounted the art critic Alice Meynell in 1882, to house the collection he had begun about a dozen years before. Although Hill owned some earlier British pictures by the likes of George Morland and David Cox, the bulk of his holdings were of contemporary works. He owned pictures by a wide range of Victorian artists, from Val Prinsep and Fred Walker to Scots such as John Pettie and William Quiller Orchardson, though he did not favour the Pre-Raphaelites.[41] Hill had an important group of canvases – including his own portrait – by Frank Holl, who had emerged in the early 1870s at the Royal Academy as a major, and moving, painter of scenes of modern urban impoverishment and distress. Hill may have purchased these out of sympathy for Holl's subjects, although family loyalty probably also came into play, as Holl's sister was married to Hill's brother.[42] The collection also included work by foreign artists, among them the Dutchman Josef Israëls ('one of the few very happy pictures he has painted', according to Meynell) and French painters: a Fantin still-life, several works each by Corot and Jean-François Millet, and a major group of some eighty oils and watercolours by Marie Cazin. Within this broad taste Hill did not neglect more radical work. In 1876 he purchased Whistler's *Nocturne in Blue and Gold: Valparaiso Bay* (1866, Freer Gallery of Art, Washington), which was bought by Ionides from the first sale of Hill's collection, held at Christie's on 25 May 1889.[43]

But the most surprising group of paintings in Hill's collection was the seven pictures by Degas that he had purchased by 1876,

fig.8
Edgar Degas
The Dance Class 1871–2
Oil on wood 19.7 × 27 | 7¾ × 10⅝
The Metropolitan Museum of Art, New York
H.O. Havemeyer Collection, Gift of Mrs H.O. Havemeyer, 1929

Degas. The extent of the personal contact between the two is a matter for speculation. But one amusing recollection of Degas's humour and anglophilia offers circumstantial evidence that he had visited Hill's home town. Sickert's obituary of Degas remembered that 'He would now and again, in compliment to my nationality, recite the legend that appears to have impressed him most at Brighton: "Ond please (with great emphasis, and an air of pathetic entreaty) hadjust yure dress biffore leaving".'[47]

In April 1876 Deschamps exhibited a cluster of ballet paintings made by Degas over the last five years. Hill purchased several. *The Dance Class* (fig.8), executed in 1871, was the oldest, a small panel crafted in considerable detail. Another was *The Rehearsal of the Ballet on Stage* (fig.9). A mixed media piece worked in '*essence*' (the thinned oil that Degas enjoyed), watercolour and pastel, this complex surface overlays a multi-figure scene delineated in a very detailed pen-and-ink drawing. Made about 1873–4, the drawing may well have been intended for publication in the *Illustrated London News*, for – as Ronald Pickvance was the first to show – the Anglo-Irish novelist George Moore, who knew Degas, mentioned in 1891 that the *ILN* had rejected a ballet subject by Degas to avoid offence to 'its rectory circulation'.[48] Degas then elaborated the rejected drawing and presented it for sale as a painting. Hill purchased it from Deschamps for 66 guineas. For the slightly smaller sum of 60 guineas Hill acquired *The Dance Class* (no.4), a painting of 1873, and another of the same title (fig.10) for 54 guineas which Degas had painted

a larger and more important cluster of the artist's work than any French *amateur* had yet collected. We do not know exactly how this came about: when Hill first noticed Degas's work, or when Degas identified a particular client. Certainly by 22 August 1875 Degas was writing from Paris to the dealer Deschamps in London, keeping him informed of his progress in completing pictures for the market and urging the need for sales: 'this is the moment for me to take flight in England'.[44] It was a juncture Degas had come to gradually. He may have first visited Britain in 1868, when Manet proposed a joint trip. Degas was certainly in London in October 1871, staying at the Conté Hotel, Golden Square, and he probably saw the Second Annual Exhibition of the Society of French Artists. He may well have passed through London again the following year, when he sailed from Liverpool to visit his family in the United States. And it is likely that he visited London in 1875, given his urgent correspondence with Deschamps, Tissot and others, the failure of the family bank the previous year giving a new urgency to making sales.[45] In addition to visits, Degas was regularly sending work to London to be shown at the Society of French Artists, though not every work shown there sold in Britain. *The False Start* (c.1866–8, Yale University Art Gallery, New Haven) failed to find a buyer at the Fourth Exhibition in 1872, was returned to Paris, and sold by Durand-Ruel the following year to Ernest Hoschedé.[46] In this developing pattern of opportunity and necessity Hill's emergence as a committed collector must have been gratifying for

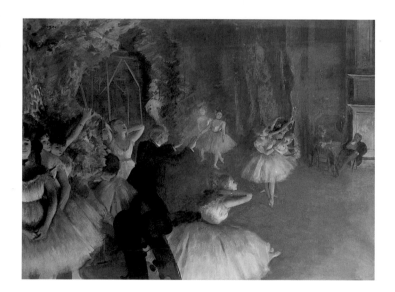

fig.9
Edgar Degas
The Rehearsal of the Ballet On Stage c.1873–4
Oil colours freely mixed with turpentine, with traces of watercolour and pastel over pen-and-ink drawing in cream-coloured wove paper, laid on Bristol board and mounted on canvas 54.3 × 73 | 21⅜ × 28¾
The Metropolitan Museum of Art, H.O. Havemeyer Collection,
Gift of Horace Havemeyer, 1929

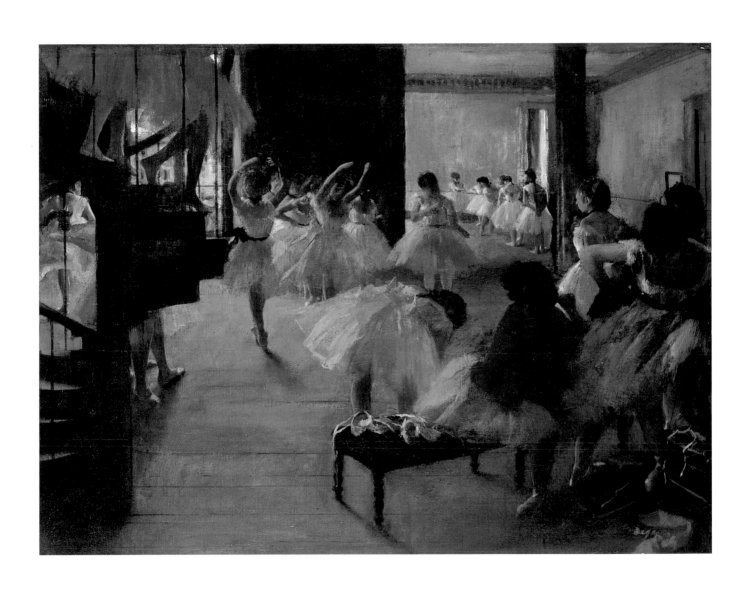

4
Edgar Degas
The Dance Class 1873
Oil on canvas 47.6 × 62.2 | 18³/₄ × 24¹/₂
Corcoran Gallery of Art, Washington, DC
William A. Clark Collection

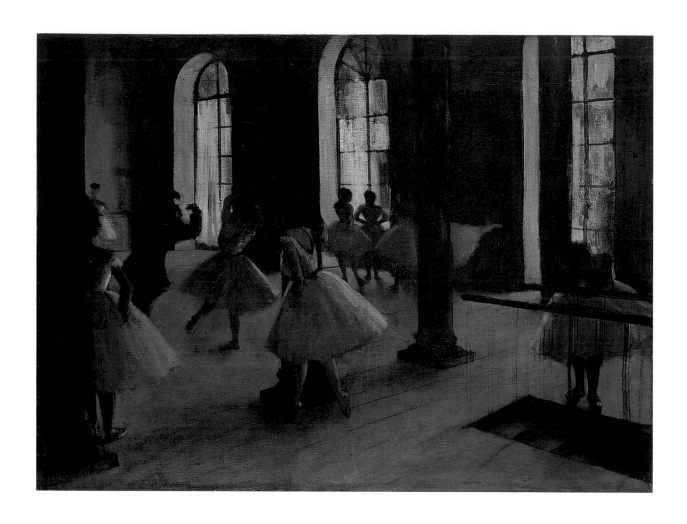

5
Edgar Degas
The Dance Rehearsal c.1873–5
Oil on canvas 40.6 × 54.6 | 16 × 21½
The Phillips Collection, Washington, DC
Partial and promised gift of anonymous donor, 2001

fig.10
Edgar Degas
The Dance Class 1873, reworked 1875–6
Oil on canvas
85 × 75 | 33½ × 29½
Musée d'Orsay, Paris

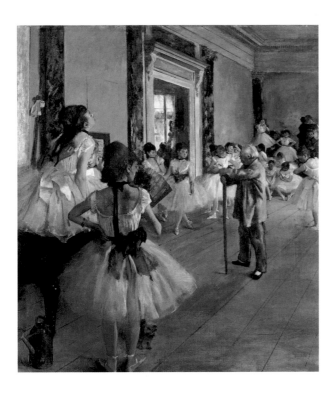

that year and then reworked in 1875–6.[49] Another painting that Hill purchased was *The Dance Rehearsal* (no.5), which is probably the picture Degas informed Deschamps in August 1875 that he was shortly to receive.[50]

Hill's taste for Degas's work is exceptional, and deserves some assessment.[51] While Hill as a businessman was no doubt aware of the potential and pitfalls of speculation in art, he does not seem to have bought Degas with a view to future profit. The pictures were still in his collection at his death in 1882, and were not sold by his family until the first sale of the collection, at Christie's in Brighton on 25 May 1889. By then Degas's stock had risen, and several of the paintings returned to France, the first of the *Dance Class* canvases being purchased by Michel Manzi, an expert printer and printmaker and friend of Degas with interests in the Galerie Boussod et Valadon, and the other by the gallery itself. If speculation was not Hill's primary motive, it is noteworthy that he did not find the ballet subjects disreputable, as Moore claimed the *Illustrated London News* had done. Perhaps Hill found the theme graceful, though Alice Meynell's account of his collection took quite the opposite

view.[52] It is possible that he responded to these scenes of exercise and rehearsal as intriguing images of an unusual corner of contemporary life, or that they struck a chord in his sympathy for the strenuous lives of the urban worker. Most significant, perhaps, is the evidence of the pictures themselves. By contrast with current British painting, Degas's works are unconventional in their sometimes economical levels of finish and, in the case of *The Rehearsal of the Ballet on Stage*, its startling mixed media. All the paintings combine unusual draughtsmanship, with figures caught in plausible but aesthetically unorthodox postures, and arresting compositions which make much of spatial voids. Degas's combination of dynamic figures and the spaces which they fill, will fill, or have filled, creating images that imply the constant and haphazard momentum of modern existence, was amongst the most advanced picture-making to be found anywhere in the mid-1870s. It is all the more remarkable that such innovative work was so admired in Brighton.

Hill did not only buy ballet pictures by Degas. At the second Impressionist exhibition, held at the Durand-Ruel gallery in the rue Le Pelletier in April 1876, Degas showed, as no.52, *Dans un Café*. This recent canvas did not sell in Paris, and was shipped to London, where Deschamps sold it to Hill. The new owner lent it to Brighton's *Third Annual Winter Exhibition of Modern Pictures*, which opened on 7 September.[53] Known today as *L'Absinthe* (no.42), this painting came to have an infamous reputation in Britain, acting as a lightning conductor for different aesthetics. In 1876 it had no such outrageous celebrity, though its subject –

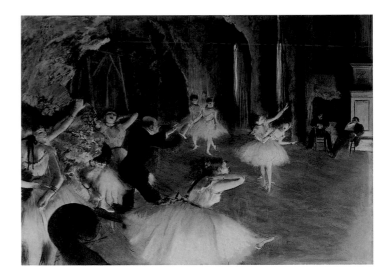

fig.11
Edgar Degas
The Rehearsal Onstage
c.1874
Pastel over brush-and-ink drawing on paper,
laid down on Bristol board and mounted on canvas
54.3 × 72.4 | 21⅜ × 28½
The Metropolitan Museum of Art, New York. H.O. Havemayer Collection, Gift of Mrs H.O. Havemayer, 1929

which can be read simply as two figures seated in a café, or more specifically as a distracted man drinking a *mazagram*, a hangover cure, avoiding the fatigued presence of a streetwalker taking a break to rest her feet – was certainly exceptional by British standards. The man had been posed by Degas's friend the artist Marcellin Desboutin, who had visited London in 1875, painting a portrait and making two etchings of Deschamps. The dealer may have drawn his client Hill's attention to Degas's canvas featuring Desboutin when it arrived in London.[54] However, Hill already had a preference for paintings of the urban disadvantaged, exemplified by his ownership of paintings by Holl such as *A Seat in a Railway Station – Third Class* (1873, private collection) and *The Song of the Shirt* (fig.12). Whatever Hill's motives for the purchase, the painting was immediately read in social terms when it was shown in Brighton. The critic of the *Brighton Gazette* was blunt. 'The perfection of ugliness: undoubtedly a clever painting, though treated in a slapdash manner, amounting to affectation. The colour is as repulsive as the figures; a brutal, sensual-looking French workman and a sickly-looking grisette; a most unlovely couple. The very disgusting novelty of the subject arrests attention. What there is to admire in it is the skill of the artist, not the subject itself.'[55] Compared to the condemnatory reactions to *L'Absinthe* in 1893, the Brighton critic made no reference to alcoholism or French decadence. While he found the subject uncomfortable for a work of art, he was nevertheless able to detect the creative – what Henry James would have called the 'plastic' – qualities in Degas's painting. Captain Henry Hill's remarkable eye for those exceptional artistic qualities is evident from the depth and liberalism of his collection of work by Degas.

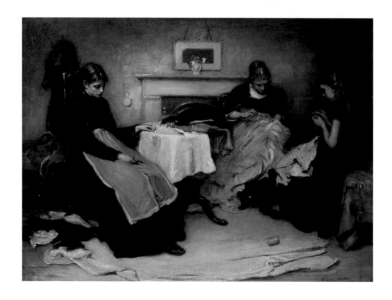

fig.12
Frank Holl
The Song of the Shirt c.1874
Oil on canvas 48.3 × 66.2 | 19 × 26
Royal Albert Memorial Museum and Art Gallery,
Exeter

COMPOSITION AND MODERNITY

The informed public of the British art world was able to glean an understanding of new developments in French painting not only from the work shown by dealers like Deschamps or lent to exhibitions by collectors such as Hill. The British press was not blind to Parisian initiatives. Philippe Burty, friend of artists and amateur of etching and Japanese prints, contributed a column on art in the French capital to the *Academy*. Its readers were apprised of '*Les Impressionnistes*' at the time of the very first exhibition in 1874, when the group of artists received their unexpected but durable soubriquet. Burty's balanced view acknowledged that the new styles on show 'produce[s] a class of work oscillating between a perfection which speaks simply to the senses, and attempts which are simply childish'. But he admitted to being 'quite won over to this doctrine', which he usefully and shrewdly characterised. He explained that 'their style of painting, whether by simplicity of design, or by simplicity of tone, or by simplicity of composition, looks like a challenge or a caricature when placed side by side with works conceived under the pre-occupation of mannered design, artificial tones, or subjects intended to provoke laughter or emotion by the most vulgar artifices.' Rather, the varied works of the new group are 'based on the swiftest possible rendering of physical sensation.' Burty gave particular praise to Degas – 'a man of the world, and a man of genius' – who he described as 'the master of a highly accomplished science of design, which he only exercises on a small scale, just as he concentrates his very delicate and refined attention on a few original types: sporting-scenes, ballet-girls on stage or at rehearsal, and washerwomen.'[56] Burty also appraised the *Academy*'s readers of the second Impressionist exhibition in April 1876. He reminded them that Degas had 'introduced himself to the London public at M. Deschamps' exhibition'. Burty's continued praise of Degas was not without a hint of criticism over his practice: 'He more often throws his sketches onto the canvas than takes time to finish them; but these in themselves are sufficient to prove the power of his imagination, his science, his intimate acquaintance with modern life, with the gestures, effect, the athletics, peculiar to each of his subjects.'[57] Burty's observations were judicious and honest. He found Degas's work exciting and exceptional, but also alarming; he implied that this kind of work, with its emphatic modernity and lack of finish allied to lack of anecdote, was at odds with the dominant taste in Britain. (The fact that Henry Hill's taste could encompass Prinsep and Fred Walker and also Degas makes it, too, exceptional.)

If aspects of the new painting emerging in Paris in the early and mid-1870s had an airing on the London market and in the London press, so artists based in the British capital were noted and respected in Paris. While involved in the organisation of what would be the first Impressionist exhibition in early 1874, Degas wrote to Tissot in London urging him to participate: 'Look here, my dear Tissot, no hesitations, no escape. You positively must exhibit at the Boulevard. It will do you good, you (for it is a means of showing yourself in Paris from which people said you were running away) and us too.'[58] What was sauce for the goose was sauce for the gander; in Degas's view, it served an artist's commercial purposes well to have an exhibition and market presence in both capitals. Despite Degas's urgings that he should join the 'salon of realists', in the event Tissot did not show in 1874, though at the subsequent Impressionist exhibition in 1876 Legros was represented by a substantial group of etchings, a gesture of cross-Channel fraternity. While never showing with the Impressionists, Tissot did follow Degas's advice to keep in touch with Paris. In 1876 he exhibited a number of his etchings at the *Exposition du Noir et Blanc*. In his review of the show the French printmaker Henri Guérard found the work 'intricate and tight' (*fin et serré*), concluding that 'the stay in London has had an influence on M.Tissot.'[59]

Differences were distinguished between artists, styles and national tastes. Burty pointed out the diversity within the exhibitors at the early Impressionist exhibitions; Guérard suggested the different levels of finish expected by British and French taste. But there was some kind of loose but cogent fraternity or consensus between a number of artists at this time, extending across the Channel and manifesting itself not only in mutual support – advice about the market, invitations to exhibitions, introductions to dealers or patrons – but also about how modern pictures might be made. Life in modern cities such as London and Paris had a mobile, hectic character, simultaneously crowded yet spatially and even psychologically fragmented, that fascinated artists of an enquiring and observant temperament, challenging them to explore beyond the descriptive or anecdotal norms that held sway in the establishment exhibitions of the two cities. Within that informal fraternity a dialogue of example and exchange began to be generated about how one might more effectively render the modern urban experience pictorially.

Degas's *The Rehearsal* (no.6) was being completed in early 1874, and was seen on his easel that February by the novelist Edouard de Goncourt, while Tissot's *Ball on Shipboard* (no.7)

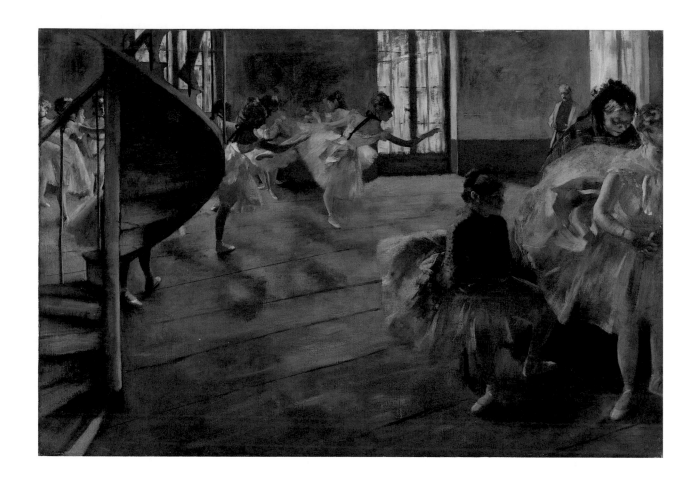

6
Edgar Degas
The Rehearsal 1873–4
Oil on canvas 58.4×83.8 | 23×33
Glasgow Museums: The Burrell Collection

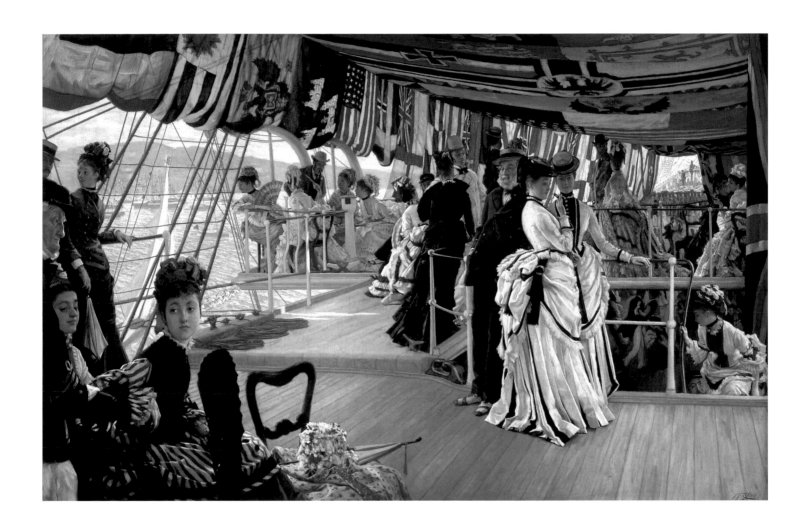

7
James Tissot
The Ball on Shipboard c.1874
Oil on canvas 84.1×129.5 | 33⅛×51
Tate . Presented by the Trustees of t he Chantrey Bequest 1937

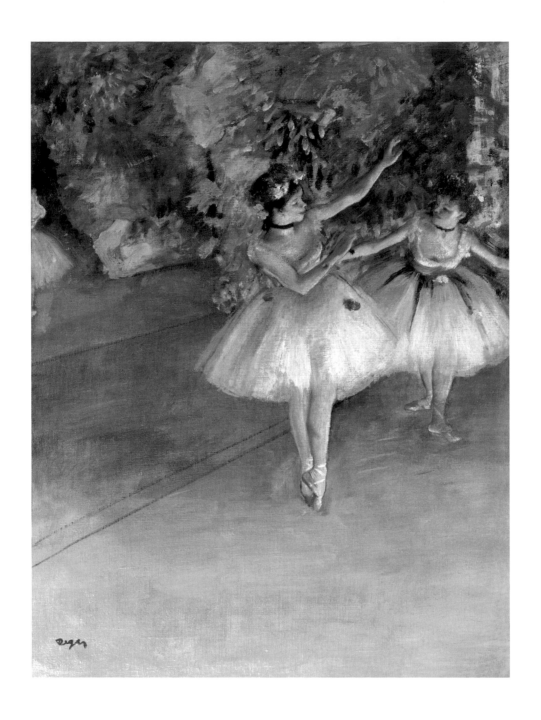

8
Edgar Degas
Two Dancers on a Stage 1874
Oil on canvas 61.5 × 46 | 24¼ × 18⅛
The Samuel Courtauld Trust,
Courtauld Institute of Art Gallery,
London

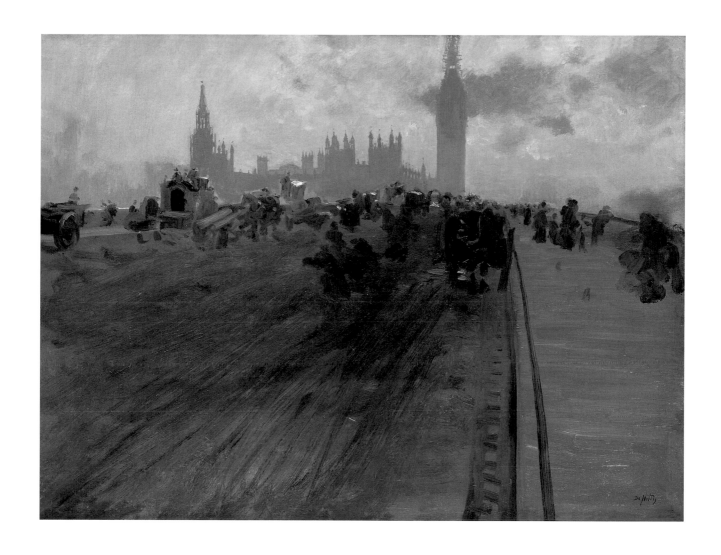

9
Giuseppe de Nittis
Westminster Bridge II c.1875
Oil on canvas 46 × 61 | 18⅛ × 24
Private collection

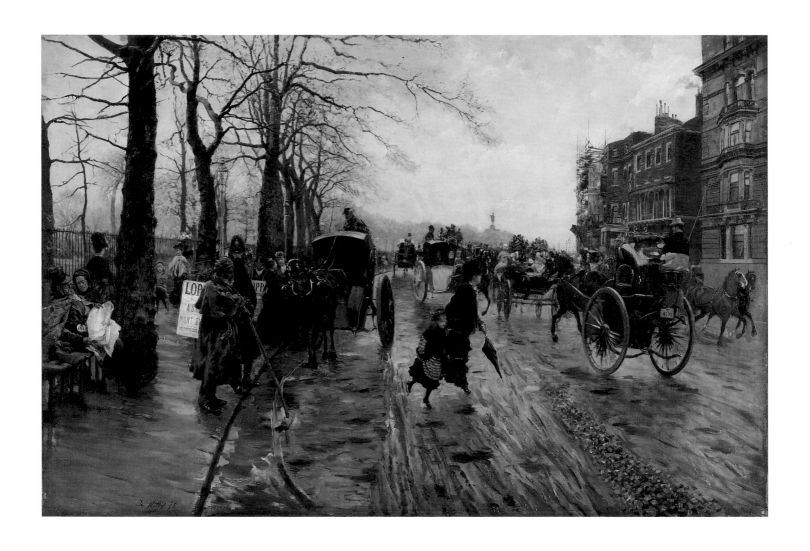

10
Giuseppe de Nittis
Piccadilly 1875
Oil on panel 84 × 120 | 33 × 47¼
Donà dalle Rose Collection

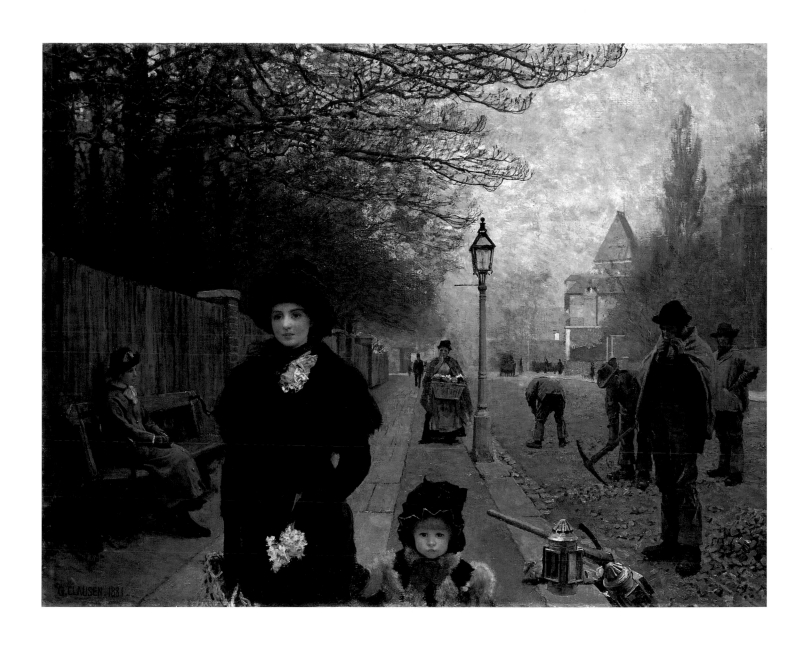

11
George Clausen
A Spring Morning, Haverstock Hill 1881
Oil on canvas 101.6×134.6 | 40×53
Bury Art Gallery & Museum, Lancashire

was exhibited at the Royal Academy in the spring of 1874.[60] The two canvases were thus being painted at the same time, one in Paris and one in London. Although it is unlikely that either artist would have seen his colleague's painting while it was in train, Degas and Tissot had by then known each other for some twenty years, advised each other about their work, and were in regular contact. The paintings immediately appear very distinct. One represents work and the lower classes, the grinding rehearsal exercises of the ballet and the young proletarian women who submitted to their discipline to earn a living; the other leisure and the upper classes, a naval review and the fashionably dressed invitees chatting under the beflagged shade of a warship. They show an interior and an exterior, the city and the sea, France and Britain. Degas's is painted in a more approximate, evident touch; Tissot's larger canvas is more detailed and finished, pitched at the RA public. Nevertheless, the two pictures share some crucial characteristics in their pictorial formulation.

Both paintings employ figures that are cut off at the edges, so the spectator is only shown a fragment of the figure. To the right of the Degas it is a ballet dancer with a peach *fichu* who leans slightly forwards, to the left dancers practising in the background, and at the upper edge a woman descending the stairs, only her lower legs visible. To the left of the Tissot there are two men who are also cropped, one an elderly gentleman in a blue naval jacket and above him a younger fellow, only his head visible, wearing a boater and a moustache – quite possibly a discreet self-portrait. Both paintings insist upon substantial open space in the fore- and middle-ground, which lead the eye into the picture's fictive depth and towards things that we 'know' are there but cannot see: in the Degas the dancers behind the spiral staircase, and in the Tissot the conversations beyond the woman in the maroon dress who is seen from behind. Both paintings include a staircase to infer other spaces – a room upstairs in the Degas, the lower deck in the Tissot – which we cannot, or cannot fully, see. Both paintings deploy the open spaces and the stairs to pull the spectator's attention in multiple directions. Just as there is no central focus in either picture, so there is no single place for the eye to settle; there is a multiplicity of incident. Both paintings include figures whose gazes reach beyond the fiction of the image: Degas's seated dancer in the green shawl, or Tissot's twisting girl in the green striped dress. Both paintings are illuminated by filtered light. While Degas veiled his windows with net curtains, Tissot used

the shade of the flags to reduce the intensity of the sunlight and its reflection off the surface of the sea, the flags and rigging serving to give his outdoor deck a quasi-interior quality. These pictorial devices and decisions were geared by the two artists to the articulation of the modern. Modernity here meant, necessarily, a plurality of possibilities, from unusual subject, chic costume and plausible lighting to manipulations of pose and composition to evoke for the spectator a sense not only of what one might see in the everyday world but how one sees it: disjointedly, partially, rapidly, and in constant flux.

Another artist enters the story here. Giuseppe de Nittis was neither French nor British but Italian, born at Barletta in Puglia in 1846. Having studied at art school in Naples, de Nittis travelled to Paris in 1867, marrying a Frenchwoman and becoming one of the stable of artists working for the dealer Adolphe Goupil. After retreating to Italy during the Franco-Prussian War, the artist returned, his work adjusting from the highly finished anecdotal subjects which were Goupil's stock-in-trade to more adventurously composed canvases of modern subjects. One of de Nittis's particular compositional gambits was the use of a sharp, even disconcerting, perspective. This was characteristic of both his landscape oil sketches, four of which he showed at the first Impressionist exhibition in 1874, to which he had been invited to contribute by Degas, and of his larger and more highly worked canvases submitted to grander forums.[61] For example, the boating picture of the Parisian suburbs, *A Bougival*, which he showed at the 1875 Salon, was noted for its unconventional perspective.[62] De Nittis made his first visit to London in 1875, staying from April to August. His work made an immediate impact on the London market, making sales worth 39,500 francs from the initial sojourn, followed by 25,000 francs the following year from the dealer Algernon Moses Marsden, whose portrait Tissot painted (1877; The Old House Foundation Ltd).[63] According to his close friend Claretie, who travelled with the artist to find material for his own novels, de Nittis made it a habit to visit London for a month or two every year during the season. Claretie took the standard critical line on de Nittis: that his cityscapes will serve as lasting historical records of the topography and atmosphere of the places he painted. But he added that the painter had specific qualities, both a 'fevered, troubled, refined' response to the modern spectacle and a cosmopolitan mutability: 'ce Napolitain est ... Parisien à Paris, comme il sera Londonner [sic] à Londres.'[64]

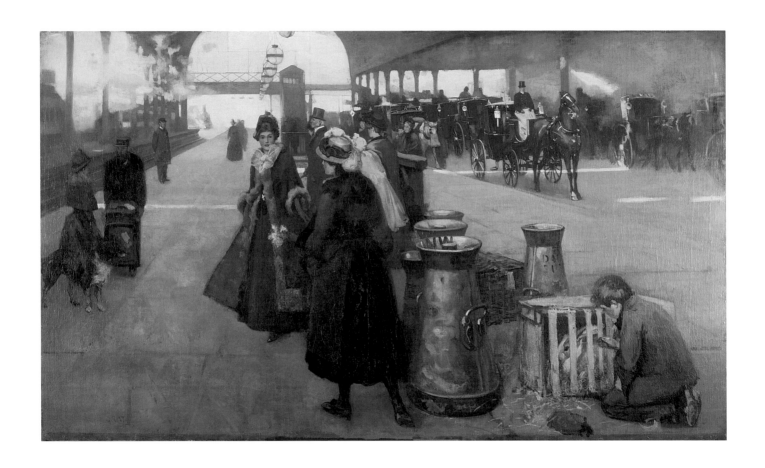

12
Sidney Starr
Paddington Station 1886
Pastel on paper 122.5 × 206 | 48¼ × 81⅛
Durban Art Gallery

fig.13
William Powell Frith
The Railway Station 1862
Oil on canvas 116.7 × 256.4 | 46 × 100
From the Picture Collection, Royal Holloway
University of London

De Nittis fitted smoothly into the Anglo-French fraternity, Degas writing to Tissot; 'How is de Nittis getting on over there? Tell me something about it.'[65] The two artists knew and admired each other's work, and once again parallels can be drawn. Although de Nittis's exhibition paintings, such as *Piccadilly* (no.10), were worked up to quite a high degree of finish, he also produced paintings which were left at a more spontaneous level of resolution. Such a canvas is *Westminster Bridge II* (no.9), painted in the mid-1870s as part of a group representing the road crossing and the Houses of Parliament which culminated in the large work that de Nittis showed at the 1878 Paris Exposition Universelle (Marzotto Collection, Valdagno). *Westminster Bridge II* was probably sketched on site from an open carriage parked at the kerb. The painter's main concern was with atmospherics, the silhouette of the Palace of Westminster against a rather livid sky. De Nittis laid in the traffic on the bridge approximately, with rapid touches economically evoking details such as the curve of a horse-collar or the posture of a pedestrian.

Coincidentally, *Westminster Bridge II* is the same size as Degas's painting *Two Dancers on a Stage* (no.8) which, again coincidentally, has a British connection. Exhibited at the Ninth Exhibition of French Artists in November 1874, *Two Dancers* was the first work by Degas purchased by Captain Henry Hill.[66] In *Two Dancers*, Degas, and in *Westminster Bridge II* de Nittis, both applied formal means to engender a sense of the spontaneous and the modern. Although the two works were prepared differently – the Degas was a work for the market based on drawings which may not have been originally made with this painting in mind, while the de Nittis was painted *sur le motif* and, although not fully finished, signed as an *impression* – both derive their immediacy from a combination of composition and touch. Perspective is a crucial shared ingredient. That in the de Nittis is more thrusting, driving the eye directly into the picture space from an open zone, through the haphazard forms of the traffic on the bridge, to the elaborate, hazy silhouette of the Palace of Westminster. Degas used a more angled perspective, evident in the rails for the stage-flats. Parallel to this regularity, he set the stylised irregularity of the two ballet dancers' fleeting positions. These were distinctly 'plastic' solutions to the painting of the modern.

De Nittis showed *Piccadilly*, one of the first of his major, finished canvases of London, in Paris at the prestigious Club des Mirlitons in spring 1876. Claretie gave it a French gloss, describing 'the extraordinary movement of the vehicles, the English atmosphere, the policeman with his face sliced by the strap of his boiled leather helmet, the Indian shivering with fever and sweeping the coke-black ground, the pink and blond babies running across the road, the immense great structures, still decorated with masons' scaffolding, and, in the depths of the picture, the tall statue of Wellington standing out against a sky crossed by a pale sun.'[67] Claretie's excited, tautological prose promoted the view, adopted by other French critics, that this painting encapsulated London's modernity.[68] De Nittis had hit upon an ideal motif, for Piccadilly was often picked out by London-based commentators on the city. Jerrold exclaimed: 'How can one ever tire of Piccadilly – now narrowed to the street that stretches from Regent Street to Hyde Park Corner? ... Here are to be studied all classes of London characters, from the fashionable man about town to the West End dog fancier.'[69] Henry James was less kind about the statue (now removed) of 'the Iron Duke in the guise of a tin soldier' and 'the vulgar little railing of the Green Park', but acknowledged that though 'the edifices are mean ... the social stream itself is monumental.'[70] De Nittis's evocation of the flow of this major London thoroughfare appeared a masterly synopsis, and the canvas immediately sold for the elevated price of 54,000 francs.[71]

Viewed once again from a parked carriage, the picture – although a substantial canvas no doubt worked in the studio – contrives a sense of spontaneous observation and execution, with the marks of the brush on the roadway very evident. De Nittis effectively combined atmospheric generality – Britain's damp autumnal ambience – and local specificity: the sandwich boards, turbaned sweeper, and numbers on the hansoms. He evoked the imperial city, with its consuls and colonials, as well as the modern metropolis. For Piccadilly is a painting about the

transitory, the *perpetuum mobile*. Not only is the cycle of the seasons suggested, but also man's more rapid patterns: the bustling traffic, the hardcore temporarily filling a rut, the advertisements and newspapers, the scaffolding to repair and replace. Unlike so many contemporary paintings of Paris, and even London, little or nothing here is chic; de Nittis's *Piccadilly* is purposeful, on the move.

De Nittis's street scenes gave a particular sophistication to the fusion of perspectival discipline and haphazard distribution of figures that was increasingly becoming a feature of naturalist painting (one thinks of Gustave Caillebotte or Hubert von Herkomer's work). But their success in London gave a notable spur to younger British artists who sought to give their work a modern edge. Around 1877 the twenty-five-year-old George Clausen, who had studied at the South Kensington Schools, settled at 4, The Mall, Hampstead.[72] There, with Robertson Reid, owner of Tissot's *Gallery of HMS Calcutta*, as a neighbour, Clausen painted several street scenes, casting himself as a painter of contemporary urban life.[73] The most important of these was *A Spring Morning, Haverstock Hill* (no.11), shown at the 1881 Royal Academy exhibition. It is an image about metropolitanisation, about nature and order. To the upper left mature trees, which as saplings would have been in open country, are restrained behind a proprietorial brick and paling fence, while to the right the earth is being worked, not for planting but to be covered with paving stones to aid the speedy transit of carriages, carts and other traffic. That sense of momentum and modernity is strongest in the central section, almost a corridor through this suburban scene, with its regular pavement, gutter and gas-lamp. Within that theatre Clausen discreetly articulated class relations. The bourgeois mother has just purchased daffodils from the proletarian woman by the lamp; she appears pensive and distracted from her daughter, perhaps having noticed the inert lower middle-class figure seated on the bench. Although Clausen's distribution of figures is very ordered, he

has attempted to introduce notions of spontaneity. The foreground figures are cropped; the labourer licks his cigarette paper. But Clausen does not achieve the illusion of the random as de Nittis could; his forms are too monumental, and *A Spring Morning* does not entirely escape both a propriety about formal order and a degree of sentimentality.

Five years later, at the Society of British Artists, Sidney Starr exhibited his large pastel *Paddington Station* (no.12). It was immediately received as 'cosmopolitan' and as 'entirely unsensational, purely artistic; and in the treatment, so full of tact': comments that showed how not only Starr but also young critics like Frederick Wedmore had absorbed the pictorial formulae imported by the likes of Degas and de Nittis.[74] The modernity of Starr's motif, like that of de Nittis's *Piccadilly*, derives in part from its multiplicity of petty likelihoods, be it the flower seller approaching the lady, the lad coaxing the caged rabbit, or the smart child with the dog talking to the porter who has her luggage. Starr set these plausibilities and class relations within appropriate pictorial patterns. The face of the top-hatted gentleman in the centre acts as a pale patch against shaded passages; a diagonal leads back towards him, so he is eventually 'found'. The railway official stands isolated, a vertical accent against the diagonal of the platform. Starr had learned much from the innovations of the 1870s: the use of perspective to suggest a sense of pace; the abandonment of a stage-like setting for an open, 'chanced upon' space; the placement of figures close to the surface to make the spectator feel part of the picture's fiction; the dismissal of the sentimental anecdotes required in paintings of the previous generation such as Frith's *The Railway Station* (fig.13) in favour of banal, momentary conjunctions. It comes as little surprise that when it was exhibited in Paris at the 1889 Exposition Universelle *Paddington Station* was distinguished with a bronze medal. For Starr's concordance of modern subject and modern composition came from across the Channel.

If composition was a crucial characteristic of modern figure painting in the 1870s, so too was pose. The two elements worked together, along with touch and colour. Composition evoked states such as proximity or disjunction, and pose behaviour or mood. All were aspects of quotidian observation and perception that were necessarily mobile and transitory, and were therefore modern. Pose played in other ways too. It could be articulated especially to convey, by drawing, how the contemporary body was held and shaped. Different postures conveyed information about the figure represented: sex, age, social status, as well as role and function, and could also transmit signals about more intimate matters such as costume, state of mind, health or sexuality. None of this was entirely new to art, of course, but artists and critics in the 1870s were often conscious, given the rapidly changing pace of their world, that it was the duty of the contemporary artist to explore specifically modern modes and nuances, eschewing tired conventional formulations. The most rigorous articulation of this view was Edmond Duranty's pamphlet *La Nouvelle Peinture*, which appeared in 1876 at the time of the second Impressionist exhibition. Although a French publication, *La Nouvelle Peinture* was alert to the cross-Channel nature of these new initiatives. Duranty did not name but alluded to the painters he linked under this modern consensus. Degas, 'a certain draughtsman ... of uncommon talent', was his pivotal figure, but he brought into play Legros, Whistler, Fantin and 'that young Neapolitan painter who loves to depict the street life of London and Paris': de Nittis.[75] At essence, the 'new painting' was cosmopolitan. It was also stylish. The modern artist might primarily be concerned with the banal and haphazard of the everyday, but the means of conveying it required skill, élan and surprise.

Whistler was a painter preoccupied with style. This emerged in the exquisitely crafted nocturnes he painted of the Thames during the 1870s, and also in his portraits. In 1872 he was commissioned to paint a portrait of Miss Cicely Alexander, the young daughter of the banker W.C. Alexander. Whistler went to great lengths obtaining fine white muslin for her dress; contrived a suave setting of panels, drapery, flowers and butterflies; and demanded many sittings until he was entirely satisfied with tone and effect.[76] Disparaged when it was first exhibited at the Flemish Gallery in a one-man show held in June 1874, *Harmony in Grey and Green: Miss Cicely Alexander* (no.13) became an iconic image of modern stylishness in British painting. 'Like no other poem in the language', waxed George Moore in the 1890s, 'the portrait of Miss Alexander enchants with the harmony of colour, with the melody of composition'; it was so quintessentially Whistlerian that 'there is really little of Japan' in a canvas 'beyond even Velasquez's capacities.'[77] But, for all Whistler's rhetorical aestheticism, the painting is more than an 'arrangement'. It is a portrait of a girl of eight, and critics in 1874 responded to it as such: 'a disagreeable presentment of a disagreeable young lady', one had it.[78] The sulky eyes and downcast mouth fit a girl who had had to stand for many unchanging hours. The pose of Cicely's legs, with her feet slightly turned out and shod in black beribboned pumps, reveal that she was currently having dancing lessons. The aesthetic that Whistler imposed was thus allied not just to observation but to the social stylishness that was being instilled in a girl of smart family. Crafted style met constructed femininity.

At the sixth Impressionist exhibition in 1881 Degas showed publicly for the first time his sculptural work, in the form of his extraordinary *Little Dancer Aged Fourteen* (no.14). Two-thirds of life-size, modelled in wax, clad in a *tutu* and gauze skirt and wearing slippers specially made for her, as had been her beribboned human-hair wig, the *Little Dancer* stunned artists, critics and public alike by its striking, even alarming, verism.[79] Jacques-Émile Blanche remembered seeing 'a short dark man with a top hat with flat brim, a long coat dropping down to shoes with square tips; he brandished a bamboo stick instead of a cane; emitted sharp cries; gesticulated in front of the vitrine which encased the wax figure.'[80] It was Whistler. His ostentatious response was surely a cry of recognition. While it is unlikely that Degas had seen *Miss Cicely Alexander* in train in Whistler's studio or on show in 1874 (though it is just possible that Whistler might have taken him to see it at Alexander's house during Degas's London visit in 1875), and evident that the *Little Dancer* evolved via a complex genesis of observation and drawing, nevertheless there is an affinity. Partly it is the fascination with the flexible body of the girl, the woman in formation. Both works of art, in their different media, play off the facial expression – mute and grumpy in the painting, pert and querulous in the sculpture – against the schooled positioning of the legs, suggesting the unresolved tensions in the girls' make-up between inner temperament and outer training. Finally, both *Miss Cicely Alexander* and the *Little Dancer* share the search for style in the modern.

During his time in London in the 1870s Jules Dalou made an impact with both allegorical sculptures and finely wrought

13
James Abbott McNeill Whistler
Harmony in Grey and Green: Miss Cicely Alexander 1872–4
Oil on canvas 190.2 × 97.8 | 74⅝ × 38½
Tate. Bequeathed by W.C. Alexander 1932

14
Edgar Degas
Little Dancer Aged Fourteen
1880–1, cast c.1922
Painted bronze with muslin and silk
98.4 x 41.9 × 36.5 | 38¾ × 16.5 × 14⅜
Tate. Purchased with assistance from the
National Art Collections Fund 1952

15
Jules Dalou
Hush-a-bye Baby c.1874
Terracotta H. 53 | 20⅞
Victoria and Albert Museum,
London

genre pieces on a smaller, sometimes table-top, scale. Exhibited at the Royal Academy in various media, these enhanced his reputation and, in bronze editions, earned him a living.[81] A favourite medium was terracotta, which has a warm, sensuous quality and made allusion to eighteenth-century practitioners such as Clodion. His terracotta *Woman Reading*, made in the mid-1870s, was owned by C.A. Ionides, and reproduced in bronze for the wider market (no.16).[82] Probably modelled by Mme Dalou, who sat for her husband to save money on models, the figure is posed in an unforced *contraposto*, the sinuously twisted body clad in a peignoir and seated on an elegant chair. For all the ordinariness of its quotidian subject, the sculpture's flowing, curving surfaces exude a fetching tactility. At the 1874 Royal Academy exhibition under the French title *La Berceuse*, Dalou showed the large terracotta *Hush-a-bye Baby* (no.15), the first two lines of the nursery rhyme being inscribed on the base, and two years later the marble version which had been commissioned by the Duke of Westminster.[83] Dalou's mother-and-baby piece, like his reader, was naturalistic in its surfaces – a woman's eye can apparently tell that the dress is woollen – and in its pose: the tender clasp of the mother's hands around the sleeping infant, her tilted head held slightly back as she gazes lovingly at her child while she sings.[84]

Although three-dimensional, Dalou's sculptures were characterised by what the critic of *The Times* called in 1874 a 'semi-pictorial realisation'.[85] The subjects were consistent with paintings of modern life, as was the naturalism of his figures, surfaces and body language. In a painting such as *The Gallery of HMS Calcutta* (no.17), Tissot, working in his different medium, was concerned with those very elements. Indeed, such is the torsion and tactility of his foreground figure that one can easily imagine her pose modelled in terracotta by Dalou. Viewing *The Gallery of HMS Calcutta* at the Grosvenor Gallery in 1877 male critics were struck by her svelte sensuality. The critic of the *Spectator* was keenly to the point – 'We would direct our readers' attention to the painting of the flesh seen through the white muslin dress' – while even Henry James was moved to acknowledge how she 'twists her perfect figure with the most charming gracefulness' within the dress with 'its air of fitting her so well.'[86] Tissot's painting functions variously. In subject it is a conversation piece, suggesting several narratives but stating none, an image of leisure and luxury against the muted backdrop of industry and trade. In execution it is an intricate orchestration of subdued tones, watery light, and relentlessly

swirling lines and curving shapes. For all its naturalism of set-
ting and moment, *The Gallery of HMS Calcutta* also plays with
style, making the physical, fashionable form imposed by the
corset on the female body the leitmotif of the image's sophisti-
cated pictorial manipulation of the modern.

A similar elision of the linear and the sculptural occurs in
Orchardson's *Master Baby* (no.18), exhibited at the Grosvenor
Gallery in 1886. Representing the artist's wife and their third
son Gordon, the painting charmingly describes a moment of
playful exchange between mother and child.[87] But, plausibly
observed as the picture may be, it is still artfully composed, the
two figures contrasting white and black, set frieze-like against
the rippling rhythm of the sofa's frame. Like Dalou's *Hush-a-
bye Baby*, with its similar theme, and Tissot's *The Gallery of
HMS Calcutta*, Orchardson's painting uses the controlled,
corseted form of the female figure as a flowing sculptural shape
in his composition, the conventions of modern fashion being
positively employed to create poses that were modern in their
likelihood, in their suggestion of the momentary, and in their
contribution to the suavity of the design. Sickert once expressed
to Degas 'my admiration for Orchardson's marvellous *Master
Baby*. He agreed.'[88] What might Degas have admired in the
Scotsman's painting? Like Whistler with the *Little Dancer*,
there was probably the recognition of a kinship. Among the
works Degas had exhibited in London at Dowdeswell's in 1883
had been a pastel of three elaborately bonneted women seen
from behind (no.20), which had attracted the delight of a
Punch cartoonist (fig.14). The motif had a fascination for Degas
at this period, and he made several pastels on the theme. The
Dowdeswell's version typically views the figures from close up
and behind, making the spectator curious about the sight or
conversation the women are sharing and which their backs keep
from us. The back view, with its triple forms trimly corseted,
allows Degas's draughtsmanship to shape the sculptural forms,
much as Tissot and Orchardson had done in their paintings. All
these works, paintings and sculptures, are images not of explicit
narrative but moments of discreet exchange, between mothers
and their babies, the young trio on the ship, the reader and her
book. All share a consensus about modernity of pose, composi-
tion and stylishness that marked the cross-Channel exchanges
of the 1870s.

16
Jules Dalou
Woman Reading
c.1877, cast c.1905–17
Bronze H. 55.9 | 22
Toledo Museum of Art
Purchased with funds from
the Libbey Endowment, Gift of
Edward Drummond Libbey

17
James Tissot
The Gallery of HMS Calcutta (Portsmouth) c.1876
Oil on canvas 68.6×91.8 | 27×36 ⅛
Tate. Presented by Samuel Courtauld 1936

18
William Quiller Orchardson
Master Baby 1886
Oil on canvas 109 × 168 | 42⅞ × 66⅛
National Gallery of Scotland,
Edinburgh

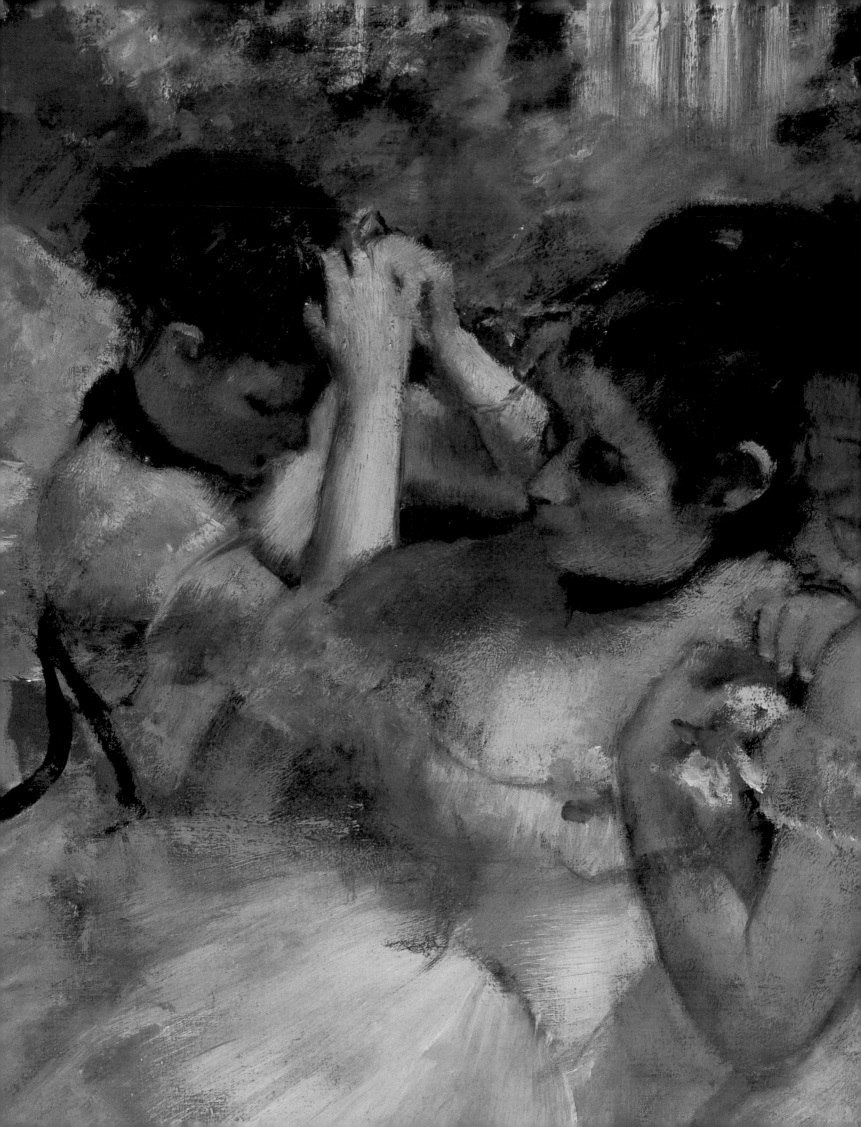

Anna Gruetzner Robins

THE GREATEST ARTIST THE WORLD HAS EVER SEEN

The one great French painter, perhaps one of the greatest artists the world has ever seen, has written his glorious page in the history of art outside the established official building, and has quietly stood aloof from its *tombolas* for places and its scrambles for medals.

Walter Sickert, 1889[1]

Walter Sickert's eulogy to Degas was by no means unique. Degas's reputation in Britain as King Impressionist was created during the 1880s, the decade when accounts of the artist-as-celebrity really took hold in the public imagination. The growing fascination with the ever-changing psychic and material aspects of selfhood, as reflected in the personality of the artist, dominated much of the cultural discourse of the 1880s, and the creation of the Degas legend is one of its primary subtexts.[2] A distinct, identifiable Degas for public consumption is presented in the art writing of this decade. Sickert's 1889 eulogy to Degas sums up a story that many others were telling.

When the second wave of Impressionist exhibitions began in London in 1882, followed by another in 1883, Degas's reputation as the foremost Impressionist in Britain was secured. The other Impressionists received trickles of appreciation, but none of them had Degas's celebrity status. 'Degas was chief of the school', claimed Frederick Wedmore (1844–1921), critic for the daily paper the *Standard* and the more highbrow weekly publication, the *Academy*. Wedmore was reviewing the exhibition *Modern French Pictures at White's Gallery* organised by Durand-Ruel, which included works by Degas, Cassatt, Monet, Sisley and Renoir, in addition to Delacroix, Delaroche, Millet, Boudin, Georges Michel and M.L. Weeks.[3] Degas complained that, in Wedmore's review, he had been 'flattered in a few courteous and pinched lines', but Wedmore certainly did his bit for championing Degas in Britain.[4] In one of the most sustained pieces of writing on Impressionism written in English during the 1880s, Wedmore praised Degas's 'interesting, brilliant, and vivacious' pictures. Later in 1883, *Paintings, Drawings and Pastels by Members of La Société des Impressionnistes*, a large exhibition again organised by Durand-Ruel, opened at the newly established Dowdeswell and Dowdeswell galleries at 133 New Bond Street in London. The show included seven works by Degas representing a range of subjects – horse racing, the ballet and the theatre, and hat shops. Degas's reputation was secured, or as Pissarro put it to Durand-Ruel: 'Degas finds himself chief of the

19
Edgar Degas
Jockeys before the Start 1878–9
Oil and *essence* on paper 104.3 × 73.7 | 41⅛ × 29
Barber Institute of Fine Arts,
The University of Birmingham

20
Edgar Degas
Women Leaning on a Rail (on the Boat) c.1883
Pastel on paper 57 × 83 | 22½ × 32¾
Private collection

fig.14
Mistaken Impressions
Cartoon published in *Punch*, 5 May 1883

fig.15
Edgar Degas
The Box at the Opéra 1880
Pastel on paper 66 × 53 | 26 × 20⅞
Private collection

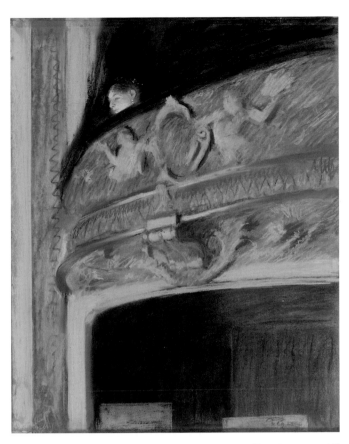

Impressionists; if only he knew! Anathema!'[5] Degas did not exhibit in the 1882 Impressionist exhibition in Paris, so Durand-Ruel must have identified the 1883 London exhibition – when at least five of the seven Degas pictures, including *Jockeys Before the Start* (no.19) and *Women Leaning on a Rail (on the Boat)* (no.20) were recent works – as an important opportunity to promote Degas abroad.[6]

Did Durand-Ruel, who had a rather cynical attitude towards the collecting habits of his clientele, choose *Jockeys Before the Start* and *Women Leaning on a Rail* because they depict the wet, misty weather conditions that the French associated with England? *Jockeys Before the Start* is a technically innovative work. It is painted with *essence*, oil paint from which most of the oil is removed, which is then thinned with turpentine to give the effect of watercolour. Degas's experimental use of *essence* for this misty landscape, with its silvery circle of sun or moon, compares to the liquid washes of colour used by Whistler to give the effect of a misty, moonlit Thames in his *Nocturnes*. British critics, who were saturated with exhibitions of watercolours, did not appreciate the experimental qualities of *Jockeys Before the Start*.[7] They did notice its daring composition, and the dramatic contrast of the vertical of the starting pole played off against the energetic movement of the three careering jockeys on horseback, placed at opposing diagonals. The crudely drawn caricature of *Jockeys Before the Start* that appeared in *Punch* captioned 'Impression in a Jockeylar Vein', with its crudely drawn pole and cut-off figures and horses (fig.14), gives a sense of the picture's impact in 1883. As the *Punch* critic commented: 'he has taken more than half a horse off his canvas?

Why didn't he content himself with cutting it off at the Mane?'[8]

The *Punch* cartoon for the first time conclusively identifies *Women Leaning on a Rail* as another of the Degas pictures shown in 1883. The work is executed in a variety of different strokes of pastel colour to emulate the stormy, overcast sky and choppy water and the various textures of the women's costumes. The women are possibly on some sort of boat, perhaps even crossing the Channel, and the daring angle of the view across their backs gives an extraordinary sense of immediacy. Their large, veiled hats catch the wind, making them seem like giant, translucent butterfly wings, or 'Fly-paper Impressions', as the *Punch* cartoonist suggested. 'More like a symphony of backs. Or are they moths? Melancholy colouring. Only three of them', was the cryptic comment of the *Punch* critic.[9] Two other works by Degas were illustrated in *Punch*. It labelled the pastel *At the Milliner's*, with its two cut-off figures of a customer and a shop assistant leaning under a tower of large hats to speak to her,

'Depression'. Nor could *Punch* resist remarking on *The Box at the Opéra* (fig.15). 'If you're waking, call me early, or the Bed Impressionist' was its response to the daring view of an opera box and a solitary figure. *Punch*'s jocular remarks tell us how Degas's representation of a way of seeing struck his British audience. As Frederick Wedmore, with more seriousness, put it: 'the chief painter of the Impressionist school has rare gifts of observation, and ... his skill and agility of hand are not less remarkable than his quickness of sight.'[10]

The future London Impressionist and great British modernist Walter Sickert, who would go on to make his mark on the art worlds of London and Paris, and the writer George Moore, saw these exhibitions. As an old man, Sickert, who 'thinks that our memories are more valuable than our thoughts', remembered what was probably his first sighting of a Degas picture, in the 1882 show.[11] This memory was sparked while he was reading Paul Jamot's commentary on *Lowering the Curtain* (fig.16) in his monographic study, *Degas*. Sickert scribbled in his copy of the book that 'Burne Jones was cross with me for admiring a "a fag-end of a ballet".'[12] Sickert owned two copies of the Jamot book, and characteristically he read and annotated both. In the second copy he had this to say about *Lowering the Curtain*: 'saw in London first Imp= St James St conversation with Burne Jones on this picture', providing definitive proof that *Lowering the Curtain* was exhibited in London in 1882.[13] The conversation about Degas's 'fag-end of a ballet' between Burne-Jones, a pillar

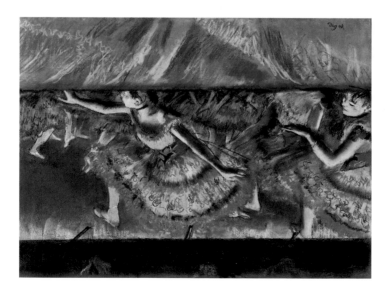

fig.16
Edgar Degas
Lowering the Curtain c.1880
Pastel on joined pieces of laid paper
54 × 74 | 21¼ × 29⅛
Private collection

of advanced British painting, and the young Sickert is fascinating because it gives us a glimpse into the mind of a modern giant. Burne-Jones, who was no lover of the contemporary working woman, was using slang when he described Degas's treatment of the ballet dancers on bended knees as a 'fag-end'. 'Fag', in the sense that Burne-Jones used it meant a cigarette butt.[14] What Burne-Jones hated, the young Sickert loved, appreciating that these slices of modern life in Degas's pictures, these fragments of a 'thing seen', were essential to Degas's modernity.[15]

The novelist and critic George Moore (1852–1933), who first met Degas in the 1870s and remained on good terms with him until he published his gossipy but highly informative 1890 article 'Degas: The Painter of Modern Life', also remembered *Lowering the Curtain*.[16] His description in *A Mere Accident*, his 1887 novel, presents the bodies of the dancers as a series of fragments – of 'arms raised', 'bosoms advanced', 'leaning hands', 'a piece of thigh'. 'The drop curtain is fast ascending, only a yard of space remains … Look at the two principal dancers! They are down on their knees, arms raised, bosoms advanced, skirts extended … leaning hands, uplifted necks, painted eyes, scarlet mouths, a piece of thigh, arched insteps … Vanity, animalism, indecency … wonderful Degas.'[17] Memories of other Degas pictures filter through Moore's prose, and frequently the same picture appears in his criticism and his novels. His description of *Jockeys Before the Start* in his first novel, *A Modern Lover* – 'The principal horse's head being cut in two by a long white post' - neatly sums up one of the startling pictorial strategies of Degas's modernity of vision.[18] Never one to miss an opportunity to repeat himself, Moore described the work again in his 1890 article: 'A racehorse walks past a white post which cuts his head in twain.'[19]

These slices of dancers, horses, shoppers and sales assistants, chattering women and theatregoers are figures in movement in Degas's pictures. Wedmore was one of the few critics to explain this point about these fragmented figures. When he looked at *Lowering the Curtain*, he saw 'a perfectly original study of the scuttering ankles of certain ballet girls under the weird and vivid illumination of the stage'.[20] Wedmore hit it on the head when he said that Degas was 'curiously alive to the charm of rapid and energetic movement, to the fascination of strenuous action'.[21]

Sickert was the first British artist to try out his own version of Degas's modern vision. Degas's connection with Sickert is so firmly part of Sickert's hagiography that few write about Sickert without mentioning Degas. The story centres on two meetings. The first took place in April 1883, when Sickert called on Degas at his Paris apartment, and Degas allowed him 'to examine all the pictures in the flat, and the wax statuettes under their glass cases' before arranging a visit to his studio the following day. The second meeting took place in Dieppe in summer 1885 when Degas made his monumental pastel drawing *Six Friends at Dieppe* (fig.17), in

which Sickert stands slightly apart from five French friends – clockwise: the young Daniel Halévy, Ludovic Halévy, the rotund Jacques-Emile Blanche, a lifetime supporter of Sickert, Henri Gervex and Albert Cavé. For the rest of his life, Sickert clung onto his memories of the making of the pastel. While the meeting was undoubtedly fruitful, it was the visit to Degas in Paris in autumn 1885, with his first wife Ellen Cobden Sickert (1848–1914), that marked a significant change in Sickert's way of thinking about Degas.

How much time did Sickert and Ellen spend with Degas in the autumn of 1885? 'He has said we must see a great deal of him in Paris at the beginning of next month', Ellen reported in September from Dieppe to her sister, Jane Cobden.[22] Degas probably made Ellen's portrait during one of these visits to his studio in autumn 1885 (no.21). Freely worked in pastel, it captures Ellen's characteristic pensive mood. She was someone who thought deeply about art and literature, sitting for a painting by Emily Osborne, *Reflections* (West Sussex Public Record Office), and later publishing *Wistons*, a novel which contains a portrait of Sickert. Ellen was actively engaged with social and political issues. In 1887 and 1888, she campaigned in Ireland for Irish Home Rule. The portrait, inscribed 'Unhappy Nelly/ Ça m'est égal', is thought to have been a portrait of the ballet dancer Nelly Franklin. A comparison with an earlier photograph of 'Nelly' or 'Nellie', as her friends and family knew her (fig.18), leaves little doubt that this is a portrait of Ellen. Admittedly she is slimmer in the photograph, but other photographs in West Sussex County

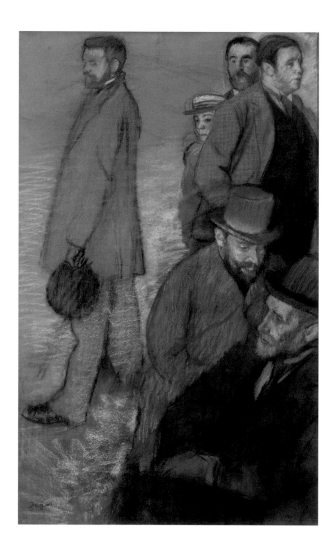

fig.17
Edgar Degas
Six Friends at Dieppe 1885
Pastel 115×71 | 45¼×28
Rhode Island School of Design,
Museum Appropriation Fund

fig.18
Ellen Cobden Sickert, 1870s
Photograph
Courtesy of the Trustees of the Cobden Estate,
with acknowledgements to
West Sussex Record Office

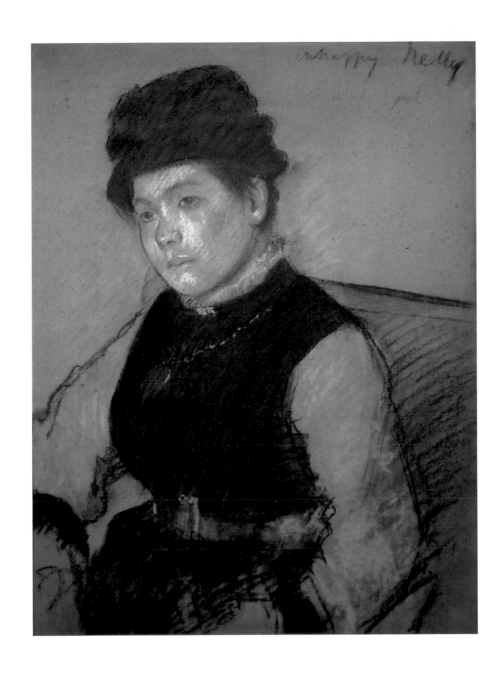

21
Edgar Degas
Unhappy Nelly c.1885
Pastel on paper 63.5 × 48 | 25 × 18⁷/₈
Museu de Montserrat
Xavier Busquets donation

22
Edgar Degas
Miss La La at the Cirque Fernando 1879
Oil on canvas 116.8 × 77.5 | 46 × 30½
National Gallery, London

Record Office show that she filled out in later years. She favours a high-necked white blouse like the one in the Degas portrait, where its distinctive white ruffle is summarily sketched against the heavier black of her tunic. The heavy gold locket, shining against the solid colour of her tunic, is similar to , if not the same locket that she wears in the photograph. Like her sister Jane, 'Nelly' supported Women's Suffrage. Her loose dark tunic is the sensible, comfortable costume of Rational Dress worn by many suffrage supporters. Furthermore, while the idiomatic translation of the inscription on the portrait, 'ca m'est égal', is 'what difference does it make', the more literal translation 'it's equal to me' suggests that Degas was making a characteristic leg-pulling reference to Nelly's gender politics. Degas may have been prompted to make the portrait as a way of winning Nelly's sympathy, because during the summer of 1885, amazing as it sounds given what we know about Degas's lack of emotional attachments to women, he developed some sort of crush on Jane Cobden. It was left to Ellen to sing his praises to her sister. Writing from Dieppe, just after Jane's departure for England, when Degas, who was staying with his old friends the Halévys, saw her off at the harbour, Nelly wrote: 'Afterwards Degas said to me "we all have such an admiration for your sister that we are jealous of one another"'.[23] Nelly wrote again to Jane about Degas after she and Sickert returned to London. 'We dined with Degas & he told me to tell you how much he wished you were of the party. His paintings are simply magnificent. I almost think them the finest in the world. You might do worse Janie dear.'[24] Sadly, Degas had no luck with Janie.

There were plenty of Degas pictures on offer in Paris. In Degas's apartment at 21 rue Pigalle, Sickert and his wife had their first sighting of *Miss La La at the Cirque Fernando* (no.22). Degas shared what would be the first of many intimacies when he explained his solution to his difficulties with the picture. Sickert's annotations in his two copies of Jamot tell the story. In his first copy, Sickert wrote: 'He had this picture hanging at his rue Pigalle residence where Nelly and me had taken the omnibus. Degas told us that he had been unable to come up with any perspective and that he had employed a professional for the drawing of the architecture of the ceiling'.[25] The second copy makes it clear that the conversation took place in 1885.[26] A detailed drawing (Barber Institute, Birmingham), 'complicated by pentimenti, diagonal construction lines and squaring-up', suggests that 'many of the construction lines' on the drawing may 'actually be by the unnamed professional'.[27]

Sickert was most likely fascinated by the elaborate lengths to which Degas went to give the effect of spontaneity. By adjusting the perspective with the help of a professional (why would there be any reason to doubt Sickert?) Degas heightened the effect of looking way up at the suspended figure of the circus performer, Miss La La, dangling by her teeth from a rope. One of Sickert's favourite sayings of Degas was that 'You give a real effect by using false means',[28] a wisdom that must have struck a chord with him, schooled as he had been by Whistler's dictum in *Mr. Whistler's Ten O'Clock* that 'Nature was always wrong', a precept that Degas and Whistler discussed in Dieppe in Sickert's company.

Degas sent Sickert, and probably Ellen, to the Champs Elysées to see the collection of Gustave Mulbacher who owned *The Rehearsal of the Ballet on Stage*, another version of which Sickert and Ellen would buy in 1889. 'I find I shall have to bring the whole school over to Paris sooner or later to make with me the Mulbacher and other pilgrimages', Sickert confessed to Blanche on his return to London, suggesting that already he had gained access to some of the eight collections of Degas in Paris, which he was able to recommend Henri Rouart's large collection to the art critic D.S. MacColl in 1892.[29]

The 'school' to which Sickert referred was a group of followers that formed around Whistler, made up of young artists including Elizabeth Armstrong (later Mrs Forbes), Sickert himself, Sidney Starr and William Stott of Oldham. They were encouraged to emulate every move of the older artist, and to paint pictures in a similar style to his own. Mortimer Menpes, another follower, recounted that Sickert 'brought enthusiastic descriptions of the ballet girls Digars [sic] was painting in Paris' and that 'we tried to combine the methods of Whistler and Digars', showing that Sickert immediately began to proselytise for Degas's art.[30] Whistler's dictatorial ways made it easy for some of them to accept another master, but not until spring 1887, when Sickert exhibited *Le Lion Comique* (fig.19) at the Royal Society of British Artists where Whistler was President, did Sickert make his enthusiasm for Degas public.

Just when did Sickert first see Degas's *The Ballet Scene from Meyerbeer's Opera 'Robert le Diable'* (no.23)? The Anglo-Greek collector Constantine Ionides (1833–1900) bought the work in 1881 and bequeathed it to the Victoria and Albert Museum in 1900, making it the first Degas to enter a public collection in Britain. It is possible that W.E. Henley (1849–1903), poet, critic and editor of the *Magazine of Art*, arranged for Sickert to see it, since he was active in arranging for others in Sickert's circle to see

23
Edgar Degas
The Ballet Scene from Meyerbeer's Opera
'Robert Le Diable' 1876
Oil on canvas 76.6 × 81.3 | 30¼ × 32
Victoria and Albert Museum, London
Bequeathed by Constantine Alexander Ionides

the collection.[31] Henley arranged for it to be brought to the *Magazine of Art* for reproduction in an article on the collection. Sickert possibly sought an introduction to the Ionides collection through Burne-Jones, a family friend.[32] Degas's picture, a vivid scene of the demonic ballet of the nuns from Meyerbeer's opera, filled Sickert's pictorial memory bank when he started work on *Le Lion Comique*, his first major music-hall picture. Sickert's mother thought that *Le Lion Comique* was a 'very clever' picture,

and she was right.[33] Sickert's choice of a flashy 'gentleman' performer, the 'lion comique', the mainstay of the early English music-hall stage, could not have been more different from Degas's grand Romantic ballet of *Robert le Diable*. The English music hall, a favoured form of entertainment for the working class, hardy attracted the smart crowd that attended the Paris opera. Degas looked at the illustrations of Gavarni and Daumier, and used this popular source to create the 'distinct' zones of the composition of *Robert le Diable*, a fact which Sickert, with his love of popular illustration, would have approved. *Le Lion Comique* reduces Degas's complex figure arrangement to a single gesticulating male performer standing against a painted backdrop, with a deeply engrossed, male violinist below. This simplification would have suited any young artist trying a hand at a new format and it is in keeping with the less sophisticated style of music-hall entertainment. Sickert was 'seeing' a memory of Degas's *Robert le Diable* and he was 'seeing' the performance of the 'lion comique' from a seat close to the stage. The palette of blue, brown, black and white of *Robert le Diable* inspires the similar palette in *Le Lion Comique*, but Sickert's colour is flashier and flatter. The *Artist* said that *Le Lion Comique* (or *Mammouth Comique*, as Sickert first entitled it) 'will interest and legitimately amuse very varied grades of society'.[34] The magazine's critic, E.J. Spence, recognised that Sickert was using a pictorial means that would reflect his own act of 'seeing' this popular form of entertainment. Spence might have been taking the words from Sickert's mouth when he wrote: 'to produce this first "impression" is the artist's aim; and he does it by splashes of apparently haphazard colour which, at some arbitrary distance, resolve themselves into the impression.'[35] The slice of musician in *Le Lion Comique* becomes a slice of the music-hall crowd in Sickert's later-1880s music-hall pictures, where a performing music-hall artiste is played off against a fragment of the audience.

In 1886, the Sickerts acquired two Degas pictures of their own. Writing to Blanche in December 1885, Ellen announced their decision to spend their money on a Degas collection. 'We are delighted that Degas is selling – I think we shall end by giving up the dull necessities of life & buying one of his pictures ourselves! They haunt our imagination. Walter had a beautiful letter from him the other day.'[36] 'Haunt' has a compelling ring. Seeing Degas's 'simply magnificent' pictures, as Ellen described them, was a mesmerising experience. The Sickerts could not get Degas out of their minds. Sickert's memories of his first sightings of Degas pictures remained with him throughout his life, and Ellen

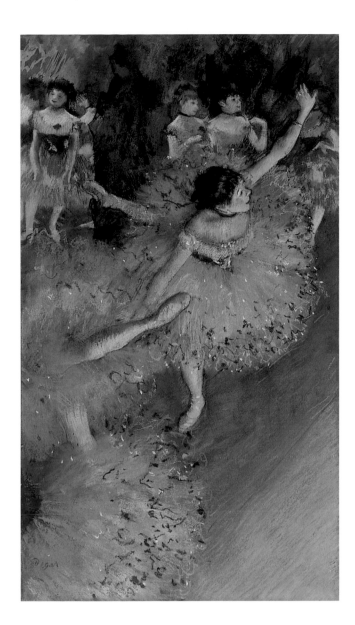

lector and editor of the *Gazette de Beaux Arts* and acquaintance of Whistler. Blanche was astonished to see it at the Sickerts because Ephrussi had pretended that he had moved the picture to a more private room in his Paris residence.

When Sickert was in Paris in spring 1886 he saw the Degas lithograph, reworked in pastel, *Mlle Bécat at the Café des Ambassadeurs* at Closet, the dealer's in the rue de Châteaudun (fig.21). Shortly after his return to London he advised Blanche: 'I want to buy a pastel lithograph of Degas that Closet has. A singer with two white gloves & many globes of light & a queer wooden thing behind & fireworks in the sky & two women's heads in the audience. Will you be so very kind as to pay him for me & ask him to pack it most carefully & send it. I enclose a cheque for £16 the price he asked me for it. If he will let you have it cheaper so much the better. In any case that must cover the cost of the carriage.'[37] Blanche arrived with the picture when he visited the Sickerts in June 1886. Three years later, Sickert completed his collection of dancers and entertainers when he bought *The Rehearsal of the Ballet on Stage* for 66 guineas (fig.9).[38]

was deeply attached to them. By late spring 1886, *The Swaying Dancer*, which Sickert, presumably on Degas's advice, called *The Green Dancer* (fig.20), was hanging in a prominent place in the Sickert's new home in West Hampstead. Blanche knew *The Green Dancer* (as I shall refer to it in this essay) well when it hung in the collection of Charles Ephrussi (1849–1905), the critic, col-

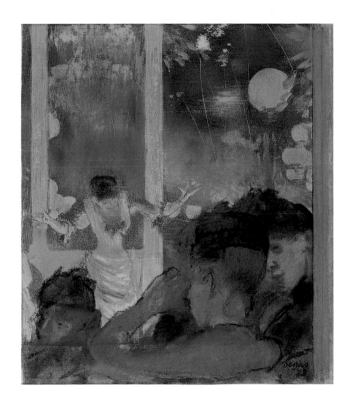

fig.22
Walter Sickert
Houndsditch (Theatrical Costumier) c.1884
Etching 68×108 | 26¾×42½
The Fitzwilliam Museum,
University of Cambridge

The Sickerts spent just under £300 in total on these three Degas pictures, not a huge sum of money, but probably much more than Sickert could possibly have afforded without the resources of his wife's private income. Undoubtedly Ellen's money paid for the Sickert Degas collection, which explains why they were exhibited under her name or her family's name (except in 1888), and why they stayed in her family after the Sickerts separated in 1897. In 1898 Ellen's sister, Jane Cobden, who married the publisher T. Fisher Unwin in 1893, lent all three of the Sickerts's Degas pictures (without Degas's approval) to the International Society, using her own name presumably to avoid controversy.[39]

The fourth Degas in the Sickert collection, *Woman at a Window*, acquired in 1902 in part exchange for *The Rehearsal of the Ballet on Stage* (see p.184), passed to another sister, Annie Cobden-Sanderson, on Ellen's death in 1914. Ellen was deeply attached to the Degas pictures, writing to Jane in 1900: 'I was much relieved also to find the telegram with the one word 'Bien' & to know the Degas is safe.'[40]

What a privilege it was to own this collection of three Degas. For Sickert, owning a Degas was everything. Writing from the Swiss Alps while on holiday at Pontresina with Ellen late in 1886, Sickert confessed to Blanche that 'I ... shall be glad to be back with the green danseuse who is better than all the scenery of Switzerland.'[41] *The Green Dancer* is one of Degas's most startling efforts at drawing the viewer's eye in the midst of the performing dancers on stage. How Sickert must have gazed at this highly memorable image of an energetic young dancer caught for a second performing an arabesque, her long thin arms stretching half-way along the diagonal of the picture, entwining with the leg of another dancer, balanced by her own upraised leg.

Sickert had two important projects in the 1880s. The first was to represent the vast urban sprawl of London, 'the four mile radius' as he described it in 1889. A series of 1884 etchings, including a music hall, a theatrical costumier and a square in the East End, Lincoln's Inn Fields, Houndsditch (fig.22), the approach road to North London from the East End, the northern suburb of St John's Wood, Hyde Park corner, Sloane Square and Chelsea in south-west London, and a music hall and restaurant in the West End, are the graphic evidence of Sickert's interest in the metropolis. Only Starr gave Sickert's project painterly form. See for example, *The City Atlas* (no.24), whose title comes from the name of the omnibus route from Trafalgar Square through the suburb of St John's Wood.

Sickert's second project was to represent the English music hall, appreciating that in these intimate, urban, interior public spaces he could represent fragments of urban life and his own modern vision of London. Undoubtedly what attracted Sickert to Degas's art was his treatment of the modern figure. On his 1885 visit, Degas showed the Sickerts some of his pastel nude bathers – some of which Sickert would see again at the 1886 Impressionist exhibition in Paris the following spring – telling them that 'I want look through a keyhole'.[42] But Sickert knew there was little chance at trying his hand at the modern nude when a prurient British public assumed Degas to be a pornographer for representing the female nude in a modern setting. Not until 1905 were any comparable Degas pastel nudes exhibited in London.[43] Sickert found a brilliant solution to the problem in the English music hall, where the scantily clad female performers provided ample opportunities for drawing a 'visible body' in modern-life situations.

Gatti's Hungerford Palace of Varieties: Second Turn of Miss Katie Lawrence (no.25) is Sickert's pictorial response to Degas's *The Green Dancer*. The picture is a later version, painted around 1903, of a subject which Sickert first explored in a lost picture of the same title. Some newly discovered drawings (including fig.23) that Sickert made in Gatti's Hungerford Palace of Varieties, the notorious music hall on Villiers Street, Charing Cross, suggest that Sickert thought about making another version of the picture in April 1888, the same month that first version was exhibited at the New English Art Club, where it received a torrent of abuse. *The Green Dancer* was exhibited under Degas's name in the same exhibition. 'Degas was kind enough to telegraph me

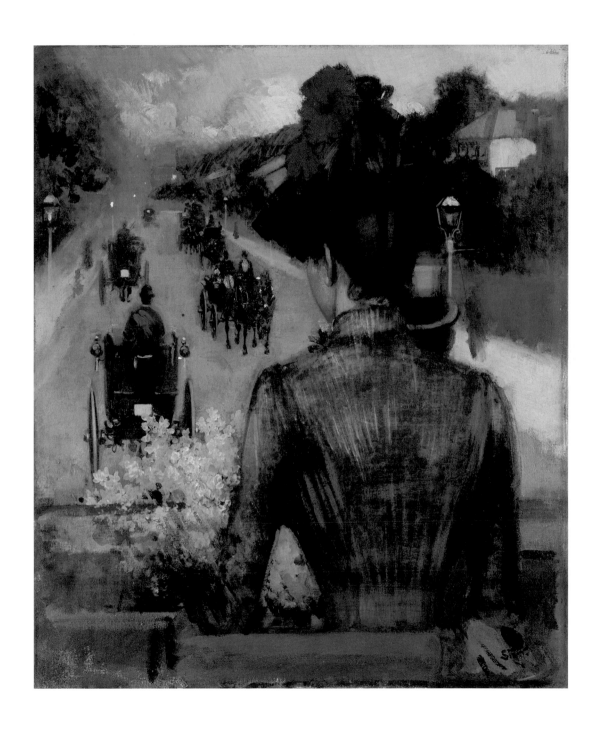

24
Sidney Starr
The City Atlas 1889
Oil on canvas 61 × 51 | 24 × 20
National Gallery of Canada, Ottawa
Gift of the Massey Collection of
English Painting 1946

fig.23
Walter Sickert
Fifteen Sketches of Music-Hall Performers 1888
Pencil on paper, backing sheet 44.5 × 28.5 | 17½ × 11¼
The Royal Pavilion, Libraries and Museums,
Brighton and Hove

permission to exhibit my green dancer there which was received with acclamation', Sickert informed Blanche.[44] Characteristic of these critical accolades were the comments of the *Manchester Guardian*, which explained that 'the apostle of pastel … contrives to win a spontaneity almost if not quite beyond the man who bears a palette on his thumb. The ballet is a favourite subject with him. It affords an opportunity for winning vivid contrasts of light and colour, and when it is still more fascinating to the impressionist, for contradicting time honoured renderings of things.'[45]

Writing in 1892, Sickert expressed his admiration for Millet's ability to represent 'the complex difficulties of suggestion of movement'. Millet 'observed and observed again, making little in the way of studies on the spot, a note sometimes of movement on a cigarette-paper', and this practice of note-taking gave him 'the secrets of light and life and movement'.[46] Sickert claimed that Degas was the 'greatest heir' to Millet and his methods, and that Degas had simply transferred 'his field of observation' from village life and peasant labour to 'the sordid toil of the green room' and 'the hectic mysteries of stage illumination'.[47] He might have been writing about himself. Sitting in the dark in Gatti's Hungerford night after night, usually four rows back, Sickert made tiny sketches, with 'hand and eye recording the fleeting effects that confronted them'.[48] Using notebooks of cheap paper, small scraps of graph paper or pages torn from a diary or an account book, Sickert made hundreds of these small sketches in monochrome pencil.

Wendy Baron has analysed the drawings for *Gatti's Hungerford*.[49] Drawings in Brighton Art Gallery cast new light on the proposed second version. The first set of fifteen drawings of varying sizes on two types of graph paper and ruled paper were mounted by Sickert on one large sheet of paper. On the bottom of the mount in Sickert's hand is the inscription 'Ap. 1888 This is a set of studies to decide on second large image.' The annotations, also in Sickert's hand, include the lyrics to a music-hall song, two names, 'Marie' and 'Rosie Maquoid' and 'if figure were life-sized picture might be 22' high', a cryptic response to the abusive reaction of the critics to the large-scale figure of Katie Lawrence in the lost version of *Gatti's Hungerford*. Getting the figure right in the second picture was important to Sickert. A second mount of eight drawings cut to varying sizes, on the same thin cream-coloured paper with a perforated edge, four of them annotated 'Oaksnight', 'June 1888', 'June 7 1888' and 'June 8', relate closely to *Gatti's Hungerford*. None of the drawings makes reference to Katie Lawrence, and since she was apparently on tour in

Australia in April 1888, we cannot assume that the second picture represents her. The purpose of these drawings was to find a satisfactory means for representing the female performer. They were also intended to capture the figure in movement, and while two drawings depict a dancing figure, most of the drawings are closely related to the yellow-frocked figure in no.25, who stands motionless with her left arm slightly raised. The pose of the

25
Walter Richard Sickert
Gatti's Hungerford Palace of Varieties:
Second Turn of Miss Katie Lawrence c.1903
Oil on canvas mounted on hardboard 84.4 × 99.3 | 33¼ × 39
Art Gallery of New South Wales, Sydney
Watson Bequest Fund 1946

26
Edgar Degas
Yellow Dancers (In the Wings) 1875–9
Oil on canvas 73.5×59.5 | 29×23⅜
Art Institute of Chicago. Gift of Mr and Mrs Gordon Palmer,
Mr and Mrs Arthur M. Wood, Mrs Bertha P. Thorne, and
Mrs Rose M. Palmer

27
Walter Richard Sickert
The Gallery at the Old Bedford c.1895
Oil on canvas 76.2×60.4 | 30×23¾
National Museums Liverpool,
The Walker

female performer in no.25 echoes that of the dancer in orange standing off-stage, her arms hanging in an awkward pose in Degas's *The Green Dancer*. Even when Sickert drew from life, Degas haunted his imagination. Inspired by the artificial light effects in Degas's *Mlle Bécat* (fig.21), Sickert created a memorable image of the London music hall in *The Oxford Music Hall* (no.28). After Sickert accrued in his memory a flood of different images, from his drawings, from Degas pictures and other sources, *The Green Dancer* was still an inspiration. Sickert tried out a variation of the orange and green, used in a different combination in *Miss La La* (no.22) in *The Gallery at the Old Bedford* (no.27) and *The Old Bedford: Cupid in the Gallery* (no.29). Areas of green and orange define the ornate architectural interior of the Old Bedford music hall and the reflection of the vaulted ceiling in the mirror, which curiously echoes the roof beams in *Miss La La*, while we the viewers look up at the 'boys in the gallery'.

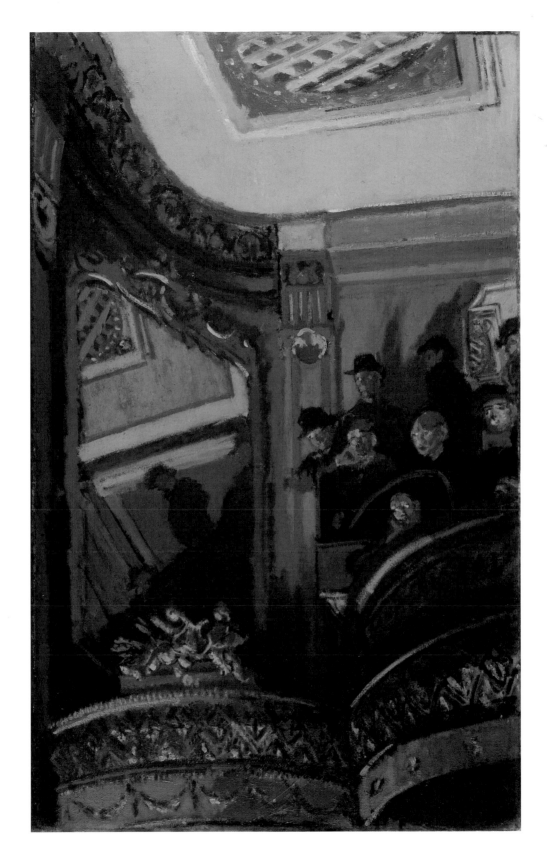

29
Walter Richard Sickert
The Old Bedford: Cupid in the Gallery c.1890
Oil on canvas 126.5 × 77.5 | 50 × 30½
National Gallery of Canada, Ottawa
Gift of the Massey Collection of English Painting 1946

When the railway magnate James Staats Forbes (1823–1904), visited the 1888 New English Art Club show, he cannot have helped but notice Degas's *The Green Dancer*. Shortly afterwards he added his own Degas, *Yellow Dancers* (no.26), to his large collection of Barbizon paintings, followed by *Young Woman with a White Scarf* (1871–2, Hugh Lane Gallery of Modern Art, Dublin) later in the decade. Exactly when and where Forbes purchased *Yellow Dancers*, which was in his collection by 1892, is not known.[50] It was a sophisticated choice. This extraordinarily close-knit arrangement of three dancers, 'with their torsos merged and their skirts dissolved in a single mass of colour', placed at a right angle to the canvas, must have seemed extraordinary to Forbes, whose collection included a number paintings of monolithic figures, set in conventional space. He possibly bought *Yellow Dancers* because he felt the pressure of competition resulting from the growing interest in Degas amongst British collectors. But Forbes had another reason for taking an interest in Degas. His nephew, the Newlyn painter Stanhope Forbes, was married to the artist Elizabeth Armstrong Forbes. Before her marriage in 1889, Elizabeth Armstrong was the only female artist accepted into the circle of artists around Sickert who took an interest in Degas. The cluster of children in Elizabeth Forbes's *Oranges and Lemons* (no.30), who form a coherent mass, arranged off-centre and spilling from left to right, must have been prompted by the arrangement of the figures in *Yellow Dancers*. The Elizabeth Forbes pastel is nearly square, a format favoured by Degas and used for *The Sprigged Frock*, a pastel by Philip Wilson Steer (no.36). As Elizabeth Armstrong she had joined the Sickerts' parties in West Hampstead where she must have seen their Degas pastels.

Writing in 1883, Frederick Wedmore commented that Degas 'proves himself a colourist' in his pastels, attaining 'a success in the indication of texture ... of quite the finest and most dignified kind.'[51] His perceptive comments were a foretaste of the enthusiasm for pastel amongst Sickert's circle. The exhibitions of Whistler's pastels were influential, but several artists in Sickert's circle including James Guthrie (no.31), Sidney Starr (no.33) and William Stott of Oldham (no.32) used pastel as Degas did for colour and texture effects. Stott in fact had first-hand contact with Degas, and seems to have made a portrait of him. Starr often drew alongside Sickert in the music hall. In Starr's *At the Café Royal* (no.33) the cut-off figures in this lively bohemian meeting place and the thickly-worked pastel colour reflect Starr's admiration for Degas. During the first years of their marriage, the Sickerts frequently entertained artists from Sickert's circle in their West Hampstead home. Their Degas collection was a micro-museum when there were few opportunities to see Degas pictures in England. Referring to *The Rehearsal of the Ballet on Stage*, which he had just bought at the sale of the widow of Captain Henry Hill (see p.66), Sickert explained: 'I find more & more in half a sentence that Degas has said, guidance for years of work.'[52] His enthusiasm had an infectious effect on Armstrong (later Forbes), Starr, Steer and the others, none of whom owned an original Degas. The Sickert collection was not a private museum like the Hill collection, where an attendant showed visitors into the two galleries in Hill's Marine Parade Brighton residence. (Whistler described one visit: 'I was shown into the galleries, and of course took a chair and sat looking at my beautiful Nocturne [*Nocturne in Blue and Gold: Valparaiso Bay*, Freer Gallery of Art, Washington, D.C. which Hill acquired in 1874–5] then, as there was nothing else to do, I went to sleep.')[53] Those outside Sickert's immediate circle could see *The Rehearsal of the Ballet* at the New English Art Club winter exhibition. The following autumn the Sickerts lent Degas's *Mlle Bécat at the Café des Ambassadeurs* to the second winter exhibition of the club. Two reviews describe 'an open-air Champs Elysées scene, with a woman of undisguised aplomb singing and gesticulating'[54] and a 'platform amidst the gas-lit greenery seen behind a foreground of pork pie hats and spectators' *gants de suede*',[55] confirming that the work exhibited as *Café Chantant* was in fact the Degas picture.

Two Degas pictures, *Dancers Preparing for Ballet* and *Two Harlequins* (National Gallery of Ireland) were bought by the Irish nationalist playwright Edward Martyn (1859–1923), the co-founder of Sinn Fein, accompanied by his boyhood friend George Moore, during a two week trip to Paris in spring 1885. The pictures were possibly on view in Martyn's London rooms. Interested parties may have been able to see the Hill collection which remained in the family until the death of Hill's widow. Sickert certainly assumed that Blanche knew of it. Even so, this added up to only a handful of Degas pictures in British and Irish collections.

The flood of reproductions of Degas pictures available today makes it difficult to imagine what it must have been like for any artists, collectors or critics in Britain who were eager to become better acquainted with his work. His reputation as a prodigious printmaker made him a natural choice for membership in the newly formed Society of Painter-Etchers (1880). Unfortunately

30
Elizabeth Forbes
Oranges and Lemons c.1890
Pastel on paper 78.5 × 72 | 31 × 28⅜
Private collection, courtesy of
The Belgrave Gallery, London

31
James Guthrie
Fire Light Reflections 1890
Pastel on board 60.5×72.2 | 23⁷/₈×28³/₈
Paisley Museum and Art Galleries

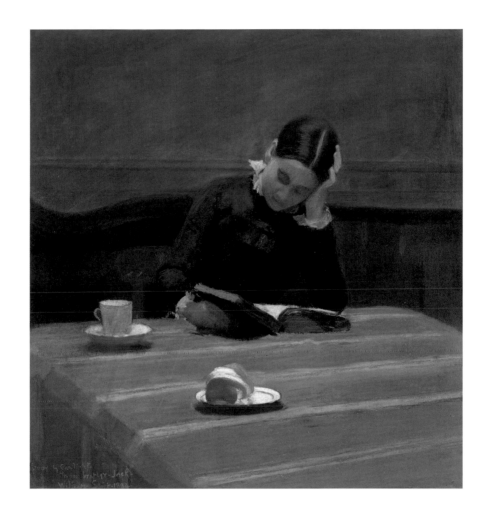

32
William Stott of Oldham
CMS Reading by Gaslight 1884
Pastel on paper 48.3 × 45.7 | 19 × 18
Private collection

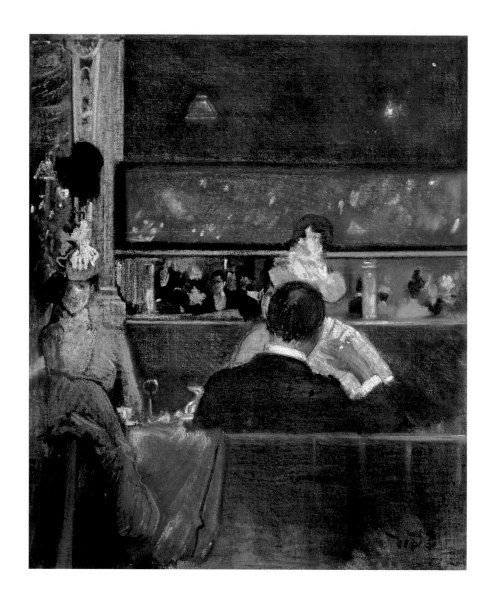

33
Sidney Starr
At the Café Royal 1888
Pastel on canvas 61×50.8 | 24×20
Private collection

fig.24
Edgar Degas
The Laundresses 1879–80
Etching and aquatint | 11.8 × 15.8 | 4⅝ × 23¼
The British Museum, London

Degas refused the offer of membership, and no original prints by Degas appear to have been exhibited in Britain in the nineteenth century. How the painter, book designer and publisher Charles Ricketts acquired the etching and aquatint *The Laundresses* (fig.24) is not known. The print is signed, in purple ink, and does not bear Degas's studio stamp.[56] This suggests that Ricketts may have acquired it from Degas on one of the trips he and his life-long companion, the artist Charles Shannon, made to Paris. He was certainly aware of Degas's reputation as a printmaker. Around 1892, Ricketts dreamed of persuading Degas (and Mary Cassatt and Berthe Morisot) to participate in an exhibiting society, devoted to all works on paper. However, his plans for the Panel Society never came to fruition.

Any Degas print would have been snapped up for study since reproductions of his pictures were few and far between. *The Ballet from Robert le Diable* was reproduced in the *Magazine of Art* in 1884; the *Art Journal* reproduced *Le Maître de Ballet* (L298) in 1888, the first Degas picture to be exhibited in Scotland; and the *Magazine of Art* used *Robert le Diable* again in 1889, together with the Sickerts's *The Rehearsal of the Ballet on Stage* and a reproduction of a Degas drawing of racehorses, which is probably the drawing Moore acquired from Degas for £7 for a friend.[57] According to Moore, George William Thornley, a reproductive printmaker, made a lithograph of the drawing.[58] Published in 1889 in an edition of 100 (see no.34), the Thornley lithographs after Degas pictures were made in collaboration with Degas: 'to capture the artist's "touch", that personal quality usually lost by the printmaker when translating a painter's syntax into that of his own medium'.[59] Nine of the pictures in the Thornley group belonged to Henri Rouart, whose collection was known to Sickert. While Sickert might have hoped for photographs of the 'great originals', he still thought 'the translator's sensitive appreciation' was 'exquisite'.[60] His comments give an inkling of their importance for Sickert, who regarded the lithographs as 'absolutely invaluable to all serious students of art'. Engaged as he was in his own learning process about Degas's compositions, it is hardly surprising that Sickert would have claimed that the lithographs were 'such an education in selection and treatment, as all the art schools and ateliers of Europe rolled into one could not supply'.[61] Four of these lithographs were part of a display of prints and photographs put together by Sickert at the 1889 New English Art Club show. They possibly came from his own collection, as by autumn 1889 Sickert had acquired the Thornley portfolio, probably from the London branch of the Goupil Gallery, where Sickert's London Impressionist exhibition was held in December 1889. His fellow exhibitor Philip Wilson Steer also owned a Thornley set.

Sickert was quick to dismiss the efforts of a 'man [who] does a smudgy sketch of a ballet-girl with high heels, and in studio light' as a way of 'imitating Degas'.[62] He was probably thinking of the efforts of Albert Ludovici, rather than the two ballet pictures by Steer, *Signorina Sozo in Dresdina* (fig.25) painted from sketches made from life, and *Prima Ballerina Assoluta*, where Steer was 'fascinated and engrossed' by 'movement – the bounding movement of the figure, and the flash of light on a great stage'.[63]

In late nineteenth-century London, the ballet was a short act in the music-hall programmes of the larger halls such as the Alhambra on Leicester Square. Sickert preferred the music-hall performers. Not once did he paint the ballet. But the Thornley lithographs were an important visual aid for him. Their distinctive linear quality made Degas's ingenious use of figures against a careful arrangement of vertical and right angles crystal clear. The complex compositions of his 1889 music-hall pictures, *Little Dot Hetherington at the Old Bedford* – which he later translated into a fan(no.40) – and *P.S. Wings in the O.P. Mirror* (no.61) are as indebted to the Thornley lithographs as much as to the Degas pictures he owned.

Ballet Class
20.3 × 26.4 | 8 × 10⅜

Dancer by the Stove
33.5 × 25 | 13⅛ × 9⅞

At the Bar: Exercises
23.4 × 28 | 9¼ × 11

Dancer Dressing
23.8 × 19.6 | 9⅛ × 7¾

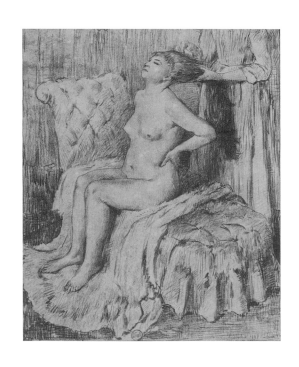

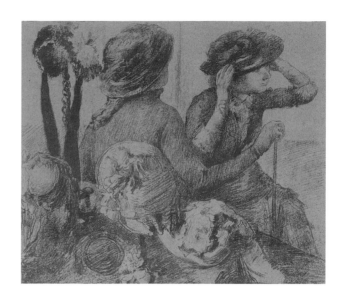

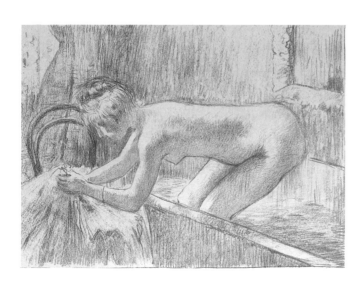

The Song of the Dog: Thérèse Valdon
36.5 × 23 | 9½ × 7⅛

Women in a Hat Shop
23.5 × 27 | 9¼ × 10⅝

Getting out of the Bath
22.2 × 29.6 | 8¾ × 11⅜

On the Beach
19.3 × 34.2 | 7⅛ × 13½

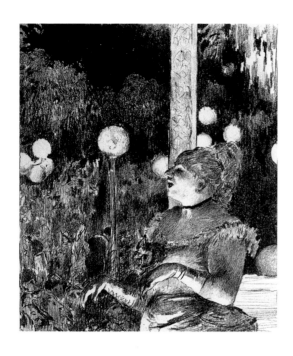

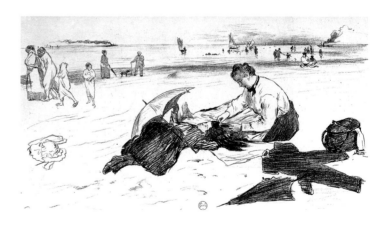

fig.25
Philip Wilson Steer
Signorina Sozo in Dresdina 1889
Oil on canvas 59.7×76.2 | 23½×30
Private collection

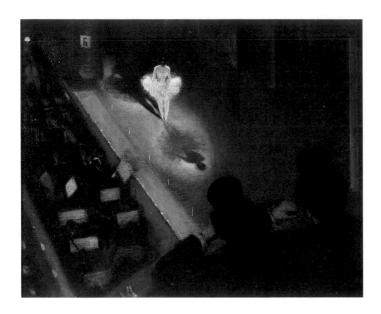

Philip Wilson Steer never painted a pastiche of a Degas picture, but the Thornley lithographs were an inspirational source for his own pictorial means. The lithograph (p.81) after Degas's *Beach Scene* (1869–70, Hugh Lane Bequest, National Gallery) was a touchstone for the arrangement of children lying on the shingle beach in Steer's *Knucklebones* (fig.26). During the years when he was forming his collection, Hugh Lane was part of Steer's circle, and it is tempting to think that he knew the Thornley lithograph of *Beach Scene* long before he bought the picture in 1912. *Mrs Cyprian Williams and her Two Little Girls* (no.37), a portrait of the artist Helen Rosalind Williams (née Campbell), who was married to the lawyer, T. Cyprian Williams, and their two daughters, is also indebted to a Thornley lithograph. The cut-off view of the seated Helen Williams, seen from above, and the sharply angled alignment of her two children makes subtle reference to the Thornley lithograph (p,80) after Degas's *The Rehearsal* (c.1873–9), The Frick Collection, New York). Helen Williams was one of the few women to exhibit at the New English Art Club, where Steer's portrait was shown in spring 1891. The picture was painted at Cyprian Williams's 'house in Hampstead, where in his early married days many young painters, now famous, of the impressionist school, musicians, and men of letters found a brilliant hostess and a most congenial welcome.'[64] The sunflower decoration on the glazed tiles on the grate, the Japanese dolls, the blue fabric with its Japanese motif, the simple arrangement of chrysanthemums,

the rattan furniture and the William Morris cushion are in the latest Arts and Crafts taste. She sits apart from her children who are absorbed in their own childish activities. Perhaps she is thinking about her own art. The softly feathered linear strokes of reds and blues in the Steer portrait echo Thornley's ingenious techniques for evoking the delicate, light-filled hues of the rehearsal room. Of all the critics, George Moore understood that Steer, like Degas, used this domestic setting to give the effect of 'a lady in her own drawing-room as she lives'.[65]

The ballet enabled Degas to depict the figure in movement and in new and unfamiliar poses. Children provided Steer with similar opportunities. The splayed legs of the two Williams children resemble a balletic pose, but few recognised Steer's efforts to represent their childish posture. *Land and Water* was not alone in complaining about the 'two quaint little seated dolls [that] pass for children'.[66] Shortly afterwards Steer embarked on a series of pictures, including *A Girl at her Toilet* (no.35), of a semi-clothed model either dancing or seated in a series of poses that try out new ways of representing the figure.

The British public had another chance to see a Degas ballet picture when Ellen Sickert lent *The Rehearsal of the Ballet on Stage* (fig.9) to the winter exhibition of the New English Art Club. It was the first time that the New Art Critics, MacColl and Moore, were able to give a concerted voice of approval to the exhibition of a Degas. There is a possibility that in 1893 Degas, probably at

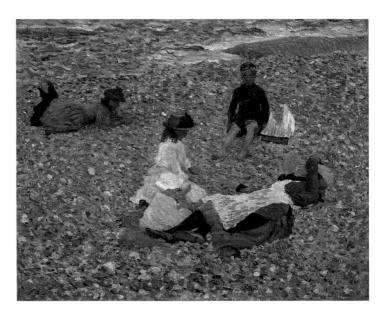

fig.26
Philip Wilson Steer
Knucklebones, Walberswick 1888–9
Oil on canvas 61×76.2 | 24×30
Ipswich Borough Council Museums and Galleries,
Suffolk

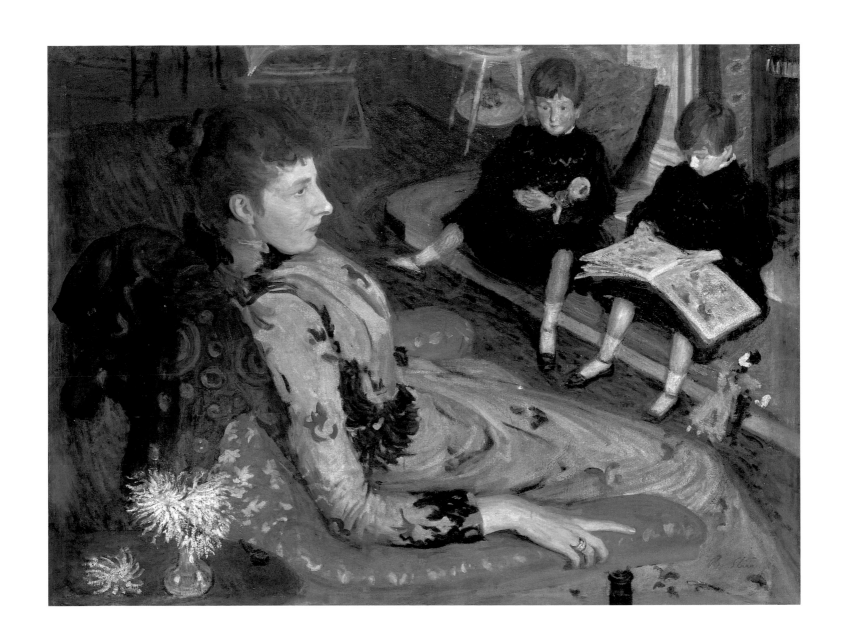

37
Philip Wilson Steer
*Mrs Cyprian Williams
and her Two Little Girls* 1891
Oil on canvas 76.2×102.2 | 30×40¼
Tate. Purchased with assistance from
anonymous subscribers 1928

No other picture by Degas has such a complicated early history as *L'Absinthe*. Degas planned to exhibit it in the second Impressionist exhibition in 1876, but instead it appeared at the third Impressionist exhibition in the following year, by which time it had been bought by Captain Henry Hill, who acquired it from Charles Deschamps, proprietor of the Deschamps Gallery in New Bond Street, sometime in spring 1876. The Hill family business, Hill Brothers, military tailors by special appointment to her Majesty in Old Bond Street, was a short walk away from the Deschamps Gallery. In September 1876 Hill lent *L'Absinthe* to the Brighton Art Gallery's *Third Annual Winter Exhibition of Modern Pictures*, where the critic of the *Brighton Gazette*, thinking that the picture represented 'a brutal, sensual-looking French workman and a sickly-looking grisette' commented that the 'disgusting novelty of the subject arrests attention.'[85]

The next chance the British public had to see *L'Absinthe* was at Christie's on 20 February 1892 when it was bought by Alexander Reid who sold it to the Edinburgh collector Arthur Kay. Kay, who attended the auction, remembered that it was 'hissed', an expression of disapproval that he believed to be unique in the context of an auction house.[86] Fascinated by *L'Absinthe*, Kay hung it 'in a position which enabled me to pass and see it constantly; every day I grew to like it better' but he claimed, 'wearied by the questionings of those who were incapable of understanding it, I exchanged it in part payment for another picture. It had not been away for 48 hours before I went back to the dealer, and, in order to recover it, bought another work by Degas [*Dancers in the Rehearsal Room*] ... *L'Absinthe* then went back into its former position.'[87] Almost exactly a year later Kay lent both Degas pictures to the Grafton Gallery in London.

The *Brighton Gazette* critic rightly recognised that *L'Absinthe* represents a disreputable man and woman, but they were also recognisable portraits of members of Degas's circle. The actress Ellen Andrée and the artist Marcellin Desboutin (1823–1902) modelled for Degas, and acted out social roles in the picture other than those they would have adopted in their own lives. Desboutin's identity was revealed during the Grafton Gallery showing. Confusion about whether it was a portrait picture or a social genre picture contributed to the controversy that erupted during this exhibition.

With its wide range of international artists, including Blanche, Boldini, Rodin and Whistler, the Grafton show was by no means an Impressionist exhibition. No particular honours were paid to the Degas pictures, which were hung away from the central room, where as D.S. MacColl pointed out they were 'so lumbered up with a screen, that it is not easy to get a general view of them'.[88] In spite of this inauspicious display, the pictures attracted some favourable notices.

But not from the *Westminster Gazette*, which thought *L'Absinthe* represented 'degraded types'.[89] The *Westminster Gazette* was a newly established (January 1893) popular evening paper, which needed more than its distinctive green paper to capture the rapidly expanding popular market. As assistant editor, J.A. Spender was 'a Jack-of-all-trades ... leader-writer ... [and] art critic [who] contrived to make a little splash in that capacity'. After reading George Moore's and D.S. MacColl's first reviews of the show, Spender took the pseudonym of 'The Philistine' and seized the opportunity for scandal.

Moore was a novelist and critic who had moved in the circle of French naturalist writers. He was the only critic writing in English to review the eighth and last Impressionist exhibition, when a controversy about Degas's bathers, who most critics believed to be prostitutes, erupted. Identifying Degas's subjects was second nature to Moore who loved to weave stories around Degas's pictures. In the case of *L'Absinthe* it backfired. Moore recognised the male sitter as 'a man I have known all my life', the etcher Marcellin Desboutin.[90] If he knew that the actress Ellen Andrée had posed for Degas, he didn't say so, but correctly assumed that Degas had represented her as a common prostitute, and provided her life-story in his column, concluding: 'The tale is not a pleasant one, but it is a lesson.'

MacColl who belonged to a different school – there is a clearer trajectory between his criticism and Pater's art for art's sake aesthetic – took a different tactic. The 'subject' ... was repulsive ... *before Degas made it his*', he claimed. Degas's talent for transforming ugly subjects into beautiful art set a new standard of picture-making, and those who did not recognise this were suffering from a 'confusion and affliction' which was 'incurable'.[91] After reading these comments by Moore and MacColl, J.A. Spender weighed in. His reply to MacColl, under the name 'The Philistine', was front page news.[92] A furious correspondence ensued between MacColl and 'The Philistine'. Others soon joined the fray and between 15 March and 8 April a flood of letters and articles were published in the *Westminster Gazette* and the *Spectator* (see pp.208–211). In an extraordinary volte-face, George Moore recanted his initial comments about *L'Absinthe* in a further three articles in the *Speaker*, and promoted the picture for its pictorial qualities alone.

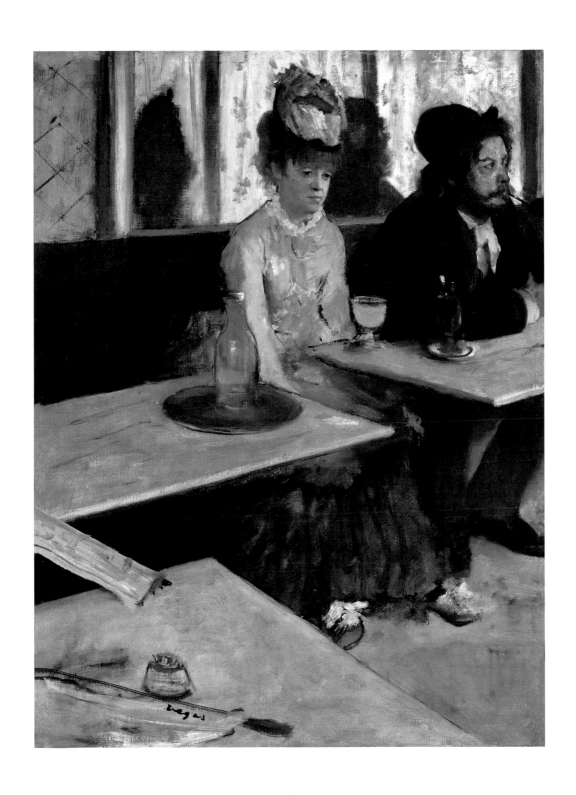

42
Edgar Degas
L'Absinthe 1875–6
Oil on canvas 92 × 68 | 36¼ × 26¾
Musée d'Orsay, Paris; bequest of comte Isaac de Camondo, 1911

L'Absinthe was exhibited under that title for the first time at the Grafton Gallery, and the title itself was certainly part of the problem. British gallery-goers of the 1890s would have viewed anyone who was partial to absinthe rather as a crack cocaine addict is viewed today. With the temperance movement at its height, Spender must have known that this 'treatise against drink', as the arch-conservative artist W.B. Richmond described it, would incite a furore.[93] The most damning condemnation came from the Arts and Crafts artist Walter Crane who linked the New Art Critics, as MacColl and Moore were labelled, to absinthe drinking. *L'Absinthe* was a study of 'human degradation ... and the outward and visible signs of the corruption of society', said Crane, before suggesting that it 'would not be without its value in a sociological museum, or even as an illustrated tract in the temperance propaganda'.[94] This brought a fury of response from both Sickert, who complained that 'too much has been made of "drink", and "lessons", and "sodden", and "boozing"',[95] and George Moore, who was compelled to recant his earlier suggestion that the 'tale' of *L'Absinthe* was 'not a pleasant one, but it is a lesson': 'The picture is a work of art, and therefore void of all ethical signification', and he referred to Desboutin's virtuous qualities as a human being, suggesting that he lived 'a very noble life', that he was always sober, and that he was not the companion of the woman, who although Moore did not deny was a prostitute, was not drunk.[96] Indeed the occupation of this woman was never an issue for the Victorians, who had been brought up on a diet of pictures of fallen women.

But this was not just a debate about alcoholism. In his first review Moore had connected Degas with a tradition of old master painting, a point that was taken up by W.B. Richmond who doubted whether Degas would ever achieve that status because he was so much part of the 'interviewing, advertising, inquisitive evolution' of the modern age.[97] Underlying this was a larger issue about a supposed quality in Degas's art that only those gifted with a privileged way of seeing could detect. By way of explanation MacColl was compelled to write an aesthetic credo about the difference between subject and technique. In his first review, MacColl had explained that *L'Absinthe* was an 'inexhaustible picture' that 'draws you back, and back again', suggesting that the art of looking at a picture was a highly disciplined visual skill.[98] Later he revealed the true extent of his belief in its importance. 'That the dignity of the performance does not depend on the dignity of the subject, but on that of him who treats it, is surely indisputable ... in painting', but he added 'it is impossible to reveal to any one who has not an eye for the language of painting, where the pictorial element comes in.'[99] Abandoning his story-telling skills, Moore joined in, with his own argument about *L'Absinthe*'s inherent visual qualities of 'synthetic' composition, with its 'beautiful, dissonant rhythm' and 'continual desire of novelty, penetrated and informed by a severely classical spirit.'[100] MacColl's and Moore's final responses during this controversy are evidence of the sophisticated understanding of the pictorial aspects of Degas's art in Britain. But Moore's earlier efforts to connect his analysis of *L'Absinthe* to social history and the debate about the role of portraiture in the picture should not be disregarded. MacColl played the winning card here. And Moore's 'take' on a social reading of Degas's art did not become an issue again until the 1970s.

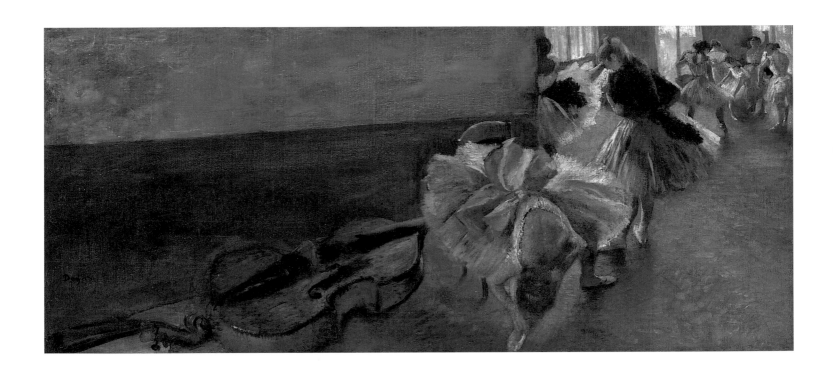

43
Edgar Degas
Dancers in the Rehearsal Room c.1882–5
Oil on canvas 39.1 × 89.5 | 15³/₈ ×35¼
The Metropolitan Museum of Art, New York.
H.O. Havemeyer Collection.
Bequest of Mrs H.O. Havemeyer, 1929

Richard Thomson

EXPORTING STYLE AND DECADENCE
THE EXCHANGES OF THE 1890s

In the 1890s Britain's imperial and economic might assured her position as one of the Great Powers. France, on the other hand, despite some colonial acquisitions in Asia and Africa, remained a lesser force, subject to debilitating internal pressures and without an ally until her defensive treaty with Russia in 1894. The French publicly worried that they were in a state of national decline, politicians and intellectuals debating openly whether the alarmingly low birth-rate, the rise of alcoholism or the spread of venereal diseases were symptomatic of social decadence, a troubling diagnosis as their nation's great rival, Germany, was buoyant demographically and economically.[1] The idea that modern society was in decadence – on the model of social Darwinism – had currency in Britain too, chiming with anxieties about loosening moral standards and the threatening political rise of the lower classes. In Marie Corelli's popular novel of 1895, *The Sorrows of Satan*, the diabolically clairvoyant Prince Rimânez insists that 'it is a decadent, ephemeral age', while Lady Sibyl, a corrupted English rose, asserts that moral decline is the 'common position of things in France, and is becoming equally common in Britain.'[2]

In the debate about decadence it was typical for the British to use French examples to exemplify their own anxieties about declining social and cultural standards. The furore over *L'Absinthe* in 1893 was a crucial example in the art world, but this had been prefigured in the literary sphere by the successive

fig.27
Théophile-Alexandre Steinlen
Hilarité
Cover of *Gil Blas illustré*, vol.5, no.15,
14 April 1895
Bibliothèque Nationale de France,
Paris

prosecutions in October 1888 and May 1889 of Henry Vizetelly, the translator and publisher of Emile Zola's novels in Britain. At the first trial the Solicitor-General had condemned the French author's *La Terre* (1887) as 'filthy from beginning to end.' He 'did not believe there was ever collected between the covers of a book so much bestial obscenity.'[3] In 1890 the dynamic Professor Patrick Geddes, then at the University of Dundee, tried to resuscitate the Collège des Ecossais in Paris, a plan that met with a qualified response from Principal Gairdner of Glasgow University: 'The greatest, indeed almost the only, objection I should feel to sending our students to Paris … is the awful sexual demoralisation ("the worship of the great goddess Lubricity", as Matthew Arnold has it) which rules everywhere in France and especially in Paris'.[4] Whether in art, literature or higher education, the influence of France was understood by the establishment to be pernicious and corrupt.

For their part, the French responded with clichés too. There was the widespread assumption that the British were prim and reserved to the point of ridicule. In an article on the contemporary poster published in the *Revue des deux mondes* in 1896, Maurice Talmeyr, while opposed to moral laxity in his compatriots' advertising imagery, praised the best French posters of artists such as Jules Chéret – 'light, subtle … [with] nuances, allusions' – above those of British designers like Dudley Hardy and Maurice Griefenhagen which are 'cold, ironic, simultaneously frenetic and stiff.'[5] But French observers were far from blind to the peccadilloes of the British. In her memoirs the dancer Jane Avril remembered how, touring the London music halls in 1896, she had been struck by the brazen prostitution in Piccadilly and Regent Street, while a visit to the capital in 1903 led the shocked George Desvallières to paint of group of canvases of seedy London café society.[6] British hypocrisy about sexual matters formed part of the French topos. This is neatly encapsulated in an illustration by Théophile Steinlen to *Gil Blas illustré* in 1895 (fig.27). It represents an English clergyman, visiting Paris to 'investigate' moral decline, being introduced to a brothel madam by a helpful gendarme and presenting as his bona fide a visiting card printed *TRECLAU*. Henri de Toulouse-Lautrec had used this jumbling of his name as a signature on his early works, so Steinlen's overt jibe at British prurience or hypocrisy incorporated an in-joke about Lautrec's propensity for brothel subjects and also, perhaps, about his anglophilia. Lautrec's striking colour lithograph *The Englishman at the Moulin Rouge* (no.44), published by the art dealing and publishing firm Boussod et Valadon

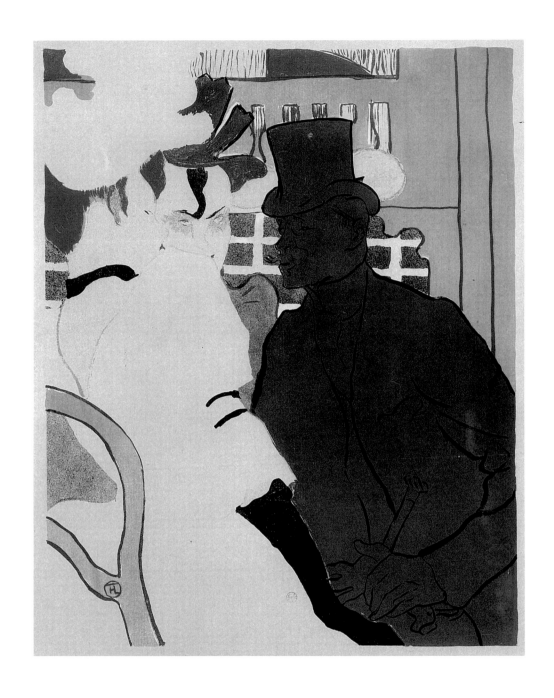

44
Henri de Toulouse-Lautrec
The Englishman at the Moulin Rouge 1892
Colour lithograph
47×37.3 | 18½×14⅝
Bibliothèque Nationale de France, Paris

in an edition of one hundred in 1892, also plays with the notion of British lechery on the loose in Paris. The male figure was posed by William Warrener, son of a Lincoln coal-merchant who had come to Paris to study as a painter at the Académie Julian in the early 1880s.[7] In Lautrec's initial portrait study of Warrener for this print, the Englishman appears fresh-faced and smiling.[8] But Lautrec altered this in the lithograph, rendering Warrener in silhouette, his decorous costume contradicted by the raddled, lecherous face as he leans towards the cruel-eyed whores who flank him. Warrener was thus adapted to fit a clichéd libidinousness, and Lautrec's arresting print takes its place in a contemporaneous line of quasi-caricatural images of British men on the razzle in Paris, from Jean-Louis Forain's *Fiez-vous donc à l'accent anglais!*, a cartoon published in *Le Fifre* in 1889 (fig.28), to Richard Ranft's etching *L'Anglais aux Folies Bergère* of 1899.[9]

French admiration for British art manifested itself during the 1890s in various ways. Turner exercised a fascination over young French landscape painters. In the spring of 1898 Paul

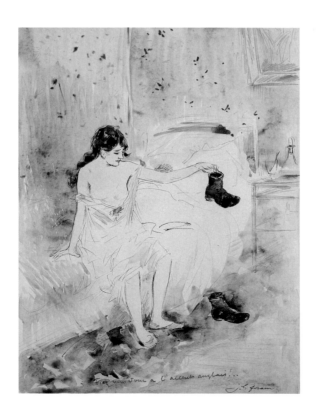

fig.28
Jean-Louis Forain
Fiez vous donc à l'accent anglais! (Can't trust an English accent!) 1889
Watercolour, gouache, pen-and-ink 35.5 × 27.7 | 14 × 10⅞
Collection of the Dixon Gallery and Gardens,
Memphis, Tennessee, Museum Purchase

Signac spent three weeks in London during which he studied Turner hard, and four years earlier Louis Valtat had been sent to London under strict instructions from his father to copy Turners closely.[10] Of the painters who preoccupy us here – figurative artists, with an emphatically modern phrasing – it was Whistler who had built up the strongest reputation in France. This had reached a climax in 1891 when the French state had purchased Whistler's portrait of his mother, *Arrangement of Grey and Black, Number 1* (1871, Musée d'Orsay, Paris), a sale which had been brokered by Maurice Joyant, manager of the Galerie Boussod et Valadon and close friend, indeed schoolfellow, of Lautrec. Whistler had run a campaign throughout the 1880s to establish a European reputation.[11] He had begun to resubmit work to the Paris Salon regularly from 1883, and had built up a vocal body of support not only among established art critics such as Joris-Karl Huysmans and Octave Mirbeau but also among the emerging generation of Symbolist writers. The poet Albert Samain, for example, noted in his *carnets*, with the preciousness typical of Symbolist phraseology, that 'Whistler has made, in the scale of architectonic sensations, based on the uniqueness of tone, some adorable delights.'[12] Although it was Edward Burne-Jones who made the greatest critical and public impact among the British artists exhibiting in Paris at the 1889 Exposition Universelle, the discerning eye of the elderly novelist Edmond de Goncourt picked out the fluid draughtsmanship of Orchardson for his own private delectation.[13] Indeed, it was often the latest British graphic art that caught the attention of the French.

Aubrey Beardsley's stylish black-and-white images appealed to French artists and writers of the Symbolist generation, sharing as they did a savour for modern decadence and a fascination with exaggerated chic to express it. In the aptly titled novel *Maîtresse d'Esthètes*, published in 1897 by Henri Gauthier-Villars (but, like most of 'Willy's' books, actually written by somebody else, in this case Lautrec's friend Jean de Tinan) the sculptor protagonist has a Beardsley pinned to his wall.[14] Beardsley's sister Mabel seems to have tried to cultivate that taste, sending Jacques-Emile Blanche a copy of *The Wagnerites* (1894, Victoria and Albert Museum, London) and suggesting that he show it to the writer Edouard Dujardin, another of Lautrec's friends.[15] While the *diseuse* Yvette Guilbert was playing a season in London in May 1896, Arthur Symons sent her some drawings by Beardsley, for which she thanked him in engagingly halting franglais: 'I receive just now your – sorry – and have immediately regardé les images! More I see what does Aubrey Beardsley more I am in love with

him!'[16] William Nicholson's equally radical woodblock prints were admired in France too, George Bottini including *November*, from the 1898 *Almanac of Twelve Sports*, in the background of a 1902 drawing of a Parisian *boîte de nuit*.[17] In 1897 Nicholson had published a superbly economical woodcut of Queen Victoria, and a hitherto unidentified thumbnail sketch reveals that Lautrec copied it.[18]

In Britain contemporary French art was still met with some suspicion. Mid-century painters of landscape and rural life such as Jean-François Millet, Camille Corot and Charles Daubigny enjoyed considerable posthumous reputations, forming a market staple. It was, in fact, the Scot David Croal Thomson, manager of the Goupil Gallery in London, affiliated to the Boussod et Valadon enterprise in Paris, who coined the term 'Barbizon School' to characterise such artists. In the 1890s it was the elegant and fashionable in French art that was often supported in Britain. Thus when the Duchess of Marlborough needed her portrait painted, she turned to the modish Carolus-Duran (1894, Blenheim Palace, Woodstock). The suave Watteau-esque drypoints of Paul Helleu had a vogue about which Sickert was waspish: 'His plates, to begin with, are larger than any of ours, and there is less in them. That little is French, and very chic. They are pretentious and superficial and vulgar.'[19] In other fields of painting, the French were considered the specialists. Fantin-Latour's flower-pieces were still pre-eminent, and in Rudyard Kipling's 1891 novel about a military painter, *The Light that Failed*, it is evident that the standard in that genre was set by Frenchmen such as Edouard Detaille.[20] Few British collectors now bought new French art. William Rothenstein's friend Arthur Studd purchased one of Monet's *Meules* series from Durand-Ruel in 1891, the year they were exhibited in Paris; by 1894 he had sold it back to the dealer.[21] Perhaps this is not surprising, as British art critics were little attuned to the rapidly emerging new styles and personalities in French art. George Moore is a case in point. For all his championing of senior artists such as Degas and Whistler and his support for British painters like Sickert and Steer, in the 1890s Moore was dismissive of artists such as Signac and Louis Anquetin, whom he had noticed emerging in Paris during the later 1880s. In *Modern Painting* he wrote inaccurately and disdainfully about Anquetin's *Rue: Cinq heures du soir* (1887, Wadsworth Atheneum, Hartford, Conn.), which he would have seen at the Salon des Indépendants in 1888.[22]

It was into this world that William Rothenstein and Charles Conder launched themselves. The Bradford-born Rothenstein had studied briefly at the Slade, and in 1889 went to Paris, attracted by the Exposition Universelle, to study at the Académie Julien. Despite only being in his late teens, Rothenstein was adept at networking. His memoirs make clear that, having hired a studio in Montmartre at the Bateau Lavoir in the rue Ravignan, many of the artists to whom he was drawn were those working in the flexible idiom of naturalism: Emile Friant, Henri Royer and Eugène Lomont. However, lunching at the Rat Mort in the place Pigalle, Rothenstein also struck up friendships with Dujardin, Lautrec and Anquetin.[23] For a young British artist to be connected with such luminaries in the Parisian avant-garde as Lautrec and Anquetin was exceptional in 1890. Rothenstein shared the Bateau Lavoir studio with Charles Conder. Conder had been born in Tottenham, but his parents had emigrated to Australia when he was a boy. Conder had cut his teeth as an illustrator and landscapist in Sydney and Melbourne. Arriving in Paris in 1890, his close friendship with Rothenstein had been an attraction of opposites. Rothenstein was short, serious, and single-mindedly

professional; Whistler nicknamed him 'parson', despite, or perhaps because of, Rothenstein being Jewish. Conder was tall, handsome, and given to excess; syphilis had been diagnosed before he left Melbourne.[24]

Rothenstein good-naturedly joked about their comradely but contrasting Montmartre friendship in a caricature (fig.29). In mock deference to France's leading mural decorator Puvis de Chavannes, and inscribed 'Fragment of sketch for decorative picture (after the closing of the Moulin Rouge)', the caricature represents a sober, cigar-puffing Rothenstein alongside a drunken Conder embracing a boulevard gas-lamp. The style of drawing, with simplified, silhouetted figures and steep perspective, shows how rapidly Rothenstein had assimilated the illustrative idioms of French periodicals such as *Le Courrier français* and *Gil Blas illustré*, for the caricatural – quickly observed, cutting in tone, attuned to social decadence – was key to the articulation of modernity in Montmartrois culture.[25] Rothenstein became acquainted with illustrators such as Steinlen and Charles Léandre, and acknowledged his debt to Louis Legrand and Ferdinand Lunel.[26] Rothenstein's drawing of Lautrec, following

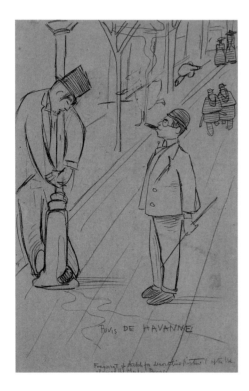

fig.29
William Rothenstein
Puvis de Havanne c.1890–1
Black chalk 37 × 24 | 14½ × 9½
Barry Humphries

fig.30
Charles-Lucien Léandre
Portrait of Henri de Toulouse-Lautrec 1896–7
Crayon on paper 47.3 × 31.1 | 18⅝ × 12¼
Jane Voorhees Zimmerli Art Museum at Rutgers,
The State University of New Jersey
Acquired with the Herbert D. & Ruth Schimmel Museum Library Fund

Will Rothenstein. found in an old sketch book of the early nineties

45
William Rothenstein
Toulouse-Lautrec c.1891–3
Pencil and chalk on brown paper 31.4 × 17.9 | 12³⁄₈ × 7
Barry Humphries

fig.31
William Rothenstein
Edgar Degas c.1892–3
Pen and brown ink on ivory laid paper discoloured to cream 20.9 × 13.5 | 8¼ × 5¼
The Art Institute of Chicago
Gift of Albert Roullier Memorial Collection 1928

46
Charles Conder
La Goulue c.1891
Black chalk on brown-grey paper 20.5 × 14.5 | 8 × 5¾
Barry Humphries

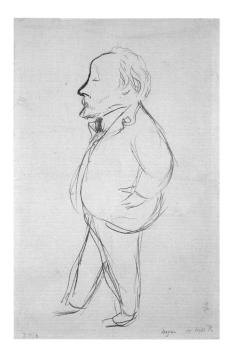

the caricatural formula of small schematic body with a large head and exaggerated facial features, bears comparison with a similar image by Léandre, though the Englishman's treatment of Lautrec's physiognomy is less overtly comic than the latter's (no.45, fig.30). Rothenstein also made a caricature of Degas (fig.31), this time in a similar vein to Pellegrini's work, posing the French artist in a stance similar to his sculpture of the *Little Dancer Aged Fourteen*, which may have been on view when Rothenstein visited Degas's studio.[27]

Conder, too, absorbed the caricatural idiom, adapting it to his preoccupation with Montmartrois nightlife. *Mardi Gras Week, Paris* is a quite highly finished drawing, perhaps intended for publication (fig.33) The division of the page into separate vignettes was typical of contemporary illustrations, not just in frothy periodicals such as *Le Courrier français* – to which draughtsmen like Lunel contributed (fig.32) – but also in sober journals like the *Illustrated Sydney News* for which Conder had worked before leaving Australia. In *Mardi Gras Week* Conder combined both framed scenes of the Moulin Rouge and isolated motifs such as the pantomime cow, all gathered under a schematic Parisian skyline surmounted by the Eiffel Tower. As both the

Moulin Rouge and the Eiffel Tower had opened to the public in 1889, the imagery and the caricatural style together exuded modernity. Conder immersed himself in the decadent lifestyle of Montmartrois nightlife. Rothenstein recalled that Conder visited the Moulin Rouge 'almost nightly', and his many drawings were produced from memory after these nocturnal shenanigans.[28] His range was varied. A rapid portrait drawing of the celebratedly lubricious dancer *La Goulue* (no.46), with her cheeky cow-lick and rich lips slightly smiling, differs, for example, from the quasi-allegorical image of a dancer seated in front of the Moulin Rouge, black-stockinged leg emerging from frothing petticoats, who holds a butterfly captive on the end of a string (no.50). If this drawing is a *jeu d'esprit* about the prostitution prevalent at such venues, *A Dream in Absinthe* is an altogether more disturbing sheet (fig.34). Executed in pen-and-ink heightened in watercolour, it presents a multiplicity of images. An artist figure, dressed in a striped burnoose and with absinthe-coloured hair, stands in front of a Japanese warrior and a grotesquely flirtatious female figure. Around them swirl images of bewildering fantasy: a comic demon sitting on a daisy; bourgeois gentlemen ogling a can-can dancer; a queue of artists carrying canvases; and a

fig.32
Ferdinand Lunel
The Dance-Hall at the Elysée-Montmartre,
Le Courrier français, 30 October 1887
Bibliothèque Historique de la Ville de Paris

fig.34
Charles Conder
A Dream in Absinthe 1890
Pen, ink and watercolour 24 × 25.3 | 9½ × 10
The Fitzwilliam Museum,
University of Cambridge

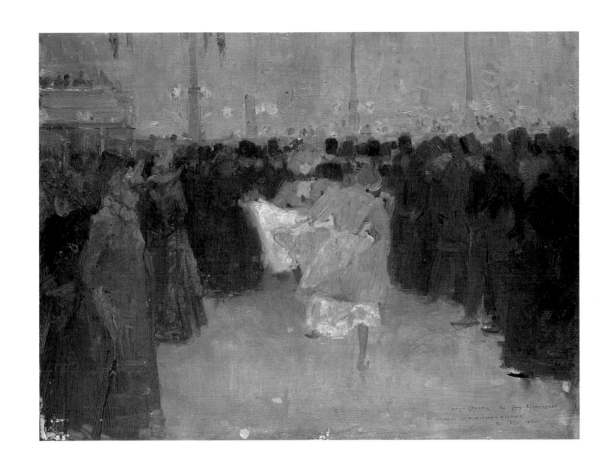

47
Charles Conder
The Moulin Rouge 1890
Oil on panel 25.6 × 34.1 | 10 × 13⅜
Manchester City Galleries

48
William Tom Warrener
Quadrille I c.1890
Oil on canvas 46 × 55 | 18 × 21³⁄₄
Usher Gallery, Lincolnshire County Council

49
William Tom Warrener
Quadrille II c.1890
Oil on canvas 46×55 | 18×21¾
Usher Gallery, Lincolnshire County Council

50
Charles Conder
Dancer at the Moulin Rouge c.1891
Pen and ink on beige paper 17 × 12 | 7 × 4¾
Barry Humphries

fig.35
Henri de Toulouse-Lautrec
*The Rehearsal of the New Girls
by Valentin le Désossé (Moulin Rouge)* 1889–90
Oil on canvas 116 × 150 | 45⅝ × 59
Philadelphia Museum of Art

plethora of bizarre birds, one aggressing another with a peacock feather, and another suspended like dead game. Cruel and incoherent, *A Dream in Absinthe* seems like a graphic fantasy improvised under the influence of that poisonous alcohol.

The Moulin Rouge also provided Conder with motifs for more descriptive work. In October 1890, not long after his arrival in Paris and within a year of the dance-hall's opening, he painted a small panel which neatly encapsulates the dance-hall's character (no.47). Conder painted wet-on-wet, the mix muting the colours, so the grey of the flooring softens the blacks of the crowded audience and the blues of the dancers' dresses. Conder enlivened his palette with licks of livid yellow and flashes of vermilion and violet. A similar loose, gestural touch and lively chromatics were used in two larger canvases painted by William Warrener (nos.48, 49). Warrener had left the Slade in 1884, moving to Paris where he studied at the Académie Julian. His work in the later 1880s followed the *plein-air* naturalism then so prevalent, and in 1887 he won an honourable mention at the Salon for *L'Aveu* (1887, private collection).[29] We know neither when nor how he met Lautrec and Rothenstein, though Warrener was another of the rare British inhabitants of Montmartre.[30] Warrener's two canvases, both entitled *Quadrille*, show that like Conder he was alert to the up-to-the-minute idioms for representing the dynamic display of the dance-halls. Both artists followed the schema popularised by illustrators such as Lunel, presenting a wall of types – dancers, prostitutes, gentlemen consumers – against an approximation of the locale. But they both seem also to have been aware of how Lautrec had adapted that illustrative formula to progressive painting, notably in his large canvas *The Rehearsal of the New Girls, by 'Valentin le Désossé' (Moulin Rouge)*, exhibited at the 1890 Salon des Indépendants (fig.35). There Lautrec had introduced figures who cross between the spectator and the scene, enhancing a sense of haphazard actuality, and used a fluid, linear application of paint to evoke the ambiance of bustle, gaslight and shadow. Both Conder and Warrener worked variations on Lautrec's formula, though Conder was less confident with his intruding figures and neither emulated Lautrec's linearity, settling for a more dabbed, yet still vibrant, touch. Warrener favoured a more overt play of complementaries than Conder, his dancers dressed in red and green, while his backgrounds shimmer in pinks and yellows.

By British standards these were exceptional paintings for the early 1890s. Not only were they schooled in progressive French composition and chromatics, they also tackled a subject which was, at least by the standards of the Royal Academy and the London press, scandalous and degenerate. This was no doubt part of the appeal to young British artists in Paris. Mixing with avant-garde artists such as Lautrec and Anquetin, Rothenstein, Conder and Warrener were temporarily casting themselves as French artists, rather than favouring London subjects as a vehicle for modernising British painting, as Sickert and others preferred. However, there was a degree of gaucheness to this. On the one hand Warrener and Conder assimilated much of their manner from Parisian prototypes, and on the other they – as were their French exemplars – were falling in with the slick packaging of the Montmartre entertainment industry. The Moulin Rouge had been opened in October 1889 by Charles Zidler, an experienced entrepreneur, who had chosen a location on the boulevard de Clichy precisely because it was on the porous class frontier between bourgeois and proletarian Paris. There Zidler sited a spectacle of confrontation and consumption, conjoining the middle-class male and the working-class woman, cash and need, in a carefully constructed and brilliantly advertised array of pleasures: bars and music, gardens and performances. The Moulin Rouge centred on the dancers. As Rothenstein remembered, 'the band would strike up, and they formed a set in the middle of the floor, while a crowd gathered closely around them.'[31] This was the can-can, performed by professionals and the subject of Conder and Warrener's paintings: the packaged spectacle. But for all

53
Henri de Toulouse-Lautrec
Charles Conder:
Study for Fashionable People at Les Ambassadeurs 1893
Oil on board 47.3 × 36.3 | 18⅝ × 14¼
Aberdeen Art Gallery and Museums Collection

entitled *Parting at Morning* (no.55) after Robert Browning's poem which Rothenstein wrote out at its lower right corner:

Round the cape of a sudden came the sea,
And the sun looked over the mountain's rim:
And straight was a path of gold for him,
And the need of a world of men for me.

This quatrain follows a twelve-line poem, 'Meeting at Night', the two quickly telling of a man's nocturnal visit to his lover by boat, and her recollection. The verse Rothenstein chose marks a division between the lovers, the man's part of which is active and material while the woman's is anguished and psychological. Rothenstein used Browning's lines not to a literary, Pre-Raphaelite end, but for something more emphatically modern. The model is represented life-size. She is a frail, boyish figure, scarcely more than adolescent, with a physique that appears undernourished. In that sense she suggests the proletarian poor of Paris. Her gaze is direct yet blank, and her stance one of lassitude and surrender. This suits both Browning's poem, with its allusions to sexual adventure and immediate abandonment, and the fascination with states of mind that so preoccupied artists and writers at this period, steeped as they were in the emotive suggestiveness of Symbolist literature and *la psychologie nouvelle* of Jean-Martin Charcot and Hippolyte Bernheim, which was advancing understanding of the human subconscious. In *Parting at Morning* Rothenstein adeptly used his sparsely effective drawing to model the fragile body, while the rubbed pastel on the skirt and the scrubby quality of the bronze paint of the background gives the image a tawdry, distressed character quite in tune with the emotional tenor of Browning's lyric. That stress on matching synthetic, pared-down pictorial means to psychological effect indicates Rothenstein's command of the aesthetic of the Symbolist avant-garde, matched by very few British painters of the early 1890s.

fig.36
Henri de Toulouse-Lautrec
Fashionable People at Les Ambassadeurs 1893
Gouache and black chalk on wove paper, mounted on cardboard
84.3 × 65.5 | 33¼ × 25¼
National Gallery of Art, Washington. Collection of Mr and Mrs Paul Mellon

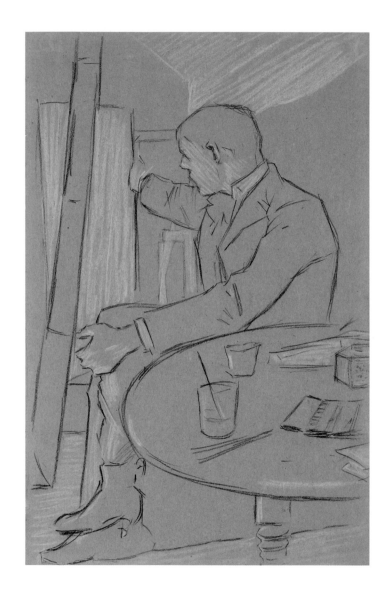

54
William Rothenstein
Conder Seated in the Studio c.1891
Black and white chalk on brown paper
36.5 × 23 | 14⅜ × 9
Barry Humphries

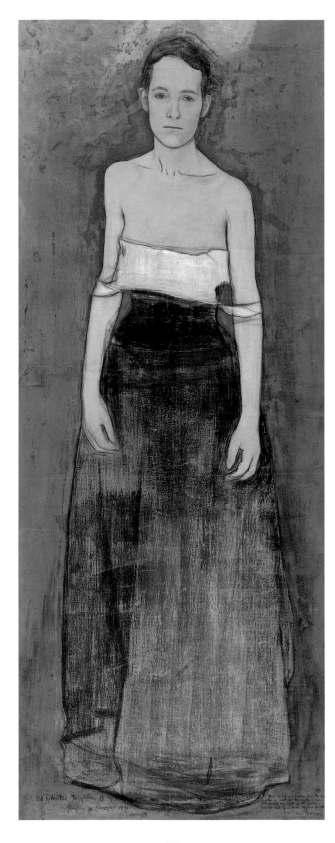

55
William Rothenstein
Parting at Morning 1891
Chalk, pastel and bronze paint on paper
129.5 × 50.8 | 51 × 20
Tate. Bequeathed by Sir John Rothenstein 1992

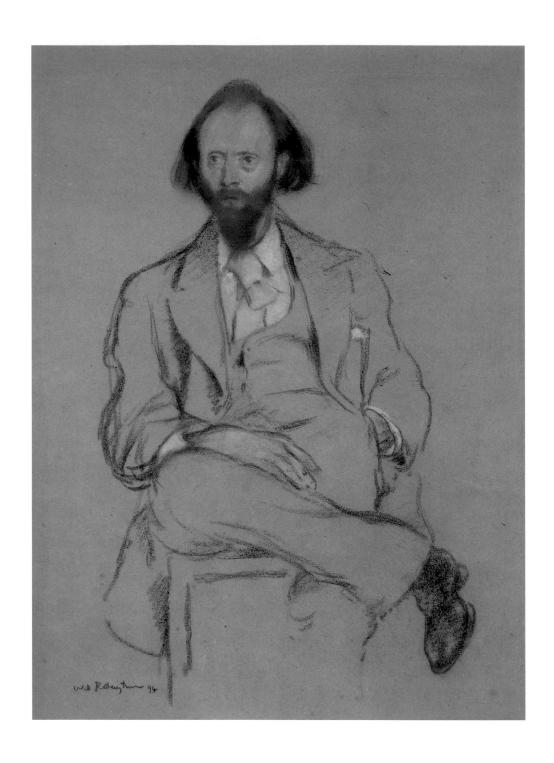

56
William Rothenstein
Arthur Symons 1894
Black chalk and pastel on paper 46.5 × 34.5 | 18¼ × 13⅝
Barry Humphries

Another work which Rothenstein exhibited *chez* Père Thomas was a portrait, now lost, of Oscar Wilde, then a substantial figure in Parisian Symbolist circles, representing the author in a red waistcoat against a gold background.[35] Rothenstein had many connections in French and British literary circles. As he gradually drifted back to Britain, finally settling in Chelsea in 1894, he acted as an informal intermediary. While staying at Oxford in 1893, where he began his lifelong friendship with Max Beerbohm, Rothenstein met the poet and critic Arthur Symons. Between them they arranged for the decrepit *poète maudit* Paul Verlaine to give lectures in London and Oxford.[36] Symons had been shown Paris by George Moore in May 1890, and would have liked to establish an equivalent to the Théâtre Libre in London.[37] Symons applied the principles of French Symbolism to his own poetry, frequently taking his subjects from London low-life, in parallel to artists such as Sickert.[38] Beerbohm found Symons 'perfectly agreeable but perfectly uninteresting – like one of those white flannels that nurses give children to wipe their faces on'.[39] Rothenstein, more generously, drew a fine pastel of him in 1894

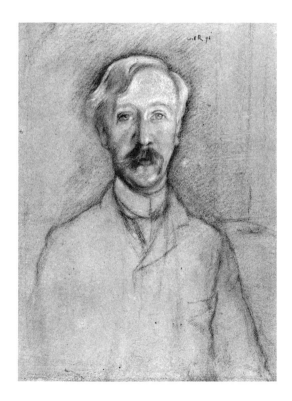

(no.56), showing Symons in informal but direct frontal pose, his high, domed head, long hair and reddish beard contrasting with the crisply conventional blacks and whites of his clothing. By the mid-1890s the Parisian edge of Rothenstein's draughtsmanship had become blunted. A red chalk drawing of Moore made in 1896 (fig.37) is an effective characterisation, with its unassumingly intelligent eyes surmounting a long undistinguished face. But its drawing lacks the telling, angular economy of his earlier Parisian drawings, its soft, less synthetic line heralding a return to a more vernacular mode.

The support that Rothenstein and Symons gave to Verlaine by setting up a British lecture tour, as well as the esteem in which Wilde was held in Paris, are demonstrative of the cross-Channel dialogue that animated the literary world during the 1890s. Wilde's sentence to two years' hard labour in May 1895 was greeted with horrified disbelief among Parisian intellectuals. Lautrec, for whom Wilde had apparently once refused to sit for a drawing, made a portrait of the writer from memory.[40] He recycled this likeness in a lithograph. The print was used on the programme for Wilde's play *Salome* when it was performed at the Théâtre de l'Oeuvre in February 1896, alongside a portrait of Romain Coolus, a friend of Lautrec's whose *Raphaël* shared the bill (no.57).[41] The staging of *Salome* was a gesture of solidarity with Wilde among French *littérateurs*. By implication their condemnation of British cant was given particular poignancy because in July 1892 *Salome* had been banned from the London stage while it had been in rehearsal with Sarah Bernhardt in the title role.

As well as literary and theatrical connections, the cultural exchanges between Britain and France also involved less elevated forms. Popular performers of all kinds and both nationalities had long travelled across the Channel to reach new audiences. In the 1890s perhaps the most pervasive form of mass culture was what was known as the music hall in Britain and the *café-concert* in France, at which a variety of entertainments were staged in succession each night: dancers, magicians, comedians and singers. The Toulouse-Lautrec family, like many French aristocrats, were anglophile. Lautrec's father, the vicomte, followed the turf, and there is a photograph of him in a kilt. The artist himself spoke serviceable English, and his anglophilia found expression in his attraction to the British stars who came to perform in the Parisian *café-concerts*. Lautrec often became briefly fascinated by an artiste, an obsession that would flare into work and then die. The first British performer to strike him so was Ida Heath. He seems to have found her nose amusing. It features promi-

57
Henri de Toulouse-Lautrec
Romain Coolus and Oscar Wilde 1896
Lithograph 30.3 × 49 | 11⅞ × 19¼
The British Museum, London

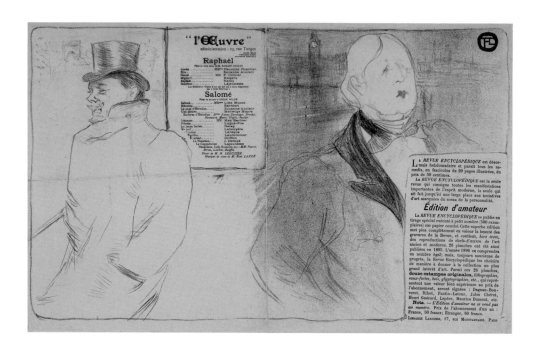

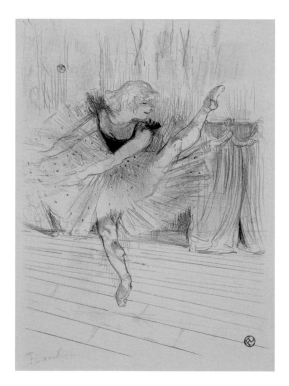

58
Henri de Toulouse-Lautrec
Miss Ida Heath 1894
Lithograph 36.4 × 26.4 | 14⅜ × 10⅜
The British Museum, London

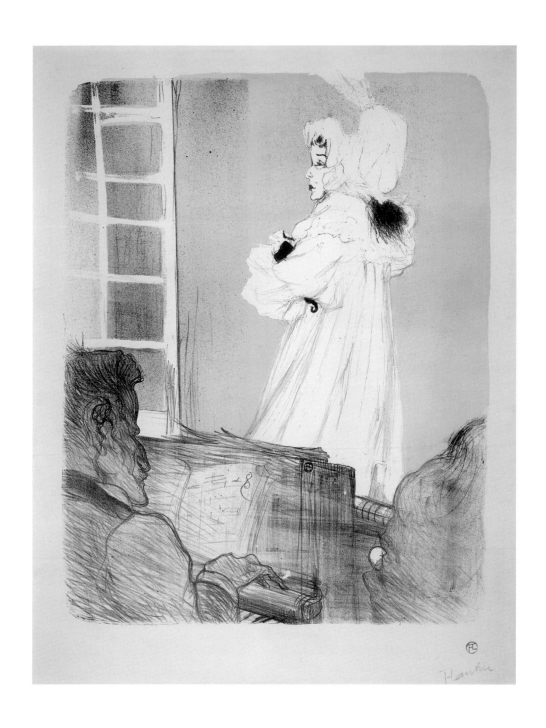

59
Henri de Toulouse-Lautrec
May Belfort (Grande planche) 1895
Colour lithograph
54.6 × 42.1 | 21¹/₂ × 16⁵/₈
The British Museum, London

nently in a lithograph of her flirting in a bar,[42] and in another, where she is shown dancing on stage, her curved proboscis is cheekily made to rhyme with her high-kicking foot (no.58).

One of the British stars upon whom Lautrec lavished considerable attention was the Anglo-Irish May Belfort. During 1895 she appeared in half a dozen lithographs and a similar number of paintings.[43] Belfort, whose real name was Mary Egan, played on the contradiction of her little-girlish Kate Greenaway dresses and the lewd innuendo of her songs.[44] One of her favourite items was 'Daddy wouldn't buy me a bow-wow', the refrain of which – 'I've got a little cat, and I'm very fond of that' – carried a double-entendre which Belfort's performance played up and which Lautrec relished in both the prints and the poster he made for her (nos.59, 60). Lautrec's poster represents Belfort in a red dress against a white background, and when, also in 1895, he made a poster for May Milton, alleged to be Belfort's lesbian lover, he printed that in blue so that they formed a visual partnership '*bien anglais*', as Maurice Joyant put it.[45] Lautrec's choice of a red dress for his poster of Belfort calls to mind the red dresses worn by the music hall performers in Sickert's *The P.S. Wings in an O.P. Mirror* and *Minnie Cunningham* (nos.61, 62). However, Lautrec probably knew neither of these paintings; the former belonged to Jacques-Emile Blanche, not an acquaintance, although he might possibly have seen the latter at the winter 1892 exhibition of the New English Art Club.[46] Perhaps the red dress was a common costume for female performers, an adolescent design cut in scarlet setting up a titillating disjunction appropriate for material such as Belfort's or Cunningham's 'I'm an old hand at love, though I'm young in years', which Sickert's canvas represented Cunningham performing. George Moore, for one, savoured her red dress: 'as light, as pretty, as suggestive as may be.'[47] For his part, Sickert never warmed to Lautrec's work. The Frenchman is not mentioned in Sickert's art criticism of the 1890s, despite what we will see was a substantial presence on the London art scene. In 1929, reviewing Symons's *From Toulouse-Lautrec to Rodin*, rich in the poet's recollections of Lautrec, Sickert sniped: 'I should like to convince my old friend that when he attributes to Lautrec a manner of painting that was "caught" from Degas, he is speaking of a catch that has been badly muffed.'[48] Sickert's antagonism to Lautrec's work bespeaks a rivalry not only over claims on Degas's heritage but also over primacy in the representation of popular entertainment in the 1890s.

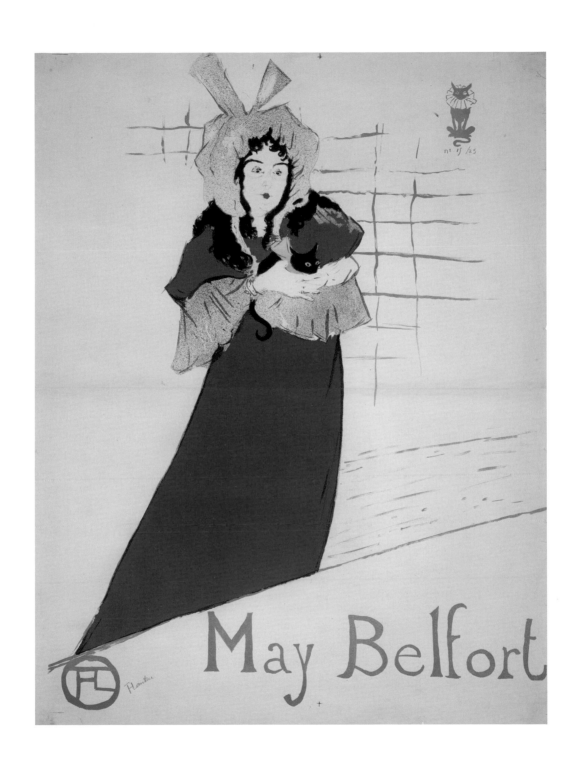

60
Henri de Toulouse-Lautrec
May Belfort 1895
Colour lithograph 79.5 × 61 | 31¼ × 24
The British Museum, London

61
Walter Richard Sickert
The P.S. Wings in the O.P Mirror 1889
Oil on canvas 61 × 51 | 24 × 19⅞
Musée des Beaux-Arts, Rouen
Jacques-Emile Blanche, 1922

62
Walter Richard Sickert
Minnie Cunningham at the Old Bedford 1892
Oil on canvas 76.5 × 63.8 | 30⅛ × 25⅛
Tate. Purchased 1976

TOULOUSE-LAUTREC
AND BRITAIN

Toulouse-Lautrec had more substantial and consistent connections with the British art world than is recognised. Brought up anglophile, he visited London regularly in the 1890s. A letter to his mother in May 1892 mentions a trip, and between 1895 and 1898 his visits seem to have been frequent. His old friend Maurice Joyant was his regular companion *'en un "go and back" rapide'*.[49] Joyant was a director of the art dealer and publishing house Boussod et Valadon, which had been Goupil et Cie until 1884, though the London branch at 5 Regent Street kept the old name. They crossed on the *Dover* or *Queen Victoria* paddle steamers, Lautrec drinking with the chief engineer whom he had befriended but remaining abstemious in London, where he was repelled by the public drunkenness. The artist had his favourite haunts in the capital – the Criterion, or Sweetings in Cheapside for the seafood; the National Gallery to admire Uccello's *Battle of San Romano* or Velásquez's *Philip IV* – and he purchased Liberty fabrics to furnish his apartment in Paris. Lautrec had many British friends and acquaintances, among them artists like Conder who he had met in Paris, Wilde who impressed him, and Whistler, to whom he was introduced by Joyant.[50]

The 1890s saw the rapid burgeoning of the poster, made possible by advances in colour printing technology and stimulated by a consumer-led economy. In Western Europe and the United States artists were quick to seize on a new opportunity to have their work seen by huge audiences, and the poster soon became not only an advertising tool but also a target for specialist collectors. Although Lautrec had only produced his first poster in late 1891, his reputation in the medium spread quickly. J. and E. Bella, a British stationery company, organised two exhibitions of posters by international artists at the London Aquarium in 1894 and again in 1896. Lautrec was represented at both, and in 1894 Bella had commissioned from him a poster to advertise their confetti (no.63). Lautrec's highly synthetic image must have looked unusual on London hoardings, with its smiling woman holding on to her hat as she is bombarded by confetti thrown by hands entering from the margins, a device Lautrec had previously used in paintings.[51] Lautrec's posters continued to be seen on London walls. In January 1896 the can-can dancer Jane Avril, one of Lautrec's passing enthusiasms four years before, wrote asking him to design a poster for a quadrille with whom she was about to play at the Palace Theatre, London (no.64). Loosely basing his design on a promotional photograph, Lautrec set the four dancers – with Jane Avril on the far left, despite the labelling – against an arresting yellow field, the gestural handling of their

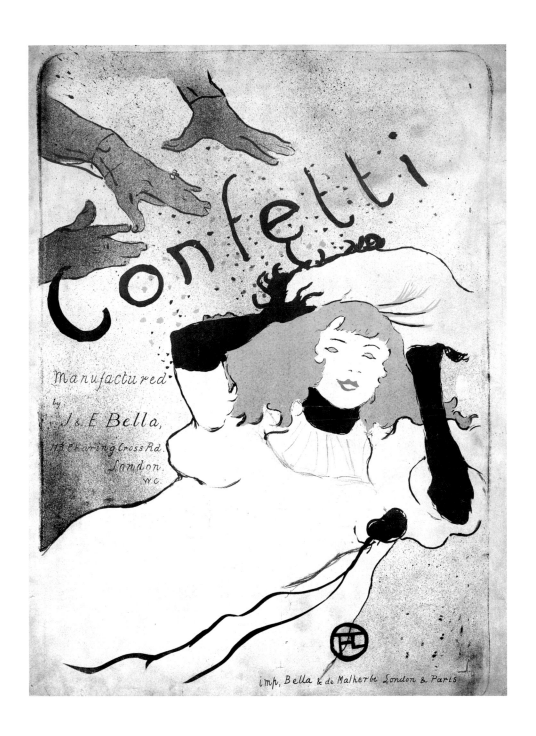

63
Henri de Toulouse-Lautrec
Confetti 1894
Colour lithograph 57×39 | $22^{1}/_{2} \times 15^{3}/_{8}$
Victoria and Albert Museum, London

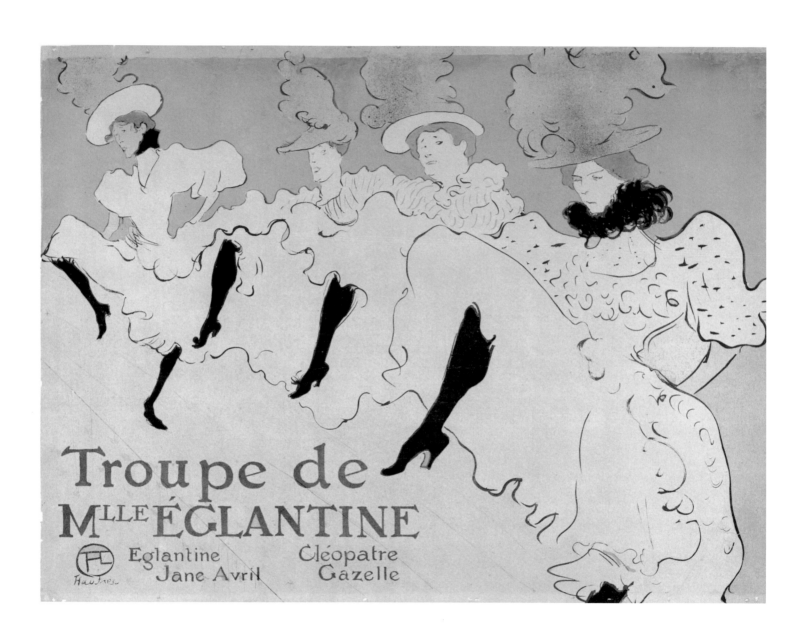

64
Henri de Toulouse-Lautrec
Troupe de Mlle Eglantine 1896
Colour lithograph 61.7 × 80.4 | 24¼ × 31⅝
Victoria and Albert Museum, London

fig.39
Henri de Toulouse-Lautrec
P. Sescau. Photographe 1896
Colour lithograph 61 × 79.5 | 24 × 31¼
Bibliothèque Nationale de France, Paris

fig.40
Advertisement for
the 'Ideal' camera from the
British Journal of Photography Almanac, 1892

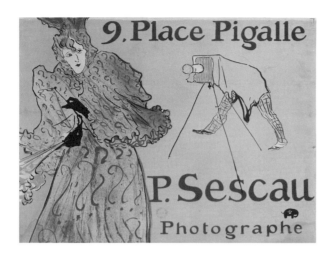

costumes far freer than the tightly disciplined line of British designers and, one might say, far more apt for the frothy subject.[52]

If *Troupe de Mlle Eglantine* played to British expectations of decadent French *frou-frou*, other posters show Lautrec working the Anglo-French exchange differently. His friend Louis Bouglé was the French agent for the bicycle company Simpson. For his professional name Bouglé took the English 'Spoke', and Lautrec called him *'l'anglais d'Orléans'*.[53] In early summer 1896 Lautrec accompanied Bouglé to Britain for a bicycling competition, returning with a commission to design a poster for Simpson's new chain, a project about which he enthused in a letter to his mother.[54] The company rejected Lautrec's first effort, representing the English cyclist Michael and trainer Choppy Warburton, but accepted the second, in which the French rider Constant Huret replaced Michael, with Bouglé and W.S. Simpson looking on (fig.38).[55] Lautrec's final poster with a British dimension was never completed. In 1898 he drafted in oil an image of a British soldier smoking a pipe for the tobacco company Job. But for reasons we do not know the image – a compact and virile motif of military pugnacity off duty – remained as an oil sketch.[56] One final and unexpected link between Lautrec's posters and Britain might be added. It appears that not only did Lautrec receive commissions for posters from or for British clients, but also that British advertising imagery may have served him for a 'French' poster. In 1896, at the height of his engagement with the world of British advertising, he designed a poster to promote his friend Paul Sescau, a professional photographer in Paris. Lautrec's design, with its elegantly attired woman to foreground left and

gentleman with camera to rear right, bears a striking resemblance to an advertisement for the Ideal camera that appeared in the *British Journal of Photography Almanac* in 1892 (figs.39, 40).[57] Perhaps Lautrec had seen this British magazine in Sescau's studio, and had simply lifted the suitable motif for his friend's poster.

fig.38
Henri de Toulouse-Lautrec
La Châine Simpson 1896
Colour lithograph 82.8 × 120 | 32 ⅝ × 47 ¼
Bibliothèque Nationale de France, Paris

In May 1898 the most substantial exhibition of Lautrec's work held in his lifetime was staged at the Goupil Gallery in London. This was an important event in the artist's career, and was clearly a market-driven attempt, building on the success of his posters, to develop a clientele for his production in other media. Lautrec and Joyant must have calculated – as Degas and de Nittis had in the 1870s – that London was a wealthy city with the potential for lucrative sales, perhaps among British gentlemen who knew their Paris. Granted the give-and-take between the two capitals and Lautrec's status as an *affichiste*, the moment must have seemed propitious for a commercial gambit in London.

The exhibition was some time in the planning, and formed part of a larger commercial strategy. In May 1897 Joyant became a controlling partner in Boussod et Valadon, the successors of the Goupil company.[58] The next month Joyant travelled to London to deal with the arrangements at the London branch in Regent Street. Lautrec accompanied him, writing to his mother from the Charing Cross Hotel: 'I've seen a lot of business settled and have good hopes for my exhibition next year.'[59] Evidently a show of Lautrec's work was part of Joyant's commercial strategy; he was hoping to open up the London market to new French art, modern in subject and style. While Lautrec was in London he made contact with British friends, arranging to lunch with Rothenstein, from whom he asked the addresses of Conder and also the critic Ranger Gull, who wrote for specialist British publication *The Poster*.[60] Lautrec was preparing the way, his networking a combination of comradeliness and tactics. For his business instincts were aroused. As he wrote to his mother on his return to Paris, he had bills to pay, and the English character was admirably superior to the French in its willingness to part with money.[61]

The preview of Lautrec's one-man show was held on Saturday 30 April 1898, with the exhibition opening on Monday 2 May. Entitled *Portraits and other works by M. Henri de Toulouse-Lautrec*, the catalogue listed seventy-eight items.[62] About one third of the exhibition comprised portraits of particular individuals, chiefly Lautrec's family and friends (nos.66, 68), the former identified only by initials, according to the contemporary conventions for catalogues. In addition, another half-dozen or more works were identified as 'Head' or 'Profile' and thus fitted, albeit generically, the portrait rubric. Another fifteen or so items represented stars of the dance-halls and *café-concert*, identified by name (no.67). Among them were performers known to the London public: Jane Avril, who had appeared at the Palace Theatre only two years before, the British May Milton and May

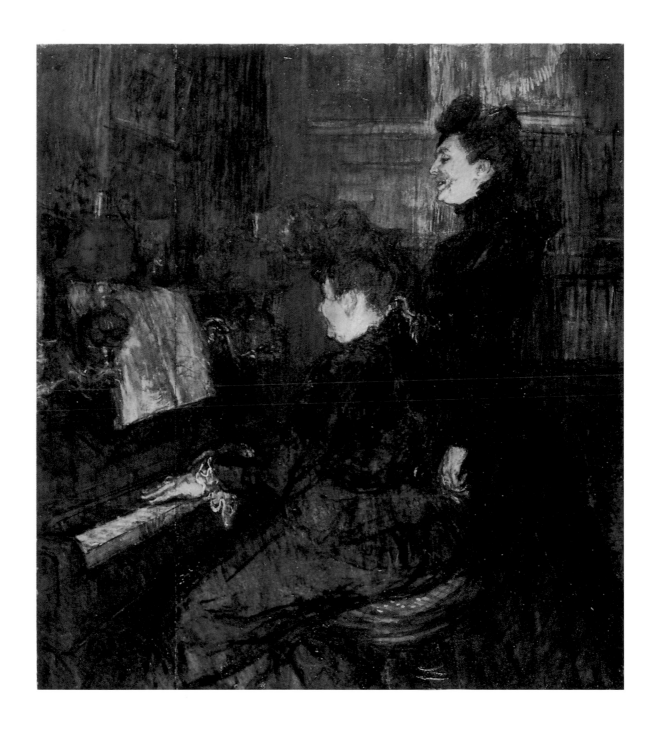

65
Henri de Toulouse-Lautrec
The Singing Lesson 1898
Oil on two pieces of cardboard mounted on panel 75.7 × 69 | 29³/₄ × 27¹/₄
Musée Mahmoud Khalil, Cairo

Belfort. In addition, a number of paintings of Montmartre night-life were included, representing places such as the Moulin Rouge and Moulin de la Galette, which would have had a resonance, perhaps a notoriety, among British visitors to Paris (fig.41). The show did not just incorporate finished portraits and paintings, in several cases works that had previously been in significant exhibitions, such as the Salon des Indépendants or Les XX in Brussels. It also put on view less formal works, no doubt pitched at lower price levels. Among these were drawings of heads probably quite highly resolved and identified by their medium, red chalk or black crayon; at least one caricature that had been published in *Le Rire*; and oil studies that were rapidly executed *études*, such as *Woman Curling her Hair* (no.69). The exhibition is also interesting for the aspects of Lautrec's work it did not display. Unless such images lurked under anonymous titles such as 'Study' or 'Models' it does not appear that any of Lautrec's paintings of brothel subjects were included. Such an omission would not only have been tactically wise given French assumptions about British prudishness; it would also have been consistent with Joyant's practice of discretion in showing Lautrec's work. In early 1896 he had staged a show at his Montmartre gallery in the rue Forest, exhibiting the *maison close* pictures not in the main rooms but in an upstairs chamber unlocked only for friends and aficionados.[63] In other words, the 1898 one-man show was tactically planned to maximize commercial success. Following the scandal over Degas's *L'Absinthe* and the Oscar Wilde trial, both Lautrec and Joyant seem to have selected the show according to their understanding of the sensibilities, or hypocrisies, of the British. Lautrec's exhibition was set up to show stylistic modernity, figures from the shared world of popular culture, with a whiff of modish Parisian low-life, but nothing too overtly decadent.

Their calculations were wrong. Not a picture was sold. According to the painter Albert Ludovici, 'only a few artists went to see [the exhibition]; most of the time the place was empty.'[64] Much of the press was silent. Of the newspapers, neither *The Times*, the *Sunday Times*, the *Observer*, the *Morning Post*, the *Daily Telegraph*, the *Manchester Guardian*, nor the *Daily Graphic* reviewed it. In the professional art reviews, it was ignored by the *Studio*, the *Magazine of Art*, and the *Year's Art*.[65] But this is not to say that the exhibition was either totally neglected or derided. There was of course some condemnation, as in the celebration of the Goupil show's closure by the anonymous reviewer in *Lady's Pictorial*: 'The Lautrec exhibition is over in this gallery, for which relief much thanks. Again the art of such men

as Corot, Daubigny ... and Maris hangs here to delight instead of affright us; for despite its cleverness the work of Lautrec is revoltingly ugly.'[66] Snowden Ward, writing in the prestigious *Art Journal*, was equally brief, writing of Lautrec as 'one of the most extreme of the followers of Degas. His subjects are unlikely to commend themselves to old ladies, but their execution is undeniably clever.'[67] Curiously, these two contrasting publications took essentially the same view, that Lautrec went beyond what British taste found acceptable in French art – and for the *Art Journal*, that was Degas, whereas for *Lady's Pictorial* it was only mild landscape painting – and that his subjects, however suavely executed, were gross. This was in effect the same position as had been taken over *L'Absinthe*. There were some more extended reviews. 'A.U.' (apparently Elizabeth Robbins Pennell, art critic of the *Star* since 1890 and, with her husband Joseph, the future biographer of Whistler), writing in the *Star*, began enthusiastically – 'For sheer brilliancy of handling, for wonderful technical ability, the Lautrec show at Goupil's should be visited' – but immediately threw up qualifications. 'I must say that I do not care for the types M. de Toulouse-Lautrec draws', 'A.U.' continued. 'There is only one type, male and female'. This point was not developed, but the assumption was surely that Lautrec's staffage was unremittingly degenerate. (This was hardly a fair point as the show included a portrait of his pious countess mother and another of the distinguished surgeon Jules-Emile Péan, no.70). 'A.U.' balanced her view by admitting that 'on the other hand, technically, there is very much to be learned from his work. His handling of water color [sic], pastel, chalk, and oil, and of all mediums, in fact, is most masterly. He finds the most curious color combinations and he records them in the most distinguished fashion. But for me, this continuous insistence on ugliness, vulgarity, and eccentricity, this painting of the same people over and over again, is really monstrous.'[68] The reviewer of the *Daily Chronicle* was unusually well informed about contemporary French art, categorising Lautrec with contemporaries like 'Forain, Steinlen, Aquétin [sic], Ibels and Willette', a range of reference at the command of few British critics in the 1890s. He found Lautrec's subjects less objectionable than partial: 'While M. de Toulouse-Lautrec is anxious to show us the life of the bourgeois and the calicot ... at the Moulin Rouge, we find him too anxious. He does not give us the life at all, but a one-sided view of it. To us it has always seemed that the interest of the Moulin Rouge was in its contrasts. It was not in the professional dancer, with her clumsy posturing, but in the crowd watching her. This crowd M. de Lautrec denies us the

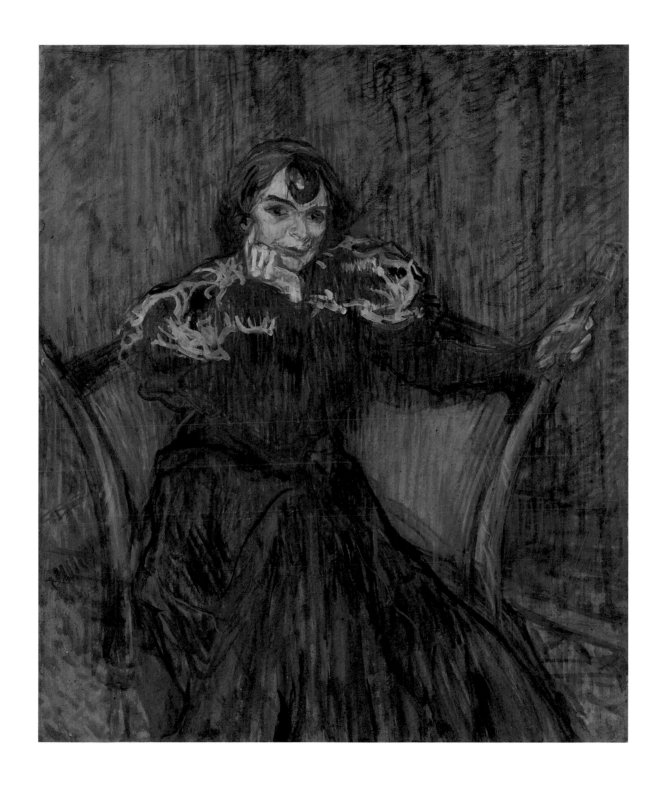

66
Henri de Toulouse-Lautrec
Mme Berthe Bady 1897
Essence on cardboard 70.5 × 60 | 27³/₄ × 23⁵/₈
Musée Toulouse-Lautrec, Albi

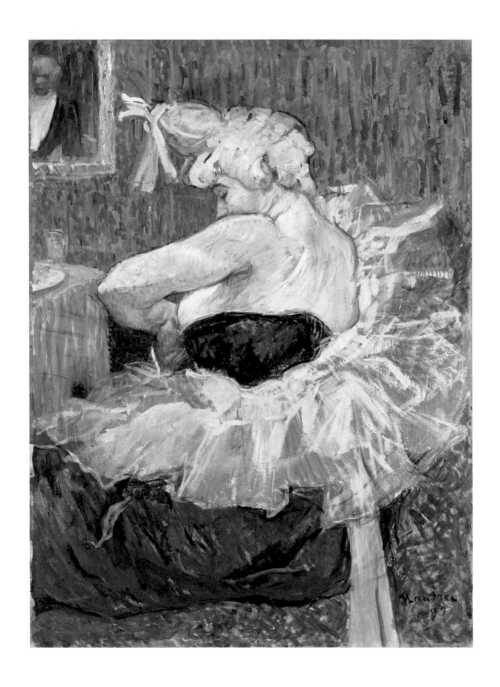

67
Henri de Toulouse-Lautrec
The Clowness Cha-U-Kao 1895
Essence on cardboard 57 × 42 | 22¹⁄₂ × 16¹⁄₂
Musée d'Orsay, Paris; bequest of comte Isaac de Camondo, 1911

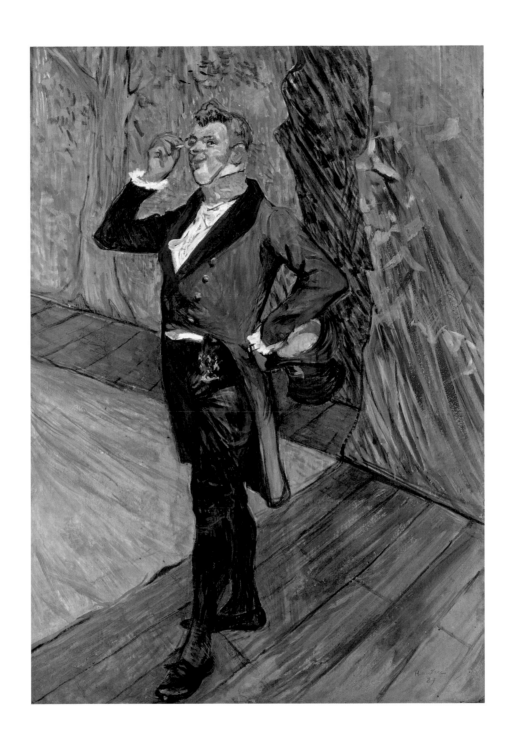

68
Henri de Toulouse-Lautrec
Monsieur Samary, of the Comédie Française 1889
Essence on cardboard 75 × 52 | 29¹⁄₂ × 20¹⁄₂
Musée d'Orsay, Paris; donation Jacques Laroche sous réserve d'usufruit, 1947

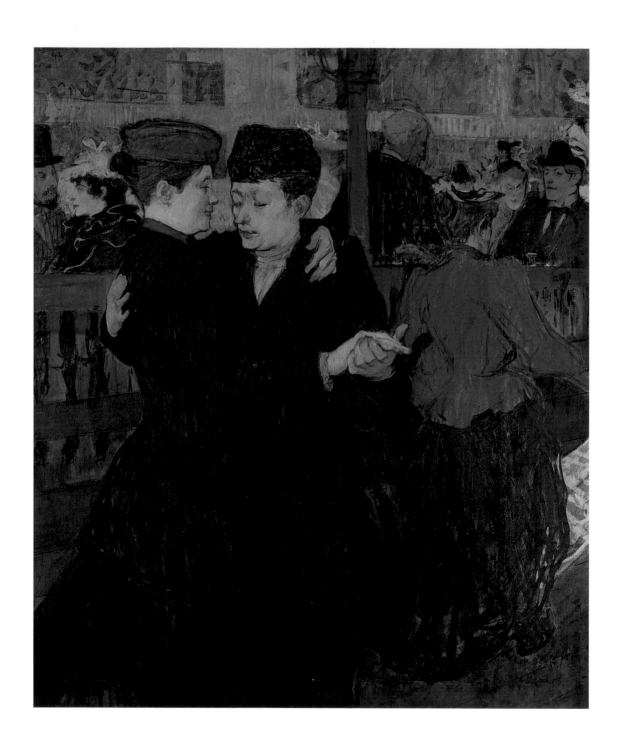

fig.41
Henri de Toulouse-Lautrec
At the Moulin Rouge – Two Dancers 1892
Oil on cardboard 93×80 | 36⅝×31½
National Gallery, Prague

69
Henri de Toulouse-Lautrec
Woman Curling her Hair 1896
Oil on board 56×39 | 22×15⅜
Musée des Augustins, Toulouse

pleasure of seeing.' Despite his 'exceedingly ugly' models, the *Daily Chronicle* acknowledged that 'technically, at times, he is magnificent. But what effect will this have on British art? None whatsoever. The Academy is supreme.'[69]

In his monograph on Lautrec, published a quarter of a century after the artist's death, Joyant claimed that one of the objects of the London exhibition had been to divert Lautrec from his excessive drinking in Paris.[70] Joyant was indeed a protective friend, but this caring argument is a thin device with which to cover a commercial failure. We have seen how the exhibition was long and tactically planned. It was linked to two other initiatives to put Lautrec's range of work in front of the London public. One of these was the removal of several works from the Goupil show, soon after the opening, to be exhibited at the International Society of Sculptors, Painters and Engravers, of which Whistler was President.[71] This was an act of solidarity with advanced trends in British art. The second was the preparation of two albums of lithographs for the London publishers Bliss and Sands, discussed below. These were aimed at the specialist markets of print collectors and fans of theatrical celebrities. The one-man show was much more than a therapeutic diversion; it was part of a coherent marketing strategy, for Joyant's business as much as for Lautrec. Why then did it founder?

The exhibition had the ill-fortune to coincide with the death of Gladstone and the birthday of Queen Victoria, and the more avoidable miscalculation of clashing with the opening of the Royal Academy's annual exhibition.[72] But despite Lautrec and Joyant's efforts to tailor the work on show to London's susceptibilities, the clichéd prejudices about French culture made their loaded presence felt. The use of words such as 'ugliness' and 'vulgarity' by British critics was, in effect, the coded introduction of moral judgement; if Lautrec's subjects could not to come up to the mark aesthetically, they inevitably failed to do so morally, representing a degenerate, foreign culture. Although the various critics were prepared to acknowledge Lautrec's technical gifts, their common term 'cleverness' suggested something somewhat deceitful and again, perhaps, foreign. Indeed, Lautrec's mature style, based on his graphic facility and ability to approximate, to synthesise, was difficult to understand because British art recognised other skills such as precision and high finish. In order to learn synthetic drawing or radical chromatics, artists like Rothenstein and Warrener had had to work in Paris. One might argue that, in fact, the critics' terminology was as intuitive as it was dismissive. Both 'ugliness' and 'cleverness' are words that

70
Henri de Toulouse-Lautrec
Dr Péan Operating 1891–2
Oil on cardboard 73.9 × 49.9 | 29 × 19⅝
Sterling and Francine Clark Art Institute,
Williamstown, Massachusetts

might be used in an apt definition of Lautrec's art as founded on a caricatural view of the world, seeking out the exaggerated, grotesque and corrupt in the modern metropolis. The caricatural was a dominant element in the Parisian modernity within which Lautrec had matured; it shaped his art and that of the contemporaries and compatriots the critic of the *Daily Chronicle* had listed. But that way of seeing, and of drawing, was largely anathema in Britain, where in the 1890s students even at a relatively advanced art school such as the Slade were encouraged to admire Watteau. Finally, the fact that Lautrec seemed to be changing artistic identities might have confused the London public: why should an artist known for his posters be presenting himself as a painter? It was a problem similar to that faced by Pellegrini in the 1870s. In the end, though, Lautrec's work failed to make much of a mark in London because of entrenched cultural prejudice. The British liked to see their morality, and thus their art, as more elevated than the French, and that was the position the public prints would promote. If Joyant and Lautrec thought that they could even lightly titillate the London audience, to infiltrate beyond the prejudices of some and to relax the hypocrisies of others, they miscalculated.

By mid-decade Lautrec had published two albums of lithographs, *Le Café-Concert* in collaboration with H.-G. Ibels in 1893 and *Yvette Guilbert* with text by Gustave Geffroy the following year.[73] In July 1896 he entered into negotiations for another album with W.H.B. Sands, director of the London publishers Bliss, Sands and Co., of 12 Burleigh Street, Strand. The intermediary was Bouglé, known in London as 'Spoke'.[74] The project progressed sporadically. Initially Lautrec was to produce images of male and female performers of the French stage and *café-concert* which would be accompanied by short profiles penned by a variety of writers; eventually the hack journalist Arthur Byl provided them all. A new dimension and urgency was added in February 1898. Yvette Guilbert, then the reigning diva of the *café-concert*,

was to play a London season from 2 May. Sands hoped to capitalise on this with a separate album devoted to her, a scheme potentially advantageous to Lautrec too as this would coincide exactly with his Goupil show. Sands wanted maximum exposure, and Lautrec's album of nine lithographs and a cover was printed in an edition of 350, compared to that of 100 for the 1894 album dedicated to her (no.71).[75] Although the format was large and arresting, the paper quality was only moderate, and the rather free graphic quality of the images, compared to the more finished character of the earlier album, attests to the pressure Lautrec was under to complete the project on time.[76] In the event, Guilbert's season was cancelled. Nevertheless, the album was published and advertised in the *Paris Magazine*, a specifically cross-Channel periodical circulated in both London and Paris which Sands launched in December 1898. Lautrec's lithograph of the *café-concert* singer Polaire was reproduced in the inaugural issue.[77] It is not certain what happened to the original project, the album of actors and actresses. On 1 April 1898 Lautrec wrote to Sands, sending him the lithographic stones and his bill for the *Yvette Guilbert* album, and also finalising the list of performers for the other album.[78] By this time twenty names had been considered, from which thirteen were finally selected. However, whether the album was published at this stage is unknown. *Thirteen Lithographs* was not advertised in *Paris Magazine*, an obvious place to puff its publication. As Sands's company was reorganised in 1898 and its records destroyed in the Second World War, the exact story may never be known. However, an edition was certainly published before 1906, and another in Belgium in about 1913 (no.72).[79] In the final analysis, Toulouse-Lautrec's links with Britain, and especially with the London art market, were more active and multifarious than is commonly acknowledged, but his impact, despite some qualified plaudits in the press, was negligible on collectors and the wider public.

71
Henri de Toulouse-Lautrec
Yvette Guilbert (album of lithographs) 1898
Lithograph
49.5 × 38 | 19$\frac{1}{2}$ × 15
The British Museum, London

72
Henri de Toulouse-Lautrec
Thirteen Lithographs, 'Louise Balthy' 1898
Lithograph
29.5 × 24.4 | 11$\frac{5}{8}$ × 9$\frac{5}{8}$
The British Museum, London

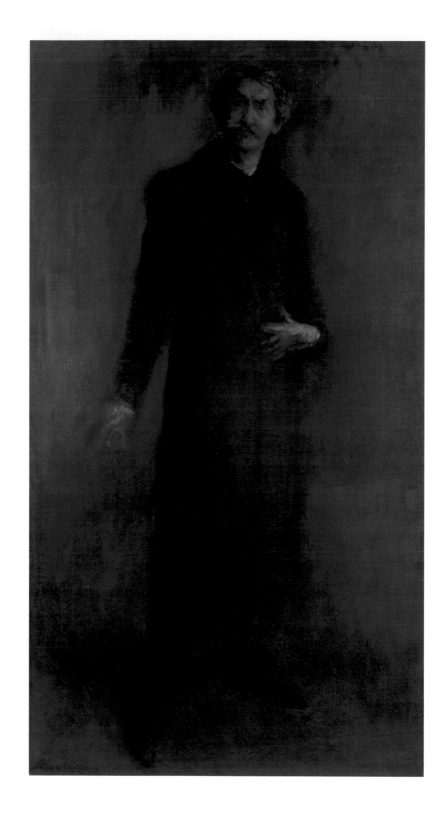

73
James Abbott McNeill Whistler
Brown and Gold: Self-portrait c.1895–1900
Oil on canvas 95.8×51.5 | 37³/₄×20¹/₄
Hunterian Art Gallery, University of Glasgow

Since the 1830s, when Beau Brummell's dandyism of costume, wit and behaviour set the tone for French followers such as Roger de Beauvoir and Jules Barbey d'Aurevilly, the model of the English gentleman had been a beacon for French males who aspired to a certain physical elegance, verbal distinction and social hauteur.[80] The paradigm was not based exclusively on dress – indeed, the tweedy provincial in Tissot's *London Visitors* (no.1) is a figure of fun – although British tailoring was much admired; even Claude Monet had his suits made in London. But it was a persona that lifted a man above the ordinary. That was a useful identity for an artist, someone who needed to demonstrate his creative individuality, his aloofness from the very middle classes who provided his public. In particular, the Parisian cultural climate of the 1880s and 1890s favoured such a model. By now well established, the Third Republic adopted a cultural stance that was civic, earnest, inclusive and dull. The generation that had grown up under this regime, Toulouse-Lautrec's age-group, frequently took a critical attitude to the dominant bourgeois society's perceived decadence, to the hypocrisy which strove to mask sexual or financial corruption with a veneer of respectability. This was the instinct that sharpened the caricatural attitude which marked the art of Lautrec and his contemporaries. Furthermore, social decadence was not only an aspect of society which the artist or writer might use as a target; it was also one in which he might revel. The dandy was a persona that lifted the artist above the social ruck, his difference suavely evident from nuances of costume, artistic and literary taste and, in all probability, his discreet scent of sexual particularity. In more specific cultural terms, the vogue of Symbolism, its writing and imagery geared by its subtlety and suggestiveness to the mind and eye of an élite in contrast to the run-of-the-mill naturalism that catered for the mass of the bourgeoisie, also promoted the notion of the dandy, a cut above the ordinary.

Whistler was one of the most successful and celebrated practitioners of this persona. Jacques-Emile Blanche's account of Whistler inspecting Degas's *Little Dancer* sculpture in 1881 (see p.43) is only one of myriad instances in which the American painter's behaviour and clothing were memorised and recorded. Blanche's absorption of Whistler's dandyism was itself a token of his own. For dandyism was a form of self-aestheticisation, blurring the lines between one's presence and one's art. This is apparent in the example of a late self-portrait by Whistler, titled *Brown and Gold* (no.73). Near completion in June 1895, the canvas was delayed by the illness and then death of Whistler's wife Beatrice.

It was shown in Paris at the 1900 Exposition Universelle, after which he may have reworked it. Dressed in his characteristic long coat, Whistler fills the picture space, his stance reminiscent of Velásquez's *Pablo de Valladolid* (c.1632–3, Prado, Madrid).[81] The reference was at once subtle and generic, the elderly artist associating himself with the aristocracy of painting both by his pose and his typical sparse, sombre tonalities. Since the 1880s Whistler had regularly exhibited his full-length portraits to increasing acclaim in London and Paris. In 1886 the anonymous *Petit Bottin des lettres et des arts* had evoked them with allusive Symbolist brevity: '*De symphonies d'ombres émergent des êtres d'élégance delicate et serpentine, lointains et qui inquiètent.*'[82] For the decadent writer Jean Lorrain, Whistler's portrait of Comte Robert de Montesquiou-Fezansac (1891–2, Frick Collection, New York), an exquisite dandy posed in full evening dress and clasping an elegant cane, was 'one of the masterpieces of the century.'[83]

Whistler's paradigm stimulated artists on both sides of the Channel to work their variants. At the Salon of 1888 Blanche exhibited his life-size full-length of his friend Louis Metman (no.74). Blanche's figure is more crisply silhouetted against its backdrop than was Whistler's usual practice and richer in detail of tie-pin and patent leather shoes, but the muted greys, blues and pinks, the suave stance, and the discreetly decorative frame all qualify as Whistlerian. Indeed, the simplicity of the form subtly conveys the compact self-absorption of the effete Metman, a *littérateur* of private means who never married.[84] Lautrec, Joyant recalled, was also very struck by Whistler's example.[85] At the Salon des Indépendants in 1891 Lautrec showed three portraits of male friends standing in his studio. One of these was a full-length of Dr Henri Bourges, with whom he shared an apartment (no.75).[86] Lautrec's painting is smaller in scale than Blanche's *Metman*, and manifests a different aesthetic. Giving the impression of being spontaneously graphic, rather than exquisitely stylish, and concerned with the action of a moment rather than knowing poise, Lautrec's *Bourges* none the less made a Whistlerian bow. When one critic complained of Lautrec's 'Monsieur en violet' this was an allusion to the tonal harmony that Whistler had made the sine qua non of the modern male portrait.[87]

Lautrec's 1891 full-lengths, in turn, did not escape the attention of Rothenstein. In 1893 Rothenstein exhibited *The Painter Charles Conder* at the Salon de la Société Nationale des Beaux-Arts, which was also shown in London at the New English Art Club the following year (no.77). Posed by Conder, the portrait is a

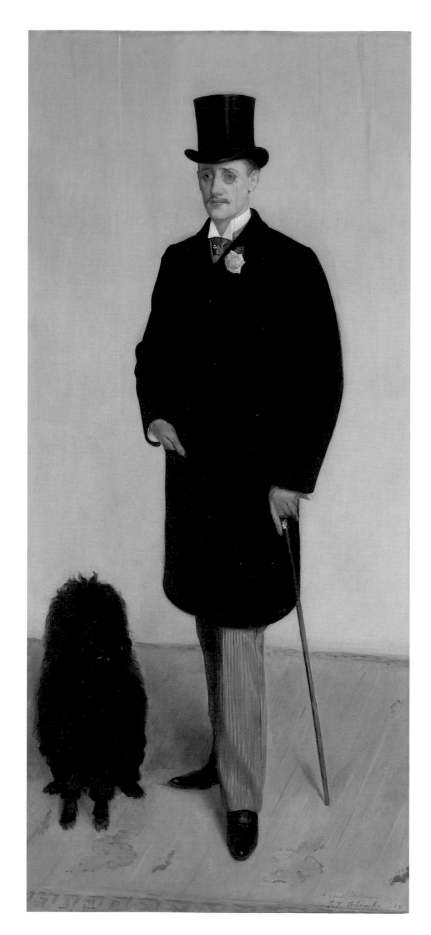

74
Jacques-Emile Blanche
Louis Metman 1888
Oil on canvas 215×95 | 84⅝×37⅜
Château-Musée de Dieppe

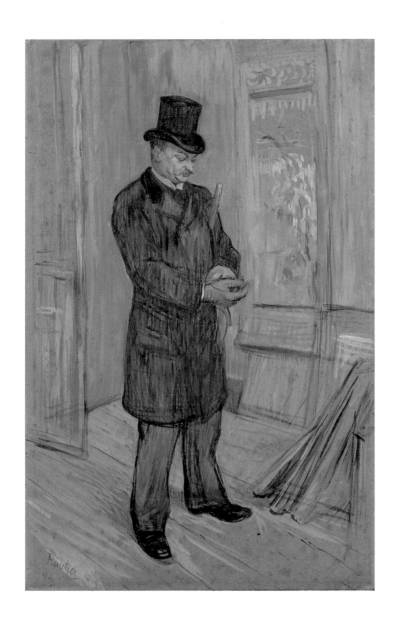

75

Henri de Toulouse-Lautrec
Portrait of Dr Henri Bourges 1891
Oil on cardboard mounted on panel 78.7 × 50.4 | 31 × 19⁷/₈
Carnegie Museum of Art, Pittsburgh. Purchase: acquired through the generosity of the
Sarah Mellon Scaife Family 1966

76
Walter Richard Sickert
Aubrey Beardsley 1894
Oil on canvas 76.2 × 31.1 | 30 × 12¼
Tate. Purchased with assistance
from the National Art Collections Fund
1932

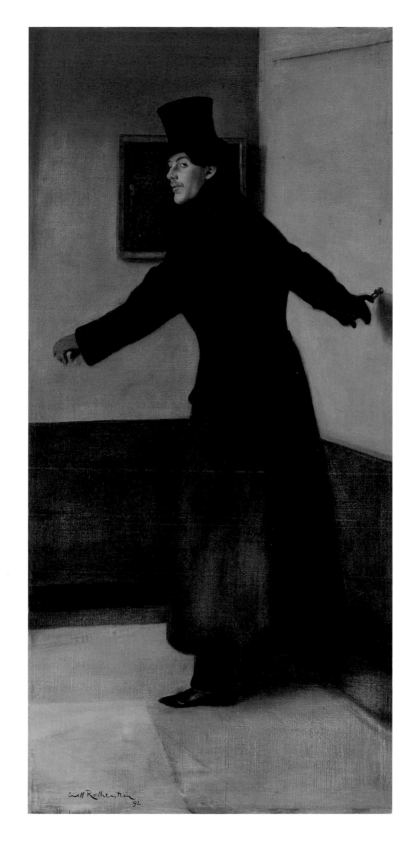

77
William Rothenstein
The Painter Charles Conder 1892
Oil on canvas 120.3 × 55.2 | 47¼ × 21¾
Toledo Museum of Art.
Purchased with funds
from the Libbey Endowment,
Gift of Edward Drummond Libbey

82
William Rothenstein
The Coster Girls 1894
Oil on canvas 101 × 76 | 39³/₄ × 29⁷/₈
Sheffield Galleries and
Museums Trust

83
Walter Richard Sickert
The Blackbird of Paradise c.1896–8
Oil on canvas 66.1×48.3 | 26×19
Leeds Museums and Galleries,
City Art Gallery

Anna Gruetzner Robins

SICKERT
AND THE PARIS
ART WORLD

Walter Sickert
Dancer of Memphis, USA
c.1904
(no.99, detail)

85
James Abbott McNeill Whistler
A Draped Model Reclining c.1900
Pastel and charcoal on brown paper 17.8 × 27.7 | 7 × 11
Hunterian Museum and Art Gallery, University of Glasgow

86
James Abbott McNeill Whistler
Nude Model Reclining 1900
Pastel on brown paper 18.1 × 27.9 | 7⅛ × 11
Private collection, England

87
Walter Richard Sickert
The Iron Bedstead c.1905
Pastel on paper 33 × 50.1 | 13 × 19¾
Private collection

88
James Abbott McNeill Whistler
The Rose Drapery c.1888–95
Chalk and watercolour on brown paper
27.7 × 18.4 | 11 × 7¼
Hunterian Museum and Art Gallery,
University of Glasgow

89
Edgar Degas
Bed-Time c.1880–5
Pastel and gouache over a monotype print on paper
22.9 × 44.5 | 9 × 17 ½
Tate. Presented by C. Frank Stoop 1933

163

green pastel accented with black charcoal in *The Iron Bedstead* and *La Coiffure*. Alexander Reid's exhibition was the first to include a Degas nude in Britain, and its mood of modest intimacy, suggests that the prurient morality that had hounded Whistler's showings of pastel nudes the decade before had been in Reid's mind when choosing this pastel by Degas.

Retiring and *Bed-Time* (no.89) belong to a small group of female nudes getting into bed, where Degas reworked Rococo iconography and introduced a more 'modern' feel to the setting.[17] The contrived naturalness of the model in *Retiring*, perched in an awkward pose while reaching for the lamp, is matched by the artful pose of the female figure who sits on the edge of the bed in Sickert's *Nude on a Bed*, which Ruth Bromberg has identified as *La Coiffure* (no.90), shown in Sickert's 1907 and 1909 Bernheim-Jeune shows. The seemingly natural but uncomfortable pose, with her legs crossed and arms held awkwardly behind her head, is that of an Antique Venus, suddenly able to bend and sit.

French critics such as Paul Jamot, who owned several works by Sickert, saw obvious pictorial affinities between Sickert's and Bonnard's figure work. As Jamot pointed out in his 1906 Salon d'Automne review, 'Sickert is wavering between Bonnard and Whistler'.[18] Jamot was no slouch when it came to Sickert and had first-hand information when he reported that Sickert 'seemed to have become more human with contact with our young school.'[19] Other French critics, including Claude Roger-Marx, author of several books on Vuillard and Louis Vauxcelles who wrote perceptively about Sickert's Paris showings, also noted his connection with Vuillard and Bonnard. In 1909 Sickert showed for the last time at the Salon des Indépendants, where he was grouped with these artists. One example of his Camden Town nude pictures, described as 'a sombre jewel', was included in Salle XX with work by Vuillard, Maurice Denis, Bonnard, Roussel, Vallotton, Lebosquet and Marquet.[20] Just how well did Sickert know Bonnard – and Vuillard for that matter? Intriguingly, one of Sickert's French pictures was entitled *Marthe*, the name of Bonnard's model and companion, later to be his wife, Marthe de Méligny. Sickert's writing on Vuillard suggests an easy familiarity with his work, and he certainly made contact with both artists. He knew Vuillard well enough to arrange an introduction for the Camden Town artists Harold Gilman and Charles Ginner when they visited Paris in 1911. Bonnard was one of Sickert's French collectors. Possibly he met Bonnard and Vuillard through the Bernheim-Jeune Gallery. All three artists were part of the gallery stable, and some of their encounters must have taken place there.

They shared a circle of French collectors including the dentist Dr Georges Viau, who owned works by Degas, Bonnard (including *The Mirror in the Green Room*, no.96), Sickert and Vuillard. Sickert's recollections of his meetings with Bonnard and Vuillard give a hint of a shared artistic bond. Sickert recalled that Bonnard and Vuillard had critiqued his pictures, saying that they 'had known that they were giving me the most precious proof of their friendship' when ' they pointed out as clearly and completely as possible the defects in my work, and the steps that I might take to correct or minimize them.'[21]

Leaving aside these shared exhibition networks and friendships, there are obvious pictorial connections between the work of the three artists. In autumn 1906, when Jamot noted Sickert's affinity with Bonnard, Sickert was working in a room in the Hôtel du Quai Voltaire, where he painted 'a whole set of interiors in the hotel, mostly nudes',[22] including *Woman Washing her Hair* (no.92) and *La Maigre Adeline* (no.93). There are faint echoes of Bonnard in *La Maigre Adeline*, where the long taut arch of the female figure is set off by the rectangular oblong of the bed and the squared bedside cabinet. Sickert's *Woman Washing her Hair* makes more than a bow to Bonnard's 1906 Salon d'Automne exhibit, *Cabinet de Toilette*. In the Bonnard painting the arched back of model and her upraised pointed left foot makes a sinuous

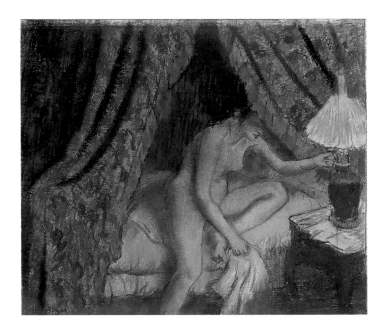

fig.44
Edgar Degas
Retiring c.1883
Pastel, with stumping, on cream wove paper
36.4 × 43 | 14³/₈ × 16⁷/₈
Art Institute of Chicago. Bequest of Mrs Sterling Morton

90
Walter Richard Sickert
La Coiffure 1905–6
Pastel on paper 69.5 × 54 | 27³⁄₈ × 21¹⁄₄
Private collection

91
Walter Richard Sickert
Cocotte de Soho 1905
Pastel on paper 62 × 50 | 24⅜ × 19¾
Private collection

curved shape, repeated in the rounded bath and basin. In Sickert's *Woman Washing her Hair* a mere fragment of the torso, breast and legs of the female figure makes a rectangular shape, echoed in the vertical frame of the doorway. The interdependence of figure and setting is taken to new extremes.[23] In 1909 Bonnard tried out a similar idea in *Reflection in a Mirror* or *The Tub* (fig.46), where the body of the female figure bends to make a rectangular shape that follows the rectangular frame of the mirrored dressing table.

A room in a cheap Paris hotel served as Sickert's studio and gave the semblance of a domestic space for the autumn 1906 nudes, including *La Maigre Adeline* and *Woman Washing her Hair*. Bonnard placed his nudes in the feminine domestic space of the dressing room, a nod to the everyday space that Degas's nudes occupy (no.89). In Vuillard's *A Nude in the Studio* (no.94), the pretext of a natural setting slips away. The easel, stacked canvases, and other art paraphernalia make the comfy sofa merely another studio prop. This privileging of the studio as the site of art practice is symptomatic of a new interest in the possibilities for creative expression sparked by the private interior space the studio exemplified. Under the wilful authority of the artist, models could be ordered to twist, contort and bend in unnatural poses or simply stand at ease. In *A Nude in the Studio*, the casual pose of the model is played off by the squared shapes of the stacked canvases and the works of art on the studio wall.

Sickert gives a nod to this rethinking about the artist's role in the painting of the nude in *The Poet and his Muse* (Towner Art Gallery, Eastbourne), where a winsome nude looks over the artist's shoulder. *The Studio: The Painting of a Nude* (fig.47) makes a complex statement about the artist as an agent who offers up various ways of looking: the reflection of the model, who stands behind the artist, a reflection of a reflection of her torso and rounded bottom in the mirror of the wardrobe door, left slightly ajar, and a partial reflection of the painter, who faces the mirror, holding a brush in his right hand. The variety of painted surfaces in *The Studio* is proof that Sickert had been an attentive student of the French School: the long slashes and curls of purple enliven the painter's dark sleeve, the same purple becomes a flat painted patch beneath this sleeve, those streaks of orange on the chair leg nicely play off the purple, daubs of light paint dissolve the massive body of the standing model. It's a mixed bag, but no more mixed than Matisse's 1906 'fauve style', which also drew on Signac's late pointillist technique. Sickert also looked to Cézanne for his surface effects. Where else would we see *The Studio*'s

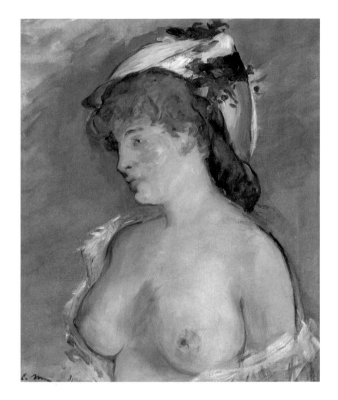

fig.45
Edouard Manet
Blonde with Bare Breasts c.1878
Oil on canvas 62 × 51 |24³/₈ × 20⅛
Musée d'Orsay, Paris

167

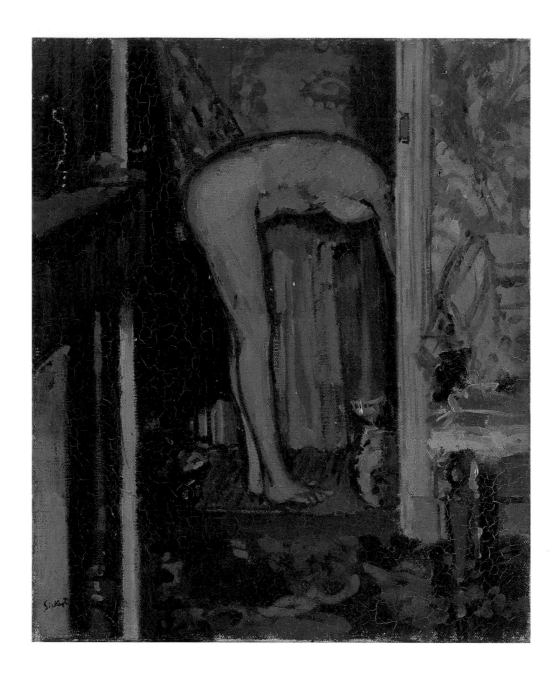

92
Walter Richard Sickert
Woman Washing her Hair 1906
Oil on canvas 45.7×38.1 | 18×15
Tate. Bequeathed by Lady Henry Cavendish-Bentinck 1940

fig.46
Pierre Bonnard
Reflection in a Mirror or *The Tub* 1909
Oil on canvas 73 × 84.5 | 28¾ × 33¼
Hahnloser Collection, Villa Flora, Winterthur

patches of purple or the patches of colour in *Giuseppina against a Map of Venice* (no.102), which serve no descriptive function, but in Cézanne? Sickert makes a curious indirect reference to Cézanne in *The Painter in his Studio*, another painted reflection of the artist, with three studio casts, one of them a cast of the flayed man attributed to Michelangelo that appears in several Cézanne still lifes including *Still Life with Plaster Cupid*, (Courtauld Institute of Art).[24] The cast also appears in the pastel *Mrs Barrett* (Tate, London).

The cast of Venus in Sickert's *The Painter in his Studio* is intriguing. Bonnard kept a postcard of the same Venus, a variant of the Knidian Venus, on his 'ancestor wall' of his studio at Le Cannet. During the period when Sickert was closest to him,

Bonnard was actively sourcing Antique Venuses for pictures of the female nude. This interest in the Antique can be connected to the 'Return to Classicism' movement, which gained a widespread following in France. Bonnard's fellow Nabis Maurice Denis was a spearhead of the movement. Many artists, including Denis, introduced classical themes and subjects in their art. Bonnard looked to Antique sculpture, sourcing different Venuses for a group of paintings of the female nude. A mirrored dressing table became a tool in a meditative exercise on the painting of the female nude. In Bonnard's *The Mirror in the Green Room* (no.96) a reflection of a clothed figure and a 'real' nude becomes a sculpted fragment in the mirror. The reflected nude has more than passing resemblance to the Medici Venus in the Uffizi.

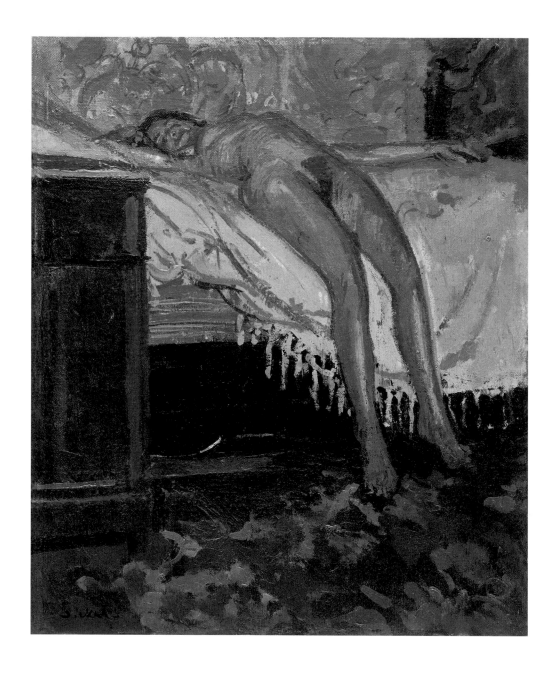

93
Walter Richard Sickert
La Maigre Adeline 1906
Oil on canvas 46.4 × 38.7 | 18¼ × 15¼
The Metropolitan Museum of Art, New York
Gift of Scofield Thayer, 1982

In Sickert's *The Studio: The Painting of a Nude* (fig.47), the reflection of the real model's reflection in the mirrored wardrobe is like a fragment of an Antique Venus. These paintings of mirror reflections by Bonnard and Sickert offer multiple choices for a self-reflective process, where the representation of the female form is the motivation for a complex form of picture-making.

Bonnard's painted Venuses differ from the numerous photographs of naked models posing as Venus in the 'instructive' manuals for the artist. Bonnard's life-long companion and wife, Marthe, was the model for his sculpted Venuses. Was Bonnard seeking a means to celebrate Marthe's body and the pleasure of sensual physical love, untainted by its association with paid sex? *Woman in Front of a Mirror* (no.95) is a testimony to Bonnard's love of Marthe as an object of his desire. The splodgy, pink-flowered wallpaper, red-and-white patterned slip-cover and luminously lit Marthe make it a luscious picture. With her plump, rounded buttocks she poses in 'reality' as a Venus Kallipygos, and in the mirror she appears as a more modest Venus, covering her breasts with a cloth. Life and art merge in the 'real space' and the mirror image.

I am arguing here that the plastic realisation of sculptural form was central to both Bonnard and Sickert's painterly aesthetic in these pictures of the female nude. Some of Sickert's nudes are reminiscent of Rodin's sculpture. Sickert, like many British artists, was on friendly terms with Rodin, and visited him in his studio on several occasions where he would have seen a full range of sculpture. He may have seen a cast of Michelangelo's *Dying Slave* (Musée du Louvre), which had a formative effect on Rodin's sculpture and is the third cast in Sickert's *The Painter in his Studio*. Rodin also looked to the Antique, claiming that it would enable the sculptor, painter or engraver to 'create work entirely in harmony ... with the works in our museums'. He published his first statement about classical sculpture in 1904 in a new review *Le Musée, Revue d'art antique*, which heralded the renewed interest in Antique art.[25] Through the process of time, classical sculpture has become a sculpture of fragments. These bits of Antiquity were a highly influential source for Rodin. *Iris* (fig.49) is a sculpted fragment where the torso functions almost like 'a mute, de-anthropomorphised face', and the fragmentation intensifies the 'boldness and frankness' of the female genitalia.[26] I see a connection between *Iris* and Sickert's *Conversations* (no.84), with its oddly foreshortened female figure, her head in shadow and one leg tucked up under her body.

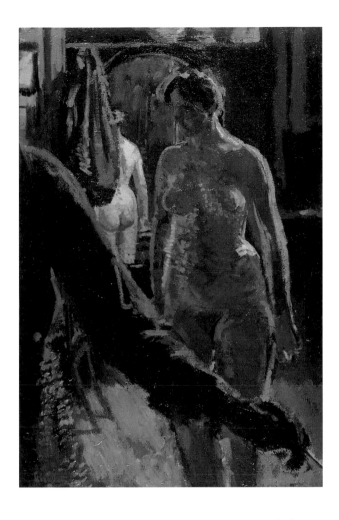

Sickert needed a bed to support these painterly fragments and the bed remained an important prop for him, as the female nude became like plasticine in his hands. The bed is central to Sickert's memorable image of the female nude in *L'Affaire de Camden Town* (fig.48). The work belongs to a large group of paintings, drawings and etchings which take the murder of a prostitute in Camden Town, a north London suburb where Sickert lived and worked, as their point of reference. In her brilliant study of the circumstances of the murder and its reporting in the popular press, Lisa Tickner rightly concludes that while the painting 'reconstitutes something of the "noise" of urban reportage', it is not an illustration of the event.[27]

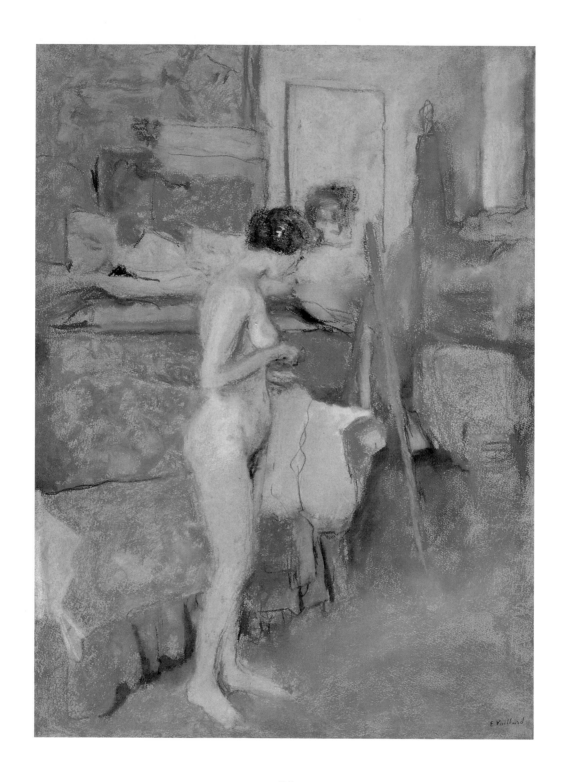

94
Edouard Vuillard
A Nude in the Studio c.1909–11
Pastel on paper mounted on canvas 64 × 47 | 25¼ × 18½
The Syndics of the Fitzwilliam Museum, Cambridge. Bequeathed by A.S.F. Gow
through the National Art Collections Fund 1978

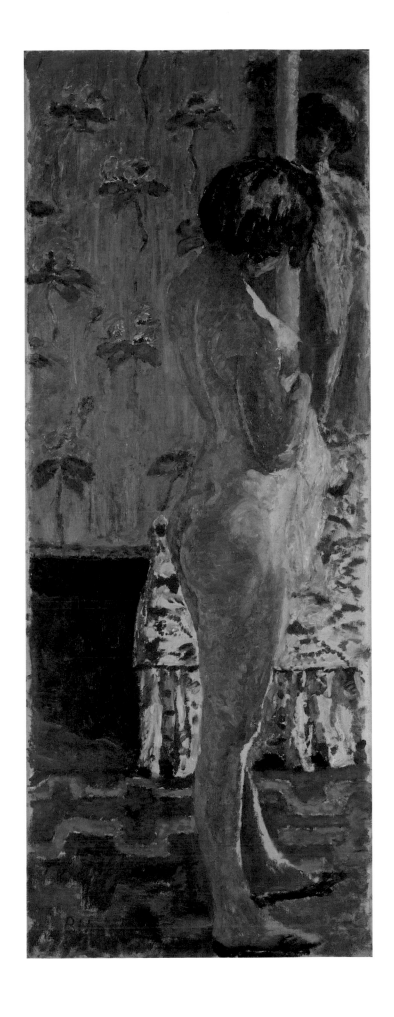

95
Pierre Bonnard
*Woman in Front of
a Mirror* c.1908
Oil on canvas
124.2 × 47.4 | 49 × 18⅝
National Gallery of Australia,
Canberra

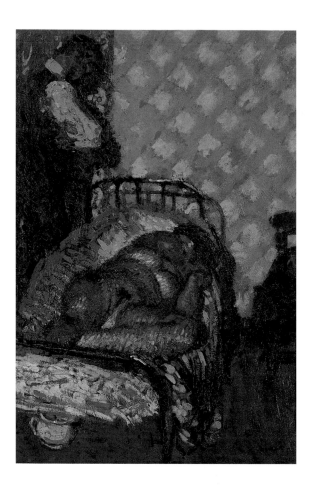

fellow anarchist Paul Signac, who knew and respected Sickert. Signac had asked him 'to buy me a Sickert of your own choice, even if it is a bit lewd' to add to his large collection of modern painting.[30] In gratitude, Sickert sent him a study for the painting, inscribed, 'A Signac'. *L'Affaire de Camden Town*, which Bonnard bought from the 1909 Bernheim-Jeune Sickert show, was one of eighty-four works put up for auction. Others who bought work included Romain Coolus, who had worked with Fénéon on *La Revue blanche* and bought two works including *La Nera* (no.103), Jamot who also bought two, and Fénéon himself.

As anarchists, Fénéon and Signac would have admired *L'Affaire de Camden Town* for its shocking female figure, with her left leg drawn up to fully expose the slit of her pubis, which together with the added frisson of the attendant male figure, shatters all bourgeois expectations about the painting of the nude. Its pose was shocking, but it was not the first time the French had seen an exposed pubis. Indeed, Fénéon, who liked to unsettle his more conventional clientele, is known to have shown a Rodin sculpture of a fragment of a female nude, thighs spread, to one startled female customer who at first failed to recognise its

L'Affaire de Camden Town was one of three pictures that Sickert exhibited in Paris, with this French title. Vauxcelles's description of the 'sombre jewel' at the Salon des Indépendants,[28] and the 'two small works worthy of Sickert' at the Salon d'Automne suggest that *L'Affaire de Camden Town* was in the earlier spring show.[29] Possibly it conjured associations with intrigue and the detective novel for a French audience, who were its first spectators, but none of the reviews which I have read mentioned this connection. Probably the French were unaware of the circumstances of the crime, and would not have known that the title referred to a murder. After all, Sickert depicted this naked woman alive, not dead, as the compositional studies make very clear. The anarchist critic, 'cultural terrorist' and manager of the Bernheim-Jeune gallery, Felix Fénéon, does not seem to have made the connection to murder when he chose the picture for his

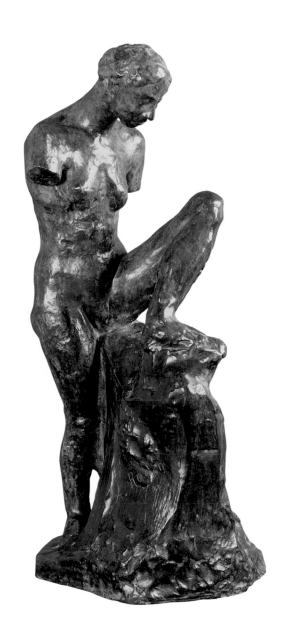

98
Auguste Rodin
Etude pour la muse nue, bras coupés 1905–6
Bronze 65.5 × 33 × 34 | 25¾ × 13 × 13⅜
Musée Rodin, Paris

fig.50
Walter Sickert
Mornington Crescent Nude 1907
Oil on canvas 45.7 × 50.8 | 18 × 20
The Fitzwilliam Museum, University of Cambridge

fat whores, pale singers, clean-shaven and sordid, poor wretches who wander in the Whitechapel alleyways, stupefied with gin. It is a nocturnal poem of London destitution and prostitution.'[47] Even Sickert's palette evoked associations in the minds of the French critics with the sordidness of London poverty. Writing in 1908, Monod said that 'his tones [are] riddled with matter of putrefaction.'[48] The following year Monod had this to say: 'His palette is a poor wretch in faded rags. Exquisite in dirtied tones, the range of black green, clay green, caviar grey, the over ripe and stewed blues and pinks, reddish, recycled reds, dead lilacs, it is steeped in London winters, and in the fowl flow of the Thames.'[49]

After his 1907 show, Sickert continued to send paintings of the female nude to the Salon d'Automne. Vauxcelles's 1908 description of *Nu*, hung in Salle XVI with Vallotton, Matisse, Lacoste and Camoin, suggests that this may be *Mornington Crescent Nude* (fig.50). 'The weight of the body of the sleeping whore is rendered with an amazing feeling for volume. Sickert knows better than anyone at the present time that with a dark and transparent sketch – and notably on black – light tones take on a harsh brightness and the light impasto of the ambiguous tones (purple, wine, blue, varied greys, subdued oranges, broken whites, warm or cool) sing with delicacy.'[50] Vauxcelles had no difficulty in appreciating the pictorial impact of the handling and colour in a painting which he believed to represent a prostitute, but in Britain complaints about this choice of subject would plague Sickert criticism, and create the myth that Sickert's choice of subjects did not matter.

concluding that 'their deformed flesh carries the stigma of the most painful of professions',[43] Vauxcelles turned to Sickert's portrait studies of prostitutes, or so Vauxcelles assumed them to be, including *Dancer of Memphis, USA*, claiming that 'one thinks of the faces of the women of an ever so British modern Tiepolo.'[44] There would be those who 'will smile with pity in front of Sickert's serious images which they characterise as "pornographic charcoals"', warned Vauxcelles, but 'Who cares! This painting is not to their taste.'[45]

By autumn 1905, when Sickert started exhibiting at the Salon d'Automne, he had returned to England to live; and while he continued to spend periods of time in France, working in Paris in autumn 1906, and taking a studio in Montparnasse at the beginning of 1907, London was his principal domicile. Camden was both the inspiration for some his best known 'Camden Town' pictures, and their place of making. French critics believed that Sickert's London map was imprinted in his painting. As Gustave Geoffroy, the perceptive critic and loyal supporter of Impressionist painting, commented: 'Sickert makes out the forms which move in obscure London bedrooms.'[46] Vauxcelles also detected a London presence. 'Sickert has fixed with a sharp clear-sightedness, the Bedford music-hall workforce, the dazed

fig.51
Henri Matisse
Blue Nude (Memory of Biskra) c.1907
Oil on canvas 92.1 × 140.4 | 36¼ × 55¼
The Baltimore Museum of Art: The Cone Collection
The Cone Collection, formed by Dr Claribel Cone and Miss Etta Cone
of Baltimore, Maryland

100
Walter Richard Sickert
La Hollandaise c.1906
Oil on canvas 51.1 × 40.6 | 20⅛ × 16
Tate. Purchased 1933

Sickert's preoccupation with the female nude reached its fruition in the Camden Town Murder series, three of which, all entitled *L'Affaire de Camden Town*, were exhibited in Paris in 1909. Vauxcelles commentary on the Sickert nudes at the Bernheim-Jeune show and his assumption that they represent poor prostitutes makes their generic connection to these earlier pictures more apparent.

Within the context of the Paris art world, Sickert's representations of prostitutes acquire a different significance. Take Sickert's *La Hollandaise* (no.100), which probably derives its title, as Richard Shone argues, from the name of the prostitute, 'la belle Hollandaise', in Balzac's *Gosbeck*.[51] Rebecca Daniels argues that the jagged slashes of paint that describe the features of the face in *La Hollandaise* leave a gaping triangular cavity for the nose, an 'allusion ...to tertiary syphilis which ate away the nose bone, leaving a hole in the face'.[52] Just at the time that *La Hollandaise* was exhibited in Sickert's 1907 Galerie Bernheim-Jeune show, Picasso was working on what one of the most important paintings of modernism, *Les Demoiselles d'Avignon*, a brothel picture with a brazen sexuality that loads prevailing fears of degeneracy and venereal disease onto the 'prostitutional body'.[53] Later in 1907, Matisse sent *Blue Nude (Memory of Biskra)* (fig.51) to the Salon des Indépendants. Biskra, on the edge of the Sahara, was well-known for its women who 'flocked to the pleasure quarter ... to earn their dowries through prostitution'.[54] In 1907 Matisse was signed on to Sickert's Paris gallery and it is tempting to think about a possible connection between the corpulent figure, with its dramatic contrast of dark and brilliant white in *La Hollandaise* and Matisse's bulbous nude conceived as a 'two-toned chiaroscuro of bright white highlights and blue shadows'.[55] My purpose here is not so much to line Sickert up against these two giants of modernism, but to shift the context for a discussion of Sickert's paintings of the nude.

101
Edgar Degas
Woman at a Window 1871–2
Oil on paper 61.3 × 45.9 | 24⅛ × 18
The Samuel Courtauld Trust,
Courtauld Institute of Art Gallery,
London

When Sickert saw Degas's *Woman at a Window* (no.101) at Durand-Ruel's in 1902, it brought back memories of an earlier sighting at the exhibition organised by Alexander Reid at the end of 1891 (see p.86). Shortly afterwards he wrote excitedly to tell Sir William Eden: 'I have just bought Degas's finest work had an eye on it 12 years or so'.[56] The picture was a replacement for Degas's *Rehearsal of the Ballet on Stage* which Ellen, now divorced from Sickert, had been forced with great reluctance to sell to ease her financial situation. She sold *The Green Dancer* the same year. Sickert bought the much cheaper *Woman at a Window* on her behalf. While *Woman at a Window* may not have been in his possession, he certainly claimed imaginative ownership of it.

Woman at a Window is another example of Degas's experimental use of *essence* (see p.55). Using a brush, Degas drew in the black lines and laid in the more solid black of the dress. The interchangeability of drawing and painting in one medium must have delighted Sickert, who valued the importance of drawing so highly. *Woman at a Window* was bought from the Cobden-Sanderson family – Annie Cobden-Sanderson was the sister of

fig.52
Walter Sickert
Putana a Casa 1903–4
Oil on canvas 45.7 × 38.1 | 18 × 15
Courtesy of the Fogg Art Museum, Harvard University Art Museums,
Loan and Promised Gift of Patricia Cornwell

Sickert's first wife – by the Goupil Gallery, London, around 1923. Sickert took charge of it and varnished the picture under the watchful eye of the gallery Director, William Marchant.[57] The procedure darkened the picture's tonality, presumably making the contrast between the black figure and the lightish brown paper less extreme.[58] Whether it was Sickert's intention, the darker tonality of *Woman at a Window* brings it closer to the dark tonal palette of *La Nera* (no.103) and some of his other Venice figure pictures.

Sickert saw Degas a great deal in 1902, and it must have been during one of his weekly dinners with him that Degas told him that 'the lady was une sorte de cocotte & during the siege of Paris he bought her a piece of raw meat which she fell upon, so hungry was she, and devoured raw.'[59] Whether or not it is true, Sickert believed it to be so. The story may have been fresh in his mind as he began a series of pictures in Venice including *La Nera* and *La Giuseppina Against a Map of Venice* (no.102) during autumn and winter 1903–4. The models for these figure pictures were two Venetian prostitutes – La Giuseppina and Carolina dell'Acqua. Women worked as artist's models for the same reason they worked as prostitutes, as a way of seeking out a living. When Sickert entitled one study of La Giuseppina, *Putana a Casa* (Prostitute at Home) (fig.52), prostitution is explicit in the title, just as it is in the later work, *Cocotte de Soho*.

Putana a Casa is painted on canvas but its technique closely resembles the '*peinture à l'essence*' technique of Degas's *Woman at a Window*, an effect Sickert consciously sought using a mixture of '1/2 raw oil and 1/2 raw turps', and mopping up any excessive oil with blotting paper. This medium and technique allowed him to experiment with oil colour as a drawing medium. The blacked-in figure of *Putana a Casa*, whose garments dissolve into black, drawn lines, takes its cue from Degas. The winter of 1903–4 was a period of technical experiment for Sickert. In *La Giuseppina Against a Map of Venice* the delicate painted black lines of Giuseppina's hair, with painterly patches of colour in the green-red range, emulate Cézanne's method of applying independent patches of colour.

There are faint echoes of Degas's *Woman at a Window* in *La Nera*, where the figure poses against a rectangular-shaped picture after a painting by the Bassano family. Sickert was probably the source of the story that *Woman at a Window* represented a window overlooking the Tuileries Gardens,[60] a 'fact' that the bright light from the window makes it impossible to verify. Degas's increasing problems with his sight possibly made looking at bright light

103
Walter Richard Sickert
La Nera 1903–4
Oil on canvas 46.3 × 38.9 | 18¼ × 15¼
City and County of Swansea,
Glynn Vivian Art Gallery Collection

104
Walter Richard Sickert
Girl at a Window, Little Rachel 1907
Oil on canvas 50.8 × 40.6 | 20 × 16
Tate . Accepted by HM Government in lieu of tax
and allocated to the Tate Gallery 1991

fig.53
Edgar Degas
Laundresses carrying Linen c.1876
Essence on paper laid on canvas | 46 × 61 | 18⅛ × 24
Private collection

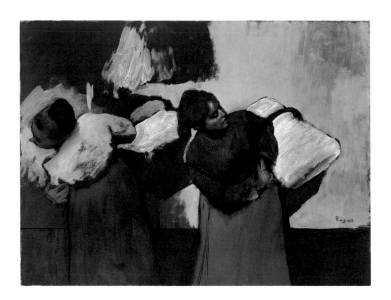

Not all of the pictorial inventiveness of Sickert's pictures can be connected to Degas. These figure pictures by Sickert can be placed in a larger pool of works, where ideas about the interdependence of the figure and its surroundings affect the representation of the figure in a variety of ways. The sinuous, serpentine figure in Vuillard's *Madame Hessel on the Sofa* (no.106) echoes the curving shape of the sofa, set off by the squared frames of pictures on the wall. Sickert admired Vuillard's 'figure in interior pictures', and there are echoes of Vuillard in some of his paintings, including *Le Tose* (no.105).

Vuillard was no stranger to Britain. The playwright and theatrical impresario Alfred Sutro was an early collector who continued to visit Vuillard in his Paris studio after their first meeting in the 1890s. In 1895, Sutro arranged for Vuillard's stage sets for Ibsen's *The Master Builder* to be used for the play's London staging, where a stagehand proceeded to hang them the wrong way round. On the advice of Theodore Duret, Albert Ludovici Jr, a Whistler follower and first secretary to the International Society, visited Bonnard and Vuillard in Paris and invited them to exhibit. Seeing their work skied when they visited the exhibition unexpectedly did not stop them from sending work to other exhibitions of the society. The printmaker Charles Mackie (1862–1920), who made contact with Gauguin and the Nabis artists in 1893, visited Vuillard's 'little garret stacked with pictures' in Paris with his wife Anne when Vuillard instructed

them 'to take the picture they liked best'. Afraid of being greedy, they took *Two Seamstresses in the Workroom* (no.107), making it the first Vuillard in a British private collection.[61]

Sickert certainly kept his eye on the Vuillard pictures in Britain. In 1910 he was bowled over by the surface effects of Vuillard's *Le Déjeuner (Friends Around the Table)* (1909, Musée d'Art Moderne, Strasbourg), which he saw at the International Society. After admiring a view of the Louvre by Pissarro, Sickert instructed his readers: 'Now, *without moving from here*, let us turn and look at Vuillard's *Déjeuner*. How his voice carries! What astounding knowledge of effect! He has proved himself delicate a thousand times. And from here how delicate and powerful is the effect of the scrawled splashes of distemper that examination will reveal. An old-fashioned person like myself ... is shocked at the violence of the means, but even my ossified intelligence must bow to the following reasoning, which my juniors have no difficulty at all in absorbing.'[62]

Sickert wrote nothing comparable about Bonnard. Instead Roger Fry, whose reviews of the Salon d'Automne in his Post-Impressionist years make interesting reading, praised Bonnard's painting effects. Referring to the Bonnard works in the 1910 Salon d'Automne, Fry wrote: 'Never has the play between the picture's surface and the ideated space, with which all pictorial art is concerned, been more subtly handled, or with more complexity.'[63] When Bonnard showed at the International Society in 1911, Fry sprang to Bonnard's defence again, praising his 'plastic feeling for form' which 'for all his delicate elusiveness of method ... imposes a definite idea and creates an illusion of reality.'[64] Fry's enthusiasm for this artist accounts for the superb Bonnards in the Tate collection, bought originally by the Bloomsbury circle. This essay suggests that there are interesting connections to be explored in the way in which Sickert and Bonnard treated the female nude between 1906 and 1909. Vuillard was equally important to Sickert, as R.H. Wilenski, in one of the first monographs claimed, when he pointed out that Sickert 'let out what he had learned from his friends Bonnard and Vuillard'.[65] Sickert's writings indicate that he admired the colour and studied naive effect of Vuillard's pictures, saying that 'his sense of colour' had a 'rudimentary quality, an almost purposed negligence ... [of] childish incapacity'.[66] To illustrate his point about Sickert and Vuillard, Wilenski took Sickert's *The Mantelpiece* (no.109), pointing out that it bore comparison to a Vuillard. Vuillard's *Woman Reading* (no.108) can be compared with good reason to *The Mantelpiece* because Sickert would have seen it at the 1911

107
Edouard Vuillard
Two Seamstresses in the Workroom 1893
Oil on millboard 13.3 × 19.4 | 5¼ × 7⅜
Scottish National Gallery of Modern Art, Edinburgh. Purchased with Assistance from
the National Art Collections Fund and the National Heritage Memorial Fund 1990

International Exhibition. The range of greens enlivened by touches of mauve in *Woman Reading*, a combination favoured by Whistler for his late seascapes and one that was frequently used by Sickert, create their own surface effect that denies the illusory function of the relatively naturalistic composition. *Woman Reading* is one of many representations of Vuillard's mother, in a familiar, everyday, domestic setting where the mirror reflection re-presents the 'real' as a painted surface. Vuillard's claim that 'I don't paint portraits, I paint people in their homes' can be connected to Degas, who also challenged the traditional boundaries between portraiture and genre painting, not least in *L'Absinthe* (see p.90).[67] The expressive interdependence of figure and setting in *Woman Reading*, with its comfortable domesticity, has links with Degas's own views about representing the figure surrounded by objects from everyday life. Sickert took a similar view of the everyday when he constructed his 'room settings', as he described them. Unlike Vuillard, Sickert rarely painted his own family and other members of his intimate circle, preferring to work from models. Like many of his other representations of young girls, *The Mantelpiece* has a mood of easy intimacy lacking in his studies representing more mature models. By 1911, Sickert was hardly a novice to these ideas about figure and setting, but I can imagine that he might have painted *The Mantelpiece*, at one time dated 1912 and more recently dated 1906, after seeing Vuillard's *Woman Reading*. Sickert's painting, which shares a similar palette, and uses the mirror above the mantelpiece for similar effects of 'real space' and painted surface, echoes the Vuillard with studied contemplation. This connection between the two painters owes as much to a shared interest in Degas and Whistler as it does to their own mutual dialogue.

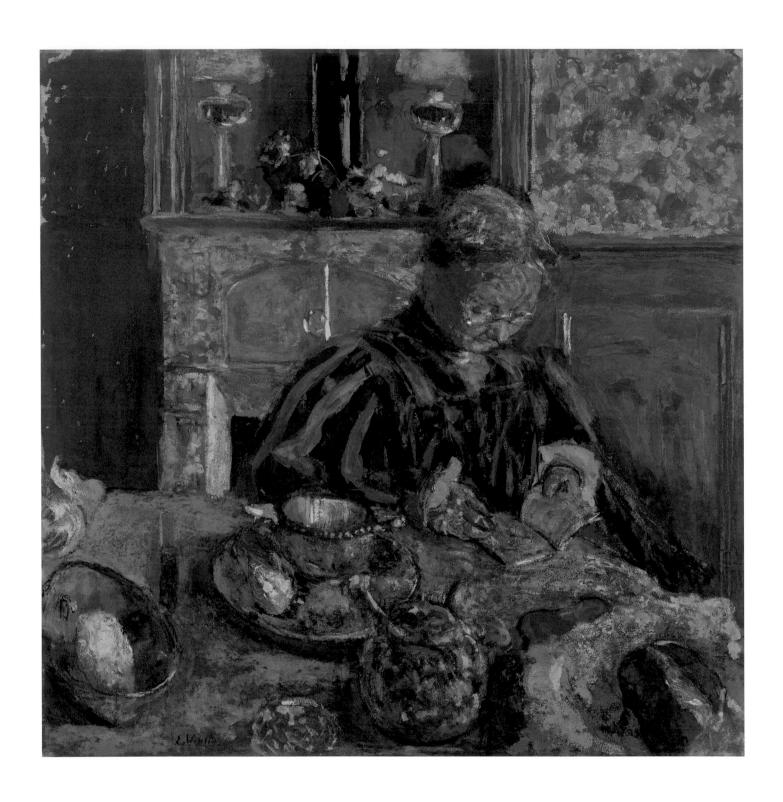

108
Edouard Vuillard
Woman Reading 1910
Glue-based distemper on paper mounted on canvas 76 × 76 | 29⁷/₈ × 29⁷/₈
Kunstmuseum, Winterthur

109
Walter Richard Sickert
The Mantelpiece c.1907?
Oil on canvas 76.2 × 50.8 | 30 × 20
Southampton City Art Gallery

DEGAS'S *INTERIOR* AND SICKERT'S *ENNUI*

Painted in one of Sickert's many London studios from sketches and studies of two of his London models – his factotum Hubby and his charlady Marie – *Ennui* is undeniably a London picture with strong links to Sickert's France. Its French title refers to the boredom that comes from enduring weariness and disgust and has a strong tradition in nineteenth-century French literature.[68] *Ennui* can be connected not to a specific French literary source but to a bank of pictures by Degas and Vuillard that evoke different psychological states through a studied arrangement of expressive figures in domestic settings. Jamot had noted 'the weariness of ennui' in some of Sickert's earlier figure pictures, and possibly his comments are the source for the title of Sickert's picture.[69] Sickert used elaborate and studied pictorial means to give an overwhelming effect of the unspoken and profound unhappiness of this shabby, podgy, middle-aged couple. It is one of four oil paintings and three etchings with that title. Using numerous drawings, Sickert arranged and rearranged the figures of Hubby and Marie, surrounded by the furniture and bric-a-brac of their domesticity. His obsessive attention to slight changes of detail that can be mapped out in the related drawings compares to Degas's compulsive pictorial strategies, where a drawing and a composition with slight variations are used repeatedly in different pictures.

I suspect that Sickert's memory of Degas's *Interior* (no.110) was on his mind as he worked out his plans for *Ennui*. It is an early picture, but it did not get a public airing until Degas deposited it with Durand-Ruel, who purchased it in the first half of 1905.[70] Sickert may have seen it in Degas's studio during one of his regular visits, or he may have seen it at Durand-Ruel's. *Interior* certainly stayed in Sickert's imagination. By the time that Jamot published his 1924 study on Degas, the idea that Degas's *Interior* represented a rape was well-established, and Jamot willingly accepted this interpretation. Sickert disagreed, and possibly repeating the explanation given to him by Degas, who referred to *Interior* as a genre picture, insisted that 'Degas a tout donner-ment voulou faire un portrait de famille'.[71] But what a family.

Considered to be one of Degas's most important paintings, *Interior* has an ambiguity that defies a single narrative meaning. What is happening in this dramatically lit bedroom, and why is the half-dressed woman cowering, watched by that stony-faced man? Degas may have been thinking of Zola's *Thérèse Raquin*,[72] and the scene of the marriage night of Thérèse and her lover. Having murdered her first husband, the two were 'doomed to live together yet without intimacy'. Another possible inspiration is Zola's *Madeleine Férat*, which contains a scene in a dreary hotel room where Madeleine and her husband Guillaume spend a night of 'quiet despair and tense exasperation'.[73] But *Interior* is not an illustration of either novel. Its mood of threatening menace and cowering melancholy, the palpable tension and the oppressive silence are real enough. Both Zola's novels and Degas's painting are the product of the same moment. Both reflect a new preoccupation, current at the time of their making, with marital discontent, alienation and entrapment.

The faint sputtering fire and the brighter glowing light of the oil lamp, traditionally a symbol of domestic happiness, are used here with dramatic irony. They barely light the darkened *Interior*, and give it a theatrical staginess that make the furniture and setting more like stage props and scenery. Aware that every room, in the words of his greatest critic Edmond Duranty, whether 'extremely furnished, papered, and carpeted, or meagrely embellished … created in every interior … a sense of family', Degas chose his set carefully.[74] The very meagreness of the room with its sparse furnishings, bare floorboards and thin rug, so different from the ornately furnished bourgeois interior of more conventional French genre painting, heightens the dramatic effect.

The pictorial means used by Degas to make such a powerful image of gender opposition inform Sickert's own pictorial construction of *Ennui*. Sickert also took great care in constructing his 'room-settings' in his studios. The second-hand furniture, the Victorian bell jar of stuffed birds, the other ornaments and the extraordinary print of the opera diva were carefully sourced from junk shops and arranged and rearranged in this room of a lodging house that Sickert preferred over a purpose-built artist's studio. Vuillard represented his mother fighting for space with a heavy chest of drawers that appears with repetitive regularity in his domestic interiors such as *Woman Sweeping* c.1889 (no.112), and a similar piece of furniture has an alarming presence in *Ennui*. In Bonnard's *Interior with Boy* (no.113), a table top pushes the figure into an uncomfortable space, comparable to the tight corner of the room in *Ennui*. Sickert's drawings and studies reveal that he stage-managed these figures and props; with his early training on the stage, it would have been second-nature to him. Pushed into a corner by the heavy brown table and large chest of drawers that leave them little space for manoeuvre, this unhappy couple are forced into a confined space which heightens the uneasy silence. As Susan Sidlauskas has observed, 'space is as

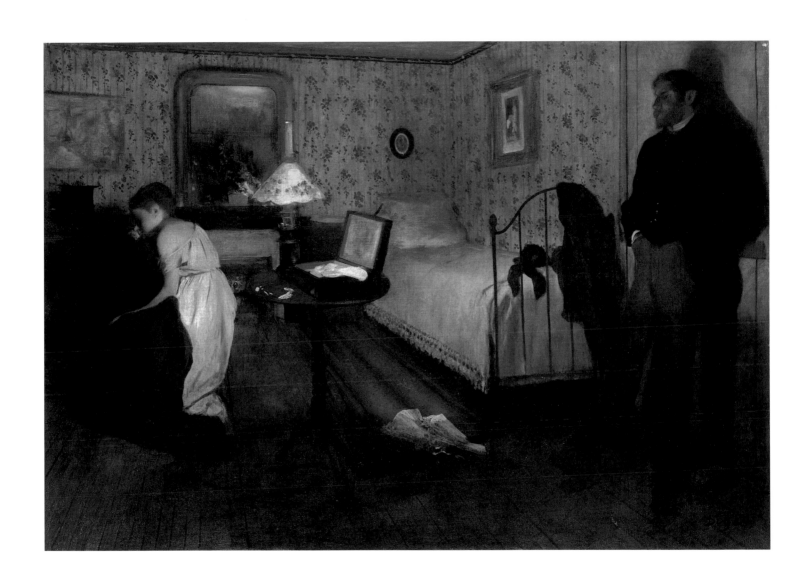

110
Edgar Degas
Interior (The Rape) 1868–9
Oil on canvas 81.3 × 114.3 | 32 × 45
Philadelphia Museum of Art
The Henry P. McIlhenny Collection,
in memory of Frances P. McIlhenny,
1986

111
Walter Richard Sickert
Ennui c.1914
Oil on canvas 152.4 × 112.4 | 60 × 44¼
Tate. Presented by the Contemporary Art Society 1924

fig.55
Edouard Vuillard
Vallotton and Misia at Villeneuve 1899
Oil on cardboard | 72 × 53 | 28⅜ × 20⅞
Private collection

palpable and vivid a presence as any sentient being' in these pictures, whether it be the gaping distance between the silent couple in *Interior* or the claustrophobic environment of *Ennui*.[75]

The sloping back of the woman who shrinks away from that stalwart man in *Interior* tells it all, and Sickert deployed a similar kind of body language with the slumped figure of the woman in *Ennui*. Like Degas, who rearranged the features of his working-class models to make them more simian-like, Sickert drew on the pseudo-science of physiognomy, a complex system that used the varying features of the human face and bodily form as markers in a perverse system of social and moral hierarchy. Degas shared Sickert's interest in physiognomy, and Sickert would have known about Degas's earlier project, including the *Little Dancer Aged Fourteen*, to use 'animal physiognomies as scientific signifiers of low class Parisiennes'.[76] (In 1914 Sickert was citing Cesare Lombroso, the criminal anthropologist whose theories Degas also knew. He linked certain physiological characteristics with degenerative traits.) A finely drawn pen-and-ink study, *Hubby and Marie* (fig.54), depicts Hubby with a snub nose and rounded

fig.54
Walter Sickert
Hubby and Marie 1914
Pen and ink and chalk
32.4 × 47.6 | 12¾ × 18¾
Harris Museum and Art Gallery, Preston

cheeks and a wide-eyed Marie with an aquiline nose. In the highly charged *Ennui*, the slouched, brooding, brown-suited, middle-aged, cigar-smoking Hubby has stronger features, and an aquiline nose. The despondent Marie is bovine with a snout face, and is almost unrecognisable as the woman in the drawing *Hubby and Marie*. Her exaggerated features accentuate her vacant mindlessness as she stares towards the empty corner, taking no comfort from the reminders of the niceties of the domestic life surrounding her.

Interior must have struck anyone familiar with Vuillard's paintings of the family interior as having an uncanny connection with them. The figures in Vuillard's 1890s domestic interiors were frequently arranged with a theatrical effect that can be connected to his close involvement with the Symbolist theatre. A dramatic purpose informs Vuillard's *Vallotton and Misa at*

112
Edouard Vuillard
Woman Sweeping c.1899
Oil on canvas 44 × 47.3 | 17³⁄₈ × 18⁵⁄₈
The Phillips Collection,
Washington, DC

113
Pierre Bonnard
Interior with Boy 1910
Oil on canvas 41 × 63.5 | 16 × 25
The Phillips Collection,
Washington, DC

Villeneuve (fig.55), where the artist Félix Vallotton and the bohemian Misia Natanson are placed centre stage, while Misia's husband, or a mere fragment of her husband, Thadée Natanson, the avant-garde publisher and collector, enters stage left. His barely visible presence, and the close physicality of the non-communicative Vallotton and Misia, alludes to the complicated emotional entanglement of the three friends. With its flattened space, played off by the surface of the picture on the wall behind and the unusual arrangement of figures, *Vallotton and Misa at*

Villeneuve must have been an important stimulus for Sickert. He undoubtedly saw Vuillard's picture at the 1905 International Society of Sculptors, Painters and Engravers exhibition in London. He would have been amused by the comments on *Vallotton and Misa* in the *Pall Mall Gazette*, a favoured evening paper: 'there is no fresh lesson to be taken from France'.[77] In later years, he often referred to the French artists he met during his Paris years and the lessons that he had learned, and there was never a moment when Sickert turned his back on France.

fig.56
Paris: Garden at the Moulin Rouge

The Moulin Rouge opened on the boulevard de Clichy in 1889.
This dance hall was frequented by artists, Toulouse-Lautrec,
Charles Conder and WilliamRothenstein among them.
Photograph, Bibliothèque Nationale de France, Paris

	LONDON	PARIS
1870	The Society of French Artists is opened by the Parisian art dealer, Paul Durand-Ruel (1831–1922), providing opportunities for French artists to exhibit in London.	
1871	**Spring:** Following the Paris Commune, Tissot and Dalou move to London. **October:** Degas visits London for the first time and stays at the Hotel Conté in Golden Square.	
1872	**November:** Fifth Exhibition of the Society of French Artists, 168 New Bond Street, organised by Durand-Ruel, including Degas.	**January:** the Parisian dealer, Durand-Ruel, begins to buy works by Degas.
1873	**Spring:** Sixth Exhibition of the Society of French Artists, including Degas.	
1874	**Spring:** Ninth Annual Exhibition of the Society of French Artists includes Degas's *Two Dancers on a Stage* (no.8). Tissot exhibits *The Ball on Shipboard* (no.7) and *London Visitors* at the Royal Academy (for another version see no.1).	**April–May:** Degas exhibits at the Société Anonyme (the First Impressionist Exhibition). De Nittis also exhibits on the invitation of Degas. Whistler declines Degas's invitation to exhibit.
1875	Tenth Annual Exhibition of the Society of French Artists, including Degas. Eleventh Annual Exhibition of the Society of French Artists, including Degas.	**June:** The Cirque Fernando opens a permanent home on the rue des Martyrs in Paris.

	LONDON	PARIS
1876	**Spring:** Twelfth Exhibition of Modern French Artists, organised by Deschamps, including *The Rehearsal of the Ballet on Stage* (fig.9) and *The Dance Class* (no.4). **June:** Degas announces that he will soon be travelling to London. Possibly he made the trip in September to see the *Third Annual Exhibition of Modern Pictures*, Royal Pavilion Gallery, Brighton, when Hill lent *In a Café (L'Absinthe)* (no.42). **30 September:** Stéphane Mallarmé's article 'The Impressionists and Edouard Manet', which contains an important account of Degas, is published in London.	**March–April:** *L'Absinthe* is listed as *Dans un café* in the catalogue of the Second Impressionist Exhibition at the Galerie Durand-Ruel. The picture is probably not included in the show, but sent to London where Deschamps sells it to Captain Henry Hill (1812–1882) for his house in Brighton. Hill buys a total of seven pictures by Degas from Deschamps. De Nittis exhibits *Piccadilly* (no.10) in the Club des Mirlitons in Paris.
1877	**Spring:** De Nittis takes a studio for his London visit opposite Tissot's St John's Wood residence. Inaugural Exhibition of the Grosvenor Gallery, including Tissot's *The Gallery of HMS Calcutta* (no.17) and Whistler.	**April:** Third Impressionist Exhibition including Degas's *In A Café (L'Absinthe)*, lent by Hill. George Moore visits the exhibition, and includes descriptions of it in his later novels.
1879	**May:** Sickert meets James Abbot McNeill Whistler (1834–1903) for the first time.	**10 April:** Fourth Impressionist Exhibition, including Degas's *Jockeys Before the Start* (no.19) and *Miss La La* (no.22). George Moore visits the exhibition.
1881		**April–May:** *Little Dancer Aged Fourteen* is exhibited at the Sixth Impressionist Exhibition. It is the most controversial work of the show and the only sculpture by Degas to be exhibited during his lifetime. Whistler visits the exhibition. **November:** The Chat Noir cabaret is established by the artist Rodolphe Salis. In 1885 it moves to larger premises at 85 boulevard Rochechouart.
1882	**July:** *Modern French Pictures*, organised by Durand-Ruel, White's Gallery, 13 King Street, St James's, including Degas's *The Box at the Opéra* (fig.15) and *Lowering the Curtain* (fig.16).	**March:** Lautrec enters teaching studio of Léon Bonnat (1833–1922) and, from September, Fernand Cormon (1845–1924).
1883	**April:** Paintings, Drawings and Pastels by Members of La Société des Impressionnistes, organised by Durand-Ruel, Dowdeswell and Dowdeswell Galleries, including Degas's *Jockeys Before the Start*, *Women Leaning on a Rail (on the Boat)* (no.20) and *The Box at the Opéra* (fig.15).	**March:** Sickert travels to Paris and stays at the Hotel du Quai Voltaire. (Oscar Wilde (1856–1900) stays there at the same time). With a letter of introduction from Whistler, he visits Degas's apartment at 21 rue Pigalle, and his studio in the rue Fontaine St Georges. He also calls on Manet who is too ill to see him. **30 April:** Manet dies at the age of fifty-one.
1884		**21 August:** Degas attends the funeral of de Nittis in Paris. Lautrec sets up his own studio in Rue Lepic, Montmartre.
1885		**April–May:** Moore takes Edward Martyn on a tour of Paris and convinces him to buy two works by Degas: *Two Dancers in their Dressing Room* and *Two Harlequins* (both National Gallery of Ireland). **22 August–12 September:** Degas visits the Halévys in Dieppe and meets Sickert for the second time. Working in Blanche's studio he makes a pastel portrait of Albert Cavé, Ludovic and Daniel Halévy, Henri Gervex, Blanche and Sickert (fig.17). **October:** Sickert and his wife Ellen visit Degas in Paris and see *Miss La La* in his apartment.
1886	**Spring:** Exhibition of the Royal Society of British Artists (RBA) includes Sidney Starr's *Paddington Station* (no.12). The New English Art Club (NEAC) is founded by a generation of British artists who look to France for their inspiration. Sickert joins in autumn 1887 and masterminds a plan to turn it into an Impressionist club. Sickert purchases *The Green Dancer* (fig.20) and *Mlle Bécat at the Ambassadeurs* (fig.21) by Degas.	**15 May:** Eighth Impressionist Exhibition opens and includes a group of pastel bathers by Degas. Sickert visits the exhibition. In a review, 'Half-a-Dozen Enthusiasts', *The Bat*, 25 May 1886, George Moore announces that 'another ten years will pass before it is generally admitted that Degas is one of the greatest artists the world has ever known'. Lautrec's work is on view at Le Mirliton, a Montmartre cabaret.

	LONDON	PARIS
1887	**Spring:** Exhibition of the RBA includes Sickert's *Le Lion Comique* (fig.19). Sickert begins to paint and exhibit music hall scenes. In particular he frequents the Bedford Music Hall, Camden Town.	Theo van Gogh buys his first Degas for the Galerie Boussod et Valadon. Theo continues to buy pastels and paintings by Degas.
1888	**April:** NEAC exhibition, including Degas's *The Green Dancer*, which Sickert lends with Degas's approval, and the first version (lost) of Sickert's *Gatti's Hungerford Palace of Varieties*. **22 October:** First Pastel Exhibition held at the Grosvenor Gallery, including work by Blanche, Fantin-Latour and Starr.	**January:** Theo van Gogh organises an exhibition of Degas pictures (mostly nudes) at the Galerie Boussod et Valadon at 19 boulevard Montmartre. Theo van Gogh buys Lautrec's *Poudre de Riz* (Amsterdam, van Gogh Museum) for his own collection. **April:** Fifteen lithographs by George William Thornley are published after paintings and pastels by Degas. Four of them are exhibited at the Galerie Boussod et Valadon (no.34). **Summer:** Deschamps, now Director of the Grosvenor Gallery, shows Degas's *The Rehearsal* (no.6) to Sickert, who writes to Blanche about it. Blanche buys the picture on 4 December from Theo van Gogh in Paris for 2,000 francs.
1889	**April:** Sickert organises an exhibition of black-and-white work in a passage leading to the main NEAC exhibition. He includes four lithographs by Thornley after Degas (see no.34). **25 May:** Sickert buys *The Rehearsal of the Ballet on Stage* (fig.9) from Henry Hill's sale at Christie's. **September:** Sickert praises Degas in the *Sun* as 'perhaps one of the greatest artists the world has ever seen'. **December:** Sickert masterminds and writes the preface to the catalogue – where he praises Degas – of an exhibition of *The London Impressionists*, at the Goupil Gallery, London, including Sickert, Steer and Starr.	**February to March:** Exhibition of William Stott of Oldham held at Durand-Ruel Galleries. **31 March:** The Eiffel Tower opens. **Spring:** Exposition Universelle opens. Sickert, who is represented with Elizabeth Armstrong Forbes, Starr and Steer amongst others, visits the British section in Degas's company where Sickert admires Orchardson's *Master Baby* (no.18). **June:** Paul Sérusier (1864–1927) forms the Nabis. Vuillard and Bonnard are amongst the first members. **5 October:** The Moulin Rouge nightclub on the boulevard de Clichy opened by Charles Zidler. Lautrec, and later Conder and Rothenstein, frequent it.
1890	**November:** George Moore publishes 'Degas: The Painter of Modern Life' in the *Magazine of Art*. Its gossip about the Degas family fortune offends Degas who never speaks to Moore again. Whistler writes a letter of commiseration to Degas.	**October:** Maurice Joyant, a friend of Lautrec since about 1872, takes over as director of Boussod et Valadon, formerly the Goupil Gallery.
1891	**Spring:** NEAC exhibition, including Steer's *Mrs Cyprian Williams and her Two Little Girls* (no.37). **November:** Exhibition of the NEAC, including works by Sickert, Starr, Steer and Degas's *The Rehearsal of the Ballet on Stage*, lent by Ellen Sickert. **December:** La Société des Beaux Arts held at Mr Collie's Rooms, 39 Old Bond Street, *A Small Collection of Pictures by Degas and Others*, including *Dancers in the Rehearsal Room* (no.43) and *Woman at a Window* (no.101). The exhibition is organised by Alexander Reid and travels to Glasgow in February 1892. Monet and Pissarro visit the London show.	**March–April:** Exhibition at the Salon des Indépendants, including work by Bonnard and Lautrec. Lautrec achieves instant fame with his first poster, *Moulin Rouge, La Goulue*, which shows La Goulue (Louise Weber) and her dancing partner, Valentin Le Désossé. **August:** First exhibition of the Nabis, including Bonnard and Vuillard. The journal *La Revue blanche* is launched by Thadée Natanson (1868–1951) and others.
1892	**31 May–10 June:** Lautrec visits London and stays at the Charing Cross Hotel. Buys furniture at Maple's and fabric at Liberty's. **November:** NEAC exhibition, including Degas's *Mlle Bécat* (fig.62) and Sickert's *Miss Minnie Cunningham* (no.62).	Warrener models for Lautrec's colour lithograph *The Englishman at the Moulin-Rouge* which is published by Boussod et Valadon in an edition of 100. **April:** Rothenstein and Conder have a joint exhibition at Père Thomas's Gallery, including *Parting at Morning* (no.55). **May:** Second Exhibition of Peintres Impressionnistes et Symbolistes, including Bonnard and Lautrec. Moore, in Paris to review the two Salons, 'A Select Few', *Speaker*, 28 May 1892, writes: 'even these humble and tardy intelligences are beginning to grow aware that Degas is almost the greatest genius the world has ever known.' **November:** Third Exhibition of Peintres Impressionnistes et Symbolistes, including Lautrec. **December:** The French singer Yvette Guilbert asks Lautrec to make a poster for her.

1893

LONDON

10 February: *Painting and Sculpture by British and Foreign Artists of the Present Day* held at the Grafton Gallery, including Degas's *L'Absinthe* (no.42) and *Dancers in the Rehearsal Room* (no.43) and Blanche's *Saville-Clark Girls* (no.80).
April: Exhibition of the NEAC, including Degas's *Dancers and Stage Scenery* (no.38).
Summer: Sickert opens The Chelsea Life School, The Vale. William Rothenstein attends the night classes.

PARIS

January–February: Lautrec and Charles Maurin (1856–1913) exhibition *Paintings, Pastels and Posters* held at the Boussod et Valadon gallery, 19 boulevard Montmartre. Degas visits and comments, 'Well, Lautrec, you're clearly one of us.'
March–April: Exhibition at the Salon des Indépendants includes Bonnard and Lautrec.
Lautrec takes part in exhibition of Société des Peintres-Graveurs at the Durand-Ruel Gallery. He becomes a member of the society in 1897.
December: Fifth Exhibition of Peintres Impressionnistes et Symbolistes, including Bonnard, Conder, Lautrec and Vuillard.

1894

LONDON

May–June: Back in London Lautrec stays at the Morelles Hotel in Charing Cross. He visits Whistler's studio and meets Oscar Wilde. He returns to London in October for the opening of *A Collection of Posters: First Exhibition at the Royal Aquarium*. Sickert paints his full-length portrait of Aubrey Beardsley (1872–1898), which is reproduced in the Decadent journal, *The Yellow Book*.

PARIS

6 March: Exhibition of Peintres Impressionnistes et Symbolistes, including Bonnard, Conder and Vuillard.
7 July: Exhibition of Peintres Impressionnistes et Symbolistes, including Bonnard, Lautrec and Conder.
22 December: Captain Dreyfus is sentenced for espionage, an act which divides much of France. Degas is strongly anti-Semitic and supports the verdict. He becomes estranged from a number of his Jewish friends during this period, including Camille Pissarro and the Halévys.

1895

LONDON

Winter: NEAC exhibition, including Sickert's *Gallery at the Old Bedford* (no.27).

PARIS

January: *Nib*, an illustrated supplement to *La Revue blanche*, is published, with text by Tristan Bernard and illustrations by Lautrec. Bonnard and the writer Romain Coolus also contribute.
February: Lautrec is invited by the Alexander Natansons to the unveiling of Vuillard's *Jardins Publics*. Through the Natansons' circle, Lautrec meets Bonnard, Vuillard, Félix Vallotton and Romain Coolus. Lautrec represents the Irish cabaret singer, May Belfort, in lithographs and paintings.
December: Salon de l'Art Nouveau, Bing, includes Blanche, Bonnard, Conder, Lautrec, Vuillard and Whistler.

1896

PARIS

10 February: Wilde's play *Salome* premiers at the Theatre de l'Oeuvre. The play had been banned in England when it was shown in July 1892.
April: Société Nationale exhibition, including Blanche and William Stott.

1897

LONDON

June: Lautrec visits London again courtesy of the Goupil Gallery.

PARIS

April: Société Nationale exhibition, including Blanche, William Stott and Whistler.

fig.57
Some More Sketches of Pictures at the Grafton Gallery
(including *L'Absinthe* [no.42] and
The Savile-Clark Girls by Jacques-Emile Blanche [no.80])
Pall Mall Budget, 2 March 1893

Anon. [J.S. Spender]
Westminster Gazette
17 February 1893

... the two works of Degas exhibited in this gallery bring so forcibly before us the artistic ideals of the "new painters" ... One is called "Absinthe" ... A man and a woman, both of the most degraded type, are seated on a bench in a wine-shop, their backs reflected in a glass screen behind them ... the total effect ... is one which most of us will be anxious to banish from our minds as quickly as possible, and neither of them tells us anything about M. Degas' skill.

D.S.M. [D.S. MacColl]
Spectator, 25 February 1893

L'Absinthe ... is the inexhaustible picture, the one that draws you back, and back again. It set a standard by which too many of the would-be "decorative" inventions in the exhibition are cruelly judged. It is what they call "a repulsive subject", two rather sodden people drinking in a *café* ... so does this master of character, of form, of colour, watch till the café table-tops and the mirror and the water-bottle and the drinks and the features yield up to him their mysterious affecting note. The subject, if you like, was repulsive as you would have seen it, *before Degas made it his*. If it appears so still, you may make up your mind that the confusion and affliction from which you suffer are incurable.

G.M. [George Moore]
Speaker, 25 February 1893

We knew Degas to be a man of consummate genius ... Look at the old Bohemian – the engraver, Deboutin [sic] ... The woman that sits beside the artist was at the Elysée Montmartre until two in the morning, then she went to the ratmort and had a *soupe aux choux*; she lives in the Rue Fontaine, or perhaps the Rue Breda; she did not get up until

half-past eleven; then she tied a few soiled petticoats round her, slipped on that *peignoir*, thrust her feet into those loose morning shoes, and came down to the café to have an absinthe before break-fast. Heavens! – what a slut! A life of idleness and low vice is upon her face; we read there her whole life. The tale is not a pleasant one, but it is a lesson ... how loose and general Hogarth's composi-tion would seem compared to this marvellous epitome ... How well the point of view was selected! The beautiful, dissonant rhythm of that composition is like a page of Wagner.'

A Philistine's Remonstrance
Westminster Gazette
9 March 1893

'Critics have in times past talked a great deal of rhapsodical nonsense about pictures ... but is there any-thing in the whole literature of the subject quite to touch this about the "mysterious affecting note" of table-tops, mirrors, water-bottles, and drinks?
... the "new critics" are in posses-sion of most of the weekly and several of the daily papers, and with one accord they tell us the same thing. These two sodden people are their ideal ... when a new critic comes forward to set up a new standard ... we are entitled to ask for his credentials. D.S.M. ... is not a critic so much as an advocate ... "Academic" is, in D.S.M.'s vocabulary, a term of derision ... the subject is nothing; the use of paint, the handling, everything ... If it is the object of the painter to cut capers upon paper or upon canvas ... why, then the two sodden people at the café may easily be "the standard", for Degas's performances are aston-ishingly clever. If you have been brought up in another way, and have been taught to think that a dignity of subject and the endeav-our to portray a thing of beauty are of the essence of art, you will never be induced to consider "L'Absinthe" a work of art, howev-er "incurable" your "affliction and

confusion" ... This is not a quarrel between one method and another – between impressionism and realism ... It touches the whole question of artistic ideals ... not even the humblest of us need entrust his conscience to a group of critics, however assertive and unanimous they may be.'

W.P.H.
Westminster Gazette
13 March 1893

'... no artist can represent exactly what he sees. He is prevented by his material ... The artist can probably tell us something we did not know before if we are given the clue to his language ... It is not forbidden to art to excite other passions than admiration. Pathos and horror are no more beyond the limits of plastic than of any other art ... many men like tragedy, and it is clearly permissible to paint it.
'That the defenders of the unusual, such as D.S.M. ... should claim for it greater virtues than it possesses is not surprising. A discoverer always thinks too much of his novelty.'

Harry Quilter
Westminster Gazette
15 March 1893

'The most important aspect of the New Art Criticism seems to have escaped the attention of your various correspondents ... D.S.M. is not to be blamed so much for his ignorance of the art of painting ... as for the undeserved ... rancour with which he attacks ... whole classes of men who had grown grey in the service of Art ... I have read no criticism in all my life more unjust, more splenetic and more absurd than the lubrications of this young gentleman.'

W.B. Richmond
Westminster Gazette,
16 March 1893

'The English Impressionists ridicule subject and "literary art". At the same time Mons. Degas is their god. Now *L'Absinthe* is a literary performance. It is not a painting at all. It is a novelette – treatise against drink. Everything valuable about it could have been done, and has been done, by Zola ... It would be ridiculous not to recognise M. Degas as a very clever man, but curiously enough his cleverness is literary far more than pictorial. This is the reason, I suspect, why a certain set of writers have taken him up; they confuse his painting and his story-telling powers.'

D.S.M.
Spectator, 18 March 1893

'Is it, or is it not, a toss-up, when a Ruskinian stands before a picture like *L'Absinthe*, what view his sentiment will impel him to take of it? In one mood, no doubt, he will sternly lay it down that the most stammering and imperfect attempt to portray the Heavenly Host would be more worthy and noble than any skilful delineation of boors carousing. But cannot one almost imagine him turning on his too faithful disciple as he regards Degas with so shocked and disapproving eye, and lecturing him thus: "There is no more pitiful symptom of diseased modern vanity than for a man who has learned neither to see nor to draw, to think that he can cover the idleness of his imagination, and the impotence of his hand, by the exalted nature of his subject. Nothing, forsooth, will serve him but angels whom he has never seen, and is not likely to see! Let him rather, with what of faithful vision and stern veracity is in him, picture some corner of this God's earth, some table-top, water-bottle, or the like! Let him leave the angels to those who have seen them, and paint his brother

'boozing' at the Blue Lion. So it may be given him in time to behold also the Heavenly Host". The one sentiment is just as good, just as misplaced, as the other; and all the time the picture has not been seen at all.'

Charles W. Furse
Westminster Gazette
18 March 1893

'... no-one has ever been so foolish as to try and eliminate "subject" from painting ... They have merely said that it can never be the *raison d'être* of a picture ... the recognition of this fact in no way interferes with the axiom that a picture must ... be a great painting ... Mr. Richmond believes that no one who looks at M. Degas's picture can be interested in its essential pictorial qualities!! which recalls the saying ... that a certain person had plenty of taste, and all of it bad. For it is difficult to understand the frame of a mind who has devoted 30 years or more to the study of art, and then looking at *L'Absinthe*, is unconscious of those qualities of draughtsmanship, design, and colour with which the picture teems.'

W.B. Richmond
Westminster Gazette
20 March 1893

'Mr. Charles W. Furse, everyone knows, is an artist of great promise, and before he took the French poison he painted manly, and to my old-fashioned taste, admirable portraits ... It is just because of those 40 years of the study of the best art of various schools that the galleries of Europe display, I do not confound good and not good painting ... Perfect craftsmanship, such as was Van Eyck's, Holbein's, Bellini's, Michael Angelo's, becomes more valuable as time goes on. Time adds to its value. The qualities admired by this new school are certainly the mirrors of that side of nineteenth-century development most opposed to fine painting ... Hurry, rush, fashions,

are the enemies of toil, patience, and seclusion, without which no great works are produced ... No doubt Impressionism is an expression in painting of the deplorable side of modern life.
'It belongs to the interviewing, advertising, inquisitive evolution, and, therefore, its existence is regretted by serious artists, painters, writers, or musicians. Mr. Furse compares the pleasures he and his friends derive from *L'Absinthe* as equal to those of a musician listening to a great "symphony" ... The vault paintings of the Sistine chapel are like a great symphony.
'The very limited little picture under discussion is like a string quartette [sic].'

Walter Crane
Westminster Gazette
20 March 1893

'Here is a study of human degradation, male and female, presented with extraordinary insight and graphic skill ... Such a study would not be without its value in a sociological museum, or even as an illustrated tract in the temperance propaganda; but when we are asked to believe that this is a new revelation of beauty – that this is the Adam and Eve of a new world of aesthetic pleasure, degraded and not ashamed, a paradise of *unnatural* selection – it is another matter.
The best answer is, perhaps, another question – How could one *live* with such a work? That is a test which never fails.'

W.S.
Westminster Gazette
20 March 1893

'Much too much has been made of "drink", and "lessons", and "sodden", and "boozing" in relation to the picture by Degas.
'I know the work of Degas very well, and his titles, and his reasons for them; and I will hazard the conjecture that *L'Absinthe* is not his title at all. I would wager,

NOTES

INTRODUCTION
pp.11–13

1. 'The Picture Season in London', *Galaxy*, August 1877, in James, 1956, p.148.
2. Moore, 1897, p.148.
3. 'The Royal Academy', *The Nation*, 6 June 1878, in James, 1956, pp.167–8.
4. 'Schools of Art', *Speaker*, 23 January 1897; 'The New English Art Club Exhibition', *The Scotsman*, 24 April 1889, in Robins (ed.), 2002, pp.132, 41–2.
5. Colvin, 1872.

MODERNITY, FIGURE, METROPOLIS: IMPORTING THE NEW PAINTING TO BRITAIN IN THE 1870s
pp.15–49

1. Nead, 2000, p.14.
2. Nead, 2000, pp.5, 100–1.
3. Schneer, 1999, p.67.
4. 'The Picture Season in London', *Galaxy*, August 1877, in James, 1956, pp.131–2.
5. Wentworth, 1984, pp.92–4.
6. Anon., 2 May 1874.
7. 'The Royal Academy', *Art Journal*, June 1874, p.164: quoted in Wentworth 1984, p.164. R. Thomson, 'Prime Site for Redevelopment', *Art History*, vol.9, no.1, March 1986, pp.108–15.
8. This interpretation was originally given in Thomson, 1986, p.114, and subsequently in Marshall/Warner, 1999, pp.72–3.
9. Wilcox, 1987, pp.15–19.
10. Weisberg, 1980, pp.281–2.
11. Rivière et al., 2003, p.186.
12. Marx, 1893, p.10.
13. E. Harris, 1976, pp.53–7; Harris/Ormond, 1976, pp.4–8, nos.10, 32.
14. Notebook 26, p.4; see Reff, 1976, vol.1, p.123.
15. F. Harris, 1934, vol.2, p.201.
16. Alley, 1958, p.171. Pellegrini made a caricature of Degas, now lost; repr. R. Thomson, 1987, fig.24.
17. Repr. R. Thomson, 1987, p.28.
18. Wentworth, 1984, pp.85–6.
19. I. Thomson, 1985, pp.223–4.
20. Harris/Ormond, 1976, pp.11–12.
21. Clapp, 1983, p.18.
22. Jerrold/Doré, 1872 (1970, pp.35, 5).
23. Claretie, n.d., pp.1–2.
24. Chesneau, n.d., p.242.
25. Notebook 21, p.31v; see Reff, 1976, vol.1, p.109.
26. Degas, 1947, p.11: Letter 1, 30 September 1871.
27. Degas, 1947, p.29: Letter 6, 18 February 1873. For the history of this painting and Degas's New Orleans connections see Brown, 1994.
28. For Monet in London in 1870–1 see House, 1978.

29. R. Thomson, 1999, p.69.
30. Abelès, 1987, p.53.
31. Druick/Hoog, 1983, p.105.
32. Druick/Hoog, 1983, pp.243, 245.
33. 'Une Exposition de tableaux à Paris (Salon de 1875)', *Le Messager de l'Europe*, June 1875, in Zola, 1974, pp.170–1.
34. Alley, 1981, p.721.
35. I am grateful to Frances Fowle for information on Robertson Reid.
36. Mathieu, 1977, p.324, no.170.
37. The letter is in the John Rylands Library, Deansgate, Manchester.
38. Frankiss, 2004, pp.470–1.
39. Gould, 1966, p.142.
40. Kauffmann, 1973, pp. ix, 25; Boggs et al., 1998–9, p.270.
41. Meynell, 1882, pp.2–5; Pickvance, 1962, pp. 789–91.
42. Treuherz, 1987, pp.76, 78, 11.
43. Meynell, 1882, p.7; Pickvance, 1962, pp.790–1.
44. Reff, 1968, p.89: Letter of 22 August 1875.
45. Boggs et al., 1988–9, pp.57, 59, 214.
46. Boggs et al., 1988–9, pp.59, 212.
47. Robins (ed.), 2002, p.416. The obituary was published in the *Burlington Magazine*, November 1917.
48. Pickvance, *Burlington Magazine*, 1963, p.260, citing George Moore in the *Spectator*, 5 December 1891.
49. Boggs et al., 1988–9, p.214.
50. Reff, 1968, p.89: Letter of 22 August 1875.
51. For an inventory, see Pickvance, *Burlington Magazine*, 1963, p.266.
52. Meynell, 1882, p.7.
53. Boggs et al., 1988–9, p.288.
54. Pickvance, *Apollo*, 1963, pp.395–6.
55. Quoted in Pickvance, *Apollo*, 1963, p.396.
56. Burty, 1874, p.616.
57. Burty, 1876, p.364.
58. Degas, 1947, p.38: Letter 12, early 1874.
59. Guérard, 1876, p.97.
60. Roberts, 1963, pp.280–1.
61. Adhémar/Clark, 1974, p.247.
62. Fizelière, 1875, p.28.
63. Castagnoli et al., 2002, p.25.
64. Claretie, 1876, pp.409, 411, 415–16.
65. Degas, 1947, p.41: Letter of (summer?) 1875.
66. Pickvance, *Burlington Magazine*, 1963, p.263.
67. Claretie, 1876, pp.411–12.
68. See also Renan, 1884, pp.399–400.
69. Jerrold/Doré, 1872 (1970, p.83).
70. 'London' (1888), in James, 1905 (1981 ed., pp.12–13).
71. Claretie, 1876, p.403.
72. McConkey, 1980, p.21
73. Thanks to Frances Fowle for information about Robertson Reid.
74. Anon., *Sunday Times*, 1886; Wedmore, 1886.
75. Duranty, 1876, pp.16, 18, 25.
76. Dorment, MacDonald et al., 1994–5, no.62.
77. Moore, 1897, pp.11–12.
78. Dorment, MacDonald et al., 1994–5, no.62.
79. For the most thorough study of the sculpture, see Kendall, 1998.

80. Blanche, 1919, p.54.
81. Caillaux, 1935, pp.7–83.
82. Bilbey/Trusted, 2002, no. 370. I am grateful to Alexandra Corney for information about Dalou.
83. Bilbey/Trusted, 2002, no.368. The marble remains in the collection of the Duke of Westminster.
84. Caillaux, 1935, p.80.
85. Anon., 1874.
86. *Spectator*, 26 May 1877, p.665, quoted in Marshall/Warner, 1999, p.85; 'The Picture Season in London', *Galaxy*, August 1877, in James, 1956, p.141.
87. Hardie, 1972, no.48.
88. Robins (ed.), 2002, p.416.

THE GREATEST ARTIST THE WORLD HAS EVER SEEN
pp.51–93

I am grateful to the British Academy for a Small Research Grant to undertake research for this essay in Paris.

1. W. Sickert, 'Mr. Walter Sickert on Impressionist Art', *Sun*, 8 September 1889, in Robins (ed.), 2002, p.57.
2. See Armstrong, 1991, pp.211–44, for an analysis of the Degas legend.
3. This information comes from the *Daily News*, 1 July 1882.
4. After reading Wedmore's review, sent to him by Blanche, Degas wrote to Albert Bartholomé, 5 August 1882. See Degas, 1947, no.49, p.71; cited in Boggs *et al*, 1988–9, p.377.
5. Bailly-Herzberg (ed.), *Correspondence de Camille Pissarro*, vol.1, 1865–85, Paris 1980, p.200.
6. Degas's exhibits included: (6) *Courses de gentlemen*, £400; identified as *The Gentlemen's Race: Before the Start*, Musée d'Orsay, L.101; (55) *La danseuse*, £50, identified as *Le Salut de l'Etoile*, L.574; (56) *Chapeaux*, £60, identified as *At the Milliner's*, 1882, pastel, L.683; (58) *Le départ jockeys*, £150, identified as *Jockeys Before the Start*, Barber Institute of Art; (59) *Femmes appuyées sur une rampe*, identified as *Women Leaning over a Railing*, L.879; (60) *Les Danseuses*, unidentified. £50; (61) *Femme dans un loge*, £50, identified as *The Box at the Opéra*, L.584, private collection.
7. Boggs, 2002, p.115.
8. 'Mistaken Impressions', *Punch, or the London Charivari*, 5 May 1883, p.208.
9. Ibid.
10. Wedmore, 1883, p.300.
11. Moore, 1918, p.27 – a reprint of Moore's 1890 article with a new introduction.
12. Sickert made these comments in his other copy of Jamot, 1924, p.87, which he gave to the artist Sylvia Gosse, now in the collection of the Institut Néerlandais, Paris.

13. See Sickert's other annotated copy of Jamot, 1924, p.87, now in the collection of the Courtauld Institute of Art. See Nochlin, 1994, for an excellent discussion of this topic.
14. Catalogue to 1886 exhibition organised by Durand-Ruel, *Special Exhibition: Works in Oil and Pastel by the Impressionists of Paris*, American Art Association and National Academy of Design, New York: twenty-five works by Degas exhibited. The catalogue featured a 'number of European newspaper reviews of Impressionist exhibitions held in Paris and London'. This included the 1882 review in the *Standard*. Compare this to the *New Times* critic: 'No. 106 "Drawing the Curtain" exhibits all the ugliest points of Ballet dancers just as the curtain drops – their distorted feet, unnatural gestures and lack-luster expressions; moreover, they appear to be female monstrosities who are on the point of being crushed by the falling mass.' David A. Brenneman, 'Degas and his American Critics' in Ann Dumas and David Brenneman, *Degas and America: The Early Collectors*, exh. cat., High Museum of Art, Atlanta 2000, p.49. The review is wrongly identified as a review of the 1883 show.
15. See Nochlin 1994.
16. Moore, 1890, pp.416–25.
17. G. Moore, *A Mere Accident*, London 1887, p.74.
18. Moore, 1883, vol.III, p.89.
19. Moore, 1890, p.423.
20. F. Wedmore, *Standard*, 13 July 1882.
21. Wedmore, 1883.
22. Ellen Cobden Sickert to Jane Cobden, ms. letter, 46D, Cobden Papers, West Sussex Record Office. The letter is dated September 1885.
23. Ibid.
24. Ellen Cobden Sickert to Jane Cobden, n.d. [late 1885], ms. letter, 47D, Cobden papers, West Sussex Public Record Office.
25. 'Il avait ce tableau [*Miss Lala*] accroché chez lui rue Pigalle d'où Nellie [sic] et moi étaient en train de prendre'. Degas 'nous a dit qu'il avait été dans l'incapacité de venir à tout avec la perspective et qu'il avait employé un professional [sic] pour le dessin de l'architecture d'un plafond.' Sickert made this annotation in his Paris copy of Jamot, 1924, against the discussion of *Miss Lala* on p.93.
26. In the Courtauld copy, p.93, Sickert wrote: 'Il nous a dit 1885 qu'il a du faire faire la perspective du toit par un professionel.'
27. Bomford et al., 2004–5, p.89.
28. 'On donne l'idée du vrai avec le faux.' Sickert repeated this wisdom on many occasions in his writings. See for example, W. Sickert, 'Degas', *Burlington Magazine*, November 1917, in Robins (ed.), 2002, p.415.

29. W. Sickert to J.-E. Blanche, 6 December 1885, ms. letter, Institut de France, 6282/157. The letter was written from 38 Albany Street where the Sickerts stayed until the decoration of their new home in Hampstead was complete.

30. Menpes, 1904, p.19.

31. I am grateful to Andrew Watson for supplying this information. It comes from his 'Collection of Constantine Alexander Ionides (1833–1900): With special reference to the French nineteenth-century paintings, etchings and sculptures', unpublished Ph.D. thesis, University of Aberdeen, 2002, pp.148–51, which I have not been able to see.

32. The picture was reproduced in C. Monkhouse, 'The Constantine Ionides Collection', *Magazine of Art*, vol.4, 1884, p.233.

33. Eleanor Sickert described it thus in an undated ms. letter to Penelope Muller, written shortly after the opening of the 1887 RBA exhibition: 'Nell and I went in the morning when there was scarcely anyone there to see Walter's picture which is very clever'. The correspondence is preserved on microfiche in the Hyman Kreitman Research Centre, Tate Britain.

34. 'Society of British Artists. Second Notice', *Artist and Journal of Home Culture*, 1 May 1887, p.149.

35. E.J. Spence, 'Jimmy's Show (concluded)', *Artist and Journal of Home Culture*, 1 July 1887, p.216. It is more than likely that Spence was responsible for the previous, unsigned review.

36. Ellen M. Cobden Sickert to Jacques-Emile Blanche, 27 December 1885, ms. letter, 6282-154, Institut de France.

37. Ms. letter, 4831-111-114, Institut de France. The undated letter is wrongly catalogued as a letter from Tuke to Blanche. I am suggesting that it was written in June 1886 because the letter was written on mourning paper (Sickert's father died in December 1885), and in a letter from Blanche to his father, 29 June 1886, he refers to *The Swaying Dancer* or *The Green Dancer* as being 'en plus celui que je lui porte' than the Degas he brought with him.

38. Hill sale, Christie's, London, 25 May 1889, no.29.

39. Numbers are from the International Society of Painters, Sculptors and Engravers 1898 catalogue:114 *Dancers*, pastel, Mrs Unwin; 115 *Dancers* (*The Green Dancer*); 116 *Dancers* (*The Rehearsal of the Ballet on Stage*); 119 *Café Chantant* (*Mlle Bécat at the Ambassadeurs*). All three pictures were illustrated in the catalogue.

40. Ellen Cobden Sickert to Jane Cobden Unwin, 15 April 1900, ms. letter, 96D, West Sussex Record Office.

41. Ms. letter, 4831-111-115, Institut de France is signed 'W.S.' and wrongly catalogued as a Tuke.

42. Sickert, 'Degas', 1917, in Robins (ed.), 2002, p.415. 'Je veux regarder par le trou de la serrure.'

43. At the Durand-Ruel exhibition at the Grafton Gallery which included *Seated Nude Drying Herself*, 1895. L.1340.

44. Sickert to Blanche, ms. letter, 4831-111-108, Institut de France. The letter is undated but internal evidence suggests a date of April or May 1888. 'M. Degas a été assez aimable de me télégraphier permission d'exposer là mon danseuse verte qui a été reçu avec acclamation.'

45. *Manchester Guardian*, 9 April 1888.

46. W. Sickert, 'Modern Realism in Painting', 1892, in Robins (ed.), 2002, p.86.

47. Ibid.

48. Smith (ed.), 2004, p.31.

49. See Baron, 1973, pp.27–9 and 302–3. Previously Gatti's *Hungerford Palace of Varieties: Second Turn of Miss Katie Lawrence*, Art Gallery of New South Wales, was dated 1887–8. Recent work by Paula Drudge, the gallery Conservator, who will discuss her research in a forthcoming article, suggests that it should be redated to c.1903.

50. Degas's ballet pictures were given very general titles such as *Dancing-lesson*, for sale at the Continental Gallery in April 1892. See 'Art Exhibitions', *Times*, 5 April 1892.

51. F. Wedmore, *Fortnightly Review*, 1883, in Flint (ed.), 1984, p.52.

52. Sickert to Blanche, ms. letter, Blanche papers, Institut de France, 7055XI 149–50. The letter, which is undated, can be dated to May/June 1889, because the Hill sale took place in May 1889.

53. S. Starr relates this story in 'Personal Recollections of Whistler', *Atlantic Monthly*, vol.101, January–June 1908, p.530.

54. F. Wedmore, 'The New English Art Club', *Academy*, 26 November 1892.

55. *Standard*, 21 November 1893. The review was almost certainly written by Frederick Wedmore who was art critic of the *Standard*.

56. I am grateful to Donato Esposito for this information.

57. See Moore, 1896.

58. Ibid.

59. D. Druick and P. Zegers, 'Degas and the Printed Image, 1856–1914' in Reed and Shapiro, 1984, p.lvii.

60. W. Sickert, 'A Portfolio of Lithographs', *New York Herald*, 4 March 1889, in Robins (ed.) 2002, p.12.

61. Ibid.

62. W. Sickert, 'Art', *Whirlwind*, 5 July 1890, in Robins (ed.) 2002, p.70.

63. 'The New English Art Club', *Standard*, 10 April 1891.

64. 'Mr. T. Cyprian Williams,' *Times*, 'Obituaries', 10 October 1932.

65. G[eorge] M[oore], 'The New English Art Club', *Speaker*, 18 April, 1891.

66. 'The New English Art Club', *Land and Water*, 18 April 1891.

67. Degas's name is included among the list of exhibitors in the catalogue.

68. *Country Gentlewoman*, 15 April 1893. The other Degas, *Chanteuses*, 'about 8 in x 5 in', 'a study of reflected lights and ugly women in evening dress, using lungs and mouths vigorously', with 'colours as a bed of tulips', a combination of 'something of an etching … monotype, and … pastel' has not been identified.

69. Sir William also owned the gouache and pastel *Dancer on Pointe: The Star*, c.1878 (Norton Simon Art Foundation, Pasadena, California), and *Laundresses Carrying Linen in Town*.

70. I am grateful to Mrs Diana Purdie, the granddaughter of Florence Hetherington (Mrs William Ritchie) for this information.

71. Moore, *Hawk*, 1890.

72. A.U. [Elizabeth Pennell], 'French and Dutch Modern Masters', *Star*, 3 January 1893.

73. All quotations are from 'French Impressionist Pictures', *Building News*, 25 December 1891.

74. Quotation and identification from Moore, 1892.

75. Fowle, 1992, no.16, identifies this picture, whose first known owner was Alexander Reid. I am grateful to her for her help with this matter. The following descriptions confirm this identification: an 'oil painted on paper', 'a notable portrait, almost a silhouette', of 'a lady seated near a window … a very effective study of contrasts of figure in shadow against the strong light of the window', and MacColl's comment about the 'lady with a very dark complexion with her back to the light'.

76. A.U. [Elizabeth Pennell], 'Modern French and Dutch Masters', *Star*, 3 January 1892.

77. Moore, 1892.

78. Ibid.

79. Ibid.

80. See Robins, 1988.

81. D.S. MacColl, *Spectator*, 2 January 1892, p.17.

82. A. Meynell, 1883, p.82.

83. F. Wedmore, 'Manet, Degas and Renoir: Impressionist Figure-Painting', *Brush and Pencil*, May 1905, vol.15, no.5, p.255.

84. The sitter in *The Little Student* is identifiable through the description of 'a boy in Highland costume writing at a desk' in 'The Grafton Gallery', *Westminster Gazette*, 17 February 1893, p.3. The review was anonymous but it is known to have been written by J.A. Spender. Pickvance, *Apollo*, 1963, p.396, no.2, identifies this picture without saying why.

85. *Brighton Gazette*, 9 September 1876, cited Pickvance, *Apollo*, 1963.

86. A. Kay, *Treasure Trove in Art*, Edinburgh 1939 , p.27.

87. A. Kay, 'The New Art Criticism', Letter to the *Westminster Gazette*, 29 March 1893; cited Pickvance, *Apollo*, 1963, p.396.

88. D.S. MacColl, 'The Grafton Gallery', *Spectator*, 25 February 1893, p.256; reprinted in part in Flint, 1984, p.281, where it is incorrectly entitled.

89. *Westminster Gazette*, 17 February 1893.

90. G.M.[George Moore], 'The Grafton Gallery – 1', *Speaker*, 25 February 1893.

91. *Spectator*, 25 February 1893.

92. The Philistine, ' The New Art Criticism: A Philistine's Remonstrance', *Westminster Gazette*, 9 March 1893, 1–2; reprinted in Flint, 1984, 283–4.

93. W.B. Richmond, 'The New Art Criticism', *Westminster Gazette*, 18 March 1893.

94. W. Crane, 'The New Art Criticism', *Westminster Gazette*, 20 March 1893.

95. W. Sickert, Letter to the Editor, *Westminster Gazette*, 20 March 1893, in Robins (ed.), 2002, p.96.

96. G.M., 'The New Art Criticism', *Speaker*, 25 March 1893.

97. W.B. Richmond, 'The New Art Criticism', *Westminster Gazette*, 20 March 1893.

98. D.S.M., *Spectator*, 15 February 1893.

99. D.S.M. 'Subject and Technique', *Spectator*, 25 March 1893. See Flint, 1988, pp.6–7, for further discussion of these issues.

100. G.M., 'The New Art Criticism – II', *Speaker*, 1 April 1893.

EXPORTING STYLE AND
DECADENCE:
THE EXCHANGES OF THE 1890s
pp.95–153

1. R. Thomson, 2004.

2. Corelli, 1895 (1998, pp.29, 297).

3. Frazier, 2000, p.175.

4. Letter of 12 July 1890 (University of Strathclyde archives, T-GED 12/3/2). I am indebted to Belinda Thomson for this reference.

5. Talmeyr, 1896, pp.205–6: 'légère, subtile … des finesses, des sous-entendus … froide, ironique, à la fois frénétique et raide'.

6. Avril, 1933; Ambroselli et al., 2003, p.58.

7. Wood/Ogborn, 1974.

8. Dortu, 1971, P.426; R. Thomson et al., 1991–2, pp.264–5.

9. *Le Fifre*, 11 May, 1889; Paris, Bibliothèque Nationale (D.3302; Ca lc (xx siècle) Ranft).

10. Cachin, 2000, p.369; Valtat, 1995, p.20.

11. Newton/MacDonald, 1978, pp.148–59.

12. Samain, 1939, p.27 (27 September 1887).

13. Goncourt, 1956, p.157 (17 October 1889).
14. Willy, 1897 (1995, p.87). For Beardsley and Britain see Desmarais, 1998.
15. Blanche, 1937, p.96.
16. Letter postmarked 6 May 1896; John Rylands Library, Deansgate, Manchester.
17. Southard, 1984, no.45.
18. Dortu, 1971, D.4.317.
19. 'The Royal Society of Painter-Etchers', *Speaker*, 20 March 1897; Robins (ed.), 2002, p.150.
20. Kipling, 1891 (1970, p.47).
21. Wildenstein W.1217a. The canvas was destroyed in the San Francisco Fire of 1906.
22. 'Monet, Sisley, Pissaro [sic] and the Decadence', in Moore, 1897, pp.93, 95.
23. Rothenstein, 1931, pp.58–9.
24. Galbally et al., 2003, p.47.
25. R. Thomson et al., 1991–2, pp.174–6.
26. Rothenstein, 1931, pp.60, 75.
27. Kendall, 1998, p.46. It is possible that Dortu, 1971, D.4.004, is a caricature by Lautrec of Rothenstein.
28. Rothenstein, 1931, pp.63, 73.
29. Wood/Ogborn, 1974, n.p.
30. Rothenstein, 1931, p.76.
31. Rothenstein, 1931, p.62.
32. Gale, 1996, pp.52–3, plates 42–3.
33. *From the Madonna to the Moulin Rouge*, 2001, no.11.
34. Rothenstein, 1931, pp.100–1.
35. Rothenstein, 1931, p.90.
36. Rothenstein, 1931, p.148.
37. Frazier, 2000, p.213.
38. Holdsworth, 1974, pp.11–12.
39. Cecil, 1964, p.93.
40. Ellmann, 1988, p.417; Dortu, 1971, P.574.
41. R. Thomson et al., 1991–2, no.112.
42. Wittrock, 1985, no.62.
43. Wittrock, 1985, nos.114–19; Dortu, 1971, P.585–9, A.230.
44. Richard Thomson, 'The Imagery of Toulouse-Lautrec's Prints', in Wittrock, 1985, pp.27–8; Chapin, 2002, p.144.
45. Wittrock, 1985, P.17; Joyant, 1927, p.111.
46. Baron/Shone, 1992–3, nos.9, 14.
47. Moore, 1897, p.205.
48. 'Some French Painters', *Fortnightly Review*, December 1929 (Robins, ed., 2002, p.596).
49. Schimmel (ed.), 1991, p.173: letter 225, 31 May 1892; Joyant, 1926, p.169.
50. Joyant, 1926, pp.168–74.
51. E.g. Dortu, 1971, P.241.
52. R. Thomson et al., 1991–2, no.85, fig. a.
53. Jourdain/Adhémar, 1952, p.86.
54. Schimmel (ed.), 1991, p.294: letter 462, May–June 1896.
55. Wittrock, 1985, P.25, 26; see also Adriani, 1988, pp.252, 254.
56. Dortu, 1971, P.666.
57. Repr. Suleman et al., 2001, p.44.
58. Schimmel (ed.), 1991, p.304: letter 480, May 1897; Lafont-Couturier et al., 1994, pp.146–7.

59. Schimmel (ed.), 1991, p.305: letter 482, 8 June 1897.
60. Schimmel (ed.), 1991, p.306: letter 483, 9 June 1897.
61. Schimmel (ed.), 1991, p.307: letter 485, June 1897.
62. Schimmel (ed.), 1991, p.335: letter 532, no.1. The list is given, with identifications, in R. Thomson et al., 1991–2, p.540.
63. Joyant, 1927, p.255.
64. Joyant, 1926, p.182; Ludovici, 1926, p.135.
65. Libovitz-Henry, 1957, pp.298, 301.
66. Anon., 11 June 1898, p.881.
67. Ward, 1898, p.187.
68. A.U., 1898.
69. Anon., 10 May 1898.
70. Joyant, 1926, p.178.
71. These were Dortu, 1971, P.417, probably P.418, P.424, an unidentified pastel, and the colour lithograph Wittrock, 1985, no.228. See R. Thomson et al., 1991–2, p.540; Schimmel (ed.), 1991, p.335, no.2.
72. Libovitz-Henry, 1957, p.297.
73. Wittrock, 1985, nos.18–28, 69–85.
74. Schimmel (ed.), 1991, p.295: letter 464, 6 July 1896; for the two projects see Dennis Cate, '*Treize Lithographies* and *Yvette Guilbert*. The Actors and Actresses of Henri de Toulouse-Lautrec' in Schimmel/Cate, 1983, pp.15–35.
75. Wittrock, 1985, nos.271–9.
76. Chapin, 2002, pp.186–90.
77. Wittrock, 1985, no.248.
78. Schimmel (ed.), 1991, pp.329–30: letter 520, 1 April 1898.
79. Wittrock, 1985, under no.249.
80. Delbourg-Delphis, 1985.
81. Dorment/MacDonald et al., 1994–5, no.205.
82. *Petit Bottin*, 1886, p.144: 'From symphonies of shadows emerge beings of delicate and serpentine elegance, distant and disquieting.'
83. Lorrain, 1936, p.147 (written 23 April 1897).
84. Roberts et al., 1997–8, no.14.
85. Joyant, 1927, p.63.
86. The others are Dortu, 1971, pp.410, 467.
87. 'X', 1891, p.222.
88. Galbally et al., 2003, p.51; Rothenstein, 1931, p.121.
89. *Yellow Book*, II, July 1894, repr. p.220.
90. Reynolds, 1984, p10; Baron, 1973, p.306.
91. Barbier (ed.), 1964, p.87; letter from Whistler to his wife, 11 June 1891.
92. Pennell, 1920, p.350.
93. I am indebted to Anna Gruetzner Robins for information on Lady Colin Campbell, discussed in greater detail in her forthcoming book.
94. Dorment/MacDonald et al., 1994–5, p.211.
95. Blanche, 1949, pp.238–9; Blanche, 1937, p.106.
96. Christie's, 22 June 1984, no.235; Munhall, 1995, repr. p.40.
97. Bennett, 1971, p.28 (11 January 1897).
98. Rook, 1979, p.107.

99. F. Wedmore, *Studio*, vol.4, December 1894, quoted in McConkey, 1995, p.183.
100. Bennett, 1971, p.28–9 (27 January 1897).

SICKERT AND THE PARIS ART WORLD
pp.155–201

I am grateful to the British Academy for awarding me a Small Research Grant which enabled me to carry out research on Sickert's critical reputation in Paris.

1. O. Sitwell, *A Free House or the Artist as Craftsman: Being the Writings of Walter Richard Sickert*, London 1947, p.xxii.
2. Sickert to Sir William Eden, ms. letter, 15 November 1901, AP22/23/6, University of Birmingham.
3. The catalogue for this exhibition is preserved in the Fonds Louis Vauxcelles, carton 63, Institut National d'Histoire de l'Art. Sickert exhibited a self-portrait.
4. W. Sickert, 'Degas', *Burlington Magazine*, 1917, in Robins (ed.), 2002, p.413.
5. Sickert to William Rothenstein, ms. letter, Auteuil, June or July 1899, Papers of Sir William Rothenstein, Houghton Library, Harvard, BMS ENG 1148 (12).
6. Sickert to Sir William Eden, Eden ms. letter, n.d. [c. February 1902], AP22/23/1, University of Birmingham.
7. This Manet has not been identified.
8. Sickert to Durand-Ruel, 2 April, 1901, ms. letter, 7756, Institut Néerlandais, Paris: 'une série d'un coin de l'église S. Marco par effets différents'.
9. Saunier, 1903, no.234, p.382: 'Je connaissais, un peu seulement, le nom de M. Walter Sickert. Dans tous les cas j'aurais été assez embarrassé pour préciser une de ses oeuvres. Maintenant je crois bien qu'il n'en sera plus ainsi. Ses vues de Dieppe ne s'oublient pas. Après Camille Pissarro, il a su évoquer, par des moyens à lui, la vieille ville et particulièrement la pittoresque église Saint-Jacques.' Sickert was exhibiting at the Societé nouvelle de Peintres et de Sculpteurs exhibition at Durand-Ruel, 14 January–7 March 1903.
10. J.-E. Blanche, 'Walter Sickert', *Exposition Walter Sickert*, Galeries Bernheim-Jeune and Fils, 8 rue Lafitte, 1–10 June 1904: 'appréciait beaucoup ses études et le tenait pour un des derniers de la bonne phalange'.

11. Blanche, December 1904, p.687: 'MM Bernheim regretteront de n'avoir pas mis dans leurs salles des toiles de Walter Sickert, qui, plus âgé que ces "néo-impressionnistes", a fait, en Angleterre, des scènes de Music-Halls et d'autres théatres, avant MM Vuillard et Bonnard, et dans une voie parallèle. M. Sickert fut, sans contredit, de toute sa génération, le plus comblé par nature, des dons qui font le peintre. Sa place était indiquée ici, il est fâcheux qu'on ne l'y ait pas appelé de Venise, où il crée chaque jour négligemment, et sans qu'on y prenne garde, de delicats petits joyaux.'
12. See C. Duncan, 'Virility and Domination in Twentieth-Century Vanguard Painting', in *The Aesthetics of Power*, Cambridge 1993, pp.81–108.
13. G. Perry, *Women Artists and the Parisian Avant-Garde*, Manchester and New York 1995, pp.118–39.
14. Perry, 2004, p.69.
15. D'Anner, 1905: 'Une chose qui frappe au Salon d'Automne, c'est l'abondance du nu. Mais quois nus, dieux immmortels!'
16. W. Sickert, 'The Dowdeswell Galleries', *New York Herald*, 10 April 1889, in Robins (ed.), 2002, p.31.
17. See R. Thomson, 1988, pp.87, 126–7 and figs.78–81, 116–18 for a discussion of these Rococo sources.
18. Translated from P. Jamot, 1906, p.484: 'Sickert hésitant entre M. Bonnard et Whistler.'
19. P. Jamot, 'Exposition Sickert, Galerie Bernheim', *La Chronique des arts et de la curiosité*, 19 January 1907, p.19: 'Semble s'être humanisé au contact de notre jeune école ...'
20. Vauxcelles, March 1909, p.2.
21. W. Sickert, 'Walter Bayes', March 1918, in Robins (ed.), 2002, p.422.
22. Sickert to Rothenstein, cited in Baron/Shone, 1992–3, p.184.
23. Baron, 1973, p.93 was the first to point out this connection.
24. See House, 1994, p.80.
25. A. Rodin, 'La Leçon de l'Antique', *Le Musée, Revue de l'Art Antique*, 1, January–February 1904, in Mitchell, 2004, p.142.
26. Potts, 2000, p.90.
27. L. Tickner, 'Walter Sickert: The Camden Town Murder and Tabloid Crime', in Tickner, 2000, p.25.
28. Vauxcelles, March 1909.
29. L. Vauxcelles, 'Le Salon d'Automne', *Gil Blas*, 1 October 1909.
30. Signac to Fénéon, 12 June 1909, Signac Archives; cited in *Signac*, exh. cat., Metropolitan Museum of Art, New York 2000, p.64. I am grateful to Susan Alyson Stein for supplying this reference.

31. The exhibition took place from 15 April to 30 June. See Normand-Romain, 1995; 'J. Newton and M. Rodin: The Whistler Monument', *Gazette des Beaux Arts*, 92, 1978, pp.221–31.

32. A. Rodin, 'Vénus: A la Vénus de Milo', *L'Art et L'Artiste*, March 1910; cited in Mitchell (ed.), 2004, p.148.

33. F. Monod, *Art et Décoration*, p.3: 'incohérent et sauvage de sa nouvelle manière n'est pas pour compenser la grossièreté des sujets.'

34. An unidentified biographical dictionary entry, c.1907, in the Fonds Louis Vauxcelles, Paris; cited in Benjamin, 1987, p.99. 35. Vauxcelles, March 1905, p.2: 'Ses têtes d'homme, aux teints plombés, aux yeux verts atteignent le summum d'expression, en leurs graves harmonies whistleriennes.'

36. Vauxcelles, 17 October 1905: 'Sickert est l'homme des harmonies vineuses et noirâtres, des nus jetés sur un lit, le soir quand les rideaux interceptent toute lumière; on songe à Edgar Poe devant ces teints plombés, et ces dégradations de tonalités cadavériques.'

37. Vauxcelles, 5 October 1906.

38. Vauxcelles, 12 January 1907, p.2. Tickner, 2000, p.238, no.134, also cites part of this review.

39. I am grateful to Guy-Patrice Dauberville for providing this information from the Bernheim-Jeune Archives, Paris.

40. Ibid: 'Qui fut admiré par Degas et Pissarro – est un dandy singulier, distant à la fois et séduisant, de qui notre Montaigne est le livre de chevet, et qui lit avec délices Martial dans le texte.'

41. Ibid.

42. Ibid: 'Voici d'abord une série de nus, peints au crépuscule, parmi: désordre pauvre des chambres garnies d'hôtels. Ce sont des filles, affalées sur le lit défait, des filles au corps flêtri, fatigués par les dures besognes de la prostitution. Nulle déclamation, nulle [?] caricatural, rien qu'évoque le rictus d'un Degas, d'un Lautrec, ou la misogynie d'un Rouault.'

43. Ibid: 'Leurs chairs déformées portent les stigmaties du plus douloureux.'

44. Ibid: 'On songe aux visages de femmes d'un Tiepolo modernisé si britannique.'

45. Ibid: 'Souriraient de pitié devant les graves visions de ce Sickert que l'un d'eux qualifie de "charbonnier pornographique". Qu'importe! Cette peinture-là n'est pas à leur mesure.'

46. Geffroy, 1905, p.5: 'M. Sickert discerne les formes qui se meurent dans les chambres obscures de Londres.'

47. Vauxcelles, 1906: 'M. Sickert a fixé avec un perspicacité aigue, le personnel des music-halls de Bedford, fillasses hébétées, blafardes minstrels, glabres et sordides, pauvresses qui déambulent dans les ruelles de Whitechapel, abruties de gin. C'est le poème nocturne de la misère et de la prostitution londoniennes.'

48. Monod, April 1908, p.2. 'Ses tons persillés de matières en putréfaction piqués sur fonds gris de boue.'

49. Monod, 1909, p.3: 'Sa palette est une pauvresse aux oripeaux flétris. Exquise dans les tons souillés, assortie de vert noir, de glaise verte, de gris caviar, de bleus et de roses blets et étouffés, de rougeâtre, de bis et de lilas morts, elle a trempé dans les hivers de Londres et dans la langue gâtée de la Tamise.'

50. Vauxcelles, 1908: 'Le poids du corps de la fille endormie est rendu avec un sentiment étonnant du volume. M. Sickert sait mieux que quelconque de l'heure actuelle que sur une esquisse sombre et transparente, et notamment sur le noir, les tons clairs prennent un éclat violent et que les empâtements légers de tons ambigues (mauves, vineux, bleus, veru [?] de grises, oranges sourds, blancs rompus, réchauffés ou refroidis, hantent avec délicatesse.'

51. R. Shone, *Burlington Magazine*, CXXVI, February 1984, supplement, p.3.

52. Daniels, 2002.

53. D. Lomas presents this argument 'In Another Frame: *Les Demoiselles d'Avignon* and Physical Anthropology', in Green (ed.), 2001, p.105 and passim.

54. Herbert, 1992, p.160.

55. Ibid., p.150.

56. 'For £400 for Mrs. Sickert, sold the one I bought for £74 or so to an American for £3000, he paying dealers percentage (say 10 p.c) & duty into America (I forget what that is).' Sickert to Sir William Eden; 'I have some very good deals in Degas's sold one I bought at Christies's for 70 gneas or so about 10 or 12 years ago for £3,000 net the purchaser paying dealer's percentage and duty in to America & so he paying about £4,000, & then *have got a masterpiece* by the same hand for £400. Of course it is very interesting in Paris and one learns a lot.' Sickert to Mrs Hulton, Bodleian, 17A. According to the Durand-Ruel stock book, Sickert bought *Woman at the Window* for Fr 10,000, 18 February 1902. See J. Sutherland Boggs et al., 1988–9, p.229.

57. Sickert's annotation, against Planche 36, a reproduction of the picture in one of his copies of Paul Jamot's *Degas*, 1924, Institut Néerlandais, Paris records: 'Peinture à l'essence sur papier resin par moi en présence de Marchant qui affirmait ne pas user venu [sic] un tableau sur papier.'

58. See House, 1994, p.88.

59. See Sickert's annotation in the Institut Néerlandais copy of Jamot's *Degas*, p.56.

60. Sickert included this information as a caption to the picture in 'Degas', *Burlington Magazine*, December 1923, in Robins (ed.), 2002, p.468.

61. Alfred Sutro first met Vuillard in the 1890s, and was still in touch the following decade when Vuillard recorded a visit in his 'Journal' on 4 October 1909 (Institut de France).

62. Sickert, 'New Wine', *New Age*, 21 April 1910, in Robins (ed.), 2002, pp.218–19.

63. Fry, 1910, p.195.

64. R. Fry, 'Plastic Design', *Nation*, 10 June 1911, in Reed (ed.), 1996, p.138.

65. R.H. Wilenski, 'Sickert's Art', in Browse, 1943, p.25.

66. W. Sickert, 'The International Society', *English Review*, May 1912, in Robins, 2004, p.314.

67. E. Vuillard, quoted by A. Chastel, *Vuillard 1868–1940*, 1946, p.94; cited in Cogeval et al. 2003, p.356.

68. See N. Moorby, "A long chapter from the ugly tale of commonplace living": The Evolution of Sickert's *Ennui*', in Smith (ed.), 2004, pp.11–14.

69. Jamot, 1907, p.19.

70. Boggs et al., 1988, p.146, states that Degas deposited it with Durand-Ruel by 15 June 1905.

71. Sickert's annotation in one of his copies of Paul Jamot's *Degas*, 1924, Institut Néerlandais, Paris.

72. Theodore Reff in his illuminating chapter, 'My Genre Painting', in Reff, London 1976, p.205, was the first to make this suggestion.

73. Reff, London 1976, p.203.

74. E. Duranty, 'The New Painting'; cited in Armstrong, 1991, p.84.

75. Sidlauskas, 2000, p.3. See also pp.124–49 for a discussion of *Ennui*.

76. A. Callen, *The Spectacular Body: Science, Method and Meaning in the Work of Degas*, New Haven and London 1995, p.22.

77. A.M., 'The International', *Pall Mall Gazette*, 9 January 1905; cited in G. Cogeval et al., 2003, p.216.

SELECT BIBLIOGRAPHY

Luce Abélès, *Fantin-Latour: Coin de table. Verlaine, Rimbaud et les Vilains Bonshommes*, exh. cat., Musée d'Orsay, Paris 1987.

Hélène Adhémar, Anthony M. Clark et al., *Centenaire de l'Impressionnisme*, exh. cat., Grand Palais, Paris 1974.

Götz Adriani, *Toulouse-Lautrec: The Complete Graphic Works*, London 1988.

Arsène Alexandre, 'Le Salon d'Automne', *Le Figaro*, 17 October 1905.

Ronald Alley, 'Notes on Some Works by Degas, Utrillo and Chagall in the Tate Gallery', *Burlington Magazine*, no.100, May 1958, p.171.

— *Catalogue of the Tate Gallery's Collection of Modern Art, other than Works by British Artists*, London 1981.

Catherine Ambroselli, et al., *George Desvallières et le Salon d'Automne*, Paris 2003.

Anon., 'Exhibition at the Royal Academy', *The Times*, 2 May 1874.

— 'Royal Academy: Third Notice', *The Times*, 1 July 1874.

— 'The Impressionists', *Daily News*, 1 July 1882.

— 'The "Impressionists"', *Standard*, 13 July 1882.

— 'The Society of British Artists', *Sunday Times*, 25 April 1886.

— 'Art and Artlessness', *Daily Chronicle*, 10 May 1898.

— 'An International Art Exhibition', *Standard*, 18 May 1898.

— 'Art Notes: Goupil Gallery', *Lady's Pictorial*, 11 June 1898, p.881.

Carol Armstrong, *Odd Man Out: Readings of the Work and Reputation of Edgar Degas*, Chicago and London 1991.

Caroline Arscott and Katie Scott (eds.), *Manifestations of Venus: Art and Sexuality*, Manchester 2000.

Jane Avril, 'Mes Mémoires', *Paris-Midi*, 7 August 1933, et seq.

Carl Paul Barbier (ed.), *Correspondance Whistler-Mallarmé*, Paris 1964.

Wendy Baron, 'Sickert's Links with French Painting', *Apollo*, March 1970, pp.186–97.

— *Sickert*, London 1973.

Wendy Baron and Richard Shone, *Sickert: Paintings*, exh. cat., Royal Academy, London 1992–3.

Felix Bauman and Marianne Karabelnik (eds.), *Degas Portraits*, London and Zurich 1994.

Roger Benjamin, *Matisse: Notes of a Painter*, Ann Arbor 1987.

Arnold Bennett, *The Journals*, Frank Swinnerton (ed.), Harmondsworth 1971.

Diane Bilbey, with Marjorie Trusted, *British Sculpture, 1470–2000: A Concise Catalogue of the Collection at the Victoria and Albert Museum*, London 2002.

Jacques-Emile Blanche, 'Notes sur le Salon d'Automne', *Mercure de France*, December 1904, pp.68–90.

— 'Salon d'Automne', *Mercure de France*, October 1905, pp.337–50.

— *Propos de peintre: De David à Degas*, Paris 1919.

— *Portraits of a Lifetime*, London 1937.

— *Souvenirs sur Walter Sickert: Précédés de Souvenirs sur Jacques-Emile Blanche par Daniel Halévy*, Alençon (Orme), 1943.

— *La Pêche aux souvenirs*, Paris 1949.

Jean Sutherland Boggs, *Degas at the Races*, exh. cat., National Gallery of Art, Washington 2002.

Jean Sutherland Boggs, Douglas Druick, Henri Loyrette, Michael Pantazzi and Gary Tinterow, *Degas*, exh. cat., Grand Palais, Paris 1988–9.

David Bomford et al., *Art in the Making: Degas*, exh. cat., National Gallery, London 2004–5.

Richard Brettell and Suzanne Folds McCullagh, *Degas in the Art Institute of Chicago*, Chicago 1984.

Marilyn R. Brown, *Degas and the Business of Art: A Cotton Office in New Orleans*, University Park 1994.

Roger Brown, *William Stott of Oldham 1857–1900: 'A Comet rushing to the Sun*, exh. cat., Gallery, Oldham, 2003.

Lillian Browse, *Sickert*, London 1943.

— *Sickert*, London 1960.

Philippe Burty, 'The Paris Exhibitions: Les Impressionnistes', *The Academy*, 30 May 1874, p.616.

— 'Fine Art: The Exhibition of the "Intransigeants"', *The Academy*, 15 April 1876, pp.363–4.

Françoise Cachin, *Signac: Catalogue raisonné de l'oeuvre peint*, Paris 2000.

Henriette Caillaux, *Aimé-Jules Dalou (1838–1902)*, Paris 1935.

Giovanni Castagnoli, Barbara Cinelli, Maria Mimita Lamberti and Maria Christina Maiocchi, *De Nittis e la pittura della vita moderna in Europa*, exh. cat., Galleria Civica d'Arte Moderna e Contemporanea, Turin, May 2002.

David Cecil, *Max*, London 1964.

Mary Weaver Chapin, 'Henri de Toulouse-Lautrec and the Café-Concert: Printmaking, Publicity and Celebrity in Fin-de-Siècle Paris', Ph.D., Institute of Fine Arts, New York University 2002.

Ernest Chesneau, *La Peinture anglaise*, Paris, n.d. [c.1883].

Samuel F. Clapp, *Gustave Doré: Watercolours, Drawings, Prints, and Sculpture*, exh. cat., Hazlitt, Gooden and Fox, London 1983.

Jules Claretie, *L'Art et les artistes français contemporains*, Paris 1876.

— *Oeuvres complètes*, Paris, n.d. [c.1914].

Guy Cogeval, Kimberly Jones, Laurence des Cars and MaryAnne Stevens, *Edouard Vuillard*, exh. cat., National Gallery of Art, Washington 2003.

Sidney Colvin, 'Society of French Artists', *Pall Mall Gazette*, 28 November 1872.

Douglas Cooper, *The Courtauld Collection of Paintings, Drawings, Engravings and Sculpture*, London 1954.

David Peters Corbett, *Walter Sickert*, London 2001.

— *The World in Paint: Modern Art and Visuality in England, 1848–1914*, Manchester and New York 2004.

Marie Corelli, *The Sorrows of Satan* (1895), Oxford 1998.

Rebecca Daniels, 'Walter Sickert and Urban Realism: Ordinary Life and Tragedy in Camden Town', *British Art Journal*, Spring 2002, vol.111, no.2, pp.58–69.

Felix d'Anner, 'Le Salon d'Automne', *L'Intransigeant*, 18 October 1905.

Jean and Henry Dauberville, *Bonnard: Catalogue raisonné de l'oeuvre peint*, 4 vols., Paris 1965–74, revised 1992.

Edgar Degas, *Letters*, ed. Marcel Guérin, Oxford 1947.

Marylène Delbourg-Delphis, *Masculin singulier: Le Dandysme et son histoire*, Paris 1985.

Jane Haville Desmarais, *The Beardsley Industry*, Aldershot 1998.

Jill De Vonyar and Richard Kendall, *Degas and the Dance*, New York 2002.

Richard Dorment, Margaret F. MacDonald et al., *James McNeill Whistler*, exh. cat., Tate Gallery, London 1994–5.

M.-G. Dortu, *Toulouse-Lautrec et son oeuvre*, 6 vols., New York 1971.

Edmond Duranty, *La Nouvelle Peinture: A propos du groupe d'artistes qui expose dans les galeries Durand-Ruel*, Paris 1876.

Douglas Druick and Michel Hoog, *Fantin-Latour*, exh. cat., Grand Palais, Paris 1983.

Richard Ellmann, *Oscar Wilde*, London 1988.

Félicien Fagus, 'Les Indépendants', *La Revue blanche*, 1 April 1903, p.541.

Marina Ferretti-Bocquillon, Anne Distel, John Leighton and Susan Alyson Stein, *Signac 1863–1935*, exh. cat., Metropolitan Museum of Art, New York 2001.

Albert de la Fizelière, *Memento du Salon de Peinture*, Paris 1875.

Kate Flint, 'Moral Judgement and the Language of English Art Criticism', *Oxford Art Journal*, vol.6, no.2, 1983, pp.59–66.

— (ed.), *Impressionists in England: The Critical Reception*, London, Boston, Melbourne and Henley 1984.

— 'The "Philistine" and the New Art Critic: J.A. Spender and D.S. MacColl's Debate of 1893', *Victorian Periodicals Review*, vol.21, no.1, Spring 1988, pp.3–8.

Frances Fowle, 'Impressionism in Scotland: An Acquired Taste', *Apollo*, December 1992, pp.374–8.

Charles C. Frankiss, 'Camille Pissarro, Théodore Duret and Jules Berthel in London in 1871', *Burlington Magazine*, vol.146, no.1216, July 2004, pp.470–2.

Adrian Frazier, *George Moore, 1852–1933*, New Haven and London 2000.

From the Madonna to the Moulin Rouge, exh. cat., National Gallery of Scotland, Edinburgh 2001.

Roger Fry, 'The Autumn Salon', *Nation*, 29 October 1910.

Ann Galbally, Barry Pearch and Barry Humphries, *Charles Conder*, exh. cat., Art Gallery of New South Wales, Sydney 2003.

Iain Gale, *Arthur Melville*, Edinburgh 1996.

Gustave Geffroy, 'Le Salon d'Automne', *Le Journal*, 22 October 1905, p.5.

Marc Gerstein, 'Degas's Fans', *Art Bulletin*, vol.64, March 1982, pp.105–18.

Edmond and Jules de Goncourt, *Journal: Mémoires de la vie littéraire, 1889–90*, vol.16, Monaco 1956.

Cecil Gould, 'An Early Buyer of French Impressionists in England', *Burlington Magazine*, vol.108, no.756, March 1966, pp.141–2.

Christopher Green (ed.), *Art Made Modern: Roger Fry's Vision of Art*, exh. cat., Courtauld Gallery, Courtauld Institute of Art, London 1999–2000.

— *Art in France, 1900–1940*, New Haven and London 2000.

— (ed.), *Picasso's 'Les Demoiselles d'Avignon'*, Cambridge 2001.

Henri Guérard, 'L'Exposition Noir et Blanc', *Paris à l'Eau-Forte*, no.168, 30 July 1876, p.97.

Joan Halperin, *Félix Fénéon: Aesthete and Anarchist in Fin-de-Siècle Paris*, New Haven and London 1988.

Vivien Hamilton et al., *Millet to Matisse: Nineteenth- and Twentieth-Century Painting from Kelvingrove Art Gallery, Glasgow*, exh. cat., Glasgow City Art Gallery, 2002.

William R. Hardie, *Sir William Quiller Orchardson, R.A.*, exh. cat., Royal Scottish Academy, Edinburgh, February 1972.

Eileen Harris, 'Carlo Pellegrini: Man and "Ape"', *Apollo*, no.167, January 1976, pp.53–7.

Eileen Harris and Richard Ormond, *Vanity Fair: An Exhibition of Original Cartoons*, exh. cat., National Portrait Gallery, London 1976.

Frank Harris, *My Life and Loves*, 2 vols., Paris 1934.

James Herbert, *Fauve Painting: The Making of Cultural Politics*, New Haven and London 1992.

Roger Holdsworth (ed.), *Arthur Symons: Selected Writings*, Cheadle 1974.

Ysanne Holt, *Philip Wilson Steer*, Bridgend 1992.

John House, 'New Material on Monet and Pissarro in London in 1871-2', *Burlington Magazine*, vol. 120, October 1978, pp.636-9.

John House et al., *Impressionism for England: Samuel Courtauld as Patron and Collector*, New Haven and London 1994.

John House and MaryAnne Stevens, *Post-Impressionism: Cross-Currents in European Painting*, exh. cat., Royal Academy, London 1979.

Timothy Hyman, *Bonnard*, London 1998.

Henry James, *English Hours* (1905), Oxford 1981.

Henry James, *The Painter's Eye*, ed. John L. Sweeney, London 1956.

Paul Jamot, 'Le Salon d'Automne', *Gazette des Beaux-Arts*, December 1906, pp.472-4.

— 'Sickert', *La Chronique des Arts et de la Curiosité*, 19 January 1907.

— *Degas*, Paris, 1924

David Fraser Jenkins and Avis Berman, *Impressionists: Whistler, Sargent, and Steer in London from Tate Collections*, exh. cat., Tate, London 2002.

Blanchard Jerrold and Gustave Doré, *London: A Pilgrimage* (1872), New York 1970.

Kimberly Morse Jones, 'The New Art Criticism in Britain 1890-95', unpublished Ph.D., University of Reading 2003.

Francis Jourdain and Jean Adhémar, *Toulouse-Lautrec*, Paris 1952.

Maurice Joyant, *Henri de Toulouse-Lautrec, 1864-1901, vol.1: Peintre*, Paris 1926; *vol.2: Dessins, Estampes, Affiches*, Paris 1927.

C.M. Kauffmann, *Victoria and Albert Museum: Catalogue of Foreign Paintings, vol.2, 1800-1900*, London 1973.

Richard Kendall, *Degas and the Little Dancer*, New Haven and London 1998.

Rudyard Kipling, *The Light that Failed* (1891), Harmondsworth, 1970.

Genniève Lacambre, Larry Feinberg et al., *Gustave Moreau, 1826-1898*, exh. cat., Grand Palais, Paris, 1999.

Hélène Lafont-Couturier et al., *Etat des lieux, no.1.*, Musée Goupil, Bordeaux 1994.

Bruce Laughton, *Philip Wilson Steer*, Oxford 1971.

Claudine Libowitz-Henry, 'L'Exposition Toulouse-Lautrec à Londres en mai 1898 et la presse anglaise', *Gazette des beaux-arts*, pér.6, vol.50, November 1957, pp.297-303.

Katherine Lochnan (ed.), *Seductive Surfaces: The Art of Tissot*, New Haven and London 1999.

Jean Lorrain, *La Ville empoisonnée: Pall-Mall Paris*, Paris 1936.

Henri Loyrette (ed.), *Degas inédit*, Paris 1989.

— *Degas*, Paris 1991.

Albert Ludovici, *An Artist's Life in London and Paris, 1870-1925*, London 1926.

D.S. MacColl, *The Life, Work and Setting of Philip Wilson Steer*, London 1945.

Kenneth McConkey, *Sir George Clausen, R.A., 1852-1944*, exh. cat., Cartwright Hall, Bradford 1980.

Kenneth McConkey, with Anna Gruetzner Robins, *Impressionism in Britain*, New Haven and London 1995.

Margaret F. MacDonald, *James McNeill Whistler's Drawings, Pastels, and Watercolours: A Catalogue Raisonné*, New Haven and London 1995.

Margaret F. MacDonald, Patricia de Montfort and Nigel Thorp (eds.), *The Correspondence of James McNeill Whistler 1855-1903*, Online Centenary Edition, Centre for Whistler Studies, University of Glasgow, 2003; w.whistler.arts.gla.ac.uk/correspondence.

Dianne Sachko MacLeod, *Art and the Victorian Middle Class: Money and the Making of Cultural Identity*, Cambridge 1996.

Nancy Rose Marshall and Malcolm Warner, *James Tissot: Victorian Life/Modern Love*, New Haven and London 1999.

Roger Marx, *The Painter Albert Besnard*, Paris 1893.

— 'Le Salon des Artistes Indépendants', *La Chronique des arts et de la curiosité*, 1 April 1903, p.101.

— 'Le Vernissage du Salon d'Automne', *La Chronique des arts et de la curiosité*, October 1906, p.264.

Pierre-Louis Mathieu, *Gustave Moreau*, Oxford 1977.

Camille Mauclair, 'Le Salon d'Automne', *Revue bleue: revue politique et litteraire*, vol.4, 21 October 1905, pp.521-5.

Jonathan Mayne, 'Degas's Ballet Scene from *Robert le Diable*', *Bulletin of the Victoria and Albert Museum*, 2, no.4, pp.148-56.

Mortimer Menpes, *Whistler as I Knew Him*, London 1904.

Alice Meynell, 'A Brighton Treasure House', *Magazine of Art*, vol.5, 1882, pp.1-7.

Willard Misfeldt, 'James Jacques Joseph Tissot: A Bio-critical Study', Ph.D., Washington University, St Louis 1971.

Claudine Mitchell (ed.), *Rodin: The Zola of Sculpture*, Aldershot 2004.

Felix Monod, 'Le Salon d'Automne', *Art et Décoration*, 1908, pp.20-1.

— 'Le Salon des Indépendants', *Supplément, Art et Décoration*, April 1908, p.2.

— 'Supplément Chronique. Un Peintre Anglais: M. Walter Sickert', *Art et Décoration*, July 1909.

George Moore, *A Modern Lover*, London 1883.

— 'Half-a-Dozen Enthusiasts', *Bat*, 25 May 1886.

— 'From the Naked Model', *Hawk*, 24 December 1889.

— 'Pictures', *Hawk*, 14 January 1890.

— 'To Paris and Back', *Hawk*, 3 June 1890.

— 'Degas: The Painter of Modern Life', *Magazine of Art*, November 1890; reprinted in *Impressions and Opinions*, London 1891, and as 'Memories of Degas' (with an introduction and illustrations of Degas pictures from Sir William Eden's collection), *Burlington Magazine*, vol.32, Jan-Feb 1918, pp.26-9, pp.63-6.

— 'Art Patrons', *Speaker*, 27 June 1891.

— 'Degas in Bond Street', *Speaker*, 2 January 1892.

— 'The New English Art Club', *Speaker*, 15 April 1893.

— 'The Taste of Tomorrow', *Daily Chronicle*, 26 May 1896.

— *Modern Painting*, new ed., London 1897.

Edgar Munhall, *Whistler and Montesquiou: The Butterfly and the Bat*, New York and Paris 1995.

Jane Munro, *Philip Wilson Steer 1860-1942: Paintings and Watercolours*, exh. cat., Fitzwilliam Museum, Cambridge 1986.

Lynda Nead, *Victorian Babylon: People, Streets and Images in Nineteenth Century London*, New Haven and London 2000.

Sasha Newman et al., *Bonnard*, exh. cat., Phillips Collection, Washington 1984.

Joy Newton and Margaret F. MacDonald, 'Whistler: The Search for a European Reputation', *Zeitschrift für Kunstgeschichte*, no.41, 1978, pp.148-59.

L. Nochlin, *The Body in Pieces: The Fragment as a Metaphor of Modernity*, London 1994.

A. Le Normand-Romain, *Rodin, Whistler et la Muse*, exh. cat., Paris 1995.

Elizabeth R. and Joseph Pennell, *The Life of James McNeill Whistler*, 6th ed., London 1920.

Gill Perry, 'Negotiating the Female Nude', in S. Edwards and P. Wood, *Art of the Avant-gardes*, New Haven and London 2004.

Petit Bottin des lettres et des arts, Paris 1886.

Enrico Piceni, *De Nittis: L'uomo e l'opera*, Busto Arsizio 1979.

Ronald Pickvance, 'Henry Hill: an Untypical Victorian Collector', *Apollo*, vol.76, 1962, pp.789-91.

— 'The Magic of the Halls and Sickert', *Apollo*, vol.76, 1962, pp.107-15.

— 'L'Absinthe in England', *Apollo*, vol.77, 1963, pp.395-8.

— 'Degas's Dancers: 1872-6', *Burlington Magazine*, vol.105, no.723, June 1963, pp.256-67.

— Edgar Degas 1834-1917, David Carritt Ltd, London 1983.

Alex Potts, *The Sculptural Imagination: Figurative, Modernist, Minimalist*, New Haven and London 2000.

Elizabeth Prettejohn, 'Aesthetic Value and the Professionaliza-tion of Victorian Art Criticism, 1837-78', *Journal of Victorian Culture*, 2, no.1, 1997.

Christopher Reed (ed.), *A Roger Fry Reader*, Chicago and London 1996.

Sue Welsh Reed and Barbara Stern Shapiro, *Edgar Degas: The Painter as Printmaker*, exh. cat., Museum of Fine Arts, Boston 1984.

Theodore Reff, 'Some Unpublished Letters of Degas', *Art Bulletin*, 50, 1968, pp.87-94.

— *Degas: The Artist's Mind*, London 1976.

— *The Notebooks of Edgar Degas*, 2 vols., Oxford 1976.

Ary Renan, 'Joseph de Nittis', *Gazette des beaux-arts*, pér.2, vol.30, 1884, pp.395-406.

John Rewald, 'Jours sombres de l'impressionnisme: Paul Durand-Ruel et l'exposition des impressionnistes à Londres en 1905', *L'Oeil*, February 1974, pp.14-19.

Gary A. Reynolds, *Giovanni Boldini and Society Portraiture, 1880-1920*, exh. cat., Grey Art Gallery, New York University, November-December 1984.

Anne Rivière, Dominique Lobstein et al., *Des Amitiés Modernes. De Rodin à Matisse. Carolus-Duran et la Société Nationale des Beaux-Arts, 1890-1905*, exh. cat., Roubaix, La Piscine, 2003.

Jane Roberts et al., *Jacques-Emile Blanche: Peintre (1861-1942)*, exh. cat., Musée des Beaux-Arts, Rouen 1997.

Keith Roberts, 'The Date of Degas's *The Rehearsal* in Glasgow', *Burlington Magazine*, vol.105, no.723, June 1963, pp.280-1.

Anna Gruetzner Robins, 'Degas and Sickert: Notes on their Friendship', *Burlington Magazine*, 130, 1988, pp.225-9.

— *Walter Sickert, Drawings, Theory and Practice: Word and Image*, Aldershot 1996.

— (ed.), *Walter Sickert: The Complete Writings on Art*, Oxford 2002.

Clarence Rook, *The Hooligan Nights* (1899), Oxford 1979.

William Rothenstein, *Men and Memories, I*, London 1931.

John Russell, *Edouard Vuillard 1868-1940*, exh. cat., Art Gallery of Ontario, Toronto 1971.

Antoine Salomon and Guy Cogeval, *Vuillard: The Inexhaustible Glance. Critical Catalogue of Paintings and Pastels*, Paris 2003.

Albert Samain, *Carnets intimes*, Paris 1939.

Charles Saunier, 'Gazette d'Art', *La Revue blanche*, 1 March 1903, p.382.

Herbert D. Schimmel and Phillip Dennis Cate (eds.), *The Henri de Toulouse-Lautrec – W.H.B. Sands Correspondence*, New York 1983.

Herbert D. Schimmel (ed.), *The Letters of Henri de Toulouse-Lautrec*, Oxford 1991.

Jonathan Schneer, *London 1900: The Imperial Metropolis*, New Haven and London 1999.

Richard Shone, 'Supplement', *Burlington Magazine*, February 1988, p.3.

—*Walter Sickert*, Oxford 1988.

Susan Sidlauskas, *Body, Place and Self in Nineteenth-Century Painting*, Cambridge 2000.

Exposition Walter Sickert, exh. cat., Galeries Bernheim-Jeune et Fils, Paris 1904, preface by Jacques-Emile Blanche.

Exposition Sickert, exh. cat., Bernheim-Jeune et Cie., Paris 1909, preface by Adolphe Tavernier.

Alistair Smith (ed.), *Walter Sickert: 'Drawing is the thing'*, exh. cat., Whitworth Art Gallery, Manchester 2004.

Mary Soames, *Winston Churchill: His Life as a Painter*, London 1990.

Edna Carter Southard, *George Bottini: Painter of Montmartre*, exh. cat., Miami University Art Museum 1984.

Andrew Stephenson, 'Buttressing Bohemian Mystiques and Bandaging Masculine Anxieties', *Art History*, 17, no.2, 1994, pp.269–78.

John Stokes, *In the Nineties*, Harpenden 1989.

Reena Suleman, Alison Smith and Robin Simon, *Public Artist, Private Passions: The World of Edward Linley Sambourne*, exh. cat., Leighton House Museum, London 2001.

Alfred Sutro, *Celebrities and Simple Souls*, London 1933.

Denys Sutton, *Walter Sickert*, London 1976.

Maurice Talmeyr, 'L'Age de l'affiche', *Revue des deux mondes*, 137, September 1896, pp.201–16.

Belinda Thomson, *Vuillard*, exh. cat., South Bank Centre, London 1971.

— *Vuillard*, Oxford 1988.

Ian Thomson, 'Tissot's Enigmatic Signatures', *Gazette des Beaux-Arts*, pér.6, vol.105, May 1985, pp.223–4.

Richard Thomson, *The Private Degas*, exh. cat., Whitworth Art Gallery, Manchester 1987.

— *Degas: The Nudes*, London 1988.

— 'Theo van Gogh: An Honest Broker', in C. Stolwijk, R. Thomson and S. van Heugten, *Theo van Gogh, 1857–1891*, exh. cat., Van Gogh Museum, Amsterdam 1999.

— *The Troubled Republic: Visual Culture and Social Debate in France, 1889–1900*, New Haven and London 2004.

Richard Thomson, Claire Frèches-Thory, Anne Roquebert and Danièle Devynck, *Toulouse-Lautrec*, exh. cat., Hayward Gallery, London 1991–2.

Lisa Tickner, *Modern Life and Modern Subjects: British Art in the Early Twentieth Century*, New Haven and London 2000.

Julian Treuherz et al., *Hard Times: Social Realism in Victorian Art*, London 1987.

Elizabeth Hutton Turner, *Bonnard: Early and Late*, exh. cat., Phillips Collection, Washington 2002.

A.U., 'Art and Artists', *The Star*, 10 May 1898.

Louis-André Valtat, *Louis Valtat (1869–1952): Exposition retrospective*, Galerie des Beaux-Arts, Bordeaux 1995.

Louis Vauxcelles, 'Les Salon des Indépendants', *Gil Blas*, 20 March, 1905.

—'Le Salon d'Automne: Supplément à *Gil Blas*', *Gil Blas*, 17 October 1905, pp.1–2.

—'Le Salon d'Automne: Supplément à *Gil Blas*', *Gil Blas*, 5 October 1906, p.2.

—'La Vie Artistique: Exposition Walter Sickert à Felix Fénéon', *Gil Blas*, 12 January 1907.

—'Les Salon des Indépendants', *Gil Blas*, 20 March 1907, pp.1–2.

—'Le Salon d'Automne', *Gil Blas*, 30 September 1907, p.3.

—'Le Salon des Indépendants', *Gil Blas*, 20 March 1908, pp.1–2.

—'Le Salon d'Automne', *Gil Blas*, 30 September 1908.

—'Le Salon des Indépendants', *Gil Blas*, 25 March 1909, pp.1–2.

—'Le Salon d'Automne', *Gil Blas*, 30 September 1909.

Snowden Ward, 'Australian Art and Other Exhibitions', *Art Journal*, 1898, p.187.

Nicholas Watkins, *Bonnard*, London 1994.

—*Bonnard: Colour and Light*, London 1998.

Frederick Wedmore, 'The Impressionists' Exhibition', *The Academy*, 28 April 1883

— 'The Society of British Artists', *The Academy*, 2 May 1886.

Gabriel P. Weisberg, *The Realist Tradition: French Painting and Drawing, 1830–1900*, exh. cat., Cleveland Museum of Art 1980.

Michael Wentworth, *James Tissot*, Oxford 1984.

Sarah Whitfield and John Elderfield, *Bonnard*, exh. cat., Tate Gallery, London 1998.

Timothy Wilcox, *Alphonse Legros, 1837–1911*, exh. cat., Musée des Beaux-Arts, Dijon 1987.

Daniel Wildenstein, *Claude Monet: Biographie et catalogue raisonné*, 5 vols., Lausanne and Paris 1974–91.

Willy [Henri Gauthier-Villars], *Maîtresse d'Esthètes* (1897), Paris 1995.

Wolfgang Wittrock, *Toulouse-Lautrec: The Complete Prints*, 2 vols., London 1985.

Richard Wood and Elizabeth Ogborn, *William Tom Warrener, 1861–1934*, exh. cat., Usher Gallery, Lincoln 1974.

'X', 'Choses et autres', *La Vie parisienne*, 18 April 1891, p.222.

Andrew McLaren Young, Margaret F. MacDonald, Robin Spencer and Hamish Miles, *The Paintings of James McNeill Whistler*, New Haven and London 1980.

Emile Zola, *Le Bon Combat: De Courbet aux impressionnistes*, ed. Jean-Paul Bouillon, Paris 1974.

Jorg Zutter, Gloria Groom et al., *Bonnard: Observing Nature*, exh. cat., National Gallery of Australia, Canberra 2003.

Note

The abbreviation 'L' in the text refers to Paul-André Lemoisne, *Degas et son Oeuvre*, 4 vols., Paris 1946–9.

JACQUES-EMILE BLANCHE
Born Auteuil, Paris, 1 January 1861
Died Paris, 20 September 1942

The son of an eminent nerve specialist, Blanche trained informally under Henri Gervex (1852–1929), and later had advice from Manet and Degas. From his early twenties he made regular visits to London where he had close contact with Whistler and Sickert. His talents as a portraitist and his fashionable social circle are evident in the number of commissions he received and from the portraits he made of eminent artists, writers and musicians including James Joyce (1882-1941), Jean Cocteau (1889-1963) and Vaslaw Nijinsky (1890-1960). He exhibited these works with the New English Art Club from 1887 and at the Paris Salon from 1882. Blanche frequently invited his artist friends to his family home (which had an adjoining studio) in Auteuil, and to his summer home Bas-Fort-Blanc, in Dieppe. When Sickert moved to Dieppe, he introduced him to many French writers and painters there, including André Gide. Towards the end of his life Blanche described Sickert as his 'best friend'. Blanche was an enthusiastic collector, and owned Sickert's *P.S. Wings in the O.P Mirror* (no.61) and *The Rehearsal* (no.6) by Degas. He remained on good terms with Degas until 1903 when Blanche, against Degas's wishes, allowed the periodical *The Studio* to reproduce the portrait he made of him.

Louis Metman 1888
Oil on canvas 215 × 95 | 84⅝ × 37⅜
Château-Musée de Dieppe
[no.**74**]

The Savile-Clark Girls c.1895
Oil on canvas 213.4 × 147.3 | 84 × 58
Leeds Museums and Galleries, City Art Gallery
[no.**80**]

GIOVANNI BOLDINI
Born Ferrara, 31 December 1842
Died Paris, 11 January 1931

Boldini was taught painting by his father, a painter and restorer, and by the age of eighteen he had already become established as a portrait painter in his native Ferrara. After inheriting some money he moved to Florence and became acquainted with the progressive Macchiaioli group of artists. Boldini visited London in 1870, and the following year settled in Paris, where he began to sell his landscapes and genre pieces through the art dealer, Adolphe Goupil (1806 or 1809–1893). From the early 1880s he produced large swagger portraits of society's fashionable faces, including *Comte Robert de Montesquiou* (1897) and *Consuelo, Duchess of Marlborough*

(1906). His style is characterised by its restless brushwork and dynamic composition, which anticipated Sickert's remark that Boldini was the 'parent of the wriggle and chiffon school of portraiture'. Boldini built up a close friendship with Degas who may have encouraged his enthusiasm for printmaking in the late 1870s, as well as his preference for using pastel for some of his large-scale portraits. In 1889 the two artists travelled to Spain, where they came under the spell of Velásquez in the Prado, and later to Morocco. By the 1890s Boldini, together with Whistler and Sargent (1856-1925), had become one of Europe's most sought-after portraitists, and he continued to receive portrait commissions until the end of his life.

James A. McNeill Whistler 1897
Oil on canvas 170.5 × 94.6 | 67⅛ × 37¼
Brooklyn Museum. Gift of A. Augustus Healy
[no.**79**]

Gertrude Elizabeth, Lady Colin Campbell
c.1897
Oil on canvas 184.3 × 120.2 | 72½ × 47⅜
National Portrait Gallery, London
LONDON ONLY
[no.**78**]

PIERRE BONNARD
Born Fontenay-aux-Roses, near Paris, 3 October 1867
Died Le Cannet, 27 January 1947

Bonnard trained as a lawyer but, at the age of twenty, decided to pursue his ambition to become an artist, enrolling at the Académie Julian and later at the Ecole des Beaux-Arts in Paris. Here he met Maurice Denis (1870–1943), Paul Sérusier (1864–1927) and Vuillard, and became part of the group of young avant-garde Parisian artists known as Les Nabis. From this period Bonnard restricted his subject matter to intimate views of domestic life, and his paintings and prints became characterised by their flattened abstracted forms and bold, bright colours. In the 1890s Toulouse-Lautrec and Bonnard became close friends, meeting regularly at the home of the publisher, Thadée Natanson. Both contributed to *La Revue blanche* and *L'Estampe originale*. With Vuillard, they also collaborated on designs for stage decor, including a notorious production of Alfred Jarry's *Ubu roi* in 1896. From the 1890s Bonnard began to paint nude female figures in domestic settings, a subject that was also to fascinate both Sickert and Degas. Bonnard and Sickert, who knew each other, shared the Parisian dealer, Bernheim-Jeune.

In the Bathroom 1907
Dans le cabinet de toilette
Oil on board 106 × 71
Private collection
Not illustrated

Woman in Front of a Mirror c.1908
Femme devant un miroir
Oil on canvas 124.2 × 47.4 | 49 × 18⅝
National Gallery of Australia,
Canberra
[no.**95**]

The Mirror in the Green Room 1909
La Glace de la Chambre Verte
Oil on paper 50.2 × 65.4 | 19¾ × 25¾
Indianapolis Museum of Art, James E. Roberts Fund
[no.**96**]

Interior with a Boy 1910
Intérieur avec un garçon
Oil on canvas 41 × 63.5 | 16 × 25
The Phillips Collection, Washington, DC
[no.**113**]

GEORGE CLAUSEN
Born London, 18 April 1852
Died Newbury, Berkshire, 22 November 1944

The son of a Danish decorator, Clausen began his artistic training at the National Art Training School in South Kensington under Edwin Long (1829-1891), and at the same time worked as an apprentice at a London firm of decorators. He continued his studies at the Antwerp Academy and the Académie Julian in Paris where he first encountered the work of the naturalist painter, Jules Bastien-Lepage, and artists associated with the French plein-air school. In 1877 Clausen settled in Hampstead, London, and began to paint scenes of contemporary urban life, often using photographs as an aide-memoire. The dramatic composition and unusual viewpoints of these works, such as *Spring Morning: Haverstock Hill* (no.11), reveal an awareness of the work of de Nittis and Tissot who were also working in London at this time. From the early 1880s Clausen began to produce large, and often idealised, paintings of fieldworkers set in Berkshire and later Essex which are characterised by their earthy colours and subdued tones. He was a founder member of the New English Art Club. Clausen was familiar with the work of Degas and he owned *Fan: Dancers* (no.39) He was knighted in 1927.

A Spring Morning, Haverstock Hill 1881
Oil on canvas 101.6 × 134.6 | 40 × 53
Bury Art Gallery & Museum, Lancashire
[no.**11**]

CHARLES CONDER
Born London, 24 October 1868
Died Virginia Water, Surrey, 9 February 1909

Spending his early years in England and India, Charles Edward Conder emigrated to Australia with his family in 1884 and began work as a surveyor. He started his studies as an artist at the Royal Art Society in Sydney, and in 1888 moved to Melbourne where his artist friends, Tom Roberts (1856-1931) and Arthur Streeton (1867-1943), accompanied him on painting expeditions and taught him to paint the local landscape in an Impressionist manner. In 1890 Conder moved to Paris to continue his studies at the Académie Julian and the Atelier Cormon. He made the most of the Parisian nightlife and began frequenting the notorious cafés and bars in the artistic quarter of Montmartre with William Rothenstein and Toulouse-Lautrec . Here he made some remarkable sketches of the dancers at the Moulin Rouge, which echo Toulouse-Lautrec's compositions. During this period he began to use watercolours on silk and make designs for painted fans, often with fanciful subjects. Conder settled in London in 1897 (although he continued to make frequent visits to Paris and Dieppe) where his work was already well known from exhibitions at the New English Art Club and the Carfax Gallery. His English friends included Aubrey Beardsley (1872-1898), Oscar Wilde (1854-1900), Blanche and Sickert. Before his early death he was committed to an asylum for the incurably insane.

The Moulin Rouge 1890
Oil on panel 25.6 × 34.1 | 10 × 13⅜
Manchester City Galleries
[no.**47**]

Dancer at the Moulin Rouge c.1891
Pen and ink on beige paper 17 × 12 | 7 × 4¾
Barry Humphries
[no.**50**]

La Goulue c.1891
Black chalk on brown grey paper 20.5 × 14.5 | 8 × 5¾
Barry Humphries
[no.**46**]

The Old Faun c.1895–1900
Pen and ink, gouache and silver paint
11.5 × 40 | 4½ × 15¾
Barry Humphries
[no.**41**]

JULES DALOU
Born Paris, 31 December 1838
Died Paris, 15 April 1902

The son of a glovemaker, Aimé-Jules Dalou trained as a sculptor at the Petite Ecole and at the Ecole des Beaux-Arts under Jean-Baptiste Carpeaux (1827-1875) and François Joseph Duret (1804-1865). A staunch Republican, Dalou was forced to move to London following the collapse of the Commune, and he remained there until the Amnesty nine years later. Being introduced to a wide circle of patrons by the Slade Professor, Alphonse Legros (1837-1911), Dalou began to execute portrait busts and genre subjects in terracotta which he sent annually to Royal Academy exhibitions. His statuettes of women reading, sewing and getting dressed were enthusiastically collected. Degas produced similar sculptures of modern subjects. Following his appointment as professor of sculpture at the South Kensington School of Art, Dalou began to influence a new generation of sculptors, Edouard Lanteri (1848-1917) amongst them, towards a more naturalist approach to the medium. On his return to Paris, Dalou was commissioned to undertake large public works in a Baroque style, his most well known being the allegorical *Triumph of the Republic* (1879-99) for the Place de la Nation. In 1889 Dalou was awarded the Grand Prix of the International Exhibition, and was later made an officer of the Legion of Honour.

Hush-a-bye Baby c.1874
La Berceuse
Terracotta H. 53 | 20⅞
Victoria and Albert Museum, London
[no.**15**]

Woman Reading c.1877, cast c.1905–17
La Liseuse
Bronze H. 55.9 | 22
Toledo Museum of Art. Purchased with funds
from the Libbey Endowment,
Gift of Edward Drummond Libbey
[no.**16**]

EDGAR DEGAS
Born Paris, 19 July 1834
Died Paris, 27 September 1917

Edgar Hilaire Germain Degas grew up in a cultured home and was destined for a legal career, but by 1854 decided to train as an artist, entering the Ecole des Beaux-Arts as a student of a former pupil of Ingres, Louis Lamothe (1822-1869). Lamothe encouraged Degas's strong sense of draughtsmanship, which he developed during his three years in Rome copying Renaissance drawings and frescoes. Having returned to Paris in 1859, Degas met Manet (1832-1883) around whom eventually coalesced the circle of young Impressionists who gathered at the Café Guerbois. By the later 1860s he began to embrace contemporary Parisian life. His paintings of ballet dancers, racecourses, theatres and cafés, which are characterised by their unusual viewpoints and asymmetrical composition, appeared regularly in exhibitions in Paris and London. By the end of the decade Degas could pick and choose his dealers, and he increasingly experimented with other media, such as printmaking and pastels. He visited England quite regularly in the mid-1870s, where many of his works were bought by collectors and artists there, including Sickert (with whom he remained friends throughout his lifetime), Clausen and Sir William Eden. As a result, he influenced a large number of British artists, such as Steer and Elizabeth Forbes, who began to use pastel and adopted his style of careful composition and strong drawing. From the 1890s, as he began to lose his eyesight, Degas principally produced pastel drawings of (primarily) dancers, women bathing and women at their toilet, and clay and wax sculptures of dancers which were left in his studio on his death, and posthumously cast in bronze. His funeral, held at Montmartre Cemetery, was attended by over one hundred people including Monet (1840-1926) and Georges Durand-Ruel (1866-1933).

Interior (The Rape) 1868–9
Intérieur
Oil on canvas 81.3 × 114.3 | 32 × 45
Philadelphia Museum of Art.
The Henry P. McIlhenny Collection,
in memory of Frances P. McIlhenny,
1986
[no.**110**]

Woman at a Window 1871–2
Femme à la Fenêtre
Oil on paper 61.3 × 45.9 | 24⅛ × 18
The Samuel Courtauld Trust,
Courtauld Institute of Art Gallery,
London
LONDON ONLY
[no.**101**]

The Dance Class 1873
La classe de danse
Oil on canvas 47.6 × 62.2 | 18¾ × 24½
Corcoran Gallery of Art, Washington, DC
William A. Clark Collection
[no.**4**]

The Rehearsal 1873–4
La Répétition de danse
Oil on canvas 58.4 × 83.8 | 23 × 33
Glasgow Museums: The Burrell Collection
LONDON ONLY
[no.**6**]

The Dance Rehearsal c.1873–5
Oil on canvas 40.6 × 54.6 | 16 × 21½
The Phillips Collection, Washington, DC.
Partial and promised gift of anonymous donor, 2001
WASHINGTON ONLY
[no.**5**]

Two Dancers on a Stage 1874
Deux danseuses en scène
Oil on canvas 61.5 × 46 | 24 ¼ × 18⅛
The Samuel Courtauld Trust,
Courtauld Institute of Art Gallery, London
LONDON ONLY
[no.**8**]

L'Absinthe 1875–6
Oil on canvas 92 × 68 | 36¼ × 26 ¾
Musée d'Orsay, Paris
Bequest of comte Isaac de Camondo, 1911
LONDON ONLY
[no.**42**]

Yellow Dancers (In the Wings) 1875–9
Danseuses se préparant au ballet
Oil on canvas 73.5 × 59.5 | 29 × 23⅜
Art Institute of Chicago.
Gift of Mr and Mrs Gordon Palmer,
Mr and Mrs Arthur M. Wood, Mrs Bertha P. Thorne,
and Mrs Rose M. Palmer
LONDON ONLY
[no.**26**]

*The Ballet Scene from Meyerbeer's Opera
'Robert le Diable'* 1876
Ballet de Robert le Diable
Oil on canvas 76.6 × 81.3 | 30¼ × 32
Victoria and Albert Museum, London
LONDON ONLY
[no.**23**]

Carlo Pellegrini c.1876–7
Oil on paper mounted on board 63.2 × 34 | 24¾ × 13⅜
Tate. Presented by the National Art Collections Fund
1916
LONDON ONLY
[no.**2**]

Jockeys before the Start 1878–9
Jockeys avant la course
Oil and *essence* on paper 104.3 × 73.7 | 41⅛ × 29
Barber Institute of Fine Arts,
The University of Birmingham
LONDON ONLY
[no.**19**]

Fan: Dancers and Stage Scenery c.1878–80
Danseuses sur la scène
Gouache with gold highlights on silk,
mounted on card 31 × 61 | 12¼ × 24
Eberhard W. Kornfeld, Bern
[no.**38**]

Fan: Dancers 1879
Eventail: danseuses
Gouache, oil pastel and oil paint on silk
30.5 × 61 | 12 × 24
Tacoma Art Museum. Gift of
Mr and Mrs W. Hilding Lindberg
[no.**39**]

Miss La La at the Cirque Fernando 1879
Mlle La La au Cirque Fernando
Oil on canvas 116.8 × 77.5 | 46 × 30½
National Gallery, London
LONDON ONLY
[no.**22**]

Little Dancer Aged Fourteen 1880–1, cast c.1922
Petite danseuse de quatorze ans
Painted bronze with muslin and silk
98.4 x 41.9 × 36.5 | 38¾ × 16.5 × 14⅜
Tate. Purchased with assistance from the National Art
Collections Fund 1952
LONDON ONLY
[no.**14**]

Bed-Time c.1880–5
Le Coucher
Pastel and gouache over a monotype print on paper
22.9 × 44.5 | 9 × 17½
Tate. Presented by C. Frank Stoop 1933
[no.**89**]

Dancers in the Rehearsal Room c.1882–5
Danseuses au foyer
Oil on canvas 39.1 × 89.5 | 15⅜ ×35 ¼
The Metropolitan Museum of Art, New York.
H.O. Havemeyer Collection, Bequest of
Mrs H.O. Havemeyer, 1929
[no.**43**]

*Women Leaning on a Rail
(on the Boat)* c.1883
Femmes accoudées à une Balustrade (sur le Bateau)
Pastel on paper 57 × 83 | 22½ × 32¾
Private collection
LONDON ONLY
[no.**20**]

Unhappy Nelly c.1885
Pastel on paper 63.5 × 48 | 25 × 18⅞
Museu de Montserrat.
Xavier Busquets donation
[no.**21**]

HENRI FANTIN-LATOUR
Born Grenoble, 14 January 1836
Died Buré, Orne, 25 August 1904

The son of a portrait painter, Ignace-Henri-Jean-Théodore Fantin-Latour moved to Paris with his family in 1841. He was accepted into the Ecole des Beaux-Arts in 1854 but left within a year, having failed to gain full admission. He continued his training by copying Old Master paintings in the Louvre, and it was here that he met Whistler. In 1859 Whistler invited him back to London and introduced him to his social circle of artists and writers. Soon after, Fantin-Latour became acquainted with Edwin and Ruth Edwards who became his principal collectors and patrons in England. During the 1860s and 1870s they enabled him to earn a steady income by clearing his studio of flowers-pieces and still-lifes and selling them to eager collectors in England, including the Greek Ionides family. These paintings were also frequently accepted for exhibition at the Royal Academy where they were much admired for their naturalistic detail. In Paris, Fantin-Latour continued to exhibit regularly at the Salon, and he became associated with large group portraits of avant-garde painters and writers, including Manet (1832-1883), Emile Zola (1840-1902) and Charles Baudelaire (1821-1867). He painted portraits of his family and musical friends, which are characterised by their austere composition and dark backgrounds. From the late 1860s Fantin-Latour was a habitué of the Café Guerbois, where he met Degas. Around 1868 Degas painted a portrait of the still-life painter, Victoria Dubourg, whom Fantin-Latour would later marry.

Mr and Mrs Edwin Edwards 1875
M et Mme Edwin Edwards
Oil on canvas 130.8× 98.1 | 51 ½ × 38 ⅝
Tate. Presented by Mrs E. Edwards 1904
[no.**3**]

ELIZABETH FORBES
Born Kingston, Ontario, 1859
Died Newlyn, Cornwall, 1912

Elizabeth Forbes trained at the South Kensington School of Art in London, and later at the Art Students' League in New York under William Merrit Chase (1849-1916). She spent several months in the artists' colony of Pont-Aven in Brittany before settling in London, where she became friends with Whistler and Sickert, who regarded her work very highly. They instructed her in the technique of drypoint, and some of her prints assimilate the subtleties of Whistler's works in this medium. In 1885 she moved to Newlyn in Cornwall and became involved with the Newlyn school of artists, marrying its leading practitioner, Stanhope Forbes (1857-1947) in 1889. Despite the opposition

from her husband towards the 'rackety' life of Sickert, she frequently attended parties at his home where she was given access to his art collection and introduced to the work of Degas. Forbes's recurring subject was women and children, and the experimental composition and technique of some of these paintings and pastels, such as *Oranges and Lemons* (no.30), reveals her knowledge and enthusiasm for Degas's work.

Oranges and Lemons c.1890
Pastel on paper 78.5 × 72 | 31 × 28⅜
Private collection, courtesy of
The Belgrave Gallery, London
[no.**30**]

JAMES GUTHRIE
Born Greenock, 10 June 1859
Died Rhu, Strathclyde, 6 September 1930

Guthrie intially trained as a lawyer at the University of Glasgow, but in 1877 gave up his studies to train as an artist under James Drummond (1816-1877). The following year he started work in John Pettie's (1839-1893) studio in London, and began producing large-scale history and genre paintings. Guthrie made two visits to Paris during the 1880s, and there made a series of pastel drawings which are considered to be his most important and experimental works. Pastel was Degas's preferrred medium and Guthrie may have been inspired to produce these drawings, which acknowledge Degas's aesthetic, after seeing exhibitions of his work in the Parisian galleries. His work in this medium was admired by Sidney Starr who wrote in praise of Guthrie's pastels in the *Whirlwind* (1890). Eventually drawn back to his native Scotland, he was visited by Arthur Melville, who accompanied him on one of his trips to Paris. Guthrie produced portraits from the late 1880s, and occasionally worked in the manner of Whistler. He was knighted in 1903.

Fire Light Reflections 1890
Pastel on board 60.5 × 72.2 | 23⅞ × 28⅜
Paisley Museum and Art Gallery
[no.**31**]

ARTHUR MELVILLE
Born Loanhead of Guthrie, Angus, Tayside,
10 April 1855
Died near Witley, Surrey, 28 August 1904

Melville began his artistic training at the Royal Scottish Academy Schools, but later moved to Paris where he attended the Académie Julian and was introduced to the work of the Impressionists. During this period he became familiar with new methods of watercolour and, between 1878 to 1881, when he was working in the thriving artistic community at

Grez-sur-Loing, he began to experiment with the medium. The innovative technique he devised, which involved working on wet paper to allow areas of colour to run together, can be seen in a group of near-abstract watercolours of the Moulin Rouge which he made during the second of his two trips to Paris in 1886 and 1889. Although Melville settled in London in 1889, he continued to make regular excursions to Europe and the Middle East where he created vivid and colourful impressions of the local scenery in watercolours and oils. He later became part of the hanging committee of the Grosvenor Gallery, and here met Clausen and Orchardson. Melville also made the acquaintance of Guthrie through his association with the Glasgow Boys, who represented the progressive and anti-establishment branch of the Scottish Academy.

Dancers at the Moulin Rouge, Paris 1889
Watercolour on paper 9.4 × 15.5 | 3¾ × 6⅛
National Gallery of Scotland, Edinburgh
[no.**51**]

Dancers at the Moulin Rouge, Paris 1889
Watercolour on paper 15.1 × 9.2 | 5⅞ × 3⅝
National Gallery of Scotland, Edinburgh
[no.**52**]

GIUSEPPE DE NITTIS
Born Barletta, Puglia, 25 February 1846
Died Saint-Germain-en-Laye, near Paris, 21 August 1884

De Nittis was one of the few Italian artists to become part of the Impressionist movement of painters. He studied at the Istituto di Belle Arti in Naples but, after being expelled for rebelling against the academic teaching methods, he spent his early years visiting Florence, Rome and Turin painting the surrounding Italian countryside. He arrived in Paris in 1867 and, despite being penniless and unable to speak French, he settled there permanently the following year. Around 1874 he met Degas who invited him to participate in the first Impressionist exhibition. The two artists were to develop a close friendship. During the 1870s de Nittis worked for the dealer, Adolphe Goupil (1806 or 1809–1893), and began to spend months at a time in London (where he established contact with Tissot) chronicling the bustling city life and urban development. His pictures, often characterised by their high viewpoints and bold compositional structures, were enthusiastically received, one critic remarking that he was, 'a southerner in the South [of Italy], French in Paris and a Londoner in London'. Influenced by Degas, de Nittis produced a large number of prints (including a drypoint of Degas) and also works in pastel.

Piccadilly 1875
Oil on panel 84 × 120 | 33 × 47¼
Donà dalle Rose Collection
[no.**10**]

Westminster Bridge II c.1875
Oil on canvas 46 × 61 | 18⅛ × 24
Private collection
[no.**9**]

WILLIAM QUILLER ORCHARDSON
Born Edinburgh, 27 March 1832
Died London, 13 April 1910

Orchardson studied art at the Trustees' Academy in Edinburgh (now the Scottish Royal Academy), where his fellow students included Thomas Faed (1826-1900) and James Archer (1823-1904). In 1862, at the age of 30, he moved to London where the historical accuracy of his literary and genre paintings was much admired and bought by a middle-class clientele. His later paintings, which portrayed the subtle dramas of upper-class life, for example *The First Cloud* (1888), received considerable interest when they were exhibited at the Royal Academy and at winter exhibitions of the French Gallery, and were admired by Whistler, Sickert and Degas. Orchardson heightened the emotional effect in these paintings by employing wide formats and empty spaces to emphasise the psychological tensions between couples. Amongst the small number of portraits he executed, *Master Baby* (no.18), which portrays his wife and child, is his most innovative in technique and composition. The painting was noticed by Degas at the Exposition Universelle in Paris in 1889, although Sickert remarked that Degas had 'liked other things of his [Orchardson's] better'. Orchardson was elected Royal Academician in 1877 and was knighted in 1907.

Master Baby 1886
Oil on canvas 109 x 168 | 42⅞ × 66⅛
National Gallery of Scotland, Edinburgh
[no.**18**]

AUGUSTE RODIN
Born Paris, 12 November 1840
Died Meudon, 18 November 1917

Now regarded as the most influential sculptor of the nineteenth century, François-Auguste-René Rodin had a slow beginnning. At the age of fourteen, he entered the Ecole Spéciale de Dessin et de Mathématiques, but was rejected three times from the Ecole des Beaux-Arts and spent several years working as an ornamental mason. In 1875 Rodin travelled to Italy where he was greatly influenced by his study of Donatello (1386/7–1466) and Michaelangelo (1475–1564). The audacious realism

of some of the sculptures he produced following his return, for example *Age of Bronze* (1876), resulted in accusations that he had deliberately cast his statues directly from life. Throughout the 1880s Rodin maintained close contacts with England, and became friends with Whistler and Sickert who frequently visited his studio. His work was made available to a circle of English collectors through William Rothenstein and Robert Ross's Carfax Gallery, and through exhibitions at the Royal Academy and the International Society. He was elected President of the former society in 1905. Although Degas was friends with many prominent sculptors, he is only known to have met Rodin on one occasion.

Etude pour la muse nue, bras coupés 1905-6
Bronze 65.5 × 33 × 34 | 25¾ × 13 × 13⅜
Musée Rodin, Paris
[no.**98**]

WILLIAM ROTHENSTEIN
Born Bradford, 29 January 1872
Died Far Oakridge, near Stroud, 14 February 1945

The son of a wool merchant, Rothenstein left Bradford at the age of sixteen to study at the Slade School of Art. In 1889 he entered the Académie Julian in Paris where he first met Charles Conder. The two artists formed a close friendship and, sharing a studio in Montmartre, they quickly became absorbed into the bohemian life of the capital. Around 1890 Rothenstein met Toulouse-Lautrec, whom he later described as 'a frank ... brutal cynic ... endowed with a keen intellect'. Recognising the talents of both Conder and Rothenstein, Toulouse-Lautrec organised a joint exhibition of their work at the Galerie Georges Thomas in Paris. The exhibition proved to be the turning point in Rothenstein's career and, enthusiastic about the work he had seen there, Degas invited Rothenstein to his studio where Rothenstein later recalled that they exchanged artistic advice about drawings, waxes and photographs. Degas became a major influence on the style and subject matter of Rothestein's work, especially in the portraits he made of his family and close friends in domestic interiors, such as Charles Conder (nos.54, 77). In 1894 he returned to London and became a member of the New English Art Club, and was appointed artistic manager of the Carfax Gallery, where he promoted the work of Sickert, Conder and others. He was knighted in 1931.

Parting at Morning 1891
Chalk, pastel and bronze paint on paper
129.5 × 50.8 | 51 × 20
Tate. Bequeathed by Sir John Rothenstein 1992
[no.**55**]

Conder Seated in the Studio c.1891
Pastel and crayon on paper
36.5 × 23 | 14⅜ × 9
Barry Humphries
[no.**54**]

Toulouse-Lautrec c.1891-3
Pencil and chalk on brown paper 31.4 × 17.9 | 12⅜ × 7
Barry Humphries
[no.**45**]

The Painter Charles Conder 1892
Oil on canvas 120.2 × 55.1 | 47¼ × 21¾
Toledo Museum of Art. Purchased with
funds from the Libbey Endowment,
Gift of Edward Drummond Libbey
[no.**77**]

Arthur Symons 1894
Black chalk and pastel on paper
46.5 × 34.5 | 18¼ × 13⅝
Barry Humphries
[no.**56**]

The Coster Girls 1894
Oil on canvas 101 × 76 | 39¾ × 29⅞
Sheffield Galleries and Museums Trust
[no.**82**]

WALTER RICHARD SICKERT
Born 31 May 1860, Munich
Died 22 January 1942, Bathampton, Somerset

The son of an artist of Danish descent and an Anglo-Irish mother, Walter Richard Sickert moved from Germany to England when he was eight years old. After spending four years as a touring actor, he studied briefly at the Slade until Whistler encouraged him to become an apprentice in his studio. In 1883, on a trip to the Paris Salon accompanying Whistler's portrait of his mother, he met Degas who would become his artistic mentor and lifelong friend. Degas urged Sickert to study the traditional skills of draughtsmanship, and many of his early paintings of the performers and audiences in London's music halls, such as *The Oxford Music Hall* (no.28), show his adoption of Degas's methods of composition and building up paintings from a basis of drawings. Sickert moved to Dieppe in 1898 and spent the next seven years living abroad, exhibiting his work frequently in Paris and making regular visits to Degas's studio. Returning to England in 1905 Sickert settled in Camden Town and began to paint a series of working-class women set in gloomy interiors. During this period he actively communicated his knowledge of French painting to a group of artists who gathered in his studio in north London and exhibited as the Fitzroy Street Group, later the Camden Town Group. Throughout his lifetime Sickert wrote and lectured about art extensively, frequently championing Impressionism and then Post-Impressionism in the face of great critical hostility.

The Oxford Music Hall c.1888-9
Oil on canvas 76.7 × 63.6 | 30¼ × 25
Art Gallery of New South Wales, Sydney.
Purchased 1944
[no.**28**]

The P.S. Wings in the O.P Mirror 1889
Oil on canvas 61 × 51 | 24 × 19⅞
Musée des Beaux-Arts, Rouen
Jacques-Emile Blanche, 1922
[no.**61**]

The Old Bedford: Cupid in the Gallery c.1890
Oil on canvas 126.5 × 77.5 | 50 × 30½
National Gallery of Canada, Ottawa. Gift of the Massey
Collection of English Painting 1946
WASHINGTON ONLY
[no.**29**]

Aubrey Beardsley 1894
Oil on canvas 76.2 × 31.1 | 30 × 12¼
Tate. Purchased with assistance from the National Art
Collections Fund 1932
[no.**76**]

The Gallery at the Old Bedford c.1895
Oil on canvas 76.2 × 60.4 | 30 × 23¾
National Museums Liverpool, The Walker
LONDON ONLY
[no.**27**]

*Fan: Little Dot Hetherington
at the Old Bedford Theatre* c.1889
24.9 × 34.4 | 9¾ × 13½
The Fan Museum, Greenwich, London
[no.**40**]

Minnie Cunningham at the Old Bedford 1892
Oil on canvas 76.5 × 63.8 | 30⅛ × 25⅛
Tate. Purchased 1976
[no.**62**]

The Blackbird of Paradise c.1896-8
Oil on canvas 66.1 × 48.3 | 26 × 19
Leeds Museums and Galleries, City Art Gallery
[no.**83**]

*Gatti's Hungerford Palace of Varieties:
Second Turn of Miss Katie Lawrence* c.1903
Oil on canvas mounted on hardboard
84.4 × 99.3 | 33¼× 39
Art Gallery of New South Wales, Sydney.
Watson Bequest Fund 1946
[no.**25**]

Conversations 1903-4
Oil on canvas 45.7 x 38.1 | 18 × 15
Private collection, courtesy Ivor Braka Ltd, London
[no.**84**]

La Giuseppina Against a Map of Venice 1903–4
Oil on canvas 50.8 × 40.6 | 20 × 16
Private collection
[no.**102**]

La Nera 1903–4
Oil on canvas 6.3 × 38.9 | 18¼ × 15¼
City and County of Swansea
Glynn Vivian Art Gallery Collection
[no.**103**]

Two Women on a Sofa: Le Tose c.1903–4
Oil on canvas 45.7 × 53.3 | 18 × 21
Tate. Bequeathed by Sir Hugh Walpole 1941
[no.**105**]

Dancer of Memphis, USA c.1904
Danseuse de Memphis, USA
Oil on canvas 50.8 × 40.7 | 20 × 16
Private collection
[no.**99**]

Cocotte de Soho 1905
Pastel on paper 62 × 50 | 24⅜ × 19¼
Private collection
LONDON ONLY
[no.**71**]

The Iron Bedstead c.1905
Le Lit de fer
Pastel on paper 33 × 50.1 | 13 × 19¾
Private collection
LONDON ONLY
[no.**87**]

La Coiffure 1905–6
Pastel on paper 69.5 × 54 | 27¼ × 21¼
Private collection
[no.**90**]

La Maigre Adeline 1906
Oil on canvas 46.4 × 38.7 | 18¼ × 15¼
The Metropolitan Museum of Art, New York.
Bequest of Scofield Thayer, 1982
[no.**93**]

Woman Washing her Hair 1906
Oil on canvas 45.7 × 38.1 | 18 × 15
Tate. Bequeathed by
Lady Henry Cavendish-Bentinck 1940
[no.**92**]

La Hollandaise c.1906
Oil on canvas 51.1 × 40.6 | 20⅛ × 16
Tate. Purchased 1933
[no.**100**]

Girl at a Window, Little Rachel 1907
Oil on canvas 50.8 × 40.6 | 20 × 16
Tate. Accepted by HM Government in lieu of tax
and allocated to the Tate Gallery 1991
[no.**104**]

The Painter in his Studio 1907
Oil on canvas 51.3 × 61 | 20¼ × 24
Art Gallery of Hamilton, Ontario
Gift of the Women's Committee 1970
[no.**97**]

The Mantelpiece c.1907?
Oil on canvas 76.2 × 50.8 | 30 × 20
Southampton City Art Gallery
[no.**109**]

Ennui c.1914
Oil on canvas 152.4 × 112.4 | 60 × 44¼
Tate. Presented by the Contemporary Art Society 1924
[no.**111**]

SIDNEY STARR
Born Kingston upon Hull, 10 June 1857
Died New York, 3 March 1925

Starr studied at the Slade School in London under Edward Poynter (1836-1919) and Alphonse Legros (1837-1911). He was taken under Whistler's wing in 1882, and in 1886 he was elected a member of the Society of British Artists, the year Whistler became president. Following Whistler's forced resignation two years later, Starr became one of a number of artists, including Sickert and Steer (1847-1926), who featured in an independent exhibition at the Goupil Gallery in 1889 called *The London Impressionists*. The exhibition was organised by Sickert, who bought Starr's small painting, *A Study* (1887), which was included amongst the exhibits. Starr was greatly influenced by Sickert had access to his collection of paintings by French artists, which included work by Degas. Both in the choice of subject matter and modern composition, *At the Café Royal* (no.33) reveals his debt to the work of Degas. In 1892 he emigrated to the United States and became a successful painter and decorative designer in New York.

Paddington Station 1886
Pastel on paper 122.5 × 206 | 48¼ × 81⅛
Durban Art Gallery
[no.**12**]

At the Café Royal 1888
Pastel on canvas 61 × 50.8 | 24 × 20
Private collection
[no.**33**]

The City Atlas 1889
Oil on canvas 61 × 51 | 24 × 20
National Gallery of Canada, Ottawa. Gift of the Massey
Collection of English Painting 1946
[no.**24**]

PHILIP WILSON STEER
Born Birkenhead, 28 December 1860
Died London, 18 March 1942

A leading figure in the English Impressionist movement, Steer enrolled at the Gloucester School of Art, and later entered the South Kensington Schools. Having failed to gain entry at the Royal Academy Schools, he continued his studies in Paris under Adolphe William Bouguereau (1825-1905) at the Académie Julian and under Alexandre Cabanel (1823-1889) at the Ecole des Beaux-Arts. He returned to England in 1884 and experimented with a number of techniques inspired by French Impressionism in a series of sea pictures. The unusual viewpoints of his figure pictures reveal a debt to Degas, for example *Mrs Cyprian Williams* (no.37) and *Knucklebones, Walberswick* (fig.22). A founder member of the New English Art Club in 1886, he became well known in avant-garde circles, and his work was collected by Sickert, Conder and Clausen. Between 1899 and 1930 he taught painting at the Slade where he continued to promote French painting.

The Sprigged Frock 1890
Pastel on paper, laid down on canvas
59.7 x 59.7 | 23 ½ × 23 ½
William Morris Gallery, London
[no.**36**]

Mrs Cyprian Williams
and her Two Little Girls 1891
Oil on canvas 76.2 ×102.2 | 30 × 40¼
Tate. Purchased with assistance from
anonymous subscribers 1928
[no.**37**]

A Girl at her Toilet c.1892–3
Oil on canvas 75 × 62 | 29½ × 24⅜
Williamson Art Gallery & Museum,
Birkenhead
[no.**35**]

WILLIAM STOTT OF OLDHAM
Born Oldham, 20 November 1857; died while crossing
from London to Belfast, 25 February 1900

Stott studied at the Manchester School of Art
briefly before moving to France where he received
instruction in the ateliers of Léon Bonnat (1833-
1922) and Jean Léon Gérôme (1824-1904) and at
the Ecole des Beaux-Arts. After spending some
time at the international colony of artists at Grez-
sur-Loing, Stott began to send his paintings to the
progressive galleries in Paris and London. He was
a member of Whistler's inner circle and remained
on close terms with him until he painted his
mistress, Maud Franklin, as Venus. Around 1883,
shortly after being introduced to Degas, Stott
began working in pastel and he produced some of
his best work in this medium. Along with Blanche
and Fantin-Latour, his pastels were frequently
exhibited at the Grosvenor Gallery and also at the
New English Art Club. Like Sickert, Stott became
an advocate of French art in England.

CMS Reading by Gaslight 1884
Pastel on paper 48.3 × 45.7 | 19 × 18
Private collection
[no.**32**]

WILLIAM THORNLEY
Born 1857
Died 1935

Thornley was initially taught painting by his father,
Morgan Alfred Thornley, and later studied under
the French landscape painter and lithographer,
Eugène Ciceri (1813-1890), and Edmond Yon
(1836-1897). He began exhibiting his paintings at
the Paris Salon in 1878, and typically produced
landscapes and marine scenes of France and Italy
in an Impressionist manner. He won the Mention
of Honour at the Salon des Artistes Français in
1881 and shortly after won a third place medal
there. In 1888 Thornley was supported by the
Parisian dealer, Theo van Gogh (1854-1891) to pro-
duce a series of lithographic reproductions after
paintings by Degas. He had received instruction in
lithography from Achille Sirouy (1834-1904), and
during the 1880s had exhibited his reproductions
after paintings by Puvis de Chavannes (1824-
1898), Corot (1796-1875) and Pissarro (1830-1903)
at the Paris Salon where they had been well
received by both artists and collectors. As his corre-
spondence with the lithographer reveals, Degas
greatly admired Thornley's work and supported
van Gogh's suggestion that they should collaborate
on a series of prints. During the following months
the two artists worked together closely, Degas cor-
recting and retouching the stones prepared by
Thornley. When the lithographs were first shown
in April 1888 Thornley's talents were praised by the
critic, Félix Fénéon, who remarked: 'through their

sparse and essential eloquence, [they] evoke the
originals'. Thornley became a member of the
Société des Artistes Lithographes Français, but few
of his later lithographs attracted as much attention.

after Edgar Degas

Portfolio
in which the set of 15 Lithographs was issued 1889
58 × 41 | 23 × 16
William Weston
not illustrated

after Edgar Degas

15 Lithographs 1889
Bibliothèque Nationale de France, Paris
[no.**34**]

Ballet Class / La Classe de Ballet
20.3 × 26.4 | 8 × 10⅜
LONDON ONLY

Dancer by the Stove / Danseuses près de la Poêle
33.5 × 25 | 13⅛ × 9⅞
WASHINGTON ONLY

At the Bar: Exercises / A la Barre
23.4 × 28 | 9¼ × 11
WASHINGTON ONLY

Dancer Dressing / La Toilette de Danseuses
23.8 × 19.6 | 9⅛ × 7¾
WASHINGTON ONLY

The Song of the Dog: Theresa Valdon
La Chanson du Chien
36.5 × 23 | 9½ × 7⅛
LONDON ONLY

Women in a Hat Shop / Chez la Modiste
23.5 × 27 | 9¼ × 10⅝
LONDON ONLY

Getting out of the Bath / La Sortie de Bain
22.2 × 29.6 | 8¾ × 11⅜
WASHINGTON ONLY

On the Beach / Sur la Plage
19.3 × 34.2 | 7⅛ × 13½
LONDON ONLY

The following lithographs are not illustrated

The Bath / Le Bain
20.3 × 20 | 8 × 7⅞
LONDON ONLY

Ballet Practice / Répétition
21.2 × 15 | 8½ × 6½
LONDON ONLY

Before the Ballet Class / Avant La Classe
27 × 22.5 | 10⅝ × 8⅞
LONDON ONLY

Going on Stage / Entrée en Scène
26 × 15.3 | 10¼ × 6
LONDON ONLY

The Jockeys: First Version / Les Jockeys: Premier Version
23.4 × 28.0 | 9¼ × 11
WASHINGTON ONLY

Young Dancer with a Fan / Petit Danseuse à L'Eventail
26.4 × 17.2 | 10⅜ × 6¾
WASHINGTON ONLY

Singer Waiting / L'Attente de la Chanteuse
24.5 × 13.6 | 9⅝ × 5⅜
WASHINGTON ONLY

JAMES TISSOT
Born Nantes, 15 October 1836
Died Château de Buillon, Doubs, 8 August 1902

The son of an influential merchant, Jacques-
Joseph-James Tissot moved from Nantes to Paris
at the age of twenty to begin his studies with Louis
Lamothe (1822-1869) and Hippolyte Flandrin
(1809-1864). In the capital he became associated
with a number of avant-garde artists, including
Whistler, Manet and Degas, and quickly became
well known at the Salon for his highly finished soci-
ety portraits and scenes of contemporary life.
Following the Franco-Prussian War and Paris
Commune in 1871, Tissot moved to London (his
motives possibly in part political but certainly
commercial), where he spent the next eleven years
painting fashionable London society. His paintings
of elegant men and women, often in extravagant
costume, boating on the Thames or strolling in gar-
dens, frequently appeared on the walls of the Royal
Academy and Grosvenor Gallery and brought him
celebrity and financial success. During the 1880s
and 1890s, following his return to Paris, Tissot
began to work on pastel portraits of women in
wealthy Parisian society. He was a long-standing
friend of Degas, whom he probably first met in the
studio of Lamothe in the 1850s. In 1882, following
the death of his mistress, Tissot moved back to Paris.

The Ball on Shipboard c.1874
Oil on canvas 84.1 × 129.5 | 33⅛ × 51
Tate. Presented by the Trustees of
the Chantrey Bequest 1937
[no.**7**]

London Visitors c.1874
Oil on canvas 86.3 × 63.5 | 34 ¼ × 24 ¾
Milwaukee Art Museum, Layton Art Collection,
Gift of Frederick Layton
[no.**1**]

The Gallery of HMS Calcutta (Portsmouth)
c.1876
Oil on canvas
68.6 × 91.8 | 27 × 36 ⅛
Tate. Presented by Samuel Courtauld 1936
[no.**17**]

HENRI DE TOULOUSE-LAUTREC
Born Albi, Tarn, 24 November 1864
Died Château de Malromé, Gironde, 9 September 1901

Toulouse-Lautrec was born into an aristocratic family, and from a young age was encouraged to develop his artistic talents. Shortly after moving to Paris with his mother he began having informal lessons with the sporting artist René Princeteau (1844-1914) followed by more formal periods of study at the teaching studios of Léon Bonnat (1833-1922) and Fernand Cormon (1845-1924). In 1884 Toulouse-Lautrec settled in Montmartre. He thrived in the cultural hub of Paris and, contemptuous of bourgeois behaviour and conventions, began to frequent the local bars and cabarets, where he surrounded himself with dancers, music hall stars and prostitutes who became the subjects of his drawings, posters and paintings. He met Degas through the musician Désiré Dihau, a mutual acquaintance, and in 1891 he told his mother that 'Degas has encouraged me by saying that my work this summer wasn't too bad'. Although the two artists did not become close friends, the subject matter and cropped composition of a number of Toulouse-Lautrec's works reveal his debt to the older artist. By the 1890s Toulouse-Lautrec had become a leading figure in the Parisian art world, his audacious graphic work appearing regularly at the Salon des Indépendants and at the Brussels-based Les XX. He visited London on several occasions, and in 1898 his solo exhibition opened at the Goupil Gallery and was attended by the Prince of Wales and a number of his Parisian friends. During the 1890s Toulouse-Lautrec began to drink heavily, and in 1899 he was confined to a sanatorium after a number of mental breakdowns, possibly due to his syphilitic condition.

Monsieur Samary,
of the Comédie Française 1889
Monsieur Samary, de la Comédie Française
Essence on cardboard 75 × 52 | 29 ½ × 20 ½
Musée d'Orsay, Paris
Donation Jacques Laroche sous réserve d'usufruit, 1947
[no.**68**]

Portrait of Dr Henri Bourges 1891
Docteur Bourges
Oil on cardboard mounted on panel
78.7 × 50.4 | 31 × 19 ⅞
Carnegie Museum of Art, Pittsburgh.
Purchase:acquired through the generosity
of the Sarah Mellon Scaife Family 1966
[no.**70**]

Dr Péan Operating 1891-2
Le Docteur Péan opérant
Oil on cardboard 73.9 × 49.9 | 29 × 19 ⅝
Sterling and Francine Clark Art Institute,
Williamstown, Massachusetts
[no.**70**]

The Englishman at the Moulin Rouge 1892
L'Anglais au Moulin Rouge
Colour lithograph 47 × 37.3 | 18 ½ × 14 ⅝
Bibliothèque Nationale de France, Paris
NOT EXHIBITED
[no.**44**]

Charles Conder: Study for
'Fashionable People at Les Ambassadeurs' 1893
Etude pour 'Aux Ambassadeurs – Gens chic'
Oil on board 47.3 × 36.3 | 18 ⅝ × 14 ¼
Aberdeen Art Gallery and Museums Collection
[no.**43**]

Confetti 1894
Colour lithograph 57 × 39 | 22 ½ × 15 ⅜
Victoria and Albert Museum, London
[no.**63**]

Miss Ida Heath 1894
Miss Ida Heath (Danseuse anglaise)
Lithograph 36.4 × 26.4 | 14 ⅜ × 10 ⅜
The British Museum, London
[no.**58**]

May Belfort 1895
Colour lithograph 79.5 × 61 | 31 ¼ × 24
The British Museum, London
[no.**60**]

May Belfort (Grande planche) 1895
Colour lithograph 54.6 × 42.1 | 21 ½ × 16 ⅝
The British Museum, London
[no.**59**]

The Clowness Cha-U-Kao 1895
La Clownesse Cha-U-Kao
Essence on cardboard 57 × 42 | 22 ½ × 16 ½
Musée d'Orsay, Paris
Bequest of comte Isaac de Camondo, 1911
LONDON ONLY
[no.**67**]

Romain Coolus and Oscar Wilde 1896
Romain Coolus et Oscar Wilde
Lithograph 30.3 × 49 | 11 ⅞ × 19 ¼
The British Museum, London
[no.**57**]

Supper in London 1896
Souper à Londres
Crayon lithograph 31.2 × 36.2 | 12 ¼ × 14 ¼
The British Museum, London
Not illustrated
[no.**95**]

Troupe de Mlle Eglantine 1896
Colour lithograph 61.7 × 80.4 | 24 ¼ × 31 ⅝
Victoria and Albert Museum, London
[no.**64**]

Woman Curling her Hair 1896
Femme se frisant
Oil on board 56 × 39 | 22 × 15 ⅜
Musée des Augustins, Toulouse
[no.**69**]

Mme Berthe Bady 1897
Essence on cardboard 70.5 × 60 | 27 ¾ × 23 ⅝
Musée Toulouse-Lautrec, Albi
LONDON ONLY
[no.**66**]

Yvette Guilbert (album of lithographs) 1898
Lithograph 49.5 × 38 | 19 ½ × 15
The British Museum, London
[no.**71**]

Thirteen Lithographs, 'Louise Balthy' 1898
Treize Lithographies, 'Louise Balthy'
Lithograph 29.5 × 24.4 | 11 ⅝ × 9 ⅝
The British Museum, London
[no.**72**]

The Singing Lesson 1898
La Leçon de Chant
Oil on two pieces of cardboard
mounted on panel 75.7 × 69 | 29 ¾ × 27 ¼
Musée Mahmoud Khalil, Cairo
[no.**65**]

EDOUARD VUILLARD
Born Cuiseaux, Saône-et-Loire, 11 November 1868
Died La Baule, near Saint-Nazaire, 21 June 1940

Brought up in modest circumstances in Paris, Vuillard decided to pursue an artistic career and in 1886 entered the Académie Julian. The following year he passed the entrance examination to the Ecole des Beaux-Arts and began to produce realistic studies of still-life and domestic interiors which were to become his most tenacious themes. In 1889, encouraged by Paul Sérusier (1864-1927), Vuillard joined the Nabis and met Bonnard. Both artists became associated with the avant-garde

journal, *La Revue blanche*, and frequented the home of the journal's co-editor, Thadée Natanson, and his wife, Misia, in the rue Saint-Florentin in Paris and later at Villeneuve-sur-Yonne. Through the Natansons Vuillard met Toulouse-Lautrec and the two artists became close friends, Vuillard painting two portraits of him at Villeneuve-sur-Yonne. Both artists had a mutual passion for the stage. Vuillard's paintings were exhibited in Britain where they were admired by a circle of collectors and critics including Sickert. The sensitive patterning of colours, and his palette, compare with works by Sickert. From 1892 Vuillard began to receive commissions to paint large decorative panels of urban landscapes and parks for his wealthy patrons, including members of the Natanson family.

Woman Sweeping c.1889
Balayage de femme
Oil on canvas 44 × 47.3 | 17 ³/₈ × 18⁵/₈
The Phillips Collection, Washington, DC
[no.**112**]

Two Seamstresses in the Workroom 1893
Deux ouvrières dans le salon de couture
Oil on millboard 13.3 × 19.4 | 5¼ × 7 ⁵/₈
Scottish National Gallery of Modern Art, Edinburgh.
Purchased with assistance from the
National Art Collections Fund and the
National Heritage Memorial Fund 1990
[no.**107**]

Madame Hessel on the Sofa 1900
Madame Hessel sur le canapé
Oil on cardboard mounted on hardboard
54.6 × 54.6 | 21½ × 21½
National Museums Liverpool, The Walker
LONDON ONLY
[no.**106**]

A Nude in the Studio c.1909–11
Nu dans le studio
Pastel on paper mounted on canvas
64 × 47 | 25¼ × 18½
The Syndics of the Fitzwilliam Museum, Cambridge.
Bequeathed by A.S.F. Gow through the National Art
Collections Fund 1978
[no.**94**]

Woman Reading 1910
La Liseuse
Glue-based distemper on paper mounted on canvas
76 × 76 | 29⁷/₈ × 29⁷/₈
Kunstmuseum, Winterthur. Presented by Hans
Reinhart 1838
[no.**108**]

WILLIAM TOM WARRENER
Born Lincoln, 8 March 1861
Died Lincoln, 13 December 1934

The son of a prominent Lincoln coal merchant, Warrener opted out of the family business and enrolled as a student at Lincoln School of Art, and in 1884 won a scholarship to attend the Slade School. Within a year he decided to continue his art training at the Académie Julian. Shortly after, Warrener moved to Montparnasse and began studying under Gustave Boulanger (1824-1888) and Jules Lefebvre (1836-1911), regularly sending in pictures to the Royal Academy and Paris Salon. However from the early 1890s he began to circulate amongst the group of bohemian artists around Toulouse-Lautrec and, as Rothenstein recalled, 'flung himself into the most advanced movements then prevalent in Paris'. Warrener produced a large number of nude subjects during this period and, like Toulouse-Lautrec, he was inspired by his visits to the Montmartre dance halls and produced a series of lively sketches of the popular evening entertainments there. The Moulin Rouge became one of his haunts and in 1892 Toulouse-Lautrec used Warrener as a model for his lithograph *L'Anglais au Moulin Rouge* (no.44). In 1906 Warrener was forced to move back to Lincoln to take over the family business following the death of his brother. Although he actively promoted art and music in the local area he did not continue painting seriously. Few of his works survive as many were destroyed after the death of his sister, and others perished in a fire at Lincoln College of Art.

Quadrille I c.1890
Oil on canvas 46 × 55 | 18 × 21³/₄
Usher Gallery, Lincolnshire County Council
[no.**48**]

Quadrille II c.1890
Oil on canvas
46 × 55 | 18 × 21³/₄
Usher Gallery, Lincolnshire County Council
[no.**49**]

Léontine c.1894
Oil on canvas, gilded timber with canvas
35 × 25 | 13³/₄ × 9⁷/₈
Usher Gallery, Lincolnshire County Council
[no.**81**]

JAMES ABBOTT McNEILL WHISTLER
Born Lowell, Massachussetts, 11 July 1834
Died London, 17 July 1903

The son of a railway engineer, Whistler studied at the West Point Military Academy but was discharged in 1854 for failing a chemistry exam. He worked briefly as cartographer for the US Coast and Geodetic Survey before travelling to Europe,

having decided to become an artist. He studied initially at the Ecole Impériale et Spéciale de Dessin in Paris and later entered Charles Gleyre's (1806-1874) studio. In 1859 Whistler moved to London and disseminated his enthusiasms for French art which greatly influenced Sickert, who became his pupil in 1882 (the two artists had met for the first time three years earlier). Whistler and Sickert remained friends until 1897 when Whistler supported Joseph Pennell during his successful libel action against Sickert for claiming that transfer lithography was not true lithography. Whistler remained in London for much of the remainder of his life, but he continued to visit Paris regularly and meet his artist friends, including Degas. In 1893 he moved his base from London to Paris where he lived until 1896, when his wife's failing health brought him back to London. In 1898 he became President of the newly formed International Society of Sculptors, Painters and Engravers , which brought together a wide group of artists in its annual exhibitions. Alongside his 'nocturnes' with musical titles and intimate landscapes and seascapes, Whistler painted many large-scale portrait arrangements. These studies in tone and colour achieved critical acclaim in London and Paris and were highly influential on British artists such as Starr.

Harmony in Grey and Green:
Miss Cicely Alexander 1872–4
Oil on canvas 190.2 × 97.8 | 74⁷/₈ × 38½
Tate. Bequeathed by W.C. Alexander 1932
[no.**13**]

The Rose Drapery c.1888–95
Chalk and watercolour on brown paper
27.7 × 18.4 | 11 × 7 ¼
Hunterian Museum and Art Gallery,
University of Glasgow
[no.**88**]

Brown and Gold: Self-portrait c.1895–1900
Oil on canvas 95.8 × 51.5 | 37³/₄ × 20¼
Hunterian Art Gallery, University of Glasgow
[no.**73**]

Nude Model Reclining 1900
Pastel on brown paper 18.1 × 27.9 | 7 ¹/₈ × 11
Private collection, England
[no.**86**]

A Draped Model Reclining c.1900
Pastel and charcoal on brown paper
17.8 × 27.7 | 7 × 11
Hunterian Museum and Art Gallery,
University of Glasgow
[no.**85**]

LENDERS AND CREDITS

LENDERS
PUBLIC COLLECTIONS

Aberdeen Art Gallery and Museums Collection | 53
Albi, Musée Toulouse-Lautrec |66
Birkenhead, Williamson Art Gallery & Museum | 35
Birmingham | Barber Institute of Fine Arts | The University of Birmingham | 19
Bury Art Gallery & Museum | 11
Cambridge | The Fitzwilliam Museum | University of Cambridge | 94
Canberra | National Gallery of Australia | 95
Cairo | Musée Mahmoud Khalil | 65
Chicago | Art Institute of Chicago | 26
Dieppe | Chateau-Musée de Dieppe | 74
Durban Art Gallery | South Africa | 12
Edinburgh | National Galleries of Scotland | National Gallery of Scotland | 18 | 51 | 52
Edinburgh, National Galleries of Scotland, Scottish National Gallery of Modern Art | 107
Glasgow, Hunterian Art Gallery, University of Glasgow | 73 | 85 | 88
Glasgow Museums, The Burrell Collection | 6
Hamilton (Ontario), Art Gallery of Hamilton | 97
Indianapolis Museum of Art | 96
Leeds Museums and Art Galleries, City Art Gallery | 80 | 83
Lincoln, Usher Gallery | 48 | 49 | 81
Liverpool, National Museums Liverpool, The Walker | 27 | 106
London, The British Museum | 57 | 58 | 59 | 60 | 71 | 72
London, Courtauld Institute of Art Gallery | 8 | 101
London, The Fan Museum | 40
London, National Gallery | 22
London, National Portrait Gallery | 78
London, Tate | 2 | 3 | 7 | 13 | 14 | 17 | 37 | 55 | 62 | 76 | 89 | 92 | 100 | 104 | 105 | 111
London, Victoria and Albert Museum | 15 | 23 | 63 | 64
London, William Morris Gallery | 36
Manchester City Galleries | 47
Milwaukee Art Museum | 1
Montserrat (Barcelona), Museu de Montserrat | 21
New York, The Metropolitan Museum of Art | 43 | 93
New York, Brooklyn Museum of Art | 79
Ottawa, National Gallery of Canada | 24 | 29
Paisley Museum and Art Gallery | 31
Paris, Bibliothèque nationale de France | 34 | 44
Paris, Musée d'Orsay | 42 | 67 | 68
Paris, Musée Rodin | 98
Philadelphia Museum of Art | 110
Pittsburgh, Carnegie Museum of Art | 75
Rouen, Musée des Beaux-Arts | 61
Sheffield Galleries and Museums Trust | 82
Southampton City Art Gallery | 109
Swansea, Glynn Vivian Art Gallery Collection | 103
Sydney, Art Gallery of New South Wales | 25 | 28
Tacoma Art Museum | 3
Toledo Museum of Art | 16 | 77
Toulouse, Musée des Augustins | 69
Washington, Corcoran Gallery of Art | 4
Washington, The Phillips Collection | 5 | 112 | 113
Williamstown, Sterling and Francine Clark Art Institute | 70
Winterthur, Kunstmuseum | 108

LENDERS
PRIVATE COLLECTIONS

Barry Humphries | 41 | 45 | 46 | 50 | 54 | 56
Eberhard W. Kornfeld, Bern | 38
Donà dalle Rose Collection | 10
Private collection, courtesy of The Belgrave Gallery, London | 30
Private collection, courtesy of Ivor Braka Ltd, London | 84
Private collections | 9 | 10 | 20 | 32 | 33 | 86 | 87 | 90 | 91 | 99 | 102

PHOTOGRAPHIC CREDITS
CATALOGUE ILLUSTRATIONS

Aberdeen Art Gallery & Museums Collections |53
 Tous droits réservés, Musée Toulouse-Lautrec, Albi, Tarn, France | 66
Galerie Kornfeld, Bern |38
Williamson Art Gallery and Museum, Birkenhead | 35
The Barber Institute of Fine Arts, The University of Birmingham | 19
Brooklyn Museum | 79
Bury Art Gallery & Museum, Lancashire | 11
Photograph courtesy of the Fitzwilliam Museum, University of Cambridge
National Gallery of Australia, Canberra | 95
The Art Institute of Chicago | 26
Durban Art Gallery | 12
© National Galleries of Scotland. Photo: Antonia Reeve | 18 | 51 | 52
The Scottish National Gallery of Modern Art | 107
Photograph courtesy of The Fine Art Society, London, UK/The Bridgeman Art Library | 33
Photography by John Gibbons | 87
© Glasgow Museums | 6
© Hunterian Museum and Art Gallery, University of Glasgow |73 | 85 | 88
Photography by Matthew Hollow |41 | 45 | 46 | 50 | 54 | 56
Indianapolis Museum of Art | 96
Leeds Museums and Galleries (City Art Gallery) U.K., www.bridgeman.co.uk | 80 | 83
Lincolnshire County Council; The Collection, Art and Archaeology in Lincolnshire | 48 | 49 | 81
National Museums Liverpool (The Walker) | 27 | 106
Belgrave Gallery, London. Photo: David Brown | 30
British Museum | 57–60 | 71 | 72
Christie's Images |84
The Samuel Courtauld Trust, Courtauld Institute of Art Gallery, London |8 | 101
Lent by the Fan Museum, Greenwich, London |40
© The National Gallery, London |22
National Portrait Gallery, London | 78
Tate | 2 | 3 | 7 | 13 | 14 | 17 | 37 | 55 | 62 | 76 | 89 | 92 | 100 | 104 | 105
Tate Photography/ Andrew Dunkley & Marcus Leith | 36 | 90 | 91 | 99
V&A Images/ Victoria and Albert Museum |15 | 23 | 63 | 64
© Manchester Art Gallery | 47
© Sterling and Francine Clark Art Institute, Williamstown, Massachusetts, USA | 70
Milwaukee Art Museum | 1
Museu de Monserrat | 21
Photograph © 1980 The Metropolitan Museum of Art |43 | 93
Toledo Museum of Art, Ohio |16 | 77
Art Gallery of Hamilton, Ontario |97
© National Gallery of Canada, Ottawa | 24 | 29
Paisley Museum and Art Galleries, Renfrewshire Council | 31
Bibliothèque National de France, Paris | 34
© photo RMN - H. Lewandowski | 42 | 67 | 68
© musée Rodin (Photo Adam Rzepka) |98
Philadelphia Museum of Art: The Henry McIlhenny Collection, in memory of Frances P. McIlhenny, 1986 | 110
Carnegie Museum of Art, Pittsburgh | 75
Private Collection | 20
Private Collection | 32
Private Collection, England. Photography by Jonathan Gooding | 86
Private Collection. HM Photographic | 102
© Musées de la Ville de Rouen . Photography Didier Tragin, Catherine Lancien | 61
© Musées de la Ville de Rouen. Photographie Catherine Lancien, Carole Loisel | 74
Sheffield Galleries and Museums Trust, UK, www.bridgeman.co.uk | 82
Southampton City Art Gallery, Hampshire, UK, www.bridgeman.co.uk | 109
City & County of Swansea: Glynn Vivian Art Gallery Collection | 103
Art Gallery of New South Wales, Sydney. Photograph: Mim Stirling | 25
Art Gallery of New South Wales, Sydney. Photograph: Brenton McGeachie | 28
Toulouse, Musée des Augustins. Photo: Bernard Delorme | 69
Corcoran Gallery of Art, Washington DC | 4
The Phillips Collection, Washington DC | 5 | 112 | 113
Tacoma Art Museum, Washington. Photo: Richard Nicol | 39
Kunstmuseum Winterthur |108

PHOTOGRAPHIC CREDITS
FIGURE ILLUSTRATIONS

Photograph by Jack Abraham | fig.30
The Baltimore Museum of Art | fig.51
© The Royal Pavilion, Libraries and Museums, Brighton and Hove | fig.23
© Fitzwilliam Museum, Cambridge |figs.22 | 34 | 50
Photography © 1997, The Art Institute of Chicago | fig.31
Photography © The Art Institute of Chicago | fig.44
National Gallery of Ireland | fig.37
Photography by Matthew Hollow | fig.29
Photography by Katya Kallsen | fig.52
© The Bridgeman Art Library |figs.12 | 19 | 26 | 42 | 49
The British Museum, London |fig.24
Private Collection c/o Browse & Darby | fig.47
From the Picture Collection, Royal Holloway, University of London | fig.13
National Portrait Gallery, London | fig.6
Photograph © The Metropolitan Museum of Art | figs.8 | 9 | 11
© The Pierpont Morgan Library 2005 | fig.21
Museo Thyssen-Bornemisza, Madrid | fig.20
© Manchester City Art Galleries | fig.7
© Manchester Art Gallery | fig.33
The Dixon Gallery and Gardens, Memphis Tennessee | fig.28
Bibliothèque Historique de la Ville de Paris, Paris | fig.32
Bibliothèque Nationale de France, Paris | fig.38 | 39
Courtesy Arsène Bonafous-Murat, Paris |fig.5
RMN, Paris | figs.10 | 45
© National Gallery in Prague | fig.41
Rhode Island School of Design, Photography by Erik Gould | fig.17
Peter Willi/ Bridgeman Art Library | fig.35
Freer Gallery of Art, Smithsonian Institution, Washington DC | fig.43
© Board of Trustees, National Gallery of Art, Washington DC | fig.36
Hahnloser Collection, Villa Flora, Winterthur | fig.46

COPYRIGHT

Jacques-Emile Blanche
 © ADAGP, Paris and DACS, London 2005
Pierre Bonnard
 © ADAGP, Paris and DACS, London 2005
George Clausen
 Estate of George Clausen
All works by Henri Matisse
 © Succession H. Matisse, 2005
Alphonse Mucha
 © Estate of Alphonse Mucha / The Bridgeman Art Library
William Rothenstein
 © Estate of William Rothenstein / The Bridgeman Art Library
Photographs by Adam Rzepka
 © ADAGP, Paris and DACS, London 2005
Walter Richard Sickert
 © Estate of Walter R. Sickert 2005.
 All Rights Reserved, DACS